LINCOLN PUBLIC LIBRARY, MASS.

P9-DFE-265

LINCOLN
LIBRARY

July 2007 709.02

LINCOLN PUBLIC LIBRARY
3 BEDFORD ROAD
LINCOLN, MA 01773
781-259-8465

DEMCO

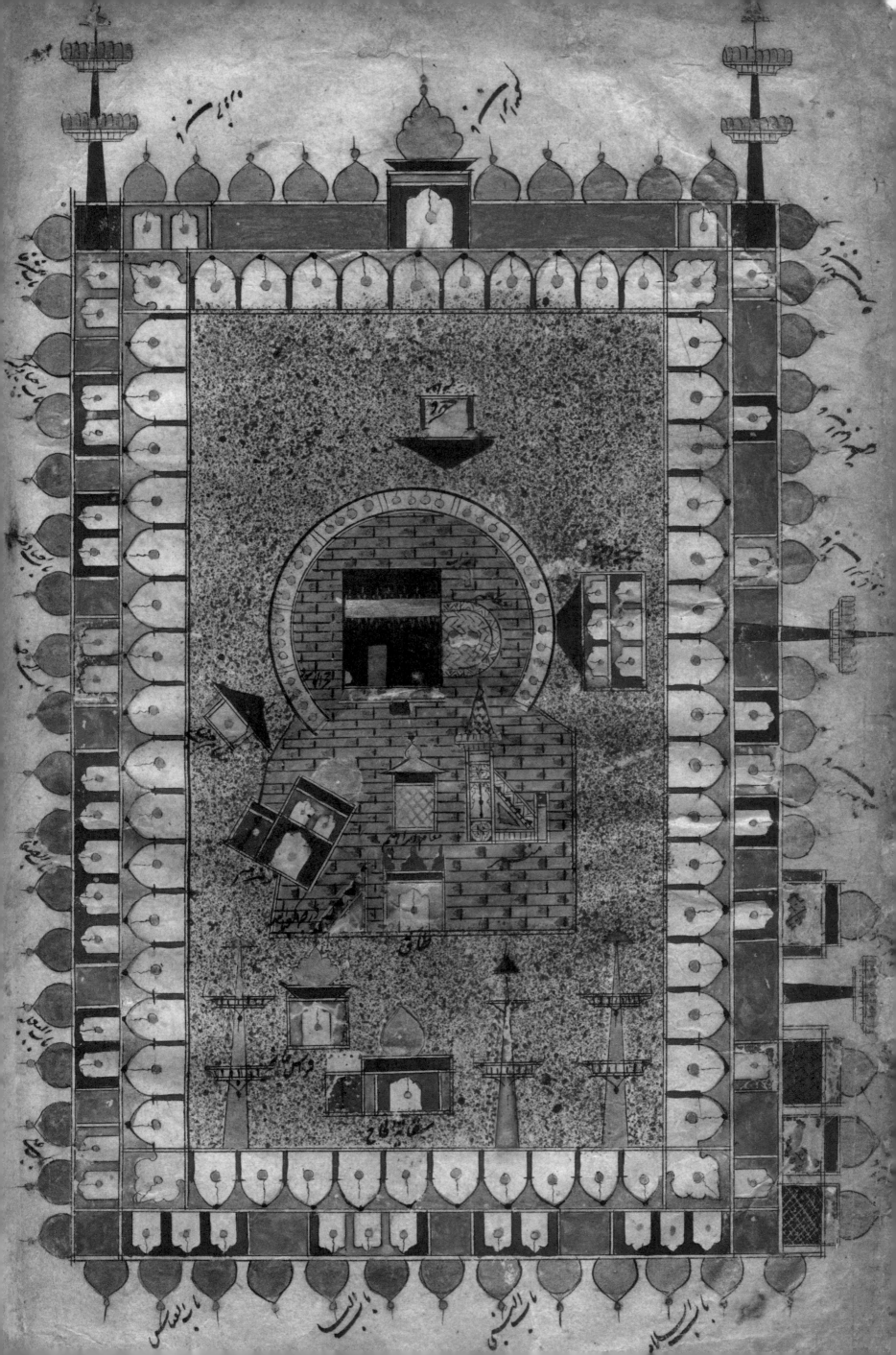

ISLAMIC ART
AND CULTURE

A VISUAL HISTORY

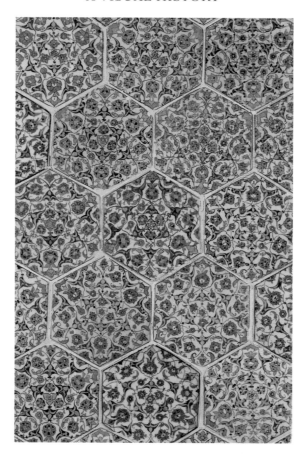

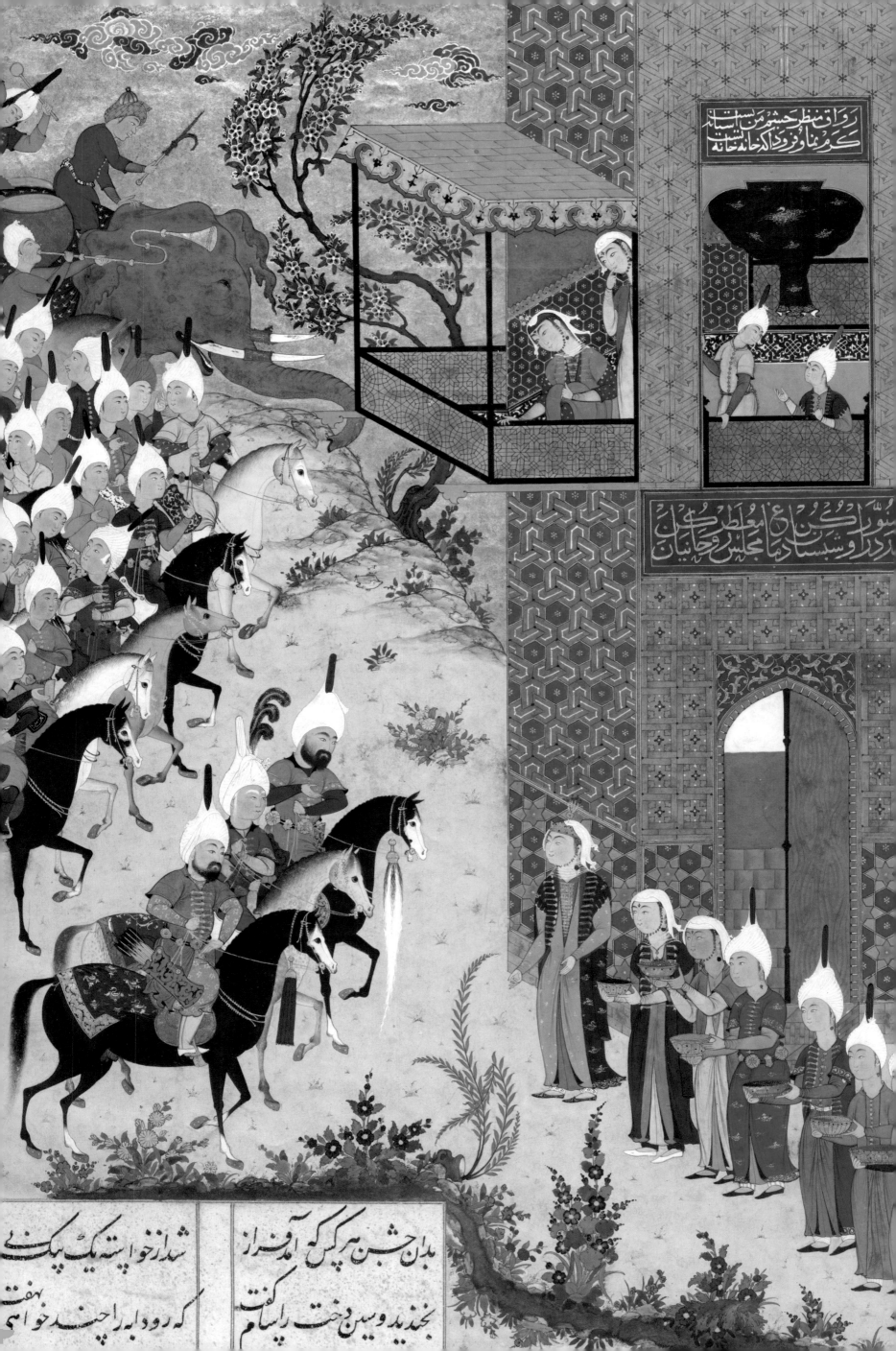

ISLAMIC ART
AND CULTURE

A VISUAL HISTORY

NASSER D. KHALILI

The Overlook Press
Woodstock & New York

First published in the United States in 2006
by Overlook Press, Peter Mayer Publishers,
Inc.

NEW YORK
141 Wooster Street, New York NY 10012

Woodstock
One Overlook Drive, Woodstock, NY 12498
www.overlookpress.com
[for individual orders, bulk and special sales,
contact our Woodstock office]

Text © Nasser D. Khalili 2005
All images from the Khalili Collection © The
Khalili Family Trust 2005
For other image copyrights, see page 183.

All rights reserved. No part of this
publication may be reproduced or
transmitted in any form or by any means,
electronic or mechanical, including
photocopy, recording, or any information
storage and retrieval system now known or
to be invented, without permission in
writing from the publisher, except by a
reviewer who wishes to quote brief passages
in connection with a review written for
inclusion in a magazine, newspaper, or
broadcast.

Cataloguing-in-Publication Data is
available from the Library of Congress

ISBN-10 1-58567-839-2
ISBN-13 978-1-58567-839-6

Publisher's note. Every effort has been
made to ensure the accuracy of the
information presented in this book. The
Publisher will not assume liability for
damages caused by inaccuracies in the data
and makes no warranty whatsoever
expressed or implied. The Publisher
welcomes comments and corrections from
readers, emailed to worthpress@aol.com,
which will be considered for incorporation
in future editions.

Contributions and research by
Rudolf Abraham.

Cartography by Macart.
Designed and produced by
DAG Publications Ltd.

Printed and bound in China.

Endpapers: Detail of calligraphic silk
textile, with repeating word, 'God'.
Possibly North Africa, 18th century.
Facing page 1: View of the Masjid
al-Haram at Mecca, from a copy of
the *Futuh al-Haramayn*, a guide to
pilgrimage. Mecca, June 1582.
Page 1: Panel of hexagonal
tiles. Ottoman Turkey
(Iznik), 16th century.
Frontispiece (page 3):
*Sam and Zal welcomed
into Kabul, where the
latter is to be betrothed
to Rudabe*, perhaps
painted under the
direction of Mir
Musavvir, from the
'Houghton'
Shahname made for
Shah Tahmasp I.
Iran, Tabriz, 1520s.
Right: Gold and
enamel *huqqa* (water-
pipe). India, Mewar
(Rajasthan), early 18th
century.
Jacket front: © Richard Nowitz /
Getty Images National Geographic
Collection

Contents

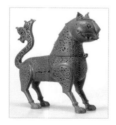
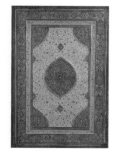

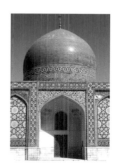

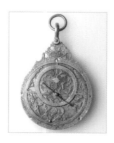

Professor Nasser D. Khalili
and the Khalili Collections

Professor Nasser D. Khalili KSS, KCFO is a scholar, collector and benefactor of international standing, who has often been called the 'cultural ambassador of Islam' by leaders of Muslim countries. After completing his schooling and national service in Iran he moved to the United States of America in 1967, where he continued his education. In 1978 he settled in the United Kingdom.

Since 1970 he has assembled a number of impressive art collections in a broad range of fields. In addition to a comprehensive collection of the arts of the Islamic world (c. 700–2000), there are collections of Japanese art of the Meiji period (1868–1912), Swedish textiles (1700–1900) and Spanish damascened metalwork (1850–1900).

Combined, the Khalili Collections comprise some 25,000 objects, which have been researched, conserved and presented to the public in a series of publications and exhibitions worldwide. The Islamic, Japanese, Swedish and Spanish collections are being catalogued in an important series of more than 40 volumes, of which over 80 per cent have been published. Once completed, the series will form a unique survey of each field and will be the biggest art publication project of any collector to date. Selected pieces from these collections have been shown in a series of major exhibitions in more than 30 museums throughout the world: *Empire of the Sultans*, an exhibition of Ottoman art from the Khalili Collections, was seen at 13 arts venues in the USA alone. In addition, key objects have been loaned to more than 40 different museums and institutions, from the Metropolitan Museum of Art, New York, USA to the State Hermitage Museum, St Petersburg, Russia.

Nasser Khalili is a frequent lecturer. He has also made notable contributions to the scholarship of Islamic art, having endowed in 1989, under the auspices of The Khalili Family Trust, the Nasser D. Khalili Chair of Islamic Art and Archaeology at the School of Oriental and African Studies, University of London, the first chair devoted to the decorative arts of Islam to be founded at any university. He has also supported a research fellowship in Islamic art at the University of Oxford. More recently, The Khalili Family Trust made a significant endowment to the University of Oxford to establish and support The Khalili Research Centre for the Art and Material Culture of the Middle East, which opened in 2005. Nasser Khalili is a graduate, Associate Research Professor and Member of the Governing Body of the School of Oriental and African Studies, and an Honorary Fellow of the University of London. He was appointed to the International Board of Overseers at Tufts University, Massachusetts, USA, in 1997 and in 2003 received the honorary degree Doctor of Humane Letters from Boston University, being elected to the Board of Trustees of Boston University later that year. In May 2005 he also received an Honorary Doctorate from the University of the Arts London, in recognition of his contribution to world art.

Nasser Khalili is the co-founder and chairman of the Maimonides Foundation, which promotes peace and understanding between Jews and Muslims. He is also co-founder of the Iran Heritage Foundation, which promotes and preserves the cultural heritage of Iran. In 1996 he was honoured with the title Trustee of the City of Jerusalem for his pursuit of culture and peace among nations and in 2003 was made a Knight Commander of the Royal Order of St Francis I (KCFO) at Westminster Cathedral in recognition of his interfaith activities. His Holiness Pope John Paul II granted him an audience at the Vatican in 2002, when he bestowed on him the Medaglia Pontificia, and in 2004 further honoured him by making him a Knight of the Equestrian Order of Pope St Sylvester (KSS).

Foreword

By the early 8th century, within little more than a few decades of the Prophet Muhammad's death, the lands of Islam stretched from the Atlantic to the China Sea and from North Africa to the frontiers of Siberia. The development of the sea-borne spice trade, and the expansion of the Silk Routes across Central Asia, brought the luxuries of the Far East and the Indies to the generally less civilized kingdoms of Northern Europe. The Abbasid caliphs in 9th-century Baghdad generously sponsored translations of the classics from Sanskrit, Greek and Syriac which revived the culture of Late Antique Alexandria. And Muslim discoveries in medicine, geography, mathematics and astronomy contributed substantially to the development of Western science in the Middle Ages: we even owe terms like algorithm, algebra and alchemy to the Islamic models upon which the Western disciplines of mathematics and chemistry were based.

The European 'Age of Exploration' in the late 15th and 16th centuries shifted the balance of power towards Europe and the New World, and the later Muslim empires, the Ottomans in Turkey, the Mughals in India and the Safavids in Iran, were slowly eclipsed, and even occupied, as in the Indian sub-continent and Southeast Asia, by the Portuguese, the Dutch and the British. Despite economic decline and the inroads of colonialism, however, in the face of these challenges Islamic cultures acquired a new resilience, gradually assimilating the technologies of the West. And with the exploitation of enormous oil resources in the Middle East in the 20th century the unprecedented prosperity prepared Islam for a new phase in its relations with the West.

With economic power came political rivalry, inevitably exacerbated by lack of understanding, which has come to a peak in the past two decades. The course of modern history, unsurprisingly, has made Islamic states suspicious of Western designs, while the West, for its part, has become obsessed with the future of Islam. There is an urgent need for greater mutual comprehension, which will open up the way to the international co-operation upon which the future of the civilized world depends.

In response to this demand there has been a boom in popular studies of Islam, sometimes, however, unrewardingly polemical, and practically all political in tenor. But Islam is more than politics or politicised religion. It is time to turn to the achievements of Islamic culture, notably to the art and architecture of Islam, which over the centuries has contributed no less than Islamic science to the West. As a subject of study, however, it is of relatively recent growth and has been too long a subject for professional scholars. The present overview for the interested non-specialist, taking account of both the history and geographical range of Islamic cultures, is thus timely. It will be read with profit by anyone anxious to discover more of the major contribution of Islam to the history of world culture.

Many of the illustrations to the present volume are from the Khalili Collection of Islamic art. This is the largest and most comprehensive collection of Islamic art in private hands in the world, with works covering almost 1400 years and an area from Spain to China, and it is hoped that in the next few years it will go on public display. Professor Nasser D. Khalili's aim has been to build a substantial body of study material, as well as a representative collection of masterpieces, and thus illuminate familiar as well as hitherto neglected aspects of the development of Islamic art. His conviction that knowledge of this art is essential to the understanding of the cultures of Islam and the Islamic countries thus finds its embodiment in the present publication.

J.M. ROGERS
Honorary Curator, The Nasser D. Khalili Collection of Islamic Art

J.M. Rogers was Deputy Keeper in the Department of Oriental Antiquities at the British Museum (1977–90); then the first holder of the Nasser D. Khalili Chair of Islamic Art and Archaeology at the School of Oriental and African Studies, University of London (1990–2001); and is now Honorary Curator of the Khalili Collection. He is the author of numerous articles and books on Islamic art and architecture, including the exhibition catalogue *Empire of the Sultans. Ottoman art in the collection of Nasser D. Khalili* (Geneva, 1995).

Preface

Collecting art has played a very important part in my life for more than three decades. During this time I have assembled significant collections representing the arts of the Islamic world, Japanese art of the Meiji period, Spanish metalwork produced by the Zuloaga family and the textile arts of countries as diverse as Sweden and India. This period of my life has been exceptionally fulfilling, giving me an enormous amount of pleasure and a true sense of achievement.

Personal satisfaction is by no means my sole motive, however, for I see these collections as a means by which I can promote a better understanding of the cultures that produced them. For this reason, I have also undertaken extensive programmes of research, publication and exhibition, making the collections available to a wider public. This is not merely an academic exercise but a challenge to intolerance, for I believe that there is much more that unites people than divides them, and an appreciation of art can be that unifying factor.

My interest in Islamic art started during my early childhood in Iran, and as a result this is by far the largest of my collections, with over 20,000 objects. Its size, of course, also reflects the large geographical area and long period of time covered by the term 'Islamic art'. The earliest pieces are from the 7th century AD, and the latest from the 20th. Some items originated from Spain and Morocco, close to the Atlantic coast, whilst others are from China and Indonesia in the Far East. My aim has been to put together a selection of objects that represents, as comprehensively as possible, the artistic production of the Muslim peoples. I am delighted to say that to a large extent that aim has been achieved.

Given my background in Iran, I look upon Islamic art as part of my heritage, and my endeavours to promote wider knowledge of it have been made with that in mind: they are a contribution from one member of the human family to another. My hope is that my work in this area will lead to a greater understanding between religions, based on education. To this end, in 1989, and under the auspices of The Khalili Family Trust, I endowed a Chair of Islamic Art and Archaeology at the School of Oriental and African Studies, University of London, and supported a fellowship at Oxford University. The Khalili Family Trust also made a significant endowment to establish the Khalili Research Centre for the Art and Material Culture of the Middle East at Oxford, which opened in July 2005.

Until now, this education programme has been aimed at the more advanced student specializing in Islamic art. *Islamic Art and Culture* is a move in a new direction for me, as it is designed as an aid to those with a budding interest in the subject. It is my hope that, in my fortunate and unusual position as a collector and an academic with experience of both East and West, I can bring a unique perspective to the text. Meanwhile, the publication's format is ideally suited to illustrate, at a glance, the glorious tradition of Islamic art and architecture, and the important contributions Muslim civilizations have made to our world culture.

Publication of *Islamic Art and Culture* would not have been possible without the support of a large number of people. First and foremost I would like to thank Rudolf Abraham for his tireless help with all aspects of preparation of the manuscript, from researching the text to choosing the images. The majority of the illustrations are drawn from my Islamic art collection, and I would like to thank my curatorial staff, especially Nahla Nassar, for their assistance with refining the text and selecting objects for illustration; and Christopher Phillips, who took many of the photographs. I am truly grateful to Professor J.M. Rogers, late of the British Museum and the School of Oriental and African Studies, University of London, and now Honorary Curator of the Collection, for contributing the Foreword. I would also like to express my gratitude to Ken Webb of Worth Press who originally developed the *Islamic Art and Culture* format; Alison Effeny, who edited the text; and David Gibbons, who designed the publication. Finally, I should like to thank my wife Marion and our three sons, Daniel, Benjamin and Raphael, for their patient support for all my projects.

NASSER D. KHALILI

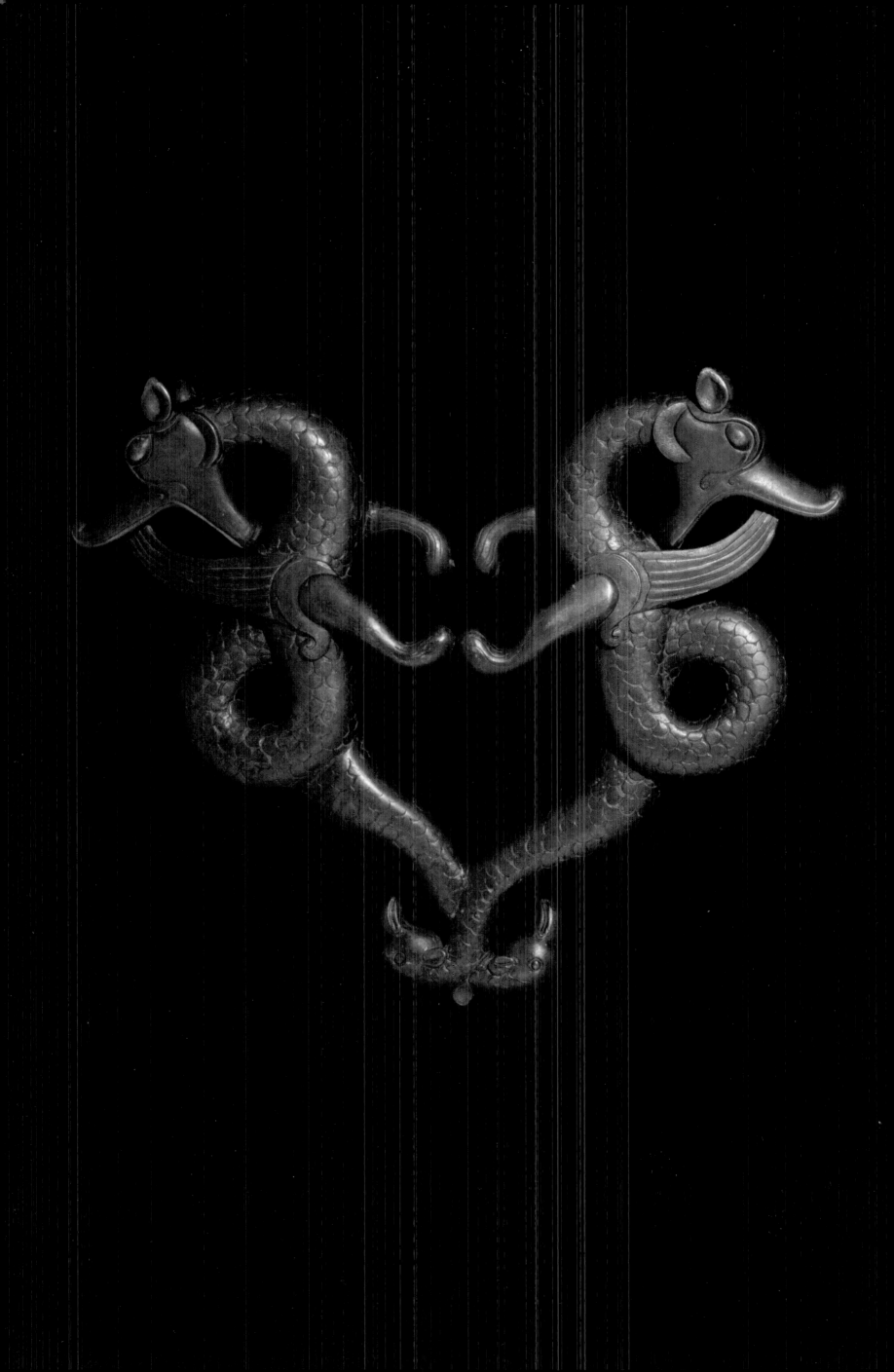

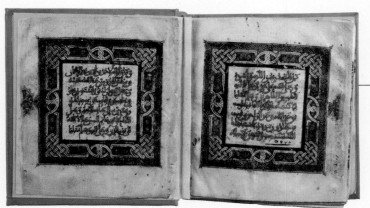

Single-volume
Qur'an on parch-
ment. Valencia,
1199–1200

● Poitiers

● Zaragoza

Toledo
●

● Valencia

ANDALUSIA

Madinat al-Zahra
●
● ● Cordoba
Seville ● Granada

Tunis ●
Qayrawan ●

● Tlemcen

MAGHRIB

Rabat
● ● Fez

ALGERIA

T U N I S

MOROCCO

● Marrakesh

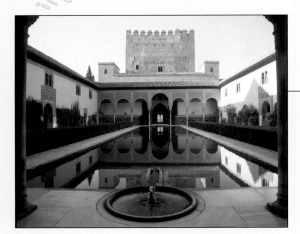

Court of the Myrtles, Alhambra Palace. Granada, 1347–8

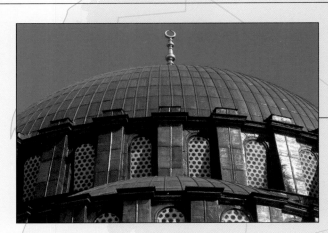

Süleymaniye
Mosque. Istanbul,
1551–7

Folio from a large Qur'an on parch-
ment. Tunisia, early 11th century

Woollen carpet.
Western Anatolia,
Uşak, late 15th–16th
century

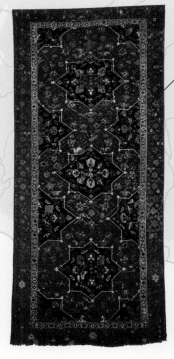

Major Historical and Cultural Sites of the Islamic World

This map locates key sites mentioned in the text.
Modern national boundaries are shown for reference,
but modern country names are only included if they
are referred to elsewhere. For more information on
modern countries, see the Reference Wheel at the
back of the book.

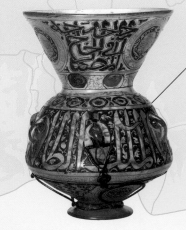

Gilded and enamelled glass mosque
lamp, with blazons of the Mamluk
Sultan Barquq. Egypt, c. 1385

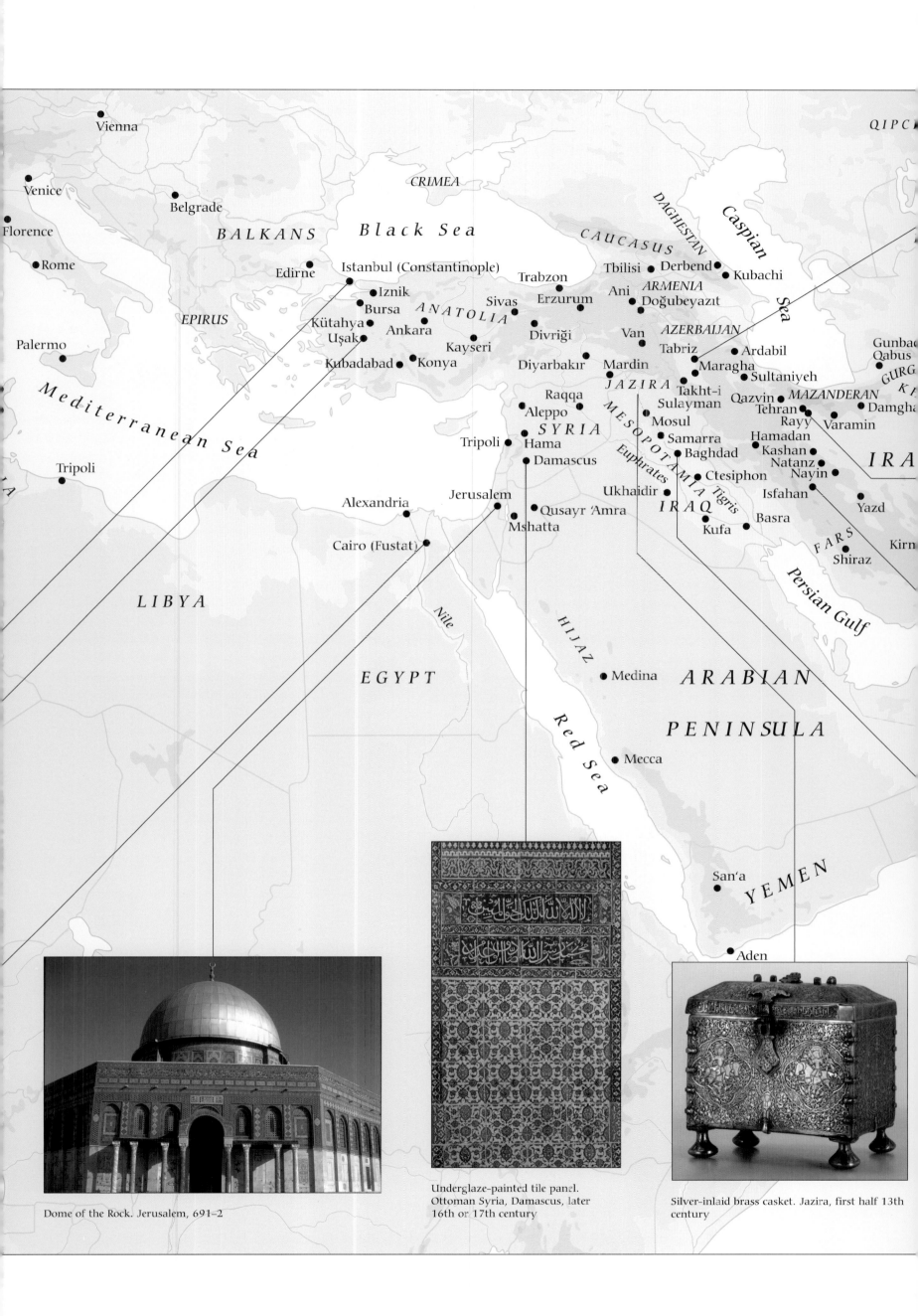

Vienna

Venice

Florence

Rome

Palermo

Tripoli

Mediterranean Sea

LIBYA

EGYPT

BALKANS

Belgrade

EPIRUS

Edirne Istanbul (Constantinople)

Iznik

Bursa

Kütahya

Uşak Ankara

Kubadabad Konya

Kayseri

CRIMEA

Black Sea

ANATOLIA

Trabzon

Sivas

Erzurum

Divriği

Diyarbakır Mardin

Raqqa

Aleppo *SYRIA*

Tripoli Hama

Damascus

Jerusalem

Alexandria

Qusayr 'Amra

Mshatta

Cairo (Fustat)

Nile

DAGHESTAN

CAUCASUS

Tbilisi Derbend

Ani *ARMENIA* Kubachi

Doğubeyazıt

Van *AZERBAIJAN*

Tabriz Ardabil

Maragha

JAZIRA Takht-i Sultaniyeh

Sulayman Qazvin

Mosul Tehran

MESOPOTAMIA Samarra Hamadan

Euphrates Baghdad Kashan

Ukhaidir Ctesiphon Natanz

Tigris Isfahan

IRAQ

Kufa Basra

Caspian Sea

QIPC

Gunba

Qabus

GURG

MAZANDERAN

Rayy Damgha

Varamin

IRA

Nayin

Yazd

FARS Kirn

Shiraz

Persian Gulf

HIJAZ

Red Sea

Medina

Mecca

ARABIAN

PENINSULA

San'a *YEMEN*

Aden

Dome of the Rock. Jerusalem, 691–2

Underglaze-painted tile panel.
Ottoman Syria, Damascus, later
16th or 17th century

Silver-inlaid brass casket. Jazira, first half 13th
century

Introduction

The Islamic era began in the year AD 622 with the *Hijra* (or emigration) of the Prophet Muhammad from Mecca to Medina. Within less than two centuries of his death in 632, Islam had spread to conquer territories stretching from Spain in the west to Afghanistan and North India in the east. Civilizations of very different religious, cultural, historic and artistic backgrounds were thus united under the single banner of Islam. A few centuries later, sizeable Muslim communities had been established in an even wider area of the Old World, running from Africa across the Indian Ocean to Southeast Asia and from there northwards through China.

In this context, the term 'Islamic art' can be used broadly to describe art produced by Muslim artists for Muslim patrons (although of course, there are numerous works produced by, or for, non-Muslims within these wide-ranging territories). It also covers a multitude of forms, ranging from architecture to book-production and the decorative arts such as glass, metalwork, pottery, jewellery and textiles. 'Islamic' does not imply that this art is exclusively religious in content or use: a significant portion of it is secular in nature. Instead, it is 'Islamic' because its artistic vocabulary is partly rooted in Muslim philosophical thought. The creative expression of the various Muslim peoples is shaped, to some extent, by the spirit and the doctrines of the Muslim faith. This is why we are able to discuss Islamic art as the art produced by the group of nations brought together under Islam, and not as the art of a single country or civilization.

One of the main characteristics of Islamic art is the paramount importance of calligraphy, and the role it played not just as an art form in its own right, but in the decoration of all other media as well, from architecture to pottery. In Islam, calligraphy is awarded a status higher than that of any other art form. As the medium through which the Qur'an was transmitted and recorded, it was only natural that the Arabic script acted as a spiritually unifying factor and received a unique, elevated position. Another important characteristic of Islamic art, and one of its most familiar features, is the extensive use of scrollwork, arabesques, geometric motifs and interlace patterns.

Contrary to popular assumption, figural imagery also plays an important role in Islamic art. Although the *hadith* (traditions) prohibit the representation of human beings and animals in a religious context, this rule does not extend to secular art. Therefore although they are almost universally avoided in mosque decoration or in Qur'ans, a wealth of figural scenes and representations of birds and animals freqently feature in secular art and architecture.

Throughout their history, Islamic art and culture have been influenced by the artistic traditions of the empires with which they came into contact, as local styles were adapted to the needs of the new faith and remodelled to comply with its religious and philosophical ideas. This interaction, frequently encouraged through trade (not to mention conquest and territorial expansion) has enriched not only the material culture of the Muslim world but also that of those pre-existing cultures. In its initial stages, Islamic art was deeply embedded in the styles prevailing before Islam, those of Byzantium in the west and Sasanian Iran in the east. By the middle of the 8th century, however, when the Abbasids came to power, Islamic art had matured into a fully independent art form.

The development of Islamic art was, until recently, believed by many to end in the early 19th century, when artistic production was seen to decline. This was considered to be a direct result of increased diplomatic and trade relations between Europe and the Muslim world. This approach, however, ignores the strong revivalist movements that sprang up at the same time in different centres within the Islamic world, and overlooks the work of many living artists, which is undeniably linked to the traditions of the past. The output of these artistic revivals, and indeed much of the work produced in the 20th century, should not be regarded as mere copying. Rather, it should be seen as embodying pride in a rich, deeply rooted, common heritage, even at a time when it was constantly being subjected to foreign influences. The same challenges and responses will form Islamic art in the multi-cultural world of the 21st century.

A NOTE ON THE ISLAMIC CALENDAR
Islamic dates are reckoned from the *Hijra* (the flight of the Prophet Muhammad from Mecca to Medina), in the year AD 622. They are usually written with the prefix AH (for *anno Hegirae*), or simply H. They are based on a lunar calendar and this dating system falls behind the Western, solar calendar by just over 11 days per year. For simplicity, this book generally gives dates according to the Western calendar or Common Era (AD).

A NOTE ON TRANSLITERATION
Short vowels are not written in either Arabic or Persian, and there are consequently a number of possible systems and conventions for rendering Arabic and Persian words in transliteration. In this book we have tried to pick the most familiar spelling in a particular context, for example Mehmed the Conqueror rather than Mehmet (or even Muhammad) the Conqueror. Modern Turkish spelling has been used, with only a few exceptions, for example, Istanbul rather than İstanbul.

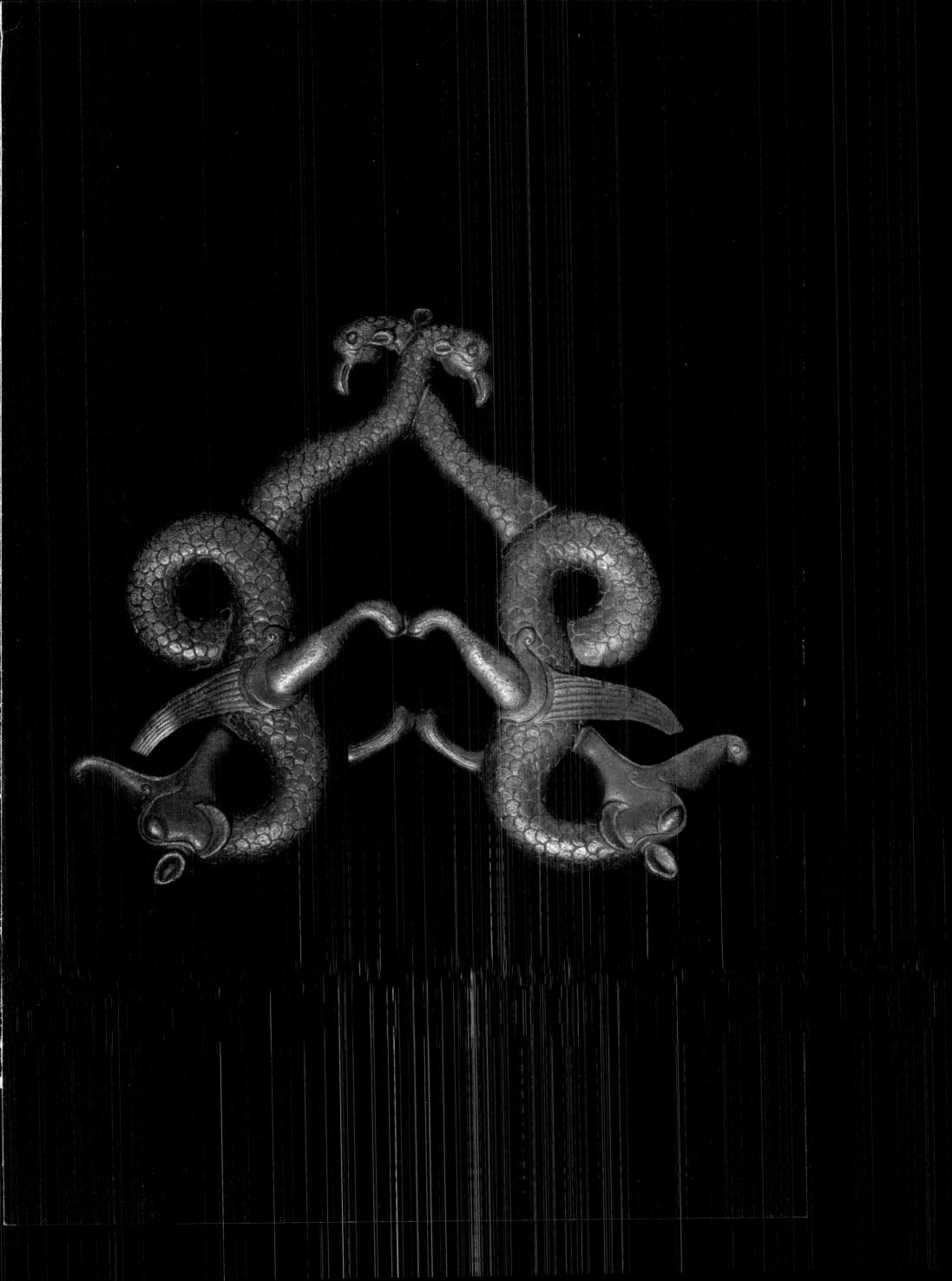

Beijing (Khanbaliq)

Frontispiece from a 30-part Qur'an. Khanbaliq (Beijing), 1401

Layla and her companions in a garden, from a *Khamse* of Nizami illustrated for the Emperor Awrangzeb. Mughal India, c. 1640–5

CHINA

Overleaf: Pair of copper alloy door handles. Jazira (southeast Turkey), early 13th century

Taj Mahal. Agra, 1632–47

BRUNEI

Cotton batik cloth. Java, early 20th century

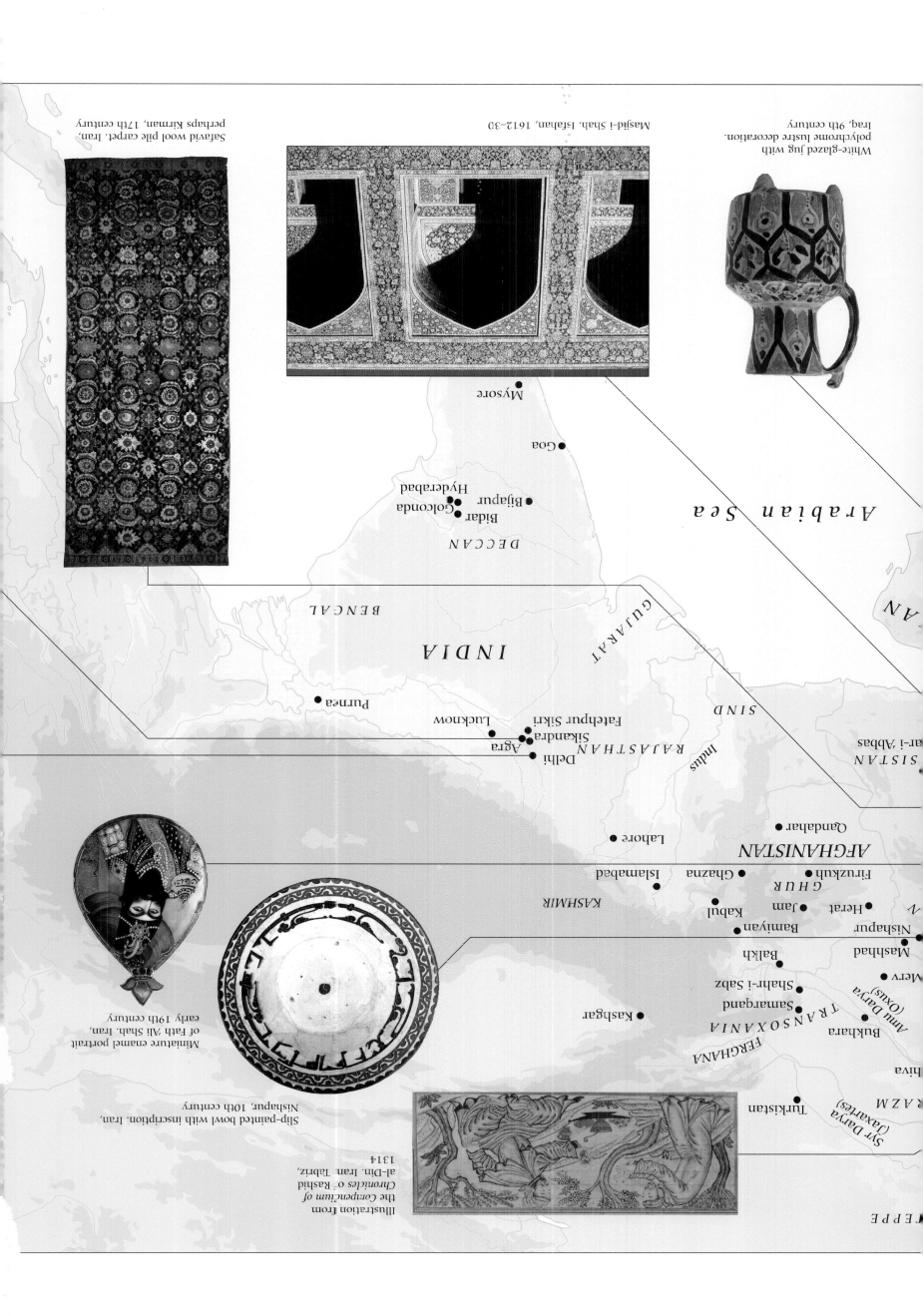

Safavid wool pile carpet, Iran,
perhaps Kirman, 17th century

Masjid-i Shah, Isfahan, 1612–30

White-glazed jug with
polychrome lustre decoration,
Iraq, 9th century

Mysore

Goa

Hyderabad
Golconda Bijapur
Bidar
DECCAN

Arabian Sea

BENGAL

GUJARAT

INDIA

SIND

Purnea

Lucknow
Sikandra Fatehpur Sikri
Agra
Delhi RAJASTHAN Indus

ar-i 'Abbas
SISTAN

Qandahar

Lahore

AFGHANISTAN

Islamabad Ghazna
Firuzkuh GHUR
KASHMIR Kabul Jam Herat Nishapur

Bamiyan Mashhad

Balkh Merv

Shahr-i Sabz
Samarqand TRANSOXANIA
Kashgar
FERGHANA
Bukhara

hiva

RAZM

Turkistan

Syr Darya
(Jaxartes)

Amu Darya
(Oxus)

Miniature enamel portrait
of Fath 'Ali Shah, Iran,
early 19th century

Slip-painted bowl with inscription, Iran,
Nishapur, 10th century

Illustration from
the Compendium of
Chronicles o' Rashid
al-Din, Iran, Tabriz,
1314

TEPPE

ISLAMIC DYNASTIES

The following list includes only major dynasties or those connected with developments in Islamic art and architecture as outlined in the text.

Dynasty	Dates	Main Areas of Control
Rashidun ('Rightly Guided' or Orthodox Caliphs)	632–661	Arabian peninsula, Iraq, Syria, Palestine, Egypt, Iran
Umayyads	661–750	Arabian peninsula, Iraq, Syria, Palestine, Egypt, North Africa, Spain, Iran, Transoxania
Abbasids	750–1258	Arabian peninsula, Iraq, Syria, Palestine, Egypt, North Africa, Iran, Transoxania
Umayyads of Spain	756–1031	Spain
Idrisids	789–985	Morocco
Aghlabids	800–909	Tunisia, Algeria and Sicily
Khwarazm Shahs	c. 1100–1231	Khwarazm (including Khiva in Central Asia), Transcaspia, Khurasan
Samanids	819–1005	Transoxania and Khurasan
Saffarids	861–1003	Sistan
Tulunids	868–905	Egypt and Syria
Zaydi Imams of Yemen	897–1962	Yemen
Fatimids	909–1171	North Africa, Egypt and southern Syria
Ziyarids	931–c. 1090	Tabaristan and Gurgan (both regions in northern Iran, on the eastern Caspian shore)
Buyids (Buwayhids)	932–1062	Iraq and western Iran
Zirids	972–1148	Tunisia
Ghaznavids	977–1186	Afghanistan, Khurasan, Baluchistan and northwest India
Qarakhanids	992–1212	Transoxania, Ferghana and eastern Turkestan
Ghurids	c. 1000–1215	Ghur (mountainous region of Afghanistan, southeast of Herat), Khurasan and north-west India
Great Seljuks	1040–1194	Iran, Iraq and Syria
Almoravids (al-Murabitun)	1062–1147	Northwest Africa and Spain
Anatolian Seljuks	1081–1307	Anatolia
Artuqids	c. 1101–1409	Diyar Bakr (region in southeast Anatolia, including modern Diyarbakir)
Zangids	1127–1251	Jazira (northern Mesopotamia) and Syria
Almohads (al-Muwahhidun)	1130–1269	North Africa and Spain
Salghurids	1148–1282	Fars
Hazaraspids	1148–1339	Luristan (a region in western Iran)
Ayyubids	1169–1260 (and until late 15th century in southeast Anatolia)	Egypt, Syria, Diyar Bakr, western Jazira, Yemen
Delhi Sultans	1206–1555	Northern India
Mongol Great Khans	1206–1368	Mongolia and conquered territories of Mongol empire, then Mongolia and China, then Mongolia
Marinids	1217–1465	North Africa
Chaghatay Khans	1227–1363	Transoxania, Semirech'ye and eastern Turkestan
Khans of the Golden Horde	1227–1395	South Russia, western Siberia and Khwarazm
Hafsids	1229–1574	Tunisia and eastern Algeria
Nasrids	1232–1492	Granada
Karts	1245–1389	Eastern Khurasan and northern Afghanistan
Mamluks	1250–1517	Egypt and Syria
Ilkhanids	1256–1353	Iran, Iraq, eastern and central Anatolia
Qaramanids	c. 1256–1475	Central and western Anatolia
Ottomans (Osmanlis)	1281–1924	Anatolia, the Balkans, Syria, Egypt and North Africa, Iraq, (much of) Arabian peninsula
Muzaffarids	1314–93	Southern and western Iran
Inju'ids	1325–53	Fars
Sultans of Kashmir	1339–1588	Kashmir
Jalayirids	1340–1432	Iraq, Azerbaijan and western Iran
Qara Qoyunlu	1351–1469	Eastern Anatolia, Iraq, Azerbaijan and western Iran
Timurids	1370–1507	Transoxania and Iran
Faruqi rulers of Khandesh	c. 1382–1601	Northwest Deccan
Aq Qoyunlu	1396–1508	Diyar Bakr and eastern Anatolia, Azerbaijan and western Iran, Fars and Kirman
Sultans of Gujarat	1403–1573	Western India
Barid Shahis	c. 1487–1619	Bidar
'Adil Shahis	1490–1686	Bijapur
Qutb Shahis	1496–1687	Golconda
Shaybanids (Uzbeks)	1500–99	Transoxania and northern Afghanistan
Safavids	1501–1722	Iran
Sultans of Brunei	15th/16th century (con-version to Islam)–present	Northern Borneo
Mughals	1526–1858	India
The Al Su'ud (Sa'ud)	1735–present	Southeast Najd, then in 20th century kings of Saudi Arabia
Afsharids	1736–96	Iran
Zands	1751–94	Iran (but not Khurasan)
Manghits	1753–1920	Khanate of Bukhara
Qungrats of Khiva	1804–1920	Khanate of Khiva
Qajars	1779–1925	Initially northern and central Iran; from 1794 all of Iran
Pahlavis	1925–79	Iran

Major Islamic Dynasties

The following pages relate the history of the major Islamic dynasties, from the death of the Prophet Muhammad in AD 632 until the fall of the last Ottoman and Qajar rulers in the early 20th century. The summaries give reign dates and list capital cities in chronological order. **In some cases, only a few rulers – those of greater artistic or political importance – have been included in the tables of rulers.** Likewise, a number of brief interregnums have been excluded. All dates refer to the reign, rather than the life, of a particular ruler.

The *Rashidun* ('Rightly Guided') or Orthodox Caliphs (632–61, Medina/Kufa). Following the death of Muhammad in 632, four members of his immediate circle ruled the Islamic world, assuming the title *Khalifa* (meaning 'successor') or Caliph. Abu Bakr was succeeded in 634 by 'Umar, under whom campaigns were directed against Byzantine Syria and Egypt, and Sasanian Iran. Damascus was taken in 635, Jerusalem in 638; while in the east the Sasanian army was defeated at Nihavand (in western Iran) in 642, and by 650 Arab armies had conquered Khurasan. The basis of civil administration in the conquered territories was also laid down during 'Umar's reign. He was succeeded by 'Uthman – a member of a powerful family from Mecca, the Banu Umayya – whose murder in 656 led to a period of unrest which has been termed the first civil war in Islam. The choice of a successor fell on 'Ali, Muhammad's cousin and, through marriage to the Prophet's daughter Fatima, also his son-in-law; this was opposed by Mu'awiya, the governor of Syria, a member of the Banu Umayya of Mecca, and a cousin of the murdered 'Uthman. 'Ali moved his capital from Medina to Kufa, but was unable to contend with the power of Mu'awiya, and he was murdered in 661.

Umayyads (661–750, Damascus). Following the murder of 'Ali, Mu'awiya (661–80) founded the Umayyad dynasty – an event contested by the Shi'a (from *shi'at 'Ali*, meaning 'the party of Ali'), who believed the caliphate should have passed instead to 'Ali's descendants. The Umayyad capital was at Damascus. Continued conquests brought the Islamic territories almost to their full extent: in the west, Arab armies crossed from Morocco into Spain in 710, and in the east, Sind was conquered the following year. With the influx of booty from these campaigns, architecture and the arts flourished. The beginnings of a distinctly Islamic style began to emerge, though it was still heavily influenced by the arts of Byzantium and Sasanian Iran. The Umayyads were faced with growing discontent from the *Mawali* (non-Arab subjects who had converted to Islam), who did not yet enjoy similar rights to their Arab counterparts, and with rival claims by the Shi'a. Ongoing rebellions in

The *Rashidun* ('Rightly Guided') or Orthodox Caliphs	
Abu Bakr	632–4
'Umar	634–44
'Uthman	644–56
'Ali	656–61

Umayyads	
Mu'awiya	661–80
Yazid I	680–83
Mu'awiya II	683–4
Marwan I	684–5
'Abd al-Malik	685–705
al-Walid	705–15
Sulayman	715–17
'Umar ibn 'Abd al-'Aziz	717–20
Yazid II	720–24
Hisham	724–43
al-Walid II	743–4
Yazid III	744
Ibrahim	744
Marwan II	744–50

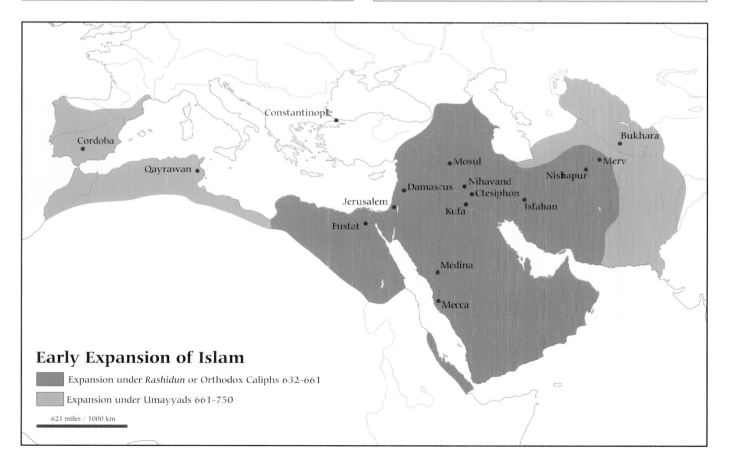

Early Expansion of Islam

- Expansion under *Rashidun* or Orthodox Caliphs 632-661
- Expansion under Umayyads 661-750

621 miles / 1000 km

the vast and diverse territories conquered by the Umayyads were exploited by al-'Abbas, a member of a rival family from Mecca who was descended from the Prophet's uncle. This led finally to the outbreak of a major revolt in eastern Iran, which spread throughout the Islamic territories. The Umayyad dynasty was overthrown, all except one of the Umayyad princes being massacred (see 'Umayyads of Spain', below), and was succeeded by the Abbasids.

Abbasids (750–1258, Baghdad/Samarra). Through their closer kinship to the line of the Prophet, the Abbasids claimed divine support and a higher degree of moral authority than the Umayyads. They emphasized these claims by stressing the idea of religious orthodoxy, and through the introduction of honorific titles (*laqab*). At the same time Sasanian models played an increasingly important role in court ceremonial and in administration. In 762 the caliph al-Mansur (754–75) moved the Abbasid capital eastwards, and founded Madinat al-Salam ('City of Peace'), better known as Baghdad. Later, in 836, the caliph al-Mu'tasim (833–42) founded a new capital at Samarra, approximately 60km up the Tigris from Baghdad. (This was partly because of conflict between the Turkish palace guards, who were slave-soldiers from Central Asia, and the local Arab population of Baghdad, and partly in order to express the glory and

prestige of his own reign.) Samarra was embellished and enlarged by succeeding caliphs, but was abandoned as a capital in 883. In the arts, a fully fledged Islamic style emerged with its own distinctive repertoire of motifs; while at the same time philosophy, literature and theology thrived, and numerous works of science were translated from Greek into Arabic. The apogee of the Abbasid period is often regarded as the reign of Harun al-Rashid (786–809). From the second half of the 9th century, however, the central power of the Abbasids was seriously eroded, as a number of minor dynasties in the provinces became increasingly powerful and independent, notably the Saffarids in eastern Iran, the Samanids in Khurasan and Transoxania, the Buyids in western Iran, and the Tulunids in Egypt and North Africa. In 945 the Shi'ite Buyids entered Baghdad and took power themselves, effectively reducing the caliph to a puppet figure. The conquests of the Seljuks, who took Baghdad in 1055, marked a return to Sunni (orthodox) Islam, although the temporal powers of the caliphate remained limited. Finally, the Mongols took Baghdad in 1258, and executed the last Abbasid caliph. The Mamluk sultan Baybars, however, installed a member of the Abbasid line as caliph in Egypt, where the dynasty survived, in name at least, until the Ottoman conquest of Cairo in 1517.

Abbasids	
Abu'l-'Abbas al-Saffah	749–54
al-Mansur	754–75
al-Mahdi	775–85
al-Hadi	785–6
Harun al-Rashid	786–809
al-Amin	809–13
al-Ma'mun	813–33
al-Mu'tasim	833–42
al-Wathiq	842–7
al-Mutawakkil	847–61
al-Muntasir	861–2
al-Musta'in	862–6
al-Mu'tazz	866–9
al-Muhtadi	869–70
al-Mu'tamid	870–92
al-Mu'tadid	892–902
al-Muktafi	902–08
al-Muqtadir	908–32
al-Qahir	932–4
al-Radi	934–40
al-Muttaqi	940–44
al-Mustakfi	944–6
al-Muti'	946–74
al-Ta'i'	974–91
al-Qadir	991–1031
al-Qa'im	1031–75
al-Muqtadi	1075–94
al-Mustazhir	1094–1118
al-Mustarshid	1118–35
al-Rashid	1135–6
al-Muqtafi	1136–60
al-Mustanjid	1160–70
al-Mustadi'	1170–80
al-Nasir	1180–1225
al-Zahir	1225–6
al-Mustansir	1226–42
al-Musta'sim	1242–58
1261–1517 Abbasid caliphs installed in Cairo under the Mamluks	

Umayyads of Spain (756–1031, Cordoba). The sole survivor of the Abbasid massacre of the Umayyads, 'Abd al-Rahman, escaped to Spain, where he and his descendants succeeded in founding an independent principality. The Umayyads of Spain at first called themselves simply Amir ('Lord'), but during the reign of 'Abd al-Rahman III (912–61) they adopted the titles Caliph and Commander of the Faithful. Their court at Cordoba was a brilliant centre of learning and the arts. However, the Umayyad caliphate disintegrated during the 11th century, for reasons not yet entirely certain, and was extinguished in 1031. Following this date power passed to a succession of local dynasties known as the Taifas; and from 1086 Muslim Spain was ruled by a succession of Berber confederates from North Africa, beginning with the Almoravids.

Umayyads of Spain	
'Abd al-Rahman I	756–88
Hisham I	788–96
al-Hakam I	796–822
'Abd al-Rahman II	822–52
Muhammad I	852–86
al-Mundhir	886–8
'Abdallah	888–912
'Abd al-Rahman III	912–61
al-Hakam II	961–76
Hisham II	976–1009, 1010–13
Power devolves on minor rulers, effective control being held by the chief minister al-Mansur (meaning 'the victorious', called Almanzor in Christian sources)	

Samanids (819–1005, Bukhara). The Samanids were a Persian dynasty, founded by a noble from Balkh. They were appointed governors of Transoxania for the Abbasids in 875, and in 900 Isma'il I (892–907) received the governorship of Khurasan. Their capital at Bukhara became a thriving cultural centre, associated with, among other achievements, the flowering of Persian language and literature; and it was under Samanid rule that Firdawsi began his great epic poem, the *Shahname*. Their power was weakened by the growing strength of the military classes, however, and from the 960s their territory was eroded by the Ghaznavids and the Qarakhanids. The last Samanid ruler was killed in 1005.

Samanids	
Nasr I	864–92
Isma'il I	892–907
Ahmad II	907–14
Nasr II	914–43
Nuh I	943–54
'Abd al-Malik I	954–61
Mansur I	961–76
Nuh II	976–97
Mansur II	997–9
Isma'il II	1000–05

Saffarids (861–1003, Sistan). The Saffarids were one of the first Iranian dynasties to challenge the rule of the Abbasids in eastern Iran, with their power centred on Sistan in southeastern Iran. By 983 they had been reduced to the status of vassals by the Buyids, and were defeated by the Ghaznavids in 1003.

Tulunids (868–905, Fustat). The Tulunid dynasty was founded by Ahmad ibn Tulun, a Turkish slave-soldier from Bukhara who later became governor of Egypt, and was one of the first dynasties to challenge Abbasid power in Egypt and Syria.

Fatimids (909–1171, Cairo). The Fatimid caliphate was founded by 'Ubaydallah al-Mahdi, originally from Syria, who in 909 proclaimed himself Caliph in direct challenge to Abbasid power; and in 969 the Fatimids took Fustat (Old Cairo), which they rebuilt as their capital, al-Qahira (meaning 'the Victorious'). The Fatimids were Isma'ilis, a more extreme branch of Shi'ism, and briefly during the reign of al-Mu'izz (953–75) even introduced Isma'ili legends onto their coinage. However, they wisely allowed the majority Sunni population of their dominions a degree of religious freedom. Fatimid power reached its height during the reign of al-Mustansir (1036–94), when their prosperity rivalled that of Baghdad. Trade with Mediterranean Europe and India, and access to the gold-mines of Africa, brought them enormous wealth and the luxury of the Fatimid court is well documented by such writers as the 11th-century traveller Nasir-i Khusraw. The Fatimids were extinguished by the Ayyubids in 1171, having lost Syria and Palestine to the Crusaders in the 11th century.

Fatimids	
'Ubaydallah al-Mahdi	909–34
al-Qa'im	934–46
al-Mansur	946–53
al-Mu'izz	953–75
al-'Aziz	975–96
al-Hakim	996–1021
al-Zahir	1021–36
al-Mustansir	1036–94
al-Musta'li	1094–1101
al-Amir	1101–31
al-Hafiz	1131–49
al-Zafir	1149–54
al-Fa'iz	1154–60
al-'Adid	1160–71

Buyids (932–1062, Rayy/Baghdad/Isfahan/Kirman). The Buyids were a dynasty from the mountainous region south of the Caspian, a traditional stronghold of Zoroastrianism, and had only recently converted to Islam. (The eclecticism of the area is reflected in the presence of a bilingual inscription in Pahlavi and Arabic on a tomb tower at Lajim, dated 1022.) Initially centred around Rayy and subject to the Samanids, the Buyids expanded their rule considerably, and entered Baghdad in 945, reducing the Abbasid caliph to a mere figurehead. Although Shi'ite, they were tolerant of other religions in their domains. At their highpoint under 'Adud al-Dawla (976–83) they controlled most of Iraq and western Iran, together with Kirman and Oman, and reduced the Saffarids of Sistan to the status of vassals. They lost Rayy to the Ghaznavids in 1029, and were defeated by the (Sunni) Seljuks, who took Baghdad in 1055; the Buyid prince in Fars survived a further seven years until he too was defeated.

Buyids	
Mu'izz al-Dawla	945–67
'Adud al-Dawla	978–83

Ghaznavids (977–1186, Ghazna). Power on the eastern fringes of the Islamic world, in Central Asia and Afghanistan, gradually passed into the hands of local Turkic tribes, newly converted to Islam, who established their own dynasties. One of the first major Turkic dynasties was the Ghaznavids. Originally local governors for the Samanids, they increasingly asserted their independence, and from the late 970s began raiding into northern India. During the reign of Mahmud (998–1030) they expanded their territory to include much of northwest India, Khurasan and eastern Iran, and in 1029 they ousted the Buyids from their capital at Rayy. The Ghaznavid capital, Ghazna in southeastern Afghanistan, became a centre of culture; and the great Persian poet Firdawsi dedicated his *Shahname* to Mahmud. They lost their territory in Iran to the Seljuks and much of western Afghanistan to the Ghurids, who sacked Ghazna in 1150. From this date the Ghaznavids ruled from Lahore, with their power restricted largely to the Punjab; they were finally extinguished by the Ghurids in 1186.

Ghaznavids	
Sebüktigin (governor for the Samanids in Ghazna)	977–97
Mahmud	998–1030
Mas'ud I	1031–40
Ibrahim	1059–99
Mas'ud III	1099–1115
Bahram Shah	1117–57

Qarakhanids (992–1212, Samarqand/Kashgar). The Qarakhanids were a royal Turkish dynasty from Central Asia who converted to Islam during the mid-10th century. They filled the power vacuum left by the weakening of the Samanids in Transoxania, and briefly held Khurasan, which they lost to the Ghaznavids in 1008. Their frontier with the Ghaznavids ran along the Oxus. The Qarakhanids were effectively a loose confederation rather than a centralized state. They were frequently at war amongst themselves, and from c. 1041 their dominions were divided between two spheres of influence, Samarqand in the west and Kashgar in the east. Unlike the Ghaznavids, who had formerly been slaves and who were to a large extent 'Persianized', the Qarakhanids brought with them their own, essentially Turkish steppe traditions (such as their own brand of feudalism), and introduced these into the Islamic sphere. In the west they became vassals of the Buddhist Qara Khitay from 1141, and were extinguished by the Khwarazm Shah 'Ala' al-Din Muhammad in 1212; while in the east their territory was lost in the early conquests of Chinghiz Khan.

Ghurids (c. 1000–1215, Firuzkuh/Ghazna). The Ghurids were a warlike race from the mountainous region of Afghanistan southeast of Herat. Originally vassals of the Ghaznavids, they sacked Ghazna in 1150, driving the Ghaznavids out of all but eastern Afghanistan, and in the west gained much of Khurasan following the collapse of Seljuk power there. These conquests were largely achieved under Sultan Ghiyath al-Din Muhammad (1163–1203) who ruled from Firuzkuh; and by Mu'izz al-Din Muhammad (1173–1206), who ruled from Ghazna and raided deep into the Indian subcontinent, conquering Delhi in 1192. A separate line of Ghurids ruled in Bamiyan. Their western dominions fell to the Khwarazm Shahs in 1215, and soon after this date were swallowed by the conquests of Chinghiz Khan. Their eastern territories passed to the Delhi Sultans, who from the death of Mu'izz al-Din Muhammad in 1206 ruled Muslim India.

Ghurids	
Husayn II	1149–61
Ghiyath al-Din Muhammad (ruler in Firuzkuh)	1163–1203
Mu'izz al-Din Muhammad (ruler in Ghazna); from 1203 ruler in Ghur and India	1173–1206
Mahmud	1206–12

Great Seljuks (1040–1194, Rayy/Isfahan). The Seljuks (or Saljuqs) were a branch of the Oghuz Turks, originally from the area east of the Aral Sea, who during the late 10th century entered the service of the Qarakhanids to fight against the Samanids. Later they moved southwest, captured Nishapur in 1038, and in 1040 wrested Khurasan from the Ghaznavids. Tughril Beg (1040–63) took the title Sultan and began to identify himself with Sunni orthodoxy, thus gaining local support in his westward advance against the Shi'ite Buyids; in 1055 he took Baghdad, defeated the Buyids and had the title Sultan confirmed by the caliph. Under Alp Arslan (1063–73) the Seljuks removed Fatimid influence from Syria, and in 1071 defeated the Byzantine armies at Manzikert (Malazgırt). Both Alp Arslan and his successor Malik Shah (1073–92) were aided by the extremely able vizier Nizam al-Mulk. The Seljuk period witnessed great developments in the arts; also notable were the widespread establishment of *madrasas* (religious colleges) in Iran, and the growing popularity of Sufism. However, central authority was gradually eroded by the increasingly powerful Atabegs.

Great Seljuks	
Tughril Beg	1040–63
Alp Arslan	1063–73
Malik Shah	1073–92
Mahmud I	1092–4
Berk-yaruq	1094–1105
Muhammad I Tapar	1105–18
Sanjar	1118–57

Almoravids (1062–1147, Marrakesh). The Almoravids were a Berber dynasty from northwest Africa, who came to power in 1056 and founded Marrakesh as their capital in 1062. They entered Spain in 1086 and defeated Alfonso VI of Leon and Castile, subdued the local Taifa dynasties, and ruled Andalusia as a province from Africa, imposing their own rigidly puritanical brand of Islam. The Almoravids were largely responsible for the spread of Islam south of the Sahara in West Africa. They were overthrown by the Almohads in 1147.

Anatolian Seljuks (1081–1307, Konya). A branch of the Great Seljuks of Iran, the Seljuks of Anatolia (also known as the Seljuks of Rum, from 'Rome', referring to Byzantine Asia Minor) established their capital at Konya. Following the Latin conquest and occupation of Constantinople (1204), the Seljuks extended their power to the Mediterranean, where they built the port of Alanya, bringing increased wealth and prosperity through trade. Defeated by the Mongols at the battle of Kösedağ in 1243, the Seljuks of Anatolia nevertheless survived as a dynasty, paying tribute to the Ilkhanids, until 1307.

Anatolian Seljuks	
Qilich Arslan II	1156–92
Kay Khusraw I	1192–7, 1205–11
Kay Kawus I	1211–20
Kay Qubadh I	1220–37
Kay Khusraw II	1237–46

Artuqids (c. 1101–1409, Hasan Keyf/Mardin). The Artuqids were a Turkish dynasty, descended from one of the Oghuz tribes. Their founder, Artuq ibn Ekseb, was made governor of Palestine by the Seljuks, but his sons were forced by the Ayyubids and Crusaders northwards to Diyar Bakr (a region in southeast Anatolia, including the modern city of Diyarbakır), where they ruled from Hasan Keyf and Mardin. They appear to have been tolerant towards their many Christian subjects in the region, and the Syrian Jacobite Patriarch was sometimes resident in Artuqid territory. They lost Hasan Keyf and other territory to the Ayyubids and the Seljuks of Rum during the 13th century, and Mardin fell to the Qara Qoyunlu in 1409.

Zangids (1127–1251, Mosul). The Zangids were founded by Zangi ibn Aq Sunqur, the son of the Seljuks' Turkish governor of Aleppo, who was appointed governor of Mosul in 1127. From this date the Zangids expanded northwards, taking advantage of the increasing weakness of Seljuk rule, and in 1144 evicted the Crusaders from Edessa (Urfa). Their power was eroded by the increasingly powerful Ayyubids, to whom they lost Syria in 1183 and the Jazira in 1250.

Almohads (1130–1269, Marrakesh/Seville). Like the Almoravids, whom they defeated when they took Marrakesh in 1147, the Almohads were a Berber dynasty from northwest Africa. They conquered North Africa as far as Tripoli, and reunited Muslim Spain, which they ruled from Seville. Their rule in Spain saw a great flowering of philosophy and the arts; Jews and Christians were persecuted heavily, however, leading to an exodus of Jews to Christian Europe. Following their defeat by Christian armies in 1212, the Almohads abandoned Muslim Spain, and in 1269 Marrakesh itself fell to another Berber dynasty, the Marinids.

Ayyubids (1169–1260, Cairo). The Ayyubid dynasty was founded by Salah al-Din (Saladin), of Kurdish descent, who had been recruited into the Turkish troops of the Zangids in Syria. He took control of Egypt following the death of the last Fatimid caliph, conquered Zangid Syria in 1183, and attacked the Crusader kingdoms, retaking Jerusalem in 1187. He encouraged a return to Sunni orthodoxy in Egypt and Syria, following the Shi'ism of the Fatimids, and (like the Great Seljuks in Iran) initiated a building programme for numerous *madrasas*. Following Saladin's death in Damascus in 1193, relatively peaceful relations were maintained with the Crusader kingdoms. The Ayyubids' northern territories were lost

to the Mongols, and in 1250–60 they were themselves overthrown by the Mamluks, who arose from their own Turkish slave-troops.

Ayyubids	
Salah al-Din (Saladin)	1169–93
'Imad al-Din	1193–8
Nasir al-Din	1193–1200
Abu Bakr Sayf al-Din	1200–18
Abu'l-Ma'ali Nasir al-Din	1213–38
Sayf al-Din	1233–40
Najm al-Din	1240–49
Ghiyath al-Din	1249–50
Muzaffar al-Din	1250–52
Lines in Syria, Diyar Bakr and Yemen not included	

The Delhi Sultans (1206–1555, Lahore/Delhi). With the death of Mu'izz al-Din Muhammad in 1206 (see 'Ghurids', above), his commander Qutb al-Din Aybak (1206–10) ruled from Lahore on behalf of the Ghurid sultan in Firuzkuh. In 1215 the Ghurids' western dominions fell to the Khwarazm Shahs, and from this date Aybak and his successors (known as the Mu'izzi Sultans or Slave Kings) ruled independently. The Mu'izzi Sultans were the first of a series of dynasties, known collectively as the Delhi Sultans, to rule independently in Muslim India; their successors, the Khaljis, penetrated as far south as the Deccan. A later dynasty, the Lodis, was defeated by the first Mughal emperor Babur in 1526 and by 1555 the Mughals had firmly established themselves in the subcontinent.

Mamluks (1250–1517, Cairo). The Ayyubids had acquired large numbers of Turkish slaves or *mamluks*, who formed the elite fighting troops. They were freed on completion of their military and religious training and took great pride in their status. With the foundering of the Ayyubid dynasty in 1250–60, power passed to the Bahri Mamluks (originally from the Qipchaq steppe in south Russia), who in 1260 defeated the Mongols at 'Ain Jalut in Palestine. This victory was followed by successful campaigns against the Crusaders, who had been driven out of Palestine by the end of the 13th century. These successes accorded considerable prestige to the Mamluks. The Mamluk sultans and their amirs initiated a huge building programme of mosques, mausoleums and *madrasas*, particularly in Cairo; and their achievements in the decorative arts are no less impressive. The

Mamluks	
BAHRI PERIOD	
Aybak	1250–57
al-Zahir Baybars	1260–77
al-Mansur Qalawun	1279–90
al-Ashraf Khalil	1290–93
al-Nasir Muhammad	1293–4, 1299–1309, 1310–41
Baybars al-Jashankir	1309–10
al-Kamil Sha'ban I	1345–6
Hasan 1347–51,	1354–61
al-Ashraf Sha'ban II	1363–77
BURJI OR 'CIRCASSIAN' PERIOD	
al-Zahir Barquq	1382–9, 1390–99
al-Nasir Faraj	1399–1412
al-Mu'ayyad Shaykh al-Zahiri	1412–21
al-Ashraf Barsbay	1422–38
al-Zahir Jaqmaq	1438–53
al-Ashraf Inal	1453–61
al-Ashraf Qaytbay	1468–96
al-Ashraf Qansuh al-Ghawri	1501–16

Bahri Mamluks were succeeded in 1382 by the Burji or 'Circassian' Mamluks (originally from the north Caucasus), who were finally extinguished by the Ottomans, who conquered Cairo in 1517.

Ilkhanids (1256–1353, Maragha/Tabriz/Sultaniyeh). Following the death of Chinghiz (Genghis) Khan in 1227, the vast Mongol empire was divided between his male relatives. Hülegü established the Ilkhanid dynasty (from the word *ilkhan*, meaning 'subordinate' or 'subject ruler') in western Iran, with its capital at Maragha. The Ilkhanids assimilated the Iranian culture of their new homeland, and like the Seljuks before them, were great patrons of the arts. Furthermore, their rule marked the first political unity Iran had experienced for a number of years, and Tabriz became a hub of trade. The early Ilkhanid rulers were sympathetic towards Christianity and Buddhism, Hülegü's own wife being a Nestorian Christian; later, Ghazan Khan (1295–1304) converted to Islam. Following the death of Abu Sa'id in 1335, the Ilkhanid dominions were divided between a succession of rival khans, and were finally swallowed up by local dynasties such as the Jalayirids and the Muzaffarids.

Ilkhanids	
Hülegü	1256–65
Abaqa	1265–82
Ahmad Tegüder	1282–4
Arghun	1284–91
Gaikhatu	1291–5
Baidu	1295
Ghazan	1295–1304
Öljeitü	1304–16
Abu Sa'id	1316–35
Arpa Khan	1335
Toghay Temür (western Khurasan and Gurgan)	1338–53

Ottomans (1281–1924, Bursa/Edirne/Iznik/Istanbul). The Ottomans began their great rise to power as one of the many Turkmen tribes operating in Anatolia, with their base in the northwest. The Latin occupation of Constantinople between 1204 and 1261, and the gradual disintegration of the Seljuk state following defeat by the Mongols in 1243, left a political vacuum in Anatolia, from which the Ottomans emerged as the leading power during the 14th century. They took Bursa in 1326, and after capturing Gallipoli in 1353 began their campaigns in the Balkans, inflicting a shattering defeat upon the combined Christian forces at the Battle of Kosovo in 1389. Edirne was taken in 1366, becoming the new Ottoman capital. The defeat of Bayazid I (1389–1402) by Timur in 1402 put a temporary check on Ottoman progress but this setback was soon reversed, and in 1453 Mehmed II ('Mehmed the Conqueror') captured Constantinople. The Ottomans occupied Safavid Tabriz in 1514, took Mamluk Cairo in 1517, laid siege to Vienna in 1529, and in 1534 captured Baghdad. These victories – achieved in part by the Ottoman adoption of firearms before the Mamluks and Safavids, and by the prowess of their elite Janissaries or 'New Troops', recruited from the Balkans – were accompanied by outstanding cultural achievements, the reign of Süleyman II ('Süleyman the Magnificent', 1520–66) in particular being celebrated as a golden age of Ottoman art. The Ottomans adopted the *millet* system, allowing the adherents of the various religious faiths within their territories a certain degree of autonomy. A slow decline in Ottoman fortunes set in from the end of the 17th century but the Ottoman

Empire remained a major power for a further 200 years; and though almost bankrupt by its end and heavily dependent on European imports, continued to produce some remarkable art and architecture. The greater part of the Ottomans' European conquests had been lost by the end of the Second Balkan War (1913), and their entry into the First World War (1914–18) on the side of the Central Powers resulted in the loss of their Arab territories. The last Ottoman sultan, Mehmed VI, was deposed in 1922, and in 1924 the caliphate was abolished.

Ottomans	
Osman Bey	1281– c. 1320
Orhan Bey (first Ottoman ruler to take the title of Sultan)	1324–62
Murad I (*Hudavendigar*, meaning 'The Ruler')	1362–89
Bayazid I (*Yıldırım*, meaning 'The Thunderbolt')	1389–1402
Süleyman I	1403–11
Mehmed I	1413–21
Murad II	1421–44, 1446–51
Mehmed II (*Fatih*, meaning 'The Conqueror')	1444–6, 1451–81
Bayazid II	1481–1512
Selim I (*Yavuz*, meaning 'The Inexorable'; known in the West as 'The Grim')	1512–20
Süleyman II (*Qanuni*, meaning 'The Lawgiver'; known in the West as 'The Magnificent')	1520–66
Selim II	1566–74
Murad III	1574–95
Mehmed III	1595–1603
Ahmed I	1603–17

Ottomans (continued)	
Mustafa I	1617–18, 1622–3
Osman II	1618–22
Murad IV	1623–40
Ibrahim I	1640–48
Mehmed IV	1648–87
Süleyman III	1687–91
Ahmed II	1691–5
Mustafa II	1695–1703
Ahmed III	1703–30
Mahmud I	1730–54
Osman III	1754–7
Mustafa III	1757–74
Abdülhamid I	1774–89
Selim III	1789–1807
Mustafa IV	1807–08
Mahmud II	1808–39
Abdülmecid I	1839–61
Abdülaziz	1861–76
Abdülhamid II	1876–1909
Mehmed V Reşad	1909–18
Mehmed VI (*Vahdeddin*) (last Ottoman sultan)	1918–22
Abdülmecid II (as caliph only)	1922–4

Muzaffarids (1314–93, Yazd/Isfahan/Kirman). The Muzaffarid dynasty was founded by Sharaf al-Din Muzaffar, a military commander of the Ilkhanids in southern Iran. From their base in Fars the Muzaffarids extended their rule to encompass Kirman and, with the weakening of the Ilkhanid state, were able to take much of southwest Iran. In 1353 they took Shiraz from the Inju'ids. Like the Inju'ids, the Muzaffarids were great patrons of the arts. Internal quarrels weakened the dynasty, and they finally fell to the Timurids in 1393.

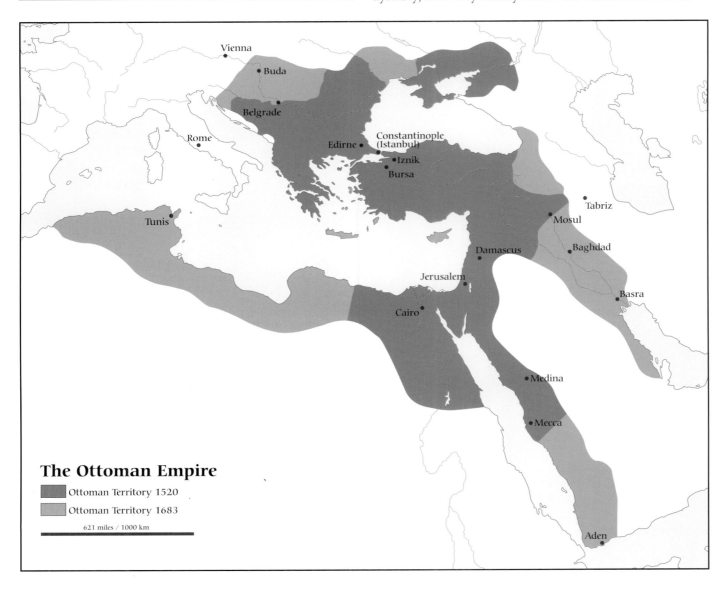

The Ottoman Empire

■ Ottoman Territory 1520
■ Ottoman Territory 1683

621 miles / 1000 km

Inju'ids (1325–53, Shiraz). The Inju'id dynasty was founded in 1325 by Sharaf al-Din Mahmud, who had been sent to Shiraz by the Ilkhanid ruler Öljeitü to manage the royal estates (*injü* in Turkish or Mongolian). He was executed in 1336 at the order of the Ilkhanid Arpa Khan, power then passing to his sons. The dynasty was soon overthrown by the Muzaffarids, who took Shiraz in 1353. Despite the brevity of their reign, their cultural achievements were considerable; and the last Inju'id ruler Abu Ishaq (1343–53) could court among the figures at his court the great Persian poet Hafiz.

Jalayirids (1340–1432, Baghdad/Tabriz). The founder of the Jalayirid dynasty was Hasan-i Buzurg, who was perhaps of Mongol origin, and was made governor of Anatolia by the Ilkhanids. He took control of Baghdad in 1340, and in 1360 his son Uways threw off Mongol allegiance and took Tabriz, before going on to conquer the Muzaffarids in Fars. Following the death of Uways in 1372 various factions vied for power with the Qara Qoyunlu, until Uways's brother Ahmad (1382–1410) finally succeeded in taking control of most of Azerbaijan and Iraq, including Tabriz and Baghdad. Sultan Ahmad was a great patron of the arts and was himself an accomplished poet. The superb miniatures produced under Uways and Ahmad mark the beginning of the great classical age of Persian painting. The Timurid campaigns in western Iran drove Ahmad to Mamluk Cairo in 1393, although he was able to return to Baghdad on Timur's death in 1405. Azerbaijan and then Baghdad soon fell to the Qara Qoyunlu, however, the Jalayirids only surviving in southern Iraq, until they were extinguished in 1432.

Jalayirids	
Shaykh Hasan-i Buzurg	1340–56
Shaykh Uways I	1356–74
Husayn I	1374–82
Sultan Ahmad	1382–1410

Qara Qoyunlu (1351–1469, Tabriz). The Qara Qoyunlu (meaning 'people of the Black Sheep') were a Turkmen tribe, probably descended from the Oghuz, with their power centred in southeast Anatolia and the Jazira. At first vassals of the Jalayirids, they soon declared their independence and took Tabriz for themselves in 1382. Qara Yusuf (1390–1400, 1406–20) was forced to seek refuge from Timur in Anatolia and then in Egypt, but on his return he took Tabriz and then Baghdad from the Jalayirids and launched campaigns against the Aq Qoyunlu in eastern Anatolia and the Georgians and the Shirvan Shahs in the Caucasus. By the mid-15th century the Qara Qoyunlu were in control of most of western Iran, including Fars and Kirman, but they were routed in 1467 by the increasingly powerful Aq Qoyunlu, who in 1469 absorbed all their lands.

Qara Qoyunlu	
Qara Yusuf	1390–1400, 1406–20
Iskandar	1420–38
Jahan Shah	1439–67

Timurids (1370–1507, Samarqand/Herat). The campaigns of Timur or Timur-i lang (meaning 'Timur the lame'), better known in the West as Tamerlane, were devastating and far-reaching. Baghdad was taken in 1393 (and again in 1401), Delhi in 1398, and the Ottoman Sultan Bayazid I was defeated near Ankara in 1402. When Timur died in 1405, he was on his way to attack China. Unlike the Mongols, however, Timur left no new administrative system in the lands he conquered; often he

returned to take a city a second time and extract a second tribute payment. Artists and craftsmen were taken to embellish his capital, Samarqand, where Timur undertook architectural projects on a colossal scale. His vast empire collapsed after his death, but Herat became a brilliant cultural centre during the 15th century under his only surviving son Shah Rukh (1405–47). He emerged as the strongest claimant to the Timurid succession and took Transoxania in 1409, installing his own son Ulugh Beg as governor of Samarqand. Herat maintained its artistic importance under Husayn Bayqara: Babur – who was to become the founder of the Mughal dynasty in India – wrote that in the whole world, there was not such a town as Herat. The Timurids finally succumbed to the Shaybanids (or Uzbeks), who had taken Transoxania by 1500.

Timurids	
Timur (Tamerlane)	1370–1405
Miran Shah (governor in Azerbaijan and western Iran)	1393–1404
Pir Muhammad	1405–07
Shah Rukh	1405–47 (until 1409 in Khurasan only)
Iskandar Sultan (governor in Fars)	1412–14
Ulugh Beg	1447–9
Abu Sa'id	1451–69
Sultan Ahmad (in Transoxania)	1469–94
Sultan Husayn (Husayn Bayqara) (in Khurasan)	1469–1506
Baysunqur (in Transoxania)	1494–5

Aq Qoyunlu (1396–1508, Diyarbakır/Tabriz). Like their rivals the Qara Qoyunlu, the Aq Qoyunlu (meaning 'people of the White Sheep') were a Turkmen tribe in eastern Anatolia, probably descended from the Oghuz. They entered marriage alliances with the Byzantines of Trebizond (Trabzon), and fought for Timur against the Ottomans. Uzun Hasan (1457–78) defeated the Qara Qoyunlu in 1467 and the Timurid ruler Abu Sa'id in 1468, after which he became master of Iraq, Azerbaijan and most of Iran, ruling from the old Jalayirid and Qara Qoyunlu capital at Tabriz. The Ottomans absorbed the Aq Qoyunlu territories in Anatolia; in 1501 they lost all their territories in Iran to the Safavids; and by 1508 the dynasty was extinct.

Aq Qoyunlu	
Jahangir	1444–57
Uzun Hasan	1457–78
Ya'qub	1478–90

Safavids (1501–1722, Tabriz/Qazvin/Isfahan). In 1501 Shah Isma'il I (1501–24) captured Tabriz from the Aq Qoyunlu and founded the Safavid dynasty. The Safavids maintained their hold on Khurasan against the Shaybanids (Uzbeks) although the Ottomans attacked in Azerbaijan, and in 1514 occupied Tabriz. Following this and other Ottoman campaigns, Shah Tahmasp I (1524–76) moved the capital to Qazvin; later, Shah 'Abbas I (1587–1629) would move it again, to Isfahan, which he set about embellishing in splendid style. As well as being responsible for the patronage of some magnificent art and architecture, the Safavids are of primary significance in the history of Iran since they imposed Shi'ism as its official religion. Safavid power weakened under later rulers, and in 1722 the Afghans under Mir Muhammad invaded and overran much of Iran. It was left to Nadir Afshar, a Turkmen chief from Khurasan, to reunite the country in 1727. Later Nadir

overthrew the Safavid ruler Tahmasp II (1722–32) and in 1736 assumed the title of Shah himself, setting up another Safavid prince as a puppet ruler.

Safavids	
Isma'il I	1501–24
Tahmasp I	1524–76
Isma'il II	1576–8
Muhammad Khudabanda	1578–87
'Abbas I	1587–1629
Safi I	1629–42
'Abbas II	1642–66
Safi II (from 1668 known as Sulayman I)	1666–94
Husayn	1694–1722
FOLLOWING DEFEAT BY MIR MUHAMMAD:	
Tahmasp II	1722–32
'Abbas III	1732–6
Nadir Shah	1736–47

Mughals (1526–1858, Kabul/Delhi/Lahore/Agra). In 1526 Babur, a descendant of Timur, unable to maintain a hold on his Central Asian homelands in the face of the Shaybanids (Uzbeks), invaded India. Defeating the Lodis (a dynasty of the Delhi Sultans) in 1526 at the battle of Panipat, he captured Delhi and established the Mughal dynasty. Initially the Mughal hold on India remained fragile and Babur's son Humayun (1530–56) was forced into exile in Iran and then Afghanistan, where he held court at Kabul; he was able to return in 1555, establishing his capital at Delhi. Humayun's son Akbar ('Akbar the Great', 1556–1605) achieved a succession of whirlwind conquests, annexing Kashmir and extending Mughal territory to include Rajasthan, Gujarat and the northern Deccan. At the same time he pursued a policy of religious tolerance, showing an openness towards Hinduism and other religions that is reflected in illustrated copies of the *Mahabharata* (the Hindu epics) made during his reign. He sought alliances through marriage, marrying an Amber princess in 1562; and in 1563–4 revoked the system of taxes burdening the Hindu population. Awrangzeb (1658–1707) accomplished the full conquest of the Deccan, and under his rule Mughal India reached its greatest territorial extent; his reign was also marked by a reaction against some of the more liberal policies introduced under Akbar. Following his death a number of conquered territories threw off their allegiance and in

1739 Nadir Shah of Iran sacked Delhi. The Mughal dynasty came to an end in 1858, when India came under British rule.

Mughals	
Babur	1526–30
Humayun	1530–40, 1555–6
Akbar I	1556–1605
Jahangir ('the World Grasper')	1605–27
Dawar Bakhsh	1627–8
Shah Jahan	1628–57
Awrangzeb (also known as 'Alamgir)	1658–1707
Bahadur Shah I	1707–12
Jahandar	1712–13
Farrukhsiyar	1713–19
Muhammad Shah	1719–48
Ahmad Shah Bahadur	1748–54
Alamgir II	1754–9
Shah 'Alam II	1759–1806
Akbar II	1806–37
Bahadur Shah II	1837–58

Qajars (1779–1925, Tehran). The Qajars were originally a Turkmen tribe inhabiting the Caspian's eastern shores. Following the disintegration of the Safavid state they expanded against the Afsharids (the descendants of Nadir Shah) and the Zands (who ruled in Fars and southern Iran) and by 1794 were in control of all Iran. The capital was transferred to Tehran, and diplomatic relations with Britain – begun by the Zands – and France pursued. Russia remained a threat in the north, however, annexing Iran's Caucasian territories, and foreign debt was considerable by the end of the 19th century. The last Qajar ruler was deposed by Reza Shah Pahlavi in 1925.

Qajars	
Agha Muhammad Khan	1779–97 (initially ruler in northern and central Iran; from 1794 ruler of all Iran)
Fath 'Ali	1797–1834
Muhammad	1834–48
Nasr al-Din	1848–96
Muzaffar al-Din	1896–1906
Muhammad 'Ali	1907–09
Ahmad	1909–25

The Timeline of Islamic Art and Culture

This Timeline presents a chronological overview of some of the major developments in Islamic art and architecture through specific examples, each one illustrated. Key events in Muslim history are also included.

The Timeline is divided into five geographical regions:

- North Africa and Spain
- The Middle East (Egypt, Syria, Jordan, Palestine, Iraq, the Arabian Peninsula)
- Anatolia and the Balkans (Turkey and Southeast Europe)
- Iran and Central Asia (including Afghanistan and the Central Asian Republics)
- The Indian Subcontinent

This arrangement is based both upon regional styles of art and architecture, and spheres of political power as they stood until the late 19th/early 20th centuries. The areas have been interpreted in their broadest sense, taking no account of modern political boundaries.

Note that Egypt is included under the Middle East rather than North Africa, reflecting its greater artistic and political links with Syria and Palestine under the Mamluks and later, the Ottomans. Areas which, although under Islamic rule or influence for a considerable time, nevertheless play only a secondary role in the development of Islamic art and architecture, are divided between the main geographical regions.

More detailed examinations of each area of the Islamic arts, with further illustrations, can be found in the *History of Islamic Art and Culture* section, and a *Glossary* of key Islamic and art historical terms is given at the end of the book.

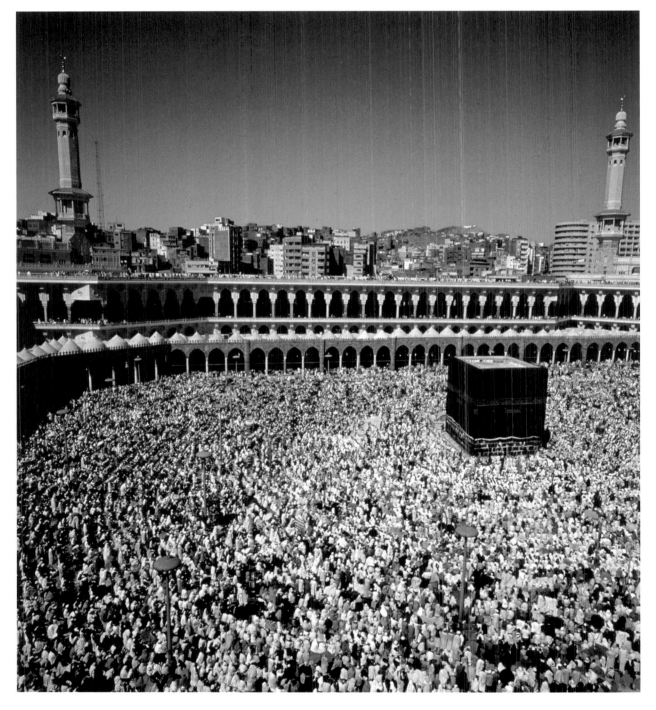

Haj pilgrims circumambulate the Ka'ba in Mecca.

THE MIDDLE EAST

7th–early 8th century: *Hijazi* script. The style of script used in western Arabia during the first decades of Islam is known as *Hijazi*. The example shown here dates from the early 8th century.

622 Hijra (flight of the Prophet Muhammad from Mecca to Medina): beginning of Islamic era.

630 Muhammad conquers Mecca.

632 Death of the Prophet Muhammad in Medina. He is succeeded by the four Orthodox or 'Rightly Guided' Caliphs: Abu Bakr, 'Umar, 'Uthman and finally 'Ali.

633–7 Arab conquest of Syria and Mesopotamia; 635–6 capture of Damascus.

639–41 Arab conquest of Egypt.

641–2 Founding of Fustat (Old Cairo).

656 Murder of 'Uthman and beginning of first civil war in Islam; 661 murder of 'Ali.

***UMAYYAD DYNASTY** (661–750, Damascus). Following the murder of 'Ali, power passes into the hands of Mu'awiya, the governor of the province of Syria, a member of the powerful Ba Umayya family of Mecca, and a cousin of the murdered caliph 'Uthman. He becomes the first Umayyad caliph. A new capita established at Damascus.*

624 House of Muhammad, Medina. The main centre for prayer in the city of Medina was the Prophet's house. It was roughly square in plan, each side measuring some 56m, with nine small rooms along the east wall. Colonnades of palm trunks supporting palm branches were soon added along the north and then the south walls as protection from the sun, and the *qibla* orientation changed from Jerusalem to Mecca. This simple form was to have a lasting influence on the development of the mosque in Islamic architecture.

637 Battle of Qadisiyya and fall of Ctesiphon.

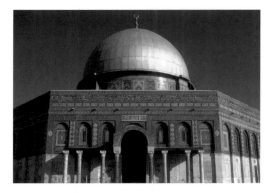

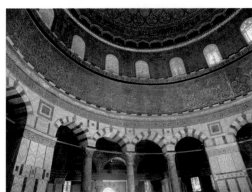

7th–8th centuries: gold sandwich-glass tiles, Syria. The Roman and Byzantine technique of sandwiching gold leaf between two layers of glass was adopted by early Muslim craftsmen. The square tile shown here was made in Syria and is similar to examples found between Aleppo and Hama. It features a cross design.

691–2 Dome of the Rock, Jerusalem. Standing near the centre of the artificial platform known as the Haram al-Sharif ('the Noble Sanctuary'), the Dome of the Rock is the earliest Islamic monument to have survived in its original form to the present day. The large central dome (left, above) is supported by a high drum pierced by 16 windows; this rests on a circular arcade surrounded by an octagonal arcade, which is in turn enclosed within another octagon. The interior is decorated with lavish mosaics (left, below), those on the exterior having been replaced with Ottoman tiles. The form and decoration of the building are largely derived from Byzantine church architecture, and the ornament contains a number of motifs from Sasanian Iran. However, the inclusion of a Qur'anic inscription clearly identifies the building as Islamic.

696–7 Umayyad coinage. Initially, the new Arab rulers adopted the local currency (and its nomenclature) of the areas under their control – the gold *dinar* and the copper *fals* (from the Byzantine *denarion* and *follis*), and the silver *dirham* (from the Sasanian *drachm*) – in some cases even including a portrait bust of a Byzantine or Sasanian monarch. However, during the administrative reforms of 'Abd al-Malik (685–705), a purely epigraphic – and therefore more distinctly Islamic – coinage was introduced, with an Arabic inscription written horizontally across the centre of the coin, surrounded by circular legends.

IRAN AND CENTRAL ASIA

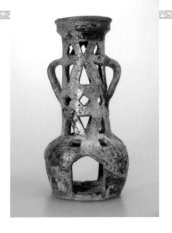

7th–8th centuries: early Islamic pottery. Pottery from the early Islamic period, such as this glazed earthenware lantern from Iran, followed Byzantine and Sasanian traditions in its form and decoration.

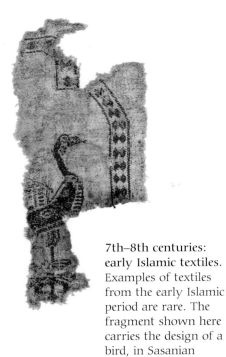

7th–8th centuries: early Islamic textiles. Examples of textiles from the early Islamic period are rare. The fragment shown here carries the design of a bird, in Sasanian style. It was produced in Iran.

ANATOLIA AND THE BALKANS

640–43 Arab campaigns in Armenia and Georgia; 654 capture of Erzurum.

674–8 First Arab siege of Constantinople.

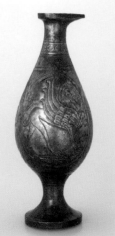

7th–8th centuries: Umayyad metalwork. The style of decoration on early Islamic metalwork is characterized by geometric and arabesque ornament, together with inscriptions in Kufic. Typically it is engraved, although some examples of inlaid decoration are known. This silver ewer features engraved griffins and an eagle within ovoid medallions, niello geometric motifs, and gilding. It was made in Iran or Central Asia during the 7th or early 8th century.

642 Sasanian army defeated at Nihavand in western Iran, followed by conquest of Azerbaijan; 649 Arab conquest of Fars; 650 conquest of Khurasan; 651 death of the last Sasanian monarch, Yazdigird III, possibly near Merv; 652 Arabs capture Merv.

NORTH AFRICA AND SPAIN

710 Arrival of Muslim armies in Spain. After sweeping across North Africa, Arab forces land in Spain, led by Tariq ibn Ziyad (after whom Gibraltar – Jabal Tariq, or Mount Tariq – is named). They defeat the Visigoths, taking their capital Toledo in 712, and are only halted near Poitiers, in central France, in 732, by Christian armies under Charles Martel.

UMAYYAD DYNASTY OF SPAIN
(756–1031, Cordoba). *The sole survivor of the Abbasid massacre of the Umayyads, 'Abd al-Rahman I (756–88), escapes to Spain, where he and his descendants found an independent principality, with its brilliant capital at Cordoba.*

784–6 Great Mosque, Cordoba. A large hypostyle hall with aisles running perpendicular to the qibla wall, the Great Mosque of Cordoba is the most important monument of Umayyad Spain. (Today it houses a Gothic cathedral at its centre.) The original structure dates to 784–6 during the reign of 'Abd al-Rahman I, but it was enlarged considerably by successive rulers. One of the most innovative features is the use of two-tiered arches – somehow reminiscent of Roman aqueducts, of which Spain has many – as a means of raising the height of the ceiling despite the use of

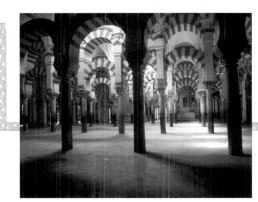

relatively short columns from older, existing buildings (left). These arches, maintained through all later additions, are further emphasized by the use of alternating red brick and white stone.

705–14/15 Umayyad Mosque ('Great Mosque'), Damascus. Built at the order of the caliph al-Walid I (705–15) at a time of political expansion, the Great Mosque of Damascus is a clear expression of the power and prestige of the Umayyads. The courtyard (below) is surrounded on three sides by covered porticoes with two levels of arcading; the fourth (qibla) wall is occupied by the covered part of the mosque, which follows the form of a classical basilica, but with the axis changed. The superb mosaics, of which some remain on the upper walls of the courtyard, contain detailed representations of plants and trees, together with clusters of buildings, depicted against a background of gold. Originally these mosaics would have covered most of the walls of the courtyard.

ABBASID DYNASTY (750–1258, Baghdad/Samarra). Ongoing rebellions in the vast and diverse territories conquered by the Umayyads finally lead to the outbreak of a major revolt in eastern Iran, which spreads throughout the Islamic territories. The Umayyad dynasty is overthrown and power passes to al-'Abbas, a member of a rival family from Mecca, who is descended from the Prophet's uncle. The Abbasid period sees the emergence of a fully fledged Islamic style with its own distinctive repertoire of motifs; while at the same time philosophy, literature and theology thrive, and numerous works of science are translated from Greek into Arabic.

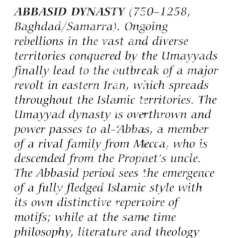

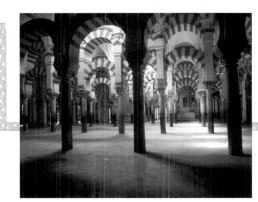

8th–9th centuries: Arabic papyri, Egypt. Many of the surviving Arabic documents from the first three centuries of Islamic rule are on papyrus. Most of these are from Fustat, and record various aspects of daily life and administration.

8th–10th centuries: mosaic glass. The production of mosaic glass flourished during the Abbasid period; some of the best-known examples were found at Samarra. Such vessels were formed from small glass discs, sections of narrow rods which were themselves made from various threads of coloured glass. The discs, arranged in a pattern, were heated until they fused, then shaped in a mould. The technique is also known as *millefiori* (meaning 'a thousand flowers' in Italian). The example shown here is from Iraq, or possibly Egypt.

Second quarter 8th century: Qusayr 'Amra, Jordan. The secular architecture of the Umayyads is best represented by a number of desert palaces scattered through modern Syria and Jordan. These palaces typically formed the centre of agricultural estates or provided hunting retreats for the new ruling elite. Qusayr 'Amra (left) contains some remarkable wall paintings with figural imagery.

736–8 Punitive expeditions to Georgia.

762 Founding of Baghdad. In 762 the caliph al-Mansur founds a new capital, officially called Madinat al-Salam ('City of Peace'), better known as Baghdad. Al-Mansur's city was circular in plan with a diameter of some 2000m, and bisected by four main thoroughfares covered with barrel vaults. It was entered through elaborate two-storeyed gateways. Houses and shops formed an outer ring, while at the centre of the city were the palace and mosque, and the Green Dome – a high dome, surmounted by a statue of a rider with a lance.

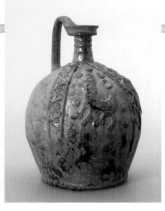

8th century: stamped pottery. This glazed earthenware jug has been decorated with stamped images of prancing lions, rosettes and bands filled with a zigzag pattern. It was made in Iran or Iraq.

8th–9th centuries: woollen tunic, Upper Egypt. This remarkably well-preserved tunic (detail shown) bears decoration which includes small panels with horses around the collar, and the shoulder bands feature extensions similar to marginal ornaments in Qur'ans.

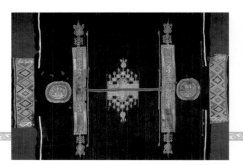

709 The Arabs take Bukhara under the leadership of Qutayba ibn Muslim, followed by the capitulation of Samarqand; 712 conquest of Khwarazm.

c. 750 The animal fables known as Kalila wa Dimna, of Sanskrit origin, translated into Arabic from a Pahlavi source. During the 13th century, they were translated into Spanish, and a later French version was acknowledged as one of the sources of La Fontaine's fables.

THE INDIAN SUBCONTINENT

Early 8th century: arrival of Muslim armies in India; 711 conquest of Sind. Traces of early Islamic architecture on the subcontinent remain from the first half of the 8th century, at Banbhore, east of Karachi, where foundations indicate a mosque of Arab plan.

751 Chinese defeated by Arab armies near Talas. Following this victory, the art of paper-making is introduced by Chinese prisoners of war.

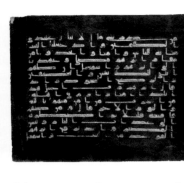

NORTH AFRICA AND SPAIN

827 Sicily conquered by Aghlabids of Tunis.

9th century: 'Blue Qur'an'. There are very few extant examples of Qur'ans dating before the 9th century. They are typically written on parchment, and the highly evolved Kufic scripts are sometimes accompanied by brilliant illumination in gold. The example shown, with its dyed pages, is from the celebrated 'Blue Qur'an'. It was copied in Tunisia or Spain in the 9th century.

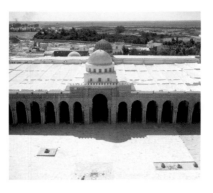

836, 862 and 875 Great Mosque, Qayrawan. The Great Mosque of Qayrawan was built on an earlier Umayyad mosque, of which only traces remain, and is a classic example of the hypostyle plan: a courtyard surrounded by porticoes, with a deeper, covered prayer hall on the *qibla* wall. Combined with this are elements of the 'T-plan' introduced in the mosque of Abu Dulaf at Samarra (c. 860). The arcades stop short of the *qibla* wall, and flank a wide central aisle (which is raised higher than the surrounding arcades, and has two domes) running from the court to the *mihrab* area.

THE MIDDLE EAST

809 Birth of Hunayn ibn Ishaq (known in the West as Joannitius, d. 873), greatest translator of Greek works into Arabic. Numerous Greek texts, subsequently lost in the original, owe their survival to translations made under the Abbasids. Hunayn alone is reported to have translated works by Hippocrates, Plato, Galen and Aristotle; his son Ishaq was to become the most important translator of Aristotle's works.

836 Founding of Samarra. Because of conflict between the Turkish guards and the local population of Baghdad, and in order to express the glory of his own reign, the caliph al-Mu'tasim founds a new capital, Samarra, approximately 60km up the Tigris from Baghdad. Samarra is embellished and enlarged by succeeding caliphs, but abandoned as a capital in 883.

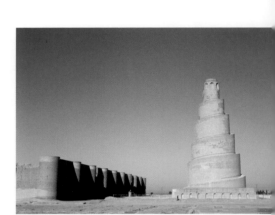

847–61 Great Mosque, Samarra. The Great Mosque at Samarra, built under the caliph al-Mutawakkil (847–61), is the largest known mosque of the Islamic world. It features a hypostyle plan, a huge *mihrab* decorated with marble columns and mosaics, and a large spiral minaret outside the confines of the buttressed walls (above right).

8th–9th centuries: lustre-painted glass, Egypt. This technique involved painting designs onto the surface of a glass vessel, in metallic pigments containing either silver or copper, or both. The vessel was then fired at a moderate temperature so that the coloured metallic film bonded to the surface, permanently staining it. Shown here (above right) is a lustre-painted glass cup made in Egypt during the 8th or 9th century.

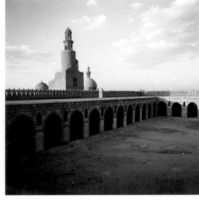

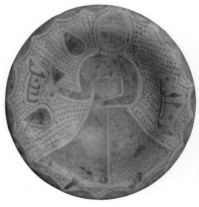

879 Mosque of Ibn Tulun, Cairo. Built by the Abbasid governor of Egypt, the powerful Turkish general Ahmad ibn Tulun, this mosque is a clear departure from local Egyptian models, and is strongly influenced by the architecture of Samarra, where Ibn Tulun had spent many years. It is built of brick, and has the familiar court surrounded on three sides by double arcades (left). It is one of the earliest surviving examples of the extensive use of pointed arches. The fountain in the centre of the court originally had a gilded dome. The present minaret dates to the 13th–14th century; the original was probably a spiral, like those in Samarra.

9th century: Abbasid blue-and-white glazed pottery, Iraq. The Abbasid potters were unable to imitate the brilliant white of Chinese porcelain. Instead, they added tin oxide to the otherwise transparent lead glaze, thus making it opaque. They then added geometric and floral patterns, together with inscriptions, in cobalt blue.

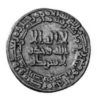
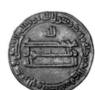

9th century: Abbasid coinage. Abbasid coinage followed the style set by the Umayyads during the reign of 'Abd al-Malik. In 827–8 the Abbasid caliph al-Ma'mun (813–33) introduced the names of mints on gold and silver coins, along with an additional marginal inscription. He also forbade the naming of subordinate officials and local governors on gold and silver coinage. Shown is a gold *dinar* of al-Ma'mun issued in 822.

9th century: Abbasid lustreware. Lustre had been used on Egyptian glass in the 8th century, but its adaptation to pottery was to prove especially popular in the Muslim world – and later (via Moorish Spain) in Renaissance Italy. The technique involved painting metallic pigments onto a glazed surface that had already been fired; and then firing the object a second time in a reducing atmosphere to leave a thin metallic film adhered to the glaze, which imparts a lustrous sheen (right).

IRAN AND CENTRAL ASIA

SAMANID DYNASTY (819–1005, Bukhara). The Samanids, a Persian dynasty, are appointed as governors of Transoxania and Khurasan for the Abbasids. Their capital, Bukhara, is a brilliant cultural centre, associated with the flowering of Persian language and literature. Under Samanid rule Firdawsi begins his great epic poem, the Shahname.

SAFFARID DYNASTY (861–1003, Sistan). The Saffarids are one of the first Iranian dynasties to challenge the rule of the Abbasids in eastern Iran.

936 Work begun on palace of 'Abd al-Rahman III at Madinat al-Zahra, near Cordoba. Madinat al-Zahra is still being excavated, but what little of the palace has survived suggests a grand complex in the spirit of the Abbasid palaces in Iraq.

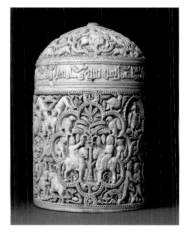

960s–970s: carved ivory, Umayyad Spain. The carved ivory boxes and caskets produced in Umayyad Spain during the 960s and 970s are some of the finest examples of the decorative arts from this period. Many of them were made at Madinat al-Zahra for the women of the royal court. They are decorated with confronted birds and animals amid intertwined foliage, with inscription bands in Kufic; sometimes (as on the so-called Pyx of al-Mughira, now in the Louvre, left), figural groups are depicted within lobed cartouches.

Early 10 century: system of proportions for Arabic scripts developed by the vizier Ibn Muqlah.

961–76 and 987 Extensions to Great Mosque, Cordoba. The most notable enlargements to the Great Mosque of Cordoba (784–6) were those of al-Hakam II and al-Mansur, carried out in 961–76 and 987 respectively. Al-Hakam added a spectacular *mihrab* in the form of a circular room, and directly in front of this a magnificent bay of polylobed arches (left); al-Mansur widened the building by eight aisles.

10th century: Fatimid lustreware. The style of decoration on these objects follows that developed at Samarra, and includes human and animal figures, but the attention to naturalistic detail is greater.

Late 10th century: cut rock crystal, Fatimid Egypt. Objects of cut glass and rock crystal were highly cherished during the Fatimid period. The example shown here, now in the Victoria & Albert Museum, London, dates from the late 10th–early 11th century, and was cut from a single block of flawless crystal. It is decorated with animals and palmette leaves.

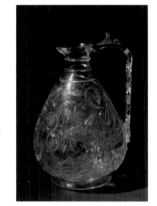

FATIMID CALIPHATE (909–1171, Cairo). The Fatimid rulers proclaim themselves caliphs in direct challenge to Abbasid power. They are Isma'ilis, an extreme branch of Shi'ism. The Fatimid caliphate reaches its peak during the reign of al-Mustansir (1036–94), when its prosperity rivals that of Baghdad.

969 Fatimid conquest of Egypt and founding of al-Qahira (Cairo), meaning 'the Victorious'.

Early 10th century: Samanid mausoleum, Bukhara. This is one of the most perfectly preserved mausoleums of the 10th century. It is square in form, with four arches carrying a dome on squinches. A small gallery runs around the top of the walls. Perhaps the most impressive feature is the decorative use of brick: baked bricks are laid both horizontally and vertically, forming zigzags and rows of circles, creating a woven effect similar to wickerwork. Brick was the main building material in Central Asia and this monument clearly illustrates the medium's superb decorative potential.

c. 970 Arrival of the Seljuk Turks in Islamic lands.

GHAZNAVID DYNASTY (977–1186, Ghazna/Lahore). Power on the eastern fringes of the Islamic world, in Central Asia and Afghanistan, gradually passes into the hands of local Turkic tribes, newly converted to Islam, who establish their own dynasties. The Ghaznavids are one of the first major Turkic dynasties.

973 Birth of al-Biruni (d. 1048), perhaps the greatest intellectual figure of medieval Islam, in a village in southern Khwarazm. As well as being a celebrated historian and geographer, al-Biruni is a highly accomplished physician, chemist, mathematician and astronomer. Following the Ghaznavid conquest of Khwarazm in 1007, al-Biruni is taken to Ghazna, where he continues to write.

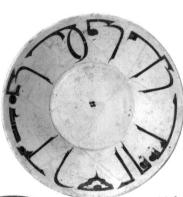

10th century: slip-painted bowls, Nishapur and Samarqand. These slip-painted earthenware bowls from Nishapur typify the ceramic production of eastern Iran during this period. The first is decorated with a superb band of calligraphy, the ascending strokes pointing inwards; the simple contrast between the white ground and the dark Kufic script is highly effective. The second example is decorated with a seated figure.

980 Birth of Ibn Sina (Avicenna, d. 1037), physician and philosopher, in a village near Bukhara. Many of Ibn Sina's works are translated into Latin as early as the 12th century; and his Qanun fi'l-Tibo ('Canons of Medicine') remains a required medical textbook in Western Europe for the next five centuries.

QARAKHANID DYNASTY (992–1212, Samarqand/Kashgar). Unlike the Ghaznavids, former slaves who are to a large extent 'Persianized', the Qarakhanids are a royal Turkish dynasty from Central Asia who have been converted to Islam. They bring with them their own steppe traditions – such as a brand of feudalism – and introduce these into the Islamic sphere.

29

NORTH AFRICA AND SPAIN

1013 Sack of Cordoba.

1031 Fall of Umayyad dynasty in Spain.

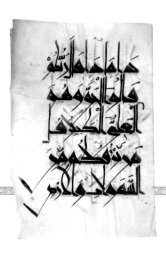

11th century: Qur'ans, North Africa. Shown here is a large-format (45 x 30cm) folio from an exceptionally fine Qur'an, probably written in Tunisia during the early 11th century.

1085 Fall of Muslim Toledo to Christian Castile.

ALMORAVID DYNASTY (1062–114[] Marrakesh). The Almoravids, a Berbe[r] dynasty from northwest Africa, are called to Spain in 1086 to fight against Alfonso VI of Leon and Castile, and rule Andalusia as a province from Africa.

THE MIDDLE EAST

c. 1000: relief-cut glass, Egypt and Iran. Two main types of cut glass are found at this time: hollow-cut glass, in which the design was cut into the surface; and relief-cut glass, in which the entire background was cut away, leaving the design to stand out in high relief. The latter type, by far the more technically difficult of the two, includes some spectacular pieces decorated with highly stylized animals, either depicted individually, in groups, or in bands. The glass beaker shown here has been decorated with running ibexes, and is dated c. 1000.

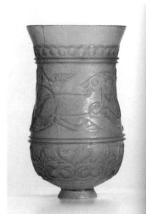

1055 Seljuks enter Baghdad.

11th century: Fatimid jewellery. Fatimid gold jewellery is characterized by its decoration, with intricate designs fashioned in elaborate openwork filigree and granulation. The ring shown here (below) was made in Egypt and dates from the 11th century.

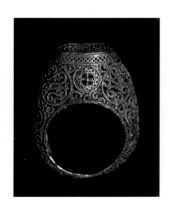

1096 Arrival of First Crusade in Near East. The various armies of the First Crusade arrive on Byzantine territory in 1096, ostensibly to deliver Jerusalem from the Turks (who have taken the city from the Fatimids), although in many cases with ambitions to carve out states for themselves. Three years later, in 1099, the Crusaders take Jerusalem. The Kingdom of Jerusalem is established as a Christian state, alongside those of Edessa, Antioch and Tripoli.

ANATOLIA AND THE BALKANS

1071 Byzantine armies defeated by Seljuks at Manzikert (Malazgirt), north of Lake Van. Following this, Turkmen tribes range increasingly westwards into Anatolia, and the Seljuks go on to occupy Syria and Palestine.

1064 Seljuks take Armenian capital, Ani.

ANATOLIAN SELJUKS (1081–1307, Konya). The Anatolian Seljuks (also known as the Seljuks of Rum, from 'Rome', referring to their settling in Byzantine Asia Minor) are a branch of the Great Seljuks of Iran, and establish their capital at Konya.

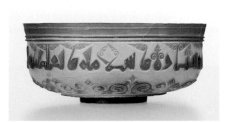

c. 1000: relief-cut glass in cameo technique, Egypt and Iran. In some examples of cut glass, the vessels were dipped in a second layer of coloured glass before the background was cut away, leaving a raised design in a different colour.

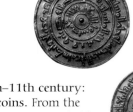

Mid 10th–11th century: Fatimid coins. From the mid-10th century Fatimid coins were characterized by an increased emphasis on circular inscriptions, and in some cases horizontal inscriptions were abandoned altogether. The example shown was struck in the name of al-Mustansir in 1052.

11th century: silk textiles, Iran. Surviving silk textiles from this period typically feature an arrangement of circular frames, each enclosing representations of animals and interspersed with vegetal designs or smaller animals, and sometimes lines of Kufic script. The circular frames with animals are a direct continuation of Sasanian motifs, but the overall designs show greater density and detail than in the Sasanian period.

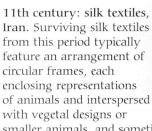

IRAN AND CENTRAL ASIA

GHURID DYNASTY (c. 1000–1215, Firuzkuh/Ghazna). The Ghurids, from the mountainous area of Afghanistan, southeast of Herat, extend their rule to include much of Khurasan, and raid deep into the Indian subcontinent, conquering Delhi in 1192.

1006–07 Gunbad-i Qabus. This spectacular tomb tower is located near Gurgan, southeast of the Caspian Sea. The exterior takes the form of a tapering ten-pointed star (right); the interior is smooth and circular. In contrast to the Samanid mausoleum in Bukhara, decoration is very restrained, and the fine brickwork is broken only by two inscription bands. It was built for a local Ziyarid prince, Qabus ibn Vashmgir, whose coffin may originally have been suspended inside.

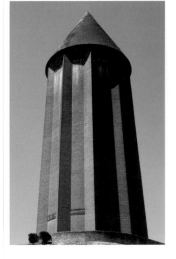

1009/10 Firdawsi's Shahname ('Book of Kings'), widely acknowledged as the greatest masterpiece of Persian literature, is completed.

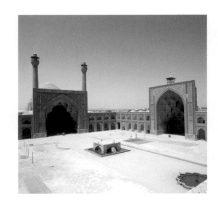

Late 11th century: Friday Mosque, Isfahan. The Friday Mosque (Masjid-i Jami') at Isfahan was probably built during the 9th–10th century. During the late 11th–early 12th century, how[ever], it was substantially transforme[d] by the Seljuks, who gave the mosque its distinctive court façade with four iwans (left), and a large dome over th[e] mihrab. This was to become the standard form of the mosque, madrasa an[d] caravanserai in Iran.

SELJUK DYNASTY (1040–1194, Rayy/Isfahan). The Seljuks are a Turkish tribe from Central Asia, members of the Oghuz and originally from the area east of the Aral Sea. They served the Qarakhanids during the 10th century, when the latter were fighting the Samanids. In the 11th century they sweep into Khurasan, take Nishapur in 1038, and in 1055 defeat the Buyids and take Baghdad.

ALMOHAD DYNASTY (1130–1269, Marrakesh/Seville). Another Berber dynasty from northwest Africa, the Almohads rule an area which includes much of northern Africa and Spain. They abandon Spain following their defeat by Christian armies in 1212, and in 1269 Marrakesh itself falls to another Berber dynasty, the Marinids.

1140 Muslim artists at work in Palermo. Muslim artists are known to have worked on the decorated wooden ceiling of the Palatine Chapel in the royal palace of the Norman king, Roger II, in Palermo. The painted decoration includes representations of animals and humans set among vine scrolls and floral compositions.

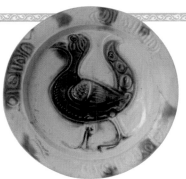

12th century: *laqabi ware*, Syria. *Laqabi* ware features carved and painted decoration, and typically shows a single motif, most often a bird

Late 12th century: 'Tell Minis' pottery, Syria. Stonepaste pottery with lustre or underglaze-painted decoration, known as Tell Minis ware, was produced in Ayyubid Syria during the 12th century. The decoration of this lustre-painted dish includes a lion attacking another animal, and floral scrolls.

1144 Crusader kingdom of Edessa destroyed by the Zangids.

1168 City of Fustat burned to prevent it falling into the hands of the Crusaders.

1154 Damascus conquered by the Zangids. The Zangids maintain their hold on Mosul and the Jazira (the area between the Middle Euphrates and the Tigris) for a number of years, but control of these areas eventually passes to the Ayyubids

AYYUBID DYNASTY (1169–1260, Cairo). Following the death of the last Fatimid caliph in 1169, the Ayyubid dynasty is founded by Salah al-Din (Saladin). After consolidating his position, Saladin attacks the Crusader kingdoms, recapturing Jerusalem in 1187.

1122 Tbilisi captured from its Arab governors by the Georgian king David the Builder.

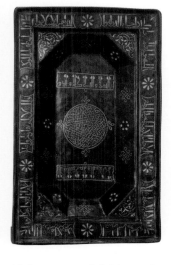

12th century: inlaid metal-work, Khurasan. Superb examples of metalwork with inlaid decoration – in silver, gold and copper – were made in Khurasan. They include pieces bearing inscriptions, arabesque (above) and human and animal figures.

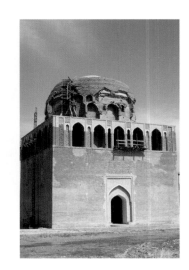

1152 Mausoleum of Sanjar, Merv. The mausoleum of Sultan Sanjar (left) is the largest and most spectacular Seljuk mausoleum to have survived to the present day. Built entirely of brick, it consists of a soaring dome some 14m in height, which rests upon an octagonal drum; this in turn sits upon a square chamber, the walls of which are particularly thick and unbroken by any major decorative scheme.

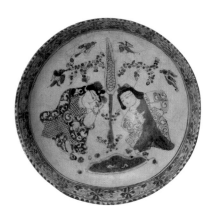

Late 12th–early 13th centuries: *mina'i* ware, Iran. In these luxurious polychrome pieces, decoration was painted both under and over a colourless or light-blue glaze. *Mina'i* ware thus requires a minimum of two firings. Many examples feature figural designs, such as representations of the royal court.

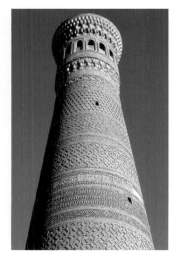

1127: Kalan Minaret, Bukhara. The Kalan minaret is a tapering cylinder more than 51m high. The entire surface of the shaft is covered with broad bands of decorative brickwork, interspaced with bands of inscription; the geometric designs within each band are different from those of the next.

THE INDIAN SUBCONTINENT

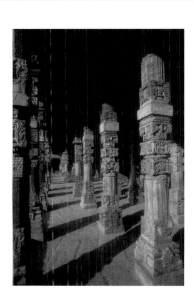

1192 Ghiyath al-Din Muhammad of Ghur defeats the Rajput Prithvi Raj and conquers Delhi.

1192–6 Quvvat al-Islam, Delhi. The mosque known as the Quvvat al-Islam (meaning 'Might of Islam') was built immediately after the Ghurid conquest and is the earliest significant Islamic monument to have survived on the subcontinent. Columns reused from Hindu and Jain temples surround the courtyard (left), with most of the figural sculpture removed, and low Hindu domes stand over the *qibla* aisle. In 1198 a richly decorated screen wall of pointed arches was added on the courtyard side of the prayer hall.

31

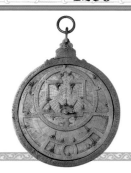

North Africa and Spain

1212 Almohads are defeated by Christian armies in Spain. Following this, Granada is the only remaining Muslim territory on the Iberian peninsula.

13th century: science, Muslim Spain. The Islamic world became heir to the astrological and cosmological traditions of the Hellenistic world and Hindu India, and much of this knowledge was then transmitted to Christian Europe through Muslim Spain. The planispheric astrolabe shown here is inscribed in Arabic which has been written in the Hebrew script. It was probably made in Spain c. 1200.

The Middle East

Early 13th-century: inlaid metalwork, Mosul. Mosul emerged as a prominent centre for the production of inlaid metalwork. Perhaps the most spectacular piece to have survived (and the only one which categorically states that it was made in Mosul) is the 'Blacas ewer', now in the British Museum (right). The decoration includes genre scenes and medallions on a background of geometric motifs.

Early 13th century: Citadel, Aleppo. A particularly fine example of the defensive military architecture of this period is the Citadel at Aleppo. Most of the present structure was built by the Ayyubid sultan al-Zahir Ghazi.

1258 Mongols take Baghdad. Following the destruction of the Isma'ili sect known as the Assassins, the Mongols capture Baghdad and execute the caliph. Later, the Mamluk sultan Baybars installs a member of the Abbasid line as caliph in Cairo.

MAMLUKS (1250–1517, Cairo). The Mamluks – who were originally bought slaves who formed the elite fighting troops of the Ayyubids – take power with the foundering of the Ayyubid state in 1250–60. The Mamluks defeat the Crusaders in 1292 and the Mongols in 1277 – victories which accord them considerable prestige.

1293–1340 Reign of Sultan al-Nasir Muhammad, one of the greatest Mamluk patrons of the arts and architecture. Although interrupted twice, the reign of the longest ruling Mamluk sultan ensures a period of great prosperity, and facilitates the development of a distinctive architectural style.

Anatolia and the Balkans

c. 1220 The family of the great Persian mystic and poet, Jalal al-Din Rumi (d. 1273), settle in Konya, having fled their native Balkh in the face of the Mongol invasion.

1228–9 Great Mosque, Divriği. The Great Mosque (or Ulu Camii) at Divriği in eastern Anatolia is a fine example of the beautiful decoration in carved stone found on many Seljuk buildings in the region.

12th–13th century: figural bronze coinage, Jazira. The bronze coinage of the Artuqids, Zangids and other dynasties in northern Mesopotamia, Anatolia and western Iran featured a variety of figural imagery drawn from Graeco-Roman, Byzantine, Parthian and Sasanian traditions. Shown here is a Zangid copper *dirham* from Mosul, struck in 1229.

1271: Gök Medrese, Sivas. Twin minarets such as those found at this *madrasa* (left) are also found in other buildings in Seljuk Anatolia, and probably have their origin in the architecture of Iran.

OTTOMAN DYNASTY (1281–1924, Bursa/ Edirne/Iznik/Istanbul). The disintegration of the Seljuk state leaves a political vacuum in Anatolia, from which the Ottomans emerge as the leading power by the second quarter of the 14th century. From their initial base in northwest Asia Minor they soon spread across most of the Near East, North Africa and the Balkans, taking Constantinople in 1453 and creating an empire which will last some 500 years.

Iran and Central Asia

1220 Eastern territories of Caliphate fall to Mongols under Chinghiz Khan.

13th century: lustre-painted ceramics, Kashan. Kashan was a leading centre of ceramic production during this period. Two examples of Kashan lustreware are shown here: a star-shaped tile decorated with a dancer; and a camel-shaped vase.

1275 Arrival of the Venetian traveller Marco Polo at the court of Kublay Khan, China.

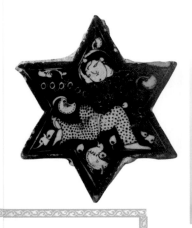

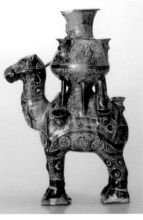

Late 13th century: figurine of seated man, Kashan. This fritware figurine has the name of the Seljuk Sultan Tughril inscribed around the brim of his hat, and is thought to have been a chess piece. This unique object, which stands a little over 40cm in height, is from Kashan.

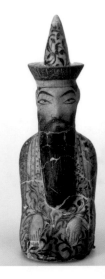

The Indian Subcontinent

THE DELHI SULTANS (1206–1555, Lahore/Delhi). Following the loss of the Ghurids' western dominions to the Khwarazm Shahs, the Mu'izzi Sultans or Slave Kings rule independently from Lahore. The successors of a Ghurid commander in India, the Mu'izzi Sultans are the first of a series of dynasties – known collectively as the Delhi Sultans – to rule independently in northern India.

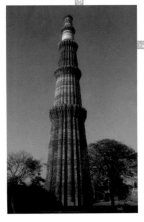

c. 1200–12: Qutb Minaret, Delhi. This huge minaret (left) was built soon after the Ghurid conquest of Delhi. It is ribbed and surrounded by decorative bands and inscriptions in carved stone.

ILKHANID DYNASTY (1256–1353, Maragha/Tabriz/Sultaniyeh). Following the death of Chinghiz (Genghis) Khan in 1227, the vast Mongol empire is divided between his male relatives. Hülegü establishes the Ilkhanid dynasty (from the word ilkhan, meaning 'subject ruler') in northwestern Iran, with its capital at Maragha.

1295 Islam becomes religion of Ilkhanids. The early Mongol rulers adopt various religious faiths – Chinghiz Khan himself follows Shamanism, Hülegü favours Buddhism. Ghazan Khan is the first to declare Islam the official religion of the state, in 1295; and his successor Öljeitü, though baptized a Christian, later converts to Islam.

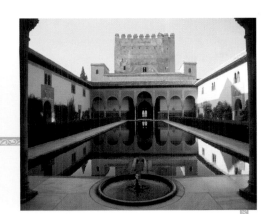

1332 Birth of Ibn Khaldun (d. 1406), greatest of Arab historians, in Tunisia.

14th century: the Alhambra, Granada. The Alhambra in Granada is one of the best-preserved palaces of the medieval Muslim world. Built under the Nasrid dynasty, it occupies a spectacular location on a low spur of the Sierra Nevada. Its name is probably a corruption of *qal'at al-hamra* (meaning 'the Red Castle'), referring to the colour of its stone walls. The complex contains numerous courtyards, colonnades, pools and fountains, with exquisite decoration in stucco and tilework. The most significant parts of the complex, including the famous Court of the Myrtles (1347–8), shown here, and the Court of the Lions (begun 1377), were built under Yusuf I and Muhammad V respectively.

14th century: marvered glass. In this technique of glass decoration, trails of glass were pressed into the body of the blown vessel by turning it against a flat stone or metal surface (known as a 'marver'). Combed patterns were often created using a toothed implement. The small bowl shown here (below) is from Egypt or the Syro-Palestine coast, and dates to the 13th–14th century.

Late 13th–early 14th centuries: Mamluk metalwork. Perhaps the single best-known piece of Mamluk metalwork is a large brass basin with silver and gold inlay, now in the Louvre and known as the 'Baptistère de St Louis' (below). The spectacular inlaid decoration includes large medallions with mounted figures, groups of servants and amirs, and bands of running animals.

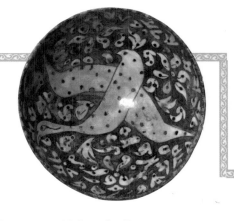

Early–mid 14th century: Mamluk Qur'ans. The superb Qur'ans produced under the Mamluks, given as endowments to religious foundations, are among their greatest artistic achievements. The calligraphy is particularly fine, as are the spectacular illuminated frontispieces based on geometric and vegetal motifs (right).

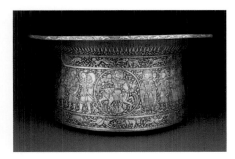

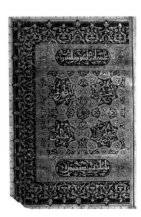

Early 14th century: Mausoleum of Öljeitü, Sultaniyeh. This vast mausoleum, the only significant part of the Ilkhanid capital at Sultaniyeh to have survived, was built for Öljeitü. The blue-tiled dome, more than 50m high, sits on an octagonal chamber with eight huge vaulted niches on the interior, and can be seen from a great distance across the surrounding plains (right).

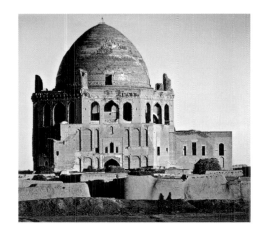

c. 1330 Birth of Timur (Tamerlane).

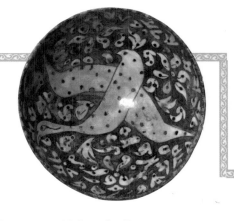

First half 14th century: 'Sultanabad' ware, northwest Iran. 'Sultanabad' ware is named after the site in northwest Iran where it was found, but it was probably manufactured at Kashan. Two levels of slip are sometimes used on a grey ground, creating an illusion of spatial recession. Vegetal ornament is less stylized than in earlier periods, and often forms a background to birds (above) or phoenixes.

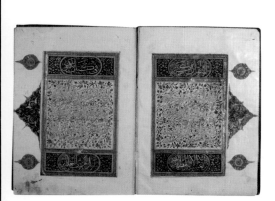

Early–mid 14th century: Ilkhanid Qur'ans. Some superb Qur'ans were produced under the Ilkhanids, in particular Öljeitü, and also for the great vizier Rashid al-Din. These have brilliantly illuminated frontispieces and are typically written in either the *muhaqqaq* or *rayhan* script. One Ilkhanid Qur'an found its way to Mamluk Cairo, where it was to influence Qur'an production there.

1314: Ilkhanid historical writing. Anxious to legitimize their rule in western Iran, the Ilkhanids were responsible for the patronage of a large body of historical writing, including the great vizier Rashid al-Din's *Jami' al-Tawarikh* ('Compendium of Chronicles'). The illustration shown here depicts Shakyamuni offering fruit to the Devil.

Second quarter 14th century: the 'Demotte' *Shahname*. Among the greatest illustrated copies of the *Shahname* to be commissioned by the Ilkhanid rulers is the 'Demotte' *Shahname*, named after the dealer who originally divided it. The page illustrated here shows Bahram Gur sending Narsi as viceroy to Khurasan; it was painted at Tabriz during the 1330s, or slightly later.

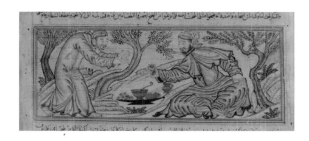

33

NORTH AFRICA AND SPAIN

Second half 14th century: mudéjar tilework, Seville. Although some parts of the palace known as the Alcazar in Seville were built under the Almohads, most of its present form and decoration date from Christian rule. During the second half of the 14th century, Pedro I commissioned *mudéjar* craftsmen (that is, Muslim inhabitants of Christian Spain) and a number of craftsmen from Granada – which was then still under Nasrid rule – to decorate the Alcazar.

THE MIDDLE EAST

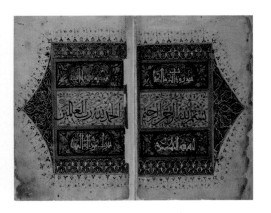

1356–61 Mosque of Sultan Hasan, Cairo. This huge mosque, which also houses a mausoleum and four *madrasas*, is the largest of medieval Cairo. Although architecturally one of the most significant buildings in the Islamic world, it was in fact never completed.

14th century: gilded and enamelled glass lamps, Cairo. Glass production had been popular in Egypt since Pharaonic times, but attained new levels of refinement under the Mamluks. This glass mosque lamp is datable c. 1385, and was made for the Burji Mamluk sultan Barquq. Clear glass was first gilded and decorated with coloured glass paste, and then heated, causing the decoration to fuse to the surface.

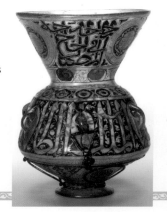

ANATOLIA AND THE BALKANS

1361 Edirne falls to the Ottomans.

1389 Serbian forces defeated by Ottomans at Battle of Kosovo.

IRAN AND CENTRAL ASIA

Late 14th–early 15th century: Timurid tilework. Timurid architectural decoration includes some magnificent tilework in a variety of techniques, including *cuerda seca*, mosaic, carved relief, and the less common *lajvardina*. Carved relief was particularly common on earlier Timurid buildings but was increasingly superseded by tile mosaic. Many of these techniques are to be found in the decoration of the remarkable group of tombs known as the Shah-i Zindeh (left) at Samarqand (1370–1405, and later).

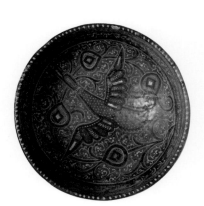

14th century: *lajvardina* pottery, Iran. The pottery known as *lajvardina* (meaning 'from lapis lazuli') was made in Iran during the 14th century, and is characterized by its cobalt-blue glaze. The small bowl shown here is dated 1376.

TIMURID DYNASTY
(1370–1507, Samarqand/Herat). The campaigns of Timur (Tamerlane) are devastating and far-reaching: Baghdad is taken in 1393, Delhi in 1398, and the Ottoman Sultan Bayazid I defeated near Ankara in 1402. Artists and craftsmen are taken from the cities Timur conquers to embellish his capital, Samarqand. His vast empire collapses after his death, but Herat emerges as a brilliant cultural centre during the 15th century under his son Shah Rukh.

1399–1404 Mosque of Bibi Khanum, Samarqand. The huge scale of Timurid architecture is readily apparent in the mosque of Bibi Khanum (left) at Samarqand, a new Masjid-i Jami' (Friday Mosque), the building of which was ordered after the capital was transferred to that city. The *iwan* is 30m high.

Mid-14th century: Qur'ans, Shiraz. The illumination of Qur'ans produced in Shiraz during the mid-14th century is characterized by a dark-blue ground, delicate floral sprays and vegetal arabesques in gold.

AQ QOYUNLU DYNASTY *(1396–1508, Diyarbakır/Tabriz). The Aq Qoyunlu (meaning 'people of the White Sheep') are a Turkmen tribe from eastern Anatolia. Following their defeat of the Qara Qoyunlu in 1467 and of the Timurid ruler Abu Sa'id in 1468, they become masters of Iraq, Azerbaijan and most of Iran, ruling from the old Jalayirid and Qara Qoyunlu capital, Tabriz.*

THE INDIAN SUBCONTINENT

1398–9 Timur's forces cross the Hindu Kush and descend upon northern India, sacking Delhi.

15th century: Mamluk gold *ashrafi*. During the reign of Sultan al-Ashraf Barsbay (1422–38), the gold *ashrafi* was introduced in an attempt to compete with the strength of the Venetian gold ducat. The Mamluk *ashrafi* weighed the same as the Venetian coin (3.5g). and featured decorative, cable-like bands dividing the lines of horizontal inscription.

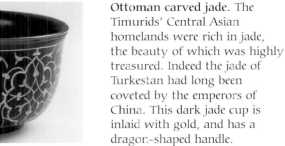

1400–02 Timur's (Tamerlane) armies sweep through Syria and Anatolia, defeating the Ottoman Sultan Bayazid I near Ankara in 1402.

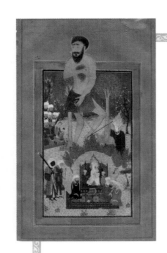

Early 15th century: Jalayirid miniatures. In Jalayirid miniatures surviving from Tabriz and Baghdad at this time, the illustrations frequently fill the entire page, and are painted with a bright palette and areas of cool blue. The page illustrated here shows the giant Uj, with the prophets Moses, Jesus and Muhammad; it was painted in the early 15th century.

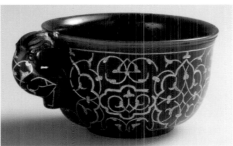

15th century: Timurid and Ottoman carved jade. The Timurids' Central Asian homelands were rich in jade, the beauty of which was highly treasured. Indeed the jade of Turkestan had long been coveted by the emperors of China. This dark jade cup is inlaid with gold, and has a dragon-shaped handle.

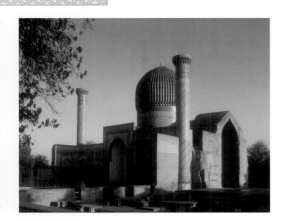

1404 Gur-i Mir, Samarqand. The mausoleum shown is part of a complex of buildings known as the Gur-i Mir, and was built for a grandson of Timur who died on campaign. Later Timur himself was buried within the complex, as were his descendants Shah Rukh and Ulugh Beg. The high, ribbed dome sheathed in ceramic tiles, set upon a tall, cylindrical drum, is a central characteristic of Timurid mausoleums.

15th century: Timurid miniatures, Herat. Among the historical texts produced at Herat for Shah Rukh is the *Majma' al-Tawarikh* ('Assembly of Histories'), a continuation of the *Jami' al-Tawarikh* of Rashid al-Din. The miniatures are characterized by a bright palette and meticulous detail: that shown here depicts Alexander and the *waq-waq* tree, and was painted c. 1425–30.

15th century: Timurid silk brocade. The silk brocade shown features a design of ogival medallions. It was made in Iran or Central Asia during the 15th century.

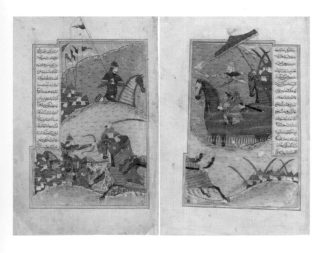

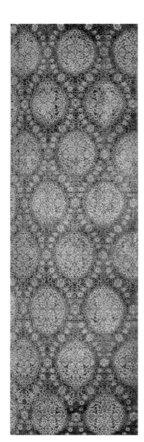

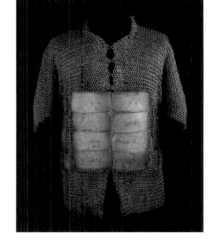

Early 15th century: Timurid miniatures, Shiraz. Early 15th-century miniatures achieved a perfect synthesis of the Jalayirid and Muzaffarid styles. The detail, distinctive rock formations and gold or deep-blue skies in these miniatures all foreshadow the great Timurid manuscripts produced a quarter of a century later at Herat.

15th century: mail and plate shirts, Iran. Muslim armour from the 14th–15th centuries onwards was usually made from metal plates joined by small rings of steel or iron (known as 'mail'), or made entirely from such rings. The plates were often inscribed with passages from the Qur'an. The example shown was probably made in the Northern Caucasus in the late 15th century.

THE MIDDLE EAST

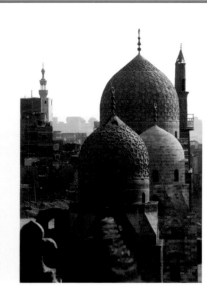

1468–96 Reign of Sultan Qaytbay. Sultan al-Ashraf Qaytbay is one of the greatest patrons of the arts during the Burji Mamluk period. The art produced during his reign shows an increased refinement and less eclecticism than under the earlier Bahri Mamluks.

NORTH AFRICA AND SPAIN

1492 Granada falls to Christian armies of Ferdinand and Isabella. This marks the surrender of the last Muslim territory in Spain, and is followed in 1499 by a campaign of forced conversion of Spain's remaining Muslims.

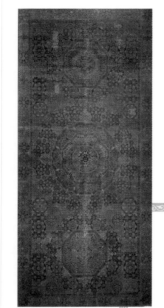

Late 15th century: Mamluk carpets. In contrast to the repeating designs found in neighbouring Anatolia during this period, Mamluk rugs have complex, centralized designs based on octagonal or star-shaped motifs, surrounded by flanking bands which often contain cartouches. The colour scheme is dominated by the use of a highly saturated red, along with green and blue and, later, yellow. Also distinctive are the absence of monumental inscriptions, otherwise so characteristic of Mamluk art; and the use of the asymmetrical (or 'Persian') knot. The exact provenance of Mamluk carpets remains a matter of debate among scholars.

Mid–late 15th century: carved masonry domes, Cairo. During this period a number of remarkable carved masonry domes were completed in Mamluk Cairo. Their development began with the domes of the funerary complex of Sultan Barsbay (1432), above, and culminated in that of the funerary complex of Sultan Qaytbay (1472–4), where finely carved geometric patterns based on a star motif run in counterpoint to elaborate, foliate arabesque. The technical difficulties of adapting such designs to the shape of a dome were considerable.

1479–80 The Venetian painter Gentile Bellini visits the court of Mehmed the Conqueror. Bellini's portrait of the sultan is now in the National Gallery, London.

Late 15th century: Ottoman silverwork. Silver mugs or jugs of this shape were produced widely during the 15th and early 16th centuries in the Ottoman territories, both in major urban centres and in provincial workshops. The example shown below left has engraved and chased decoration, including medallions with split-palmette leaves, a deer-like animal and a rabbit. It was made in Ottoman Turkey or the Balkans.

ANATOLIA AND THE BALKANS

1453 Fall of Constantinople. An Ottoman army under Mehmed II ('the Conqueror') captures the city, after an assault lasting more than seven weeks. The city is made the new Ottoman capital, its name eventually changing to Istanbul.

1462 Ottoman conquest of Bosnia.

Second half 15th century: early Ottoman Qur'ans, Istanbul. The superb illumination of this Qur'an (right), with its Shirazi motifs in a new colour scheme, is typical of Ottoman Qur'ans of the 15th century.

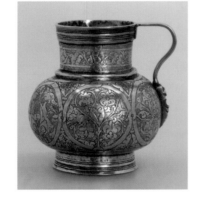

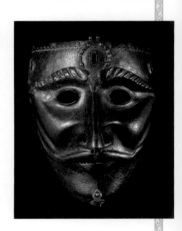

Late 15th century: Ottoman and Turkmen war masks. War masks such as this one were worn by the Ottomans in Turkey and by Turkmen troops in western Iran, and would originally have been attached to a helmet. The example shown here has beaten and engraved decoration, and was possibly made for the Aq Qoyunlu during the late 15th century.

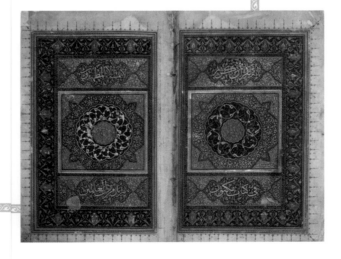

IRAN AND CENTRAL ASIA

15th century: Timurid metalwork. Timurid and Turkmen metalwork from the 14th and 15th centuries includes candlesticks with sockets in the form of intertwined dragons. They have bell-shaped bases, some of which are decorated.

Late 15th century: Timurid inlaid metalwork. Jugs such as this, with globular bodies, gold and silver inlaid decoration and dragon handles, were produced in northeast Iran during the late 15th century. Slightly earlier examples feature inscriptions; the jug shown here is covered by a network of arabesques. It may originally have had a domed lid. The distinctive shape of the body was followed in Ottoman examples, such as the silver mug or jug shown right.

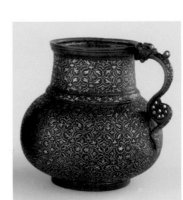

Late 15th century: Timurid pottery. This underglaze-painted bottle, decorated with birds among billowing, Chinese-style clouds, is a particularly fine example of Timurid pottery from this period. It was made in Iran.

1516–17 Ottoman conquest of Syria and Egypt, and fall of the Mamluks.

1534 Ottomans take Baghdad; 1539 Ottomans take Aden.

1521 Belgrade falls to Ottomans; 1529 first Ottoman siege of Vienna.

Late 15th–early 16th century: Ottoman calligraphy. One of the greatest and most esteemed calligraphers of the Ottoman period was Shaykh Hamdullah (1429–1520), who is credited with having instructed Sultan Bayazid II. Shown above is a leaf from a calligraphic album by Shaykh Hamdullah, which dates from the early 16th century.

16th century: Ottoman portolan charts. Ottoman portolan charts (from the Italian and Catalan *carta portolana* or *portolano*) generally focus on the Mediterranean and, to a lesser extent, the Black Sea, the northwest African coast and the Atlantic coast of Europe. Perhaps the most famous Ottoman topographical manuscript is the *Kitab-i Bahriye* ('Book of Seamanship'), a portolan atlas by the great Ottoman admiral and cartographer Piri Reis, which dates from the 1520s. The view of Istanbul shown (right) is datable to c. 1670.

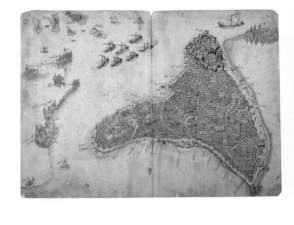

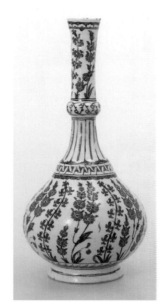

16th century: Iznik pottery. Iznik pottery and tiles are characterized by floral motifs in rich, deep colours offset against a brilliant white ground, and by their shining glazes. Shown here is a ceramic flask decorated with repeated floral sprays, made at Iznik in the 16th century.

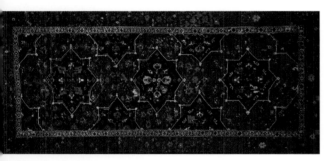

16th century: Uşak carpets, Turkey. The luxurious Ottoman rugs known as Uşaks were produced in the town of Uşak in western Anatolia, which was an established centre for carpet weaving from at least the late 15th century. A number of different types of Uşak carpet were made, the majority characterized by their bold star or medallion motifs. The production of 'star' and 'medallion' Uşaks continued for over 200 years, and many examples have survived, particularly in Italy.

16th century: Ottoman bindings. The binding shown here is from a manuscript of the *Mantiq al-Tayr* ('Conference of the Birds') of Farid al-Din 'Attar, and is dated c. 1540–50. The black leather is pressure-moulded, and the fine decoration includes chinoiserie cloud-scrolls and floral scrolls.

1520–66 Reign of Süleyman the Magnificent. The reign of Süleyman I (called Qanuni, meaning 'the Lawgiver', but known in the West as Süleyman the Magnificent), is generally regarded as the apogee of the Ottoman period. As well as marking the greatest period of expansion (Ottoman forces conquer Serbia in 1521, reach Vienna in 1529, and take Baghdad in 1534), his reign sees the patronage of some of the most significant monuments of Ottoman architecture, including Sinan's great Süleymaniye complex in Istanbul.

SAFAVID DYNASTY (1501–1722, Tabriz/Qazvin/Isfahan). *In 1501 Shah Isma'il captures Tabriz from the Aq Qoyunlu dynasty and founds the Safavid dynasty. Following repeated Ottoman attacks on Tabriz, his son Tahmasp moves the capital to Qazvin; later, Shah 'Abbas moves it again, to Isfahan. As well as being responsible for the patronage of some magnificent art and architecture, the Safavids are of great significance in the history of Iran since they impose Shi'ism as its official religion.*

1514 Defeat of Safavid armies at Çaldiran by the Ottoman Sultan Selim I (known as 'the Grim'), and Ottoman sack of Tabriz.

Late 15th–early 16th century: lacquer bindings, Herat. Bindings in 'bookbinder's lacquer' have a papier-mâché base, which is painted with designs and coated with a layer of brilliant varnish. Shown here is one of the earliest known lacquer bindings, made in Herat c. 1490–1510. It is decorated with gold arabesques on a black ground, showing the influence of Chinese T'angjin lacquer.

First half 16th century: Safavid miniatures, Tabriz. A magnificent *Shahname* (often referred to as the 'Houghton' *Shahname* after the owner who separated the manuscript) was commissioned by Shah Isma'il I and continued to be produced under Shah Tahmasp I at Tabriz between c. 1522 and the 1530s. This outstanding manuscript included some 258 miniatures and involved all the leading artists and craftsmen of the period. The large pages (approximately 47 × 31cm) are sprinkled with gold, the format of each illustration individually conceived. Shading is treated with extraordinary subtlety, and colours enhanced by the addition of gold, silver and mother of pearl.

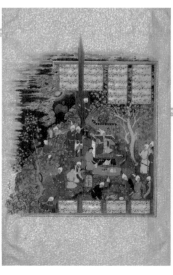

1534–5 Ottomans occupy Tabriz.

THE INDIAN SUBCONTINENT

MUGHAL DYNASTY (1526–1858, Kabul/Delhi/Lahore/Agra). *In 1526 Babur, a descendant of Timur, unable to maintain a hold on his Central Asian homelands due to the strength of the Shaybanids (Uzbeks), invades India. Defeating the local rulers at the battle of Panipat, he captures Delhi, and establishes the Mughal dynasty. His descendants enlarge their territory to include Rajasthan, Gujarat and the Deccan.*

37

NORTH AFRICA AND SPAIN

1556 Phillip II introduces a law forbidding Spain's remaining Muslims to speak Arabic or practise their faith.

THE MIDDLE EAST

16th century: Ottoman *tuğras*. A particular characteristic of Ottoman calligraphy is the *tuğra*. This consisted of the name of the sultan together with that of his father, followed by the traditional Turkish title *Khan* and the words 'ever victorious'. The earliest surviving *tuğra* dates from the first half of the 14th century, and is relatively simple; by the 16th century, the design had become considerably more elaborate. Shown here is the *tuğra* of Murad III, dated 1576.

1570 Ottomans capture Cyprus.

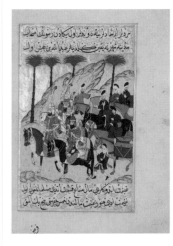

Mid–late 16th century: Ottoman miniature painting. Ottoman miniature painting reached its peak during the second half of the 16th century, when such works as the great *Süleymanname* and the *Tarikh-i Sultan Süleyman* ('History of Sultan Süleyman'), commissioned by Süleyman the Magnificent and Murad III respectively, were produced. Shown here is a page from the *Siyer-i Nebi*, a Turkish version of the 'Life of Muhammad', written in Istanbul c. 1594–5.

16th century: cane shields, Ottoman Turkey. Cane shields were a standard element of Ottoman armour. The cane was wound with silk thread, different colours being used to create decorative patterns.

Second half 16th century: Ottoman pottery, Damascus. Syria, in particular Damascus, was also an important production centre for Ottoman pottery. Tiles and pottery produced in Damascus from the late 1560s have a characteristic palette of blue, turquoise, bright green and manganese purple – the bole red of Iznik and Kütahya wares is notably absent.

1588 Death of Sinan.

16th century: archer's thumb rings, Ottoman Turkey. An archer would wear a thumb-ring or *zehg* on the thumb of the right hand, that is, the hand which pulled the string of the bow taught. When released, the string slid easily over the ring's smooth surface. Many are of jade, and some later, Mughal examples are beautifully decorated with gold inlay and precious stones.

ANATOLIA AND THE BALKANS

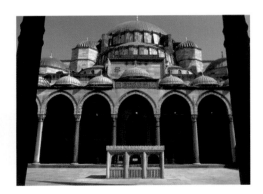

1551–7 Süleymaniye complex, Istanbul. The Süleymaniye complex (above) was built for Süleyman the Magnificent, and along with the Selimiye in Edirne is generally regarded as the greatest work of the architect Sinan. It is in a superb location, commanding impressive views over the Golden Horn, and the mosque is surrounded by various colleges with living quarters, a hospital and a soup kitchen. The interior of the mosque is magnificently spacious. The huge dome is flanked by two half domes, each opening into smaller domes, and is supported by four massive square piers.

16th century: Ottoman silk brocades. Silk brocades and garments such as kaftans were highly prized during the Ottoman period. Floral designs predominate, with many parallels to those found on Iznik tiles. In contrast to the naturalism that characterizes Safavid textile designs, those on Ottoman silks remain comparatively formal and stylized. The 'ogival lattice' design popular under the Mamluks is also found on many Ottoman silks (below).

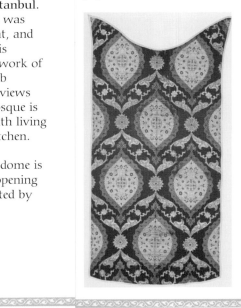

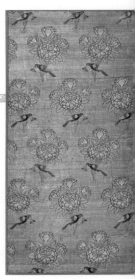

Late 16th–17th centuries: Safavid silk brocades, Isfahan. In contrast to the somewhat stylized designs of Ottoman silks, those made in Iran during this period show a remarkable degree of naturalism, with many parallels to Safavid miniature painting. In some cases, miniature painters actually designed the patterns for the silk weavers. Typical subjects included birds and animals among elaborate foliage and flowers (right), and figural subjects derived from illustrated manuscripts.

1587–1629 Reign of Shah 'Abbas I. The reign of Shah 'Abbas I is probably the pinnacle of the Safavid period. In 1598 he moves his capital from Qazvin to Isfahan and sets about lavishly decorating the city with some stunning architecture, including the Masjid-i Shah (also called the Masjid-i Emam, shown opposite) and Masjid-i Shaykh Lutfallah. He also resettles some 3,000 Armenians from Julfa in Azerbaijan to New Julfa, a suburb of Isfahan, to bolster the silk trade.

IRAN AND CENTRAL ASIA

1555 Peace of Amasya ends Ottoman–Safavid hostilities.

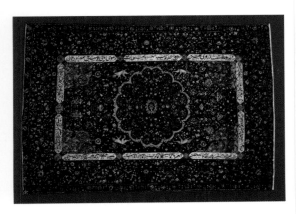

16th–17th centuries: Safavid–Uzbek wars.

16th century: Safavid carpets. Some magnificent carpets were produced in Safavid Iran, the best known being the two 'Ardabil' carpets commissioned by Shah Tahmasp I (1524–76), and now in the Victoria & Albert Museum, London, and the Los Angeles County Museum of Art. These and other Safavid carpets, such as the beautifully preserved example shown here, feature 'medallion' designs with a central sun-disc or star and framing bands. They were probably woven at Kashan.

THE INDIAN SUBCONTINENT

Second half 16th century: Mughal painting. One of the most important manuscripts to be prepared by the royal workshop of the Mughal emperor Akbar (1556–1605) was a huge 14-volume copy of the *Hamzaname*, originally with some 1,400 illustrations. The project lasted for approximately 15 years, and shows the assimilation of a number of diverse painting styles. Many of the artists in Akbar's royal workshop bore Hindu names.

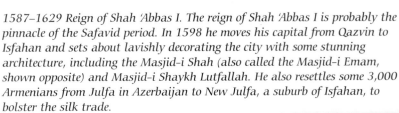

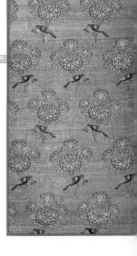

9 Phillip III orders final expulsion of in's Muslim population, estimated at ut half a million.

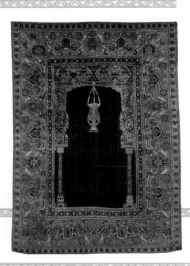

Late 16th–17th century: Ottoman 'prayer' rugs, Cairo. The carpet shown here, which features a *mihrab*-like niche, is of a type known as 'prayer' rugs – although there is no evidence that they were in fact used for prayer. Such carpets were originally produced in Ottoman Cairo, although later some of the best examples may have been made in Bursa or Istanbul. They are typically decorated in the *saz* style popular at the Ottoman court in the later 16th century.

1683 Second Ottoman siege of Vienna.

1699 Treaty of Carlowitz.

17th century: steel fretwork, Iran. A variety of objects in fretwork steel were produced in Iran during the Safavid and Qajar periods. The example shown is part of a standard, and was made in the 17th century.

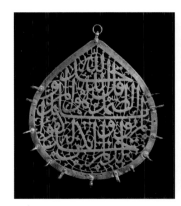

1612–30 Masjid-i Shah, Isfahan. The Masjid-i Shah in Isfahan (also called the Masjid-i Emam) is an outstanding example of Safavid architecture. Almost the entire surface of the interior, together with the main portal façade, is sheathed in polychrome glazed tiles (predominantly turquoise, and largely replaced in the 1930s). The soaring bulbous dome, some 52m high, is also covered with tiles decorated with spiralling arabesques.

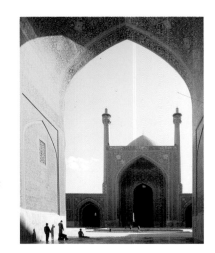

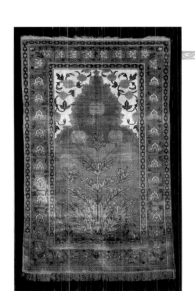

17th century: Mughal carpets, India. Carpets were probably introduced to the subcontinent during the period of the Delhi Sultanate (1206–1555); under the Mughals their production attained great refinement. During the reign of Shah Jahan (1628–57) and later, one group of Mughal carpets was characterized by extremely detailed and naturalistic portrayals of individual plants, framed within a niche (left).

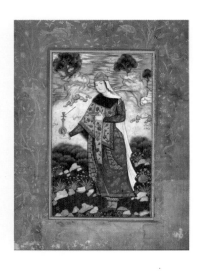

17th century: Safavid painting. Single-figure paintings became popular in Qazvin during the 16th century, and continued in Isfahan during the 17th century. That shown here depicts a lady of the court holding a water pipe, against a background of purplish rocks, oriental plane trees and billowing clouds. It was painted in Isfahan c. 1640–50.

17th century: Mughal gold coins. Coins from the reign of Jahangir (1605–27) include a spectacular series based on signs of the zodiac (left, Taurus).

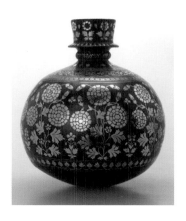

1602–27, 1630–38 Ottoman–Persian wars.

17th century: *bidri* ware, Mughal India. *Bidri*-ware vessels were made from an alloy containing zinc, and inlaid with silver, brass and occasionally gold. They were then coated with salts mixed with mud, which blackened the vessel but not the inlay. The technique is thought to have originated in the Deccan, but production later spread to other centres. Shown is the base from a *huqqa* (water pipe).

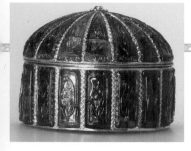

17th century: Mughal jewellery. India is rich in gems and precious stones and has a long history in the production of luxurious jewellery. Shown here is an emerald-covered gold box, dating from the early 17th century.

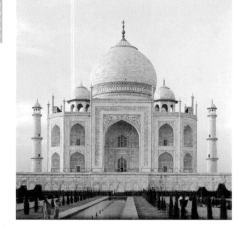

1632–47 Taj Mahal, Agra. The Taj Mahal was built by Shah Jahan for his favourite wife Mumtaz Mahal, who died in childbirth in 1631. The octagonal tomb is surmounted by a huge, bulbous central dome set on a cylindrical drum, and surrounded by four corner-pavilions crowned with *chhatris*. It is faced entirely with white marble, and stands on a high platform with four tall minarets. This platform is flanked by a mosque and a guesthouse in red sandstone. The mausoleum stands at the northern end of a rectangular garden with an elongated pool at its centre. The garden is entered through a massive gateway to the south, from where the mausoleum is seen reflected across the pool.

1628–57 Reign of Shah Jahan.

1648 Shah Jahan moves his capital to Delhi.

00 Formation of the East India Company.

1658 Shah Jahan imprisoned by his son Awrangzeb, who then has his brothers executed and goes on to seize the Mughal throne.

39

THE MIDDLE EAST

NORTH AFRICA AND SPAIN

1830 French invasion of Algeria
1881 French occupy Tunisia;
1911 Italian invasion of Libya

1798–1801 French troops occupy Egypt.

ANATOLIA AND THE BALKANS

1727 First Turkish printing press in Istanbul. Although the printing press is closed in 1742, an official gazette is introduced in the 19th century under the reformer, Sultan Mahmud II.

1766 Great earthquake in Istanbul.

1839 British take Aden.

IRAN AND CENTRAL ASIA

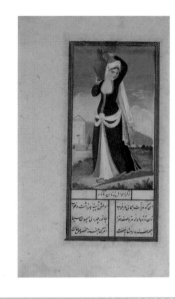

Early 18th century: Ottoman painting. Under Sultan Ahmed III (1703–30), a distinctive style was developed by the court painter Levni. Single female figures were a popular subject, depicted with lighthearted gestures, in a pale palette as in the manuscript page shown (left).

Mid 19th century: works of the Balian family of architects, Istanbul. The Balian family (among whom three studied in Paris) were responsible for introducing French architectural fashions to Istanbul.

19th century: inscribed leaf skeletons, Turkey. The art of writing on leaf skeletons became popular during the later Ottoman period. The leaves used were typically tobacco or ivy, although those of the horse chestnut, as well as fig and mulberry, were also used. They were gilded, and inscribed with religious or moral sayings.

1722 Safavid dynasty overthrown by Mir Muhammad, Afghan ruler of Qandahar. Mir Muhammad invades Fars province, routs the Persian army and marches on Isfahan, finally taking the city after a seven-month siege.

1736 Nadir Shah declares himself Shah of Persia, invades India in 1738 and in 1740 sacks Bukhara and Khiva; 1747 assassination of Nadir Shah.

QAJAR DYNASTY (1779–1925, Tehran). The Qajars were originally a powerful Turkmen tribe from the Caspian's eastern coast. The founder of the dynasty, Agha Muhammad, captures Tehran in 1786 and makes it his capital. He is crowned Shah in 1796.

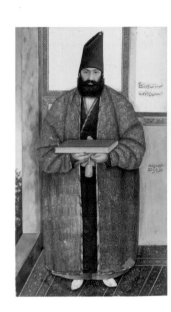

Mid-19th century: Qajar portraiture. The style of painting which flourished under the Qajars shows marked European influence. Shown here are a miniature enamelled portrait of Fath 'Ali Shah (1797–1834), and a work by the court painter Abu'l-Hasan Ghaffari.

THE INDIAN SUBCONTINENT

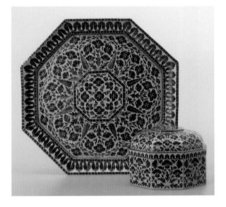

17th–18th centuries: enamelled gold, Mughal India. The art of decorating gold objects with engraving and enamelling was popular in Mughal India from the 17th century onwards. Shown here are a tray and casket, produced in northern India c. 1700.

1739 Nadir Shah sacks Delhi.

19th century: architecture, Khiva. While many examples of Ottoman architecture from the late 19th century were heavily influenced by European styles, a more traditional style prevailed further east. At Khiva, for example, a revivalist movement led to the construction of buildings which more or less followed established Timurid formulas. Shown here (right) is the Kaltar minaret, begun in 1852 but left uncompleted.

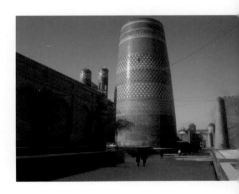

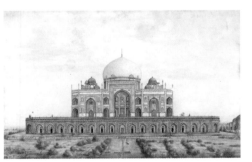

17th–18th centuries: painted textiles, Mughal India. Shown here is a cotton cloth painted with rows of flowering plants.

Late 18th–early 19th century: Company style, India. The style of paintings produced for officials of the East India Company, often referred to as the 'Company Style', shows a marked European influence. Subjects included architectural studies (above), and studies of Indian flora and fauna (right).

1803 British take control of Delhi.

19th–20th centuries: pottery, Morocco. Tin-glazed pottery and other wares were produced in Morocco well into the 19th and even 20th centuries. The bowl shown here dates from the early or mid-19th century; brighter colours predominate on later examples. A number of motifs were derived from Nasrid and Ottoman sources.

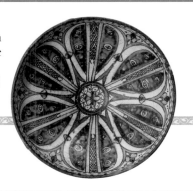

1956 Tunisia, Morocco and Sudan declare independence; 1969 Libya becomes a republic.

1991 Beginning of civil war in Algeria.

1953 Egypt proclaimed a republic.

1982 Israeli invasion of Lebanon.

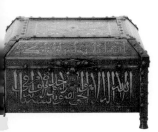

Late 19th century: Mamluk Revival, Egypt. An increasing interest in the cultural legacy of the Mamluks led to a revivalist movement among Egyptian artists and craftsmen, as this beautiful Qur'an box of 1897 clearly shows.

1956 Israel–Egypt war; 1967 and 1973 Israel–Arab wars.

1990–91 Iraqi invasion of Kuwait, Gulf War.

1908 Young Turks Revolution. A group of Ottoman military officers, known as the Young Turks, force the sultan to adopt constitutional reforms.

1948 Establishment of modern state of Israel.

2003 US-led invasion of Iraq.

1912–13 First and Second Balkan wars.

1853–5 Crimean War.

1878 Congress of Berlin. Occupation of Bosnia-Herzegovina by Austria-Hungary, Russian occupation of eastern Turkey.

1922–4 End of Ottoman Empire. The last Ottoman sultan, Mehmed VI, is deposed in 1922, the Turkish Republic inaugurated in 1923, and the caliphate abolished in 1924.

1853 Dolmabahçe Saray, Istanbul. This palace was built on the Bosphorus for Abdülmecid I by the architect Karabet Balian, and shows the influence of European architecture in Ottoman Turkey during the 19th century.

Early 20th century: Ottoman calligraphy. The sustained level of refinement attained by Ottoman calligraphers is illustrated by this composition in the form of a lion, which dates from 1913.

859 Russian annexation of Chechnya and aghestan; 1868 Russian annexation of khara and Samarqand; Russian conquest Central Asia completed in 1883 with nexation of Merv.

1925 End of Qajar dynasty; accession of Reza Shah, first ruler of Pahlavi dynasty.

1979 Iranian revolution, Shah deposed; creation of Islamic Republic of Iran.

c. 1970 to the present: Iranian cinema. Directors including Dariush Mehrjui, Mohsen Makhmalbaf and Abbas Kiarostami have garnered an unprecedented number of international awards.

th century: Qajar lacquer. The art lacquer decoration was popular nder the Safavids and continued nder the Qajar dynasty. Among jects decorated in lacquer were doors, irror cases, pen boxes and okbindings. Shown here are a detail a pen box painted with battle scenes ft) and a bookbinding featuring alistic plant studies (below).

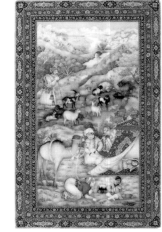

19th–20th centuries: Iranian revivalism. Artists such as the painter Husayn Bihzad (1894–1968), who specialized in copies of the late Timurid and Safavid styles (left), were part of a cultural movement that looked back to more glorious periods in Iranian history.

1979 Soviet invasion of Afghanistan.

1991 Fall of Soviet Union, former Soviet republics in Central Asia and the Caucasus gain independence.

1996 Taliban take over Kabul.

1980–88 Iran–Iraq war.

2001 US bombing of Afghanistan, fall of Taliban.

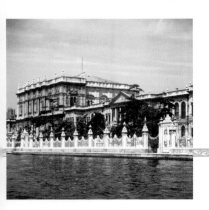

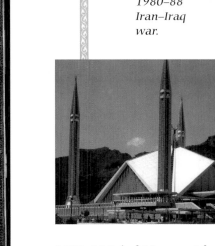

19th–20th centuries: textiles, Uzbekistan. Traditional textiles continue to be produced in Uzbekistan to the present day. Shown here is a 19th-century silk and velvet *ikat* coat with embroidered sleeves, from Bukhara.

Early 20th century: batik textiles, Java. This batik shawl, with its religious inscriptions, may have formed part of a wedding outfit.

1976–86 Faisal Mosque, Islamabad. This huge mosque is named after the late King Faisal of Saudi Arabia, who funded its construction. It was designed by a Turkish architect, Vedat Dalokay, and employs a modern, tent-like structure instead of a traditional dome. The complex also houses a research centre, library, lecture hall and museum.

57 Indian Mutiny. 1858 India falls under ish rule; end of Mughal dynasty.

1947 India wins independence; partition of India and Pakistan.

41

The Written Word: Calligraphy

Calligraphy has always held a preeminent position in Islamic art. As the medium of the Qur'an, the word of God, Arabic script was accorded an exceptional status in Islamic society; and in the absence of religious imagery, the written word became a form of visual expression, with inscriptions fulfilling the function of holy pictures in other religions. Calligraphy appears on all forms of Islamic art, from pottery and ceramics to metalwork and architectural decoration, and of course in Qur'ans, the development of which will be outlined separately (see 'The Word of God: Qur'ans', below).

The study of the history of calligraphy itself forms a long and venerable tradition in the Islamic world, from the *Fihrist*, a bibliographical work by the 10th-century Baghdadi scholar Ibn al-Nadim, to the comprehensive overview written in 1759 by the Ottoman calligrapher Müstakim-zade. The tradition continued into the 20th century among Turkish and Persian scholars such as I.M.K. Inal and M. Bayani. Since these accounts generally took the form of a series of biographies, we have more information about the most celebrated calligraphers than about any other group of Muslim artists.

THE DEVELOPMENT OF ISLAMIC SCRIPTS

The style of script that existed in western Arabia in the first decades following the *Hijra* is known as *Hijazi*, and is characterized by a slight slant to the right. The few examples of *Hijazi* which survive indicate that this script was still evolving and that a set of rules governing its standard use had not yet been fully codified.

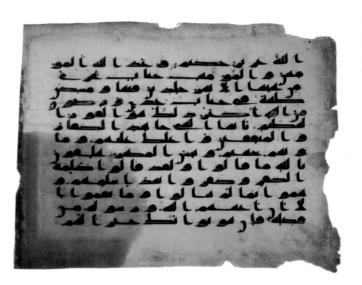

Single folio from a Qur'an on parchment with Kufic script. Perhaps 9th century.

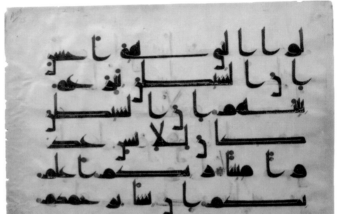

Single folio from a Qur'an on parchment with Kufic script. 9th century.

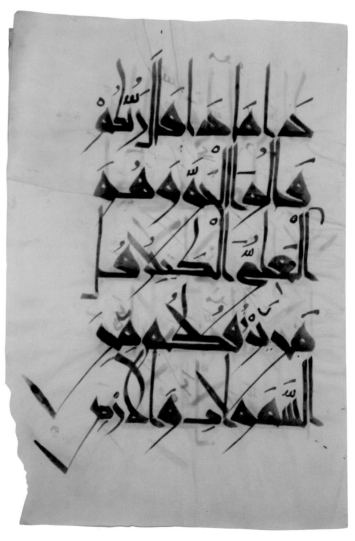

Folio from a large Qur'an on parchment with grand Kufic script. Tunisia, early 11th century.

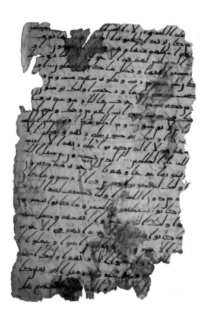

Single folio from a Qur'an on parchment with *Hijazi* script. Early 8th century.

Hijazi was superseded by the angular script commonly known as Kufic. This appellation refers to the town of Kufa in southern Iraq, and was chosen by the Lutheran cleric Jacob Georg Christian Adler (1756–1834) while cataloguing the Qur'anic collection of the Royal Library at Copenhagen. It has since been recognized that the term is not entirely suitable: research has revealed a far greater diversity of styles under this general heading than had been originally noted, and very little is known about what the script(s) in use at Kufa actually looked like. More recent terms for these angular styles are the 'Early Abbasid styles' (for Kufic), and the 'New Style' (for the variant that developed in the eastern Islamic lands, formerly referred to as Eastern Kufic; see below); and careful study of the characteristics of these scripts, on the basis of the treatment of specific letters, reveals a consid-

erable number of sub-groups. An analysis of these would be unnecessarily complex here, however, and for the sake of simplicity the terms 'Kufic' and 'Eastern Kufic', though in some ways technically unsound, have been retained.

By its angular nature, Kufic was highly suited to architectural decoration, either in stone or mosaic; and it rapidly became the automatic choice for the writing of Qur'ans. Curvilinear scripts were developed by scribes during the Umayyad and Abbasid periods for use in secular writing, the most common being the plain scribal hand known as *naskh*.

A system of diacritics to indicate short vowels, which are not written in Arabic, was devised by Abu'l-Aswad Du'ali in the second half of the 7th century, in the form of red and yellow dots; two of his pupils extended this system by adding dots above or below the line to differentiate between letters of the same form. The administrative reforms of 'Abd al-Malik (685–705), who made Arabic the official chancery language of the Umayyad Empire, undoubtedly played a part in these developments. A system of proportions for scripts, based on a dot the width of a pen nib and the first letter of the Arabic alphabet, the vertical *alif*, was developed by the vizier Ibn Muqlah in the early 10th century.

In Iran and the eastern Islamic lands, the greater use of paper rather than parchment in the production of Qur'ans gave rise to the development of a more slender and refined script, commonly known as Eastern Kufic, which predominated from the 10th to the 13th centuries. Its use was not confined to Qur'ans and other works on paper, however, and it is found in a variety of contexts from pottery to architectural decoration. At the same time, the main curvilinear scripts, in particular *naskh*, *thulth*, *muhaqqaq* and *rayhan*, were developing in the eastern Islamic lands. *Muhaqqaq* and *rayhan* were used almost exclusively for Qur'ans copied in this region from the 11th century. *Riqa'* and *tawqi'* were employed as chancery hands, although the former also came to be used for *sura* headings in Qur'ans during later periods.

The scripts of North Africa and Spain (*maghribi*, *sudani* and *andalusi*) are of a notably different character from those of the central Islamic lands – especially in their use of deep, curving loops below the baseline.

Two of the most celebrated calligraphers of the medieval Islamic period were Ibn al-Bawwab (d. 1031), who was active in Baghdad during the Buyid period; and the great Yaqut al-Musta'simi (d. 1298), the most prominent calligrapher of the 13th century, whose style influenced numerous successive generations. Yaqut, who was of Turkic origin, was secretary to al-Musta'sim, the last Abbasid caliph.

Although by the 15th century *nasta'liq* had become the most popular script in Iran, its use in Qur'ans remained extremely rare. From the beginning of the 18th century, however, a distinctly Iranian style of *naskh* began to develop, which came to be used as the standard Qur'anic hand throughout the 19th century in Iran. This development is associated with the celebrated calligrapher Mirza Ahmad Nayrizi from the province of Fars, who after settling in Isfahan towards the end of the 17th century began to work for the court of Shah Sultan Husayn (1694–1722). Nayrizi's *naskh* is characterized by its relatively large size and exceptional clarity, and by the equal weight given to both vowels and consonants, with diacritics placed at exactly the same distance above and below the consonants throughout the text. Nayrizi was active from the 1670s to c. 1740. His work was copied many times by later Iranian calligraphers, including the great 19th-century poet and calligrapher Visal.

In India during the pre-Mughal period, a distinctive form of *naskh* known as *bihari* (perhaps a reference to the town of Bihar in eastern India, or to the size, or *bahar*, used to prepare paper for writing) was commonly used in the writing of Qur'ans. This hand, which is characterized by its thick horizontal strokes, largely disappeared following the establishment of the Mughal dynasty. The Mughal rulers Akbar (1556–1605), Jahangir (1605–27) and Shah Jahan (1628–57) showed a greater interest in *nasta'liq* than in *naskh*.

Calligraphy reached a spectacular degree of refinement during the Ottoman period. One of the finest early Ottoman calligraphers was Shaykh Hamdullah (1429–1520). Shaykh Hamdullah is best known for his *naskh* and *thulth*, derived from the style of Yaqut al-Musta'simi; his *naskh* was to become the standard Qur'anic script during the later Ottoman period. The greatest exponent of the calligraphic legacy of Shaykh Hamdullah, and one of the most distinguished of all Ottoman calligraphers, was Hafiz Osman (d. 1698–9). Hafiz Osman

The Six 'Classical Hands'

The six basic forms of Arabic script (or the six 'classical hands' in calligraphy) are *naskh*, *thulth*, *muhaqqaq*, *rayhan*, *tawqi'* and *riqa'*. From these a number of variations evolved: *nasta'liq*, *shikaste*, *divani*, *ta'liq*, *ijaze* and *ruq'a*; and in North and West Africa, *maghribi*, *sudani* and *andalusi*. The particular characteristics of these styles can perhaps best be appreciated by a comparison of the following examples by the present-day calligrapher Mohamed Zakariya:

Naskh in the style of Ibn al-Bawwab (d. 1031)

Jali [large] *thulth* after Ibn al-Bawwab

Jali muhaqqaq in the style of Yaqut (d. 1298)

Rayhan after Ibn al-Bawwab

Tawqi' in gold

Riqa' in the style of Ibn al-Bawwab

43

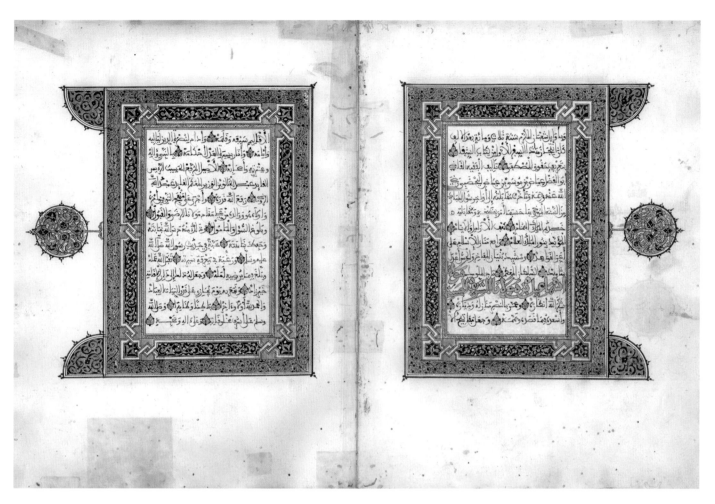

Two-page colophon and dedication in *maghribi* script from a royal copy of the *Kitab al-shifa bi-taʿrif huquq al-mustafa*, commissioned by the Sultan of Morocco, Mawlana Ismaʿil ibn Mawlana al-Sharif al-Husayni. Morocco, 18–28 April 1692.

was largely responsible for the revival of *naskh* and the other classical hands, the use of which had declined somewhat by the end of the 16th century. It is a testament to the great esteem in which Shaykh Hamdullah and Hafiz Osman were held that many later Ottoman scribes traced their calligraphic 'genealogy' to these two figures.

Another celebrated Ottoman calligrapher was Ahmed Karahisari (c.1468–1556), a student of Asadallah Kirmani of Kirmanshah, a town in western Iran. Karahisari evidently felt the debt to his master to be sufficiently profound that, even at the height of his maturity, he chose to sign his work '… Ahmed Karahisari, one of the pupils of Seyyid Asadallah Kirmani….' Inscriptions by Karahisari still grace the great Süleymaniye and the Piyale Paşa mosques in Istanbul, and two of his masterly *basmalas* (a frequently occurring invocation which trans-

Far left: Album page with compositions in *naskh* signed by Ahmad Nayrizi. Iran, 1709–10.

Left: Folio from a Qurʾan written in *bihari*. India, 15th century.

Above: Calligraphic panel (*levha*) in *jali thulth* by Sultan Mahmud II after Mustafa Rakım. Ottoman Turkey, 19th century.

Right: Detail of an inscription in *jali thulth*, commemorating the renovation of the water spout of the Ka'ba by Sultan Abdülmecid I. Ottoman Turkey, 19th century.

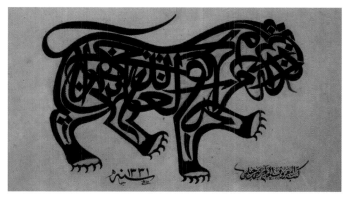

Right: Calligraphic composition in *thulth* in the form of a lion. Turkey, dated 1913.

Bottom: Page from an album of *mufradat* by Mehmed Şevki. Ottoman Turkey, 1866–7.

lates as 'In the name of God, the Compassionate, the Merciful') became among the most widely known examples of calligraphy in the Islamic world through 19th-century lithographic reproductions.

Calligraphy formed part of the traditional education of the Ottoman sultans, Sultan Bayazid II (1481–1512) having been taught by the great Shaykh Hamdullah himself. Perhaps the most skilled of the Ottoman sultans in this field was Sultan Mahmud II (1808–39). Ottoman calligraphy maintained its high level of refinement well into the later period, as is confirmed by the work of Mustafa İzzet, the most esteemed Ottoman calligrapher of the 19th century, and many superb examples from the late 19th and even the early 20th centuries. The chancery hand, known as *divani*, was used by the extensive Ottoman bureaucracy.

NON-QUR'ANIC CALLIGRAPHY

While the most important application of calligraphy remained the writing of Qur'ans, a number of other distinct and often highly sophisticated genres developed, associated specifically with the calligrapher's art.

Practice sheets, on which the calligrapher endeavoured to refine his skills, were known as *musawwada* in Arabic, as *karalama* in Ottoman Turkey and *siyah mashq* in Iran. In each case the term means 'to blacken', referring to the tendency to cover as much of the sheet as possible. Technique played a more important role than content in these sheets. The calligrapher would write diagonally between lines, even upside down, turning the page as he worked and focusing on the form of the calligraphy itself; the text, in contrast, sometimes has little meaning. Eventually such practice sheets became highly valued and were collected by connoisseurs.

Albums or exercise books in which the individual letters of the Arabic alphabet (known as *mufradat*) were written, together with all their possible combinations, provide an important source of examples of the refinement of calligraphy. That these albums were studied and compiled not just by students but also by master calligraphers implies a continual search for perfection by these artists.

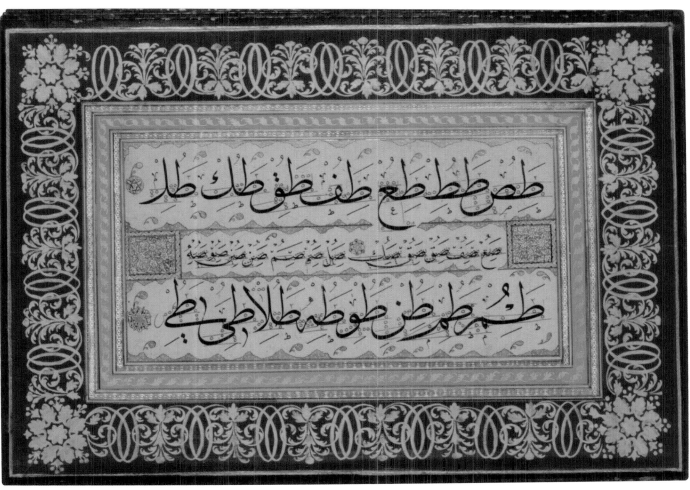

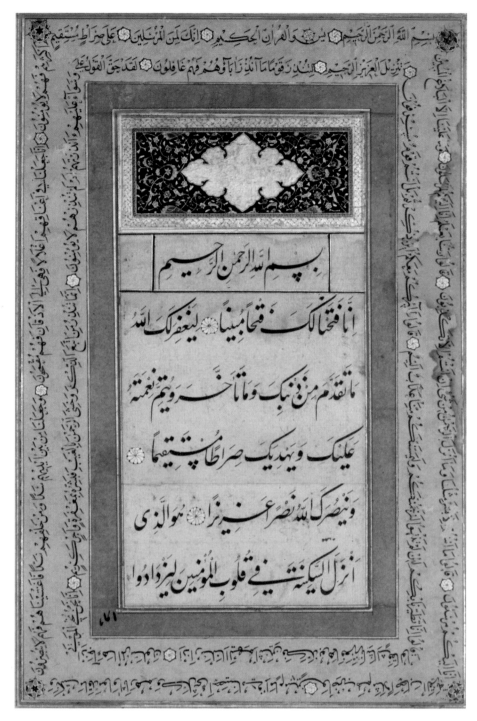

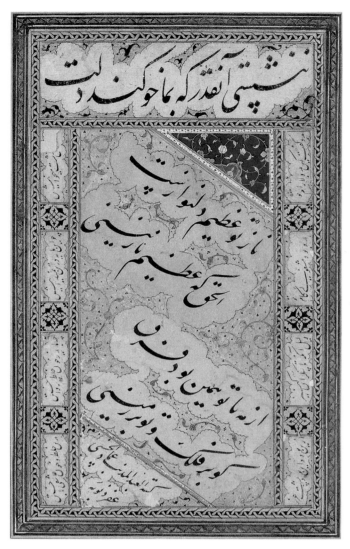

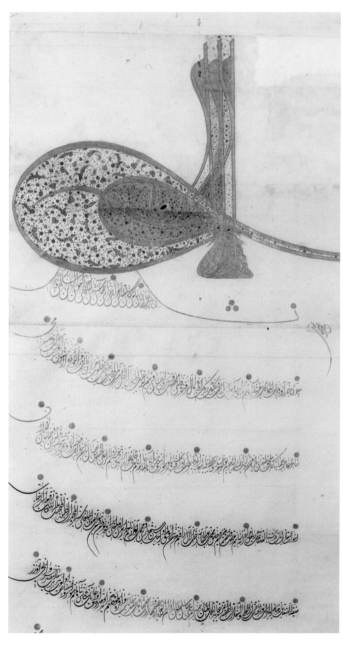

Above: Album page with Qur'anic verses, written in *nasta'liq* (central panel) and *naskh* (margins) probably by Shah Mahmud Nishapuri. Iran, mid-16th century.

Above, far right: Page written in *nasta'liq* by Mir 'Imad al-Hasani, from an album of *muraqqa'at*. Iran, second half 16th century.

Far right: Detail of an imperial decree (*firman*) bearing the *tuğra* of Sultan Murad III. Ottoman Turkey, 1576.

A form particular to Ottoman calligraphy is the *tuğra*. This comprised the name of the sultan and that of his father, the traditional Turkish title *Khan* and later, the words 'ever victorious'. The earliest surviving *tuğra*, in the name of Orhan Ghazi, dates from the first half of the 14th century and is relatively simple in design. By the 16th century, however, the designs of *tuğras* had become considerably more elaborate.

One of the most popular calligraphic formats was the *qit'a* (from the Arabic root 'to cut', 'to separate'). In Iran, the *qit'a* took the form of a vertical composition, across which lines of poetry were written diagonally in elegant *nasta'liq*, some letters being exaggerated in length. In contrast, the format of the Ottoman *qit'a* (or *kit'a* in Turkish) was horizontal, with a line of large script written across the top, and several lines of smaller script below; *thulth* and *naskh* were the most commonly used scripts.

Album collections, or *muraqqa'* (literally 'a collection of fragments'), were popular throughout the Islamic world, and reached their most spectacular form at the 17th-century courts of Mughal India. These disparate collections included examples of calligraphy, paintings and drawings by earlier and contemporary masters; albums containing only calligraphy are comparatively rare, however. These include a volume in the Topkapı Saray Library, assembled for the Timurid prince Baysunqur Mirza; and a volume in the Khalili Collection, which bears the seal of Gawhar Shah, daughter of the Safavid ruler Shah Isma'il I (1576–8).

Calligrapher's Tools

The most important tool of the calligrapher's art was the reed pen. The nib was cut at different angles, according to which script it was to be used for, using a special knife known in Turkish as a *kalem-traş*. The blade of such knives was of tempered steel and varied in size and shape, again depending on the type of nib to be cut; the handles were typically of bone, ivory or stone. A rest of finely carved bone, mother of pearl or ivory was used to hold the pen firmly while the nib was being cut, and when it was not being used.

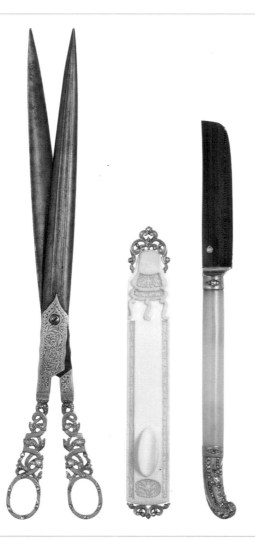

Set of calligrapher's tools, and four ivory pen rests. Ottoman Turkey, 19th century.

Above: From left to right: composition in gold *thulth* on a tobacco leaf; composition in gold *nasta'liq* on an ivy leaf; composition in *thulth* on a horse chestnut leaf. Ottoman Turkey, 19th century.

During the later Ottoman period the art of writing on leaf skeletons became popular. The leaves used were most often tobacco or ivy, although the much coarser horse chestnut was also used, as well as fig and mulberry The leaves were first pressed and dried, though not so much

Right: Calligraphic piece (*kıt'a*) in *thulth* and *naskh* from an album by Shaykh Hamdullah. Ottoman Turkey, early 16th century.

that they lost their flexibility. Gilded text – typically a profession of faith or a verse from the Qur'an – was then added to the back of the prepared leaf, generally using a stencil through which a mixture of pigment and gum arabic was applied. Finally, the leaf tissue surrounding the text was carefully removed from the skeleton by pricking or piercing with a fine point. The centre of production seems to have been Bursa in western Anatolia. These leaves became especially popular among Sufi orders, and many surviving examples may be found in the Mevlana Museum in Konya, the centre of the Mevlevi Sufi order.

Many calligraphers were connected to Sufi orders, including the great Ottoman masters Shaykh Hamdullah and Ahmed Karahisari, who were members of the Khalwati order. Furthermore, calligrapher's tools were often made by Sufis, as indicated by the turbans carved onto many ivory or bone pen rests.

Another popular form of calligraphy was *ghubar* or writing in miniature. The technique was originally used

for writing messages to be sent by pigeon post, where information had to be compressed into as small a space as possible; but it soon developed into a genre of its own, to be used on scrolls, for talismanic or esoteric writings, as well as in the writing of Qur'ans. On scrolls, for example, the miniature inscriptions might in their turn form the individual letters and words of larger inscriptions, or they might form the background of these larger inscriptions. *Ghubar* writing generally measures only 1.3mm in height, and only rarely more than 3mm.

Calligraphy was often copied by using perforated sheets known as *kalıps* (from the Arabic *qalib*). A copy of the calligraphy on the *kalıp* was made by tapping charcoal through it onto a clean sheet below – a technique corresponding to 'pouncing' as practised by European artists of the Renaissance and later periods. Large calligraphic panels known as *levhas* were often produced through the use of *kalıps*. *Levhas* were extremely popular in Ottoman Turkey, from where they spread to Iran.

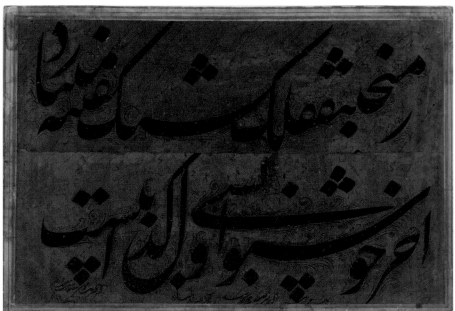

Above left: Large calligraphic panel (*levha*) in *jali thulth* by Mustafa İzzet. Ottoman Turkey, 1856–7.

Left: Calligraphic panel (*levha*) in *nasta'liq* by Malik Muhammad. Iran, 19th century.

Below left: Detail of a stencil (*kalıp*). Ottoman Turkey, 19th century.

Below: Detail of a *ghubar* composition signed by Mehmed Nuri Sivasi. Ottoman Turkey, probably Sivas, 1880–81.

Bottom: Detail of a scroll with a *ghubar* composition in black and red ink. Iran, 18th–19th century.

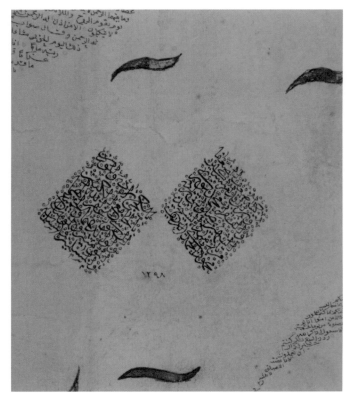

Illuminated frontispiece, and two folios written in *muhaqqaq* and Kufic by Yaqut al-Musta'simi, from part 15 of a 30-part Qur'an. Iraq, probably Baghdad, 1282–3.

The Word of God: Qur'ans

Qur'ans form the largest body of illuminated manuscripts in the Islamic world, and in some cases constitute the only surviving form of manuscripts from a given period. Their development has been bound inextricably to that of the Arabic script (see 'The Written Word: Calligraphy', above) and they form a key part of the overall body of material which constitutes the arts of the Islamic book (see also 'Miniature Painting' and 'Bookbinding', below). Qur'ans should be considered separately from secular or non-Qur'anic manuscripts, however, if only because of the complete absence in them of figural imagery.

That the surviving Qur'an manuscripts are of such consistently high quality, and that so many have survived to the present day, is due to the centrality of the Qur'an in the Islamic faith and to the consequent special protection accorded to Qur'ans through the course of history. In contrast to figural imagery or secular art, Qur'ans were extremely unlikely to be destroyed, unless as a result of damage by fire or water. Special protective cases and bags were used for storing and protecting them, while the dry climate of the central Islamic lands greatly facilitated the preservation of paper manuscripts. A notable exception is the Qur'ans of Umayyad Spain, the vast majority of which were destroyed by the Christian armies of the *Reconquista*. None has survived in Spain itself.

THE EARLY PERIOD

There are very few surviving Qur'ans from the early Islamic period; the oldest extant examples are thought to be from the 8th century. Early Qur'ans are typically written on parchment, with a horizontal page format (although one of the earliest known examples, an 8th-century Qur'an now in the British Library, London, is actually vertical); Kufic script is favoured (for a discussion of Kufic, see 'The Written Word: Calligraphy'). The calligraphy of early Qur'ans is frequently accompanied by illumination in the form of geometric and vegetal ornament, for example on frontispieces and headings for chapters (*suras*) and markers for individual verses or groups of verses. In examples from North Africa such ornamental headings are often contained in a rectangular cartouche. Marginal ornament, in the form of a vignette, is also common. The layout of each page was carefully planned using a system of ruled lines, usually scored with a dry point, before the text or decoration was added. Occasionally, the pages themselves were dyed, perhaps most famously in the so-called Blue Qur'an, which is thought to have been produced in Tunisia or Spain. Pages in pink, violet and orange also exist.

From the end of the 9th century, and through the

Folio written in Kufic, from the so-called Blue Qur'an, on parchment. Tunisia or Spain, 9th century.

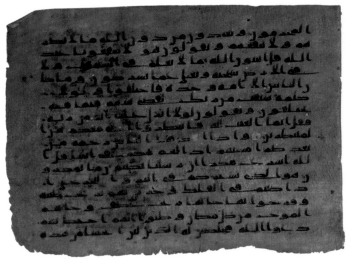

Folio written in Kufic, from a Qur'an on orange parchment. End of the 8th century.

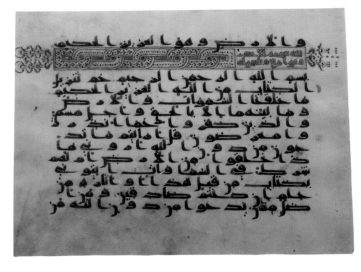

Folio written in Kufic, from a Qur'an on parchment. Second half of the 9th or early 10th century.

course of the 10th and 11th centuries, manuscripts of the Qur'an underwent a number of changes in format, size and materials, together with developments in scripts and decoration. Horizontal formats were largely replaced by vertical ones, giving rise to compositional changes on the page, in that the codex was now longer than it was wide. Both single-volume and multi-volume copies of the Qur'an were produced (*mushaf* and *rab'a* respectively), the latter most commonly in 30 volumes, although divisions ranging from two to 60 volumes are known (each division known as *juz'*). These changes in format were accompanied by a much greater variation in size than had previously been common. Parchment was largely superseded by the use of paper.

An exception to these changes was the Maghrib (North Africa and Spain), which remained more conservative in its treatment of Qur'ans. A square format was often

Paper Making and Preparation

By the 11th century a highly sophisticated level of paper making had evolved. Pulp from rags and textile waste was used; this was laid in moulds which left a visible impression (known as 'laid lines') on the finished sheets. The manufacture of wove paper was also introduced: it was moulded on fabric, which resulted in a more featureless finish. The sheets of paper were then burnished. A soft, heavy paper was made before 1400; thereafter a thinner paper was produced which was harder and more polished.

adopted; multi-volume Qur'ans most commonly appeared in four volumes.

The changes in scripts and decoration were no less notable. The so-called Kufic scripts which had predominated in Qur'an production until this time were superseded by the curvilinear *muhaqqaq*, *naskh* and *rayhan*. The earliest known Qur'an to be written in *naskh* is dated 1000–01 and was copied in Baghdad; the earliest known Qur'an to be written in *muhaqqaq* is dated 1160 and was copied in Iran. *Thulth* was generally used for inscriptions such as colophons and dedications, and for *sura* headings; sometimes (as in a seven-part Qur'an made for the Mamluk amir Baybars al-Jashankir in 1304–06) it was used for the whole text of the Qur'an. Eastern Kufic did not die out entirely, however, and it continued to be used in some Qur'ans until the 12th century, while at the same time becoming increasingly decorative and notably less clear. Again the Maghrib proved an exception to these developments, with the *andalusi* and *maghribi* scripts predominating.

Textual divisions within the Qur'an, such as verses, chapters (*suras*) and sections (*juz'*), were marked by illumination. Verses were typically marked by rosettes within the text, groups of verses by marginal devices. Panels were used for the titles of individual *suras*, and marginal inscriptions marked the divisions between *juz'*.

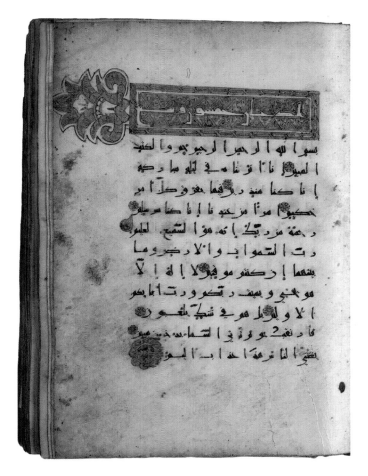

Folio written in Eastern Kufic, from a ten-part Qur'an on parchment. 10th century.

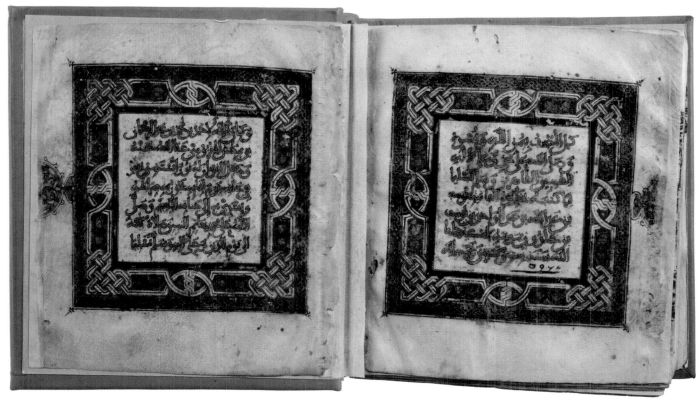

Two-page colophon written in gold *naskh*, from a single-volume Qur'an on parchment. Spain, Valencia, 1199–1200.

Frames were sometimes added in the outer margins; these became very popular during the Seljuk period. From the end of the 9th century tables were included at the beginning of some Qur'ans, listing the number of verses, words, letters and diacritical points. By the end of the 11th century these had been superseded by elaborately illuminated frontispieces, with no text other than occasionally verses from the Qur'an.

Geometric and vegetal ornament continued to form the decorative element in the illumination of Qur'ans. Designs on frontispieces included a motif of two intersecting circles with an additional motif positioned in the area where they overlap. Geometric ornament reached its most complex and accomplished in the star-polygon frontispieces of Ilkhanid and Mamluk Qur'ans, particularly those dating from the reign of the Mamluk Sultan Sha'ban (1363–75). Other geometric motifs included interlace patterns in panels surrounding *sura* headings and in frontispieces. Following the Mongol conquests of the 13th century, chinoiserie elements joined the repertoire of vegetal orna-

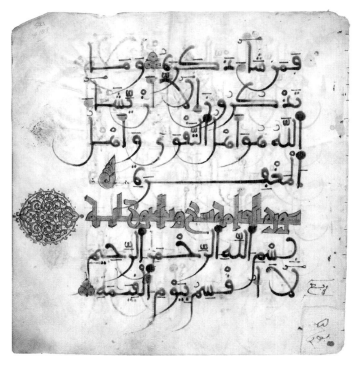

Folio written in *maghribi*, from a square-format Qur'an on parchment. North Africa, c. 1250–1350.

ment, with lotuses and peonies in particular being used in Mamluk Qur'ans of the 14th century.

QUR'ANS OF THE 14TH AND 15TH CENTURIES

Ilkhanid illumination from the beginning of the 14th century is characterized by bold designs combining geometric forms with arabesque, strapwork and multi-coloured petal borders. This style is epitomized by two monumental and outstandingly beautiful 30-part Qur'ans written for the Ilkhanid ruler Öljeitü, one copied in Baghdad in 1306–13, and the other in Mosul in 1306–11 (now in the British Library); and a Qur'an copied for an unnamed patron (probably Ghazan Khan) in Baghdad in 1302–08. The illumination of both Baghdadi Qur'ans was the work of Muhammad ibn Aybak; the Mosul Qur'an was copied by the calligrapher 'Ali ibn Muhammad ibn Zayd al-Husayni. A large and exception-ally beautiful single-volume Qur'an copied by al-Husayni in Mosul in 1300–01 has also survived.

Purely decorative frontispieces were gradually aban-doned in favour of a new arrangement, in which illumi-nation typically began on the first page of text, with the

Illuminated frontispiece from a Qur'an. Iraq or Iran, c. 1000–1050.

Illuminated frontispiece from part 28 of a 30-part Qur'an, written for Qutb al-Din Muhammad ibn Zangi ibn Mawdud, ruler of Sinjar and Nisibin. Jazira (Sinjar or Nisibin), 1198–1219.

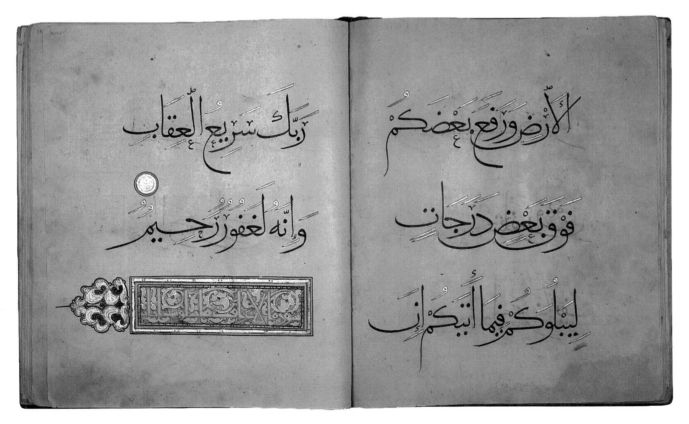

Two folios written in *muhaqqaq*, with an illuminated *sura* heading in Kufic, from part 8 of a 30-part Qur'an. Northwest Iran (Azerbaijan), c. 1175–1225.

Far right:
Illuminated
finispiece from a
single-volume
Qur'an, which
bears the name of
the scribe 'Ali ibn
Muhammad ibn
Zayd al-Husayni.
Iraq, probably
Mosul, 1300–01.

recto of the first folio being left blank. The introduction of a rosette or roundel on the first page, an innovation which was to become widespread, is first seen in a Qur'an copied in Maragha and dated 1338–9.

During the second quarter of the 14th century Shiraz was under the rule of the local Inju'id dynasty. Parts of a 30-part Qur'an have survived from this period, written for the Inju'id princess Fars Malik Khatun. These contain two distinct styles of illumination. The later of these (probably c. 1370) is characterized by a dark-blue ground, delicate floral sprays and vegetal arabesques in gold, and anticipates the Timurid style of the following century. Another volume from the same period, containing five *suras* of the Qur'an, is in a similar style. It contains the earliest known example of a *sura* set in a cartouche with cusped ends, a motif apparently derived from the Chinese *jui* scepter, which would become widespread in the 15th century.

Other surviving examples from this outstanding period of manuscript production include a single-volume Qur'an by the great 14th-century Tabrizi calligrapher 'Abdallah al-Sayrafi, a figure much celebrated for his architectural inscriptions. In Anatolia during the 14th century copies of the Qur'an with a distinctive three-line format in *muhaqqaq* and bright polychrome illumination were produced.

Many exceptionally fine Qur'an manuscripts were made by the Mamluks during the 14th century and the first decade of the 15th century, in Cairo and Damascus. These were often given as part of the endowment (*waqf*) of a religious foundation. The earliest known Mamluk Qur'an is a seven-part example written for Baybars al-Jashankir between 1304 and 1307, and illuminated by Sandal. One of the most accomplished figures associated with Mamluk Qur'ans of the 1330s was the Cairene scribe and illuminator Ahmad al-Mutatabbib.

It is the Qur'ans associated with the reign of Sultan Sha'ban (1363–76) that mark the apogee of Mamluk Qur'an production, and constitute some of the most magnificent manuscripts in the history of Islamic art. Illuminated frontispieces in Qur'ans of the 1360s and 1370s were typically decorated with star-polygon motifs. Two of the most celebrated figures associated with these Qur'ans are the scribe Yahya ibn 'Umar, originally from Khurasan, who settled in Damascus, and the illuminator

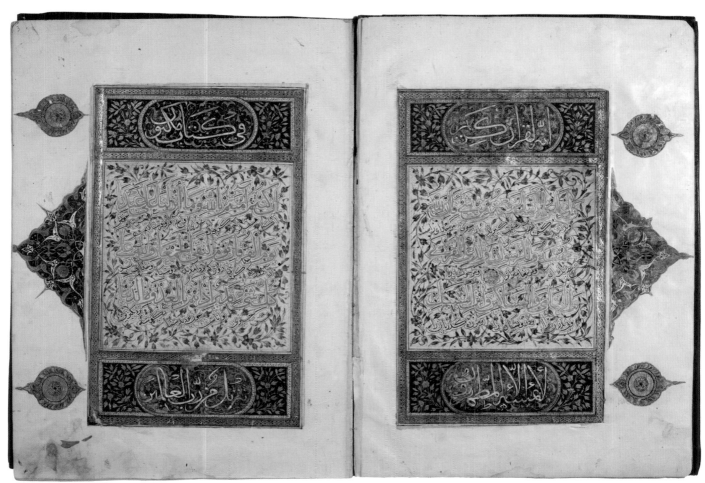

Ibrahim al-Amidi, who was from Amida (modern Diyarbakır in southeast Turkey).

Geometric ornament became less popular in Qur'an illumination during the 15th century. Under the descendants of Timur, who ruled from Herat, and the Qara Qoyunlu and Aq Qoyunlu, who ruled from Tabriz, a new style came to be favoured, characterized by gold floral sprays and coloured blossoms on a blue ground. These floral components were soon joined by scrolls, palmettes and interlocking cartouches. The basic elements of this new style had already made an appearance in manuscripts produced in Shiraz during the 1370s; it was to become supremely influential at the Safavid, Ottoman

Illuminated
opening with the
main text written
in *muhaqqaq*, from
a 30-part Qur'an,
copied for Fars
Malik Khatun, the
daughter of the
founder of the
Inju'id dynasty.
Iran, Shiraz,
1336–57.

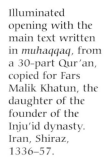

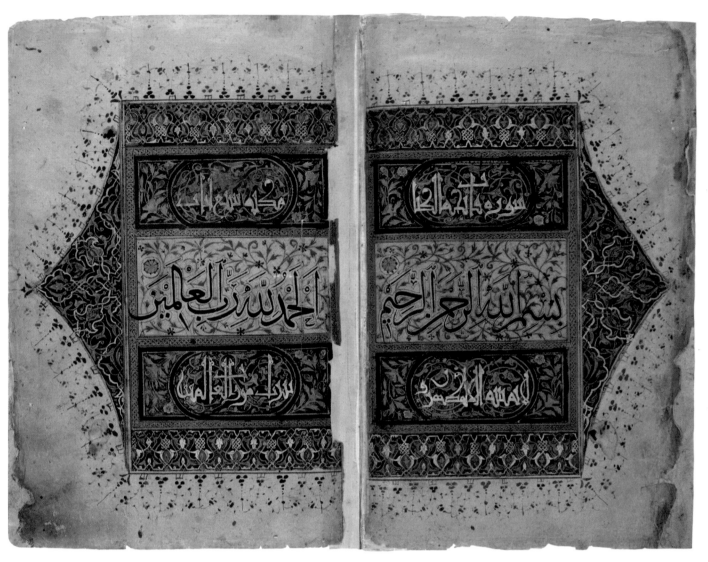

Illuminated opening written in *thulth*, with panels of white Kufic, from a volume containing five *suras* from the Qur'an. Iran, probably Shiraz, 1336–54.

and Mughal courts throughout the 15th and 16th centuries. (The exception to this phenomenon was once again the Maghrib, which continued to follow its own well-established geometrical traditions.) The style also made an impact on Qur'an production under the Circass-ian Mamluks, when towards the end of the 15th century a number of Turkmen artists from the Aq Qoyunlu lands of eastern Turkey and western Iran settled in Egypt and Syria. Often it is difficult to establish the precise origins of some Qur'ans of this period, their style being a mixture of Mamluk and Timurid elements. One of the greatest calligraphers of the second half of the 15th century was 'Abd al-Rahim Khwarazmi, or 'Anisi', who worked in Baghdad, Tabriz and Shiraz and was present at the court of the Aq Qoyunlu Sultan Ya'qub (1478–90).

The size of Qur'ans produced in the 15th century is generally smaller than that of the monumental, multi-volume sets of the preceding century. A type of *naskh* in

Illuminated opening written in *naskh*, from a single-volume Qur'an. Herat, c. 1430–1550.

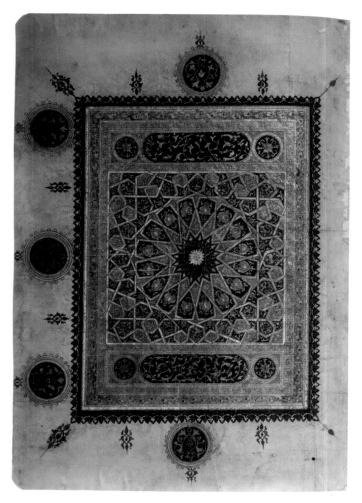

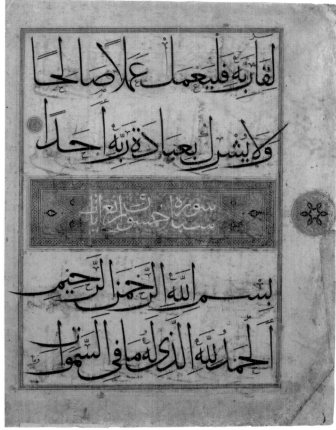

Far left:
Illuminated
frontispiece from a
single-volume
Qur'an. Mamluk,
probably Cairo,
1382–3.

Left: Folio written
in black *muhaqqaq*
outlined in gold,
from a volume
containing a
collection of *suras*.
Iraq or Iran,
c. 1350–1420.

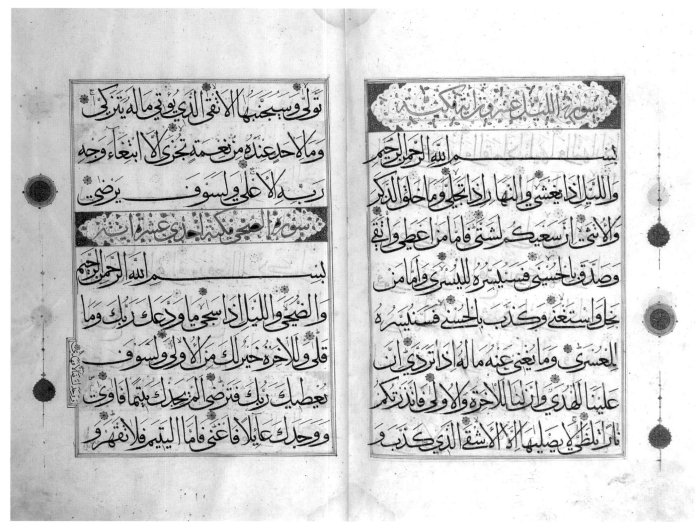

Two folios written
in *muhaqqaq*, with
sura headings in
gold *thulth*, from
a single-volume
Qur'an. Iran,
Tabriz or Shiraz,
c. 1480–90.

the style of the 13th-century Baghdadi calligrapher Yaqut al-Musta'simi was generally favoured; however, *muhaqqaq* was also popular, especially in the few larger Qur'ans, such as the huge volume known as the 'Baysunqur' Qur'an, dated c. 1400–05.

THE SAFAVID AND QAJAR PERIODS

In Safavid Iran, Tabriz, Shiraz and Herat remained the most important centres of manuscript production throughout the 16th century. Single-volume Qur'ans were favoured, often opening with illuminated medallions

containing a passage from the Qur'an. The opening *suras* are richly illuminated and typically arranged across two pages. A large *naskh* or *muhaqqaq* is often used for the text, with *sura* headings in *riqa'*; in some examples large and small scripts such as *thulth*, *muhaqqaq* and *naskh* are combined and arranged in panels. Verses are separated by gold rosettes, knots, stars or circles. Groups of five or ten verses are marked by circles, rosettes or medallions in the margin, containing palmettes, stylized floral sprays or the words *khams* or '*ashar* ('five' and 'ten' in Arabic respectively) in *thulth*. One of the most accomplished figures

Two folios written in *naskh* and *thulth* by Ruzbihan Muhammad al-Tab'i al-Shirazi (also known as Ruzbihan Muzahhib, 'the Illuminator'), from a single-volume Qur'an. Iran, Shiraz, 1545–6.

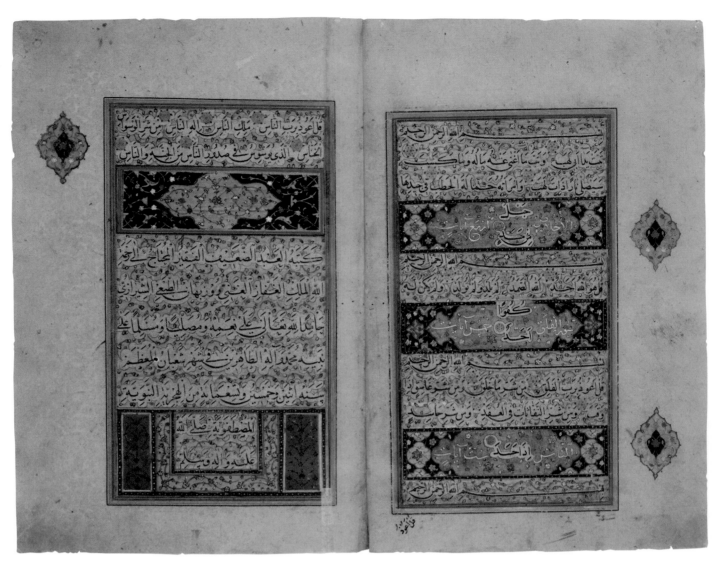

associated with Qur'an manuscript production in Shiraz during this period was the scribe-illuminator Ruzbihan Muzahhib. Ruzbihan is also notable for having signed both the illumination and text of his works.

One of the finest Safavid manuscripts to have survived from the 16th century is a Qur'an produced in either Shiraz or Qazvin, and dated 1552. Although its exact provenance is unknown, it later formed part of the collection of the Mughal emperor Shah Jahan, to whom it may have been given by a Safavid shah; and it has been suggested that it was written for Shah Tahmasp I (1524–76). Each page of text is divided into five panels, which are written in either blue *muhaqqaq* or gold *naskh*; *sura* headings are in gold *thulth*. The Qur'anic text is

Illuminated opening written in *thulth*, *muhaqqaq* and *naskh* arranged in panels, from a single-volume Qur'an. Herat or Tabriz, c. 1525–50.

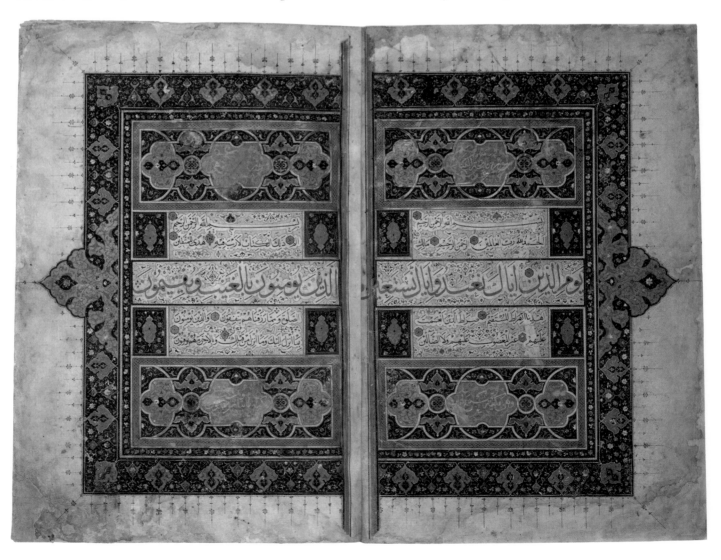

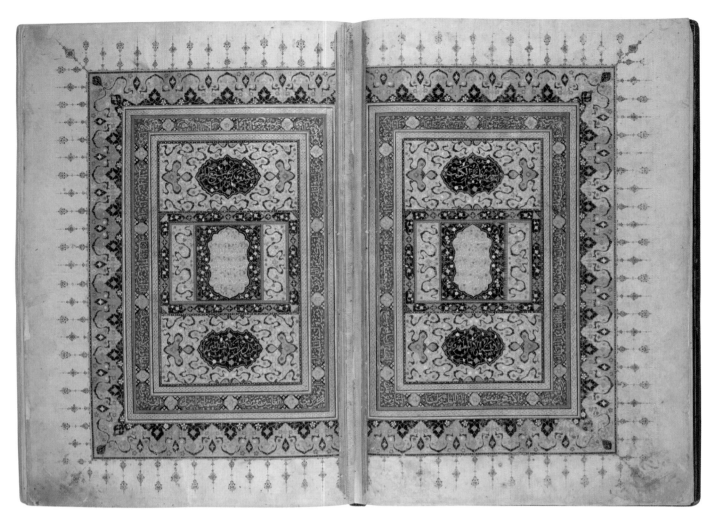

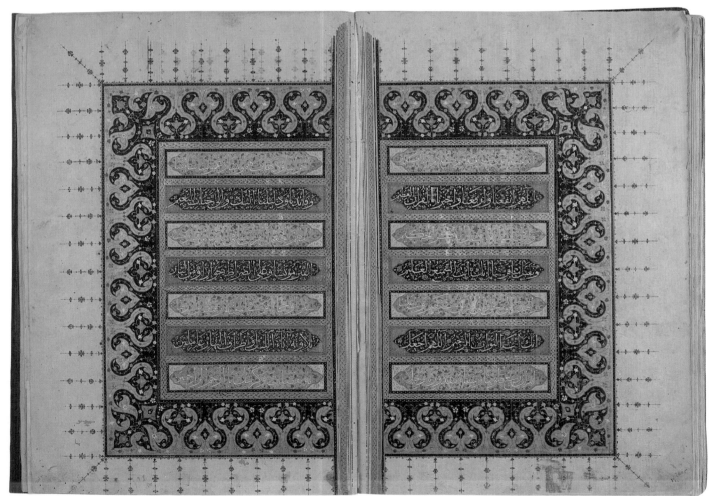

Illuminated opening written in *thulth* and *naskh*, and a prayer to be recited on concluding a reading of the Qur'an, both from a single-volume Qur'an which was most probably copied for the Safavid shah Tahmasp I (1524–76). Iran, Shiraz or Qazvin, 1552.

followed by a prayer arranged in a series of panels, each written in white *muhaqqaq* set within a cartouche with cusped ends. The spectacular illumination features cloud scrolls together with a variety of floral motifs.

The text of Safavid Qur'ans from the 17th and early 18th centuries is frequently divided by gold rules, the black *naskh* of the main text often interspersed with interlinear Persian glosses in fine red *nasta'liq*. *Sura* headings are written in white, or sometimes red, *riqa'*. The sumptuous illumination includes scrollwork and various floral motifs, and sometimes incorporates an index of *sura* titles. The most celebrated calligrapher of the period,

and perhaps the greatest master of *naskh* in Iran in any era, was the calligrapher Mirza Ahmad Nayrizi, whose last recorded work is a single-volume Qur'an dated 1740–41. Isfahan and Shiraz were the most important centres of Qur'an production during this period.

Many Qur'ans produced in Iran under the Qajars (from 1796) contain particularly rich illumination; the text is frequently in *naskh*, with interlinear glosses in *nasta'liq*. During the 19th century, a number of 17th-century Safavid Qur'ans were repaired, a process which would usually include remargining, restoration of the illumination, and rebinding.

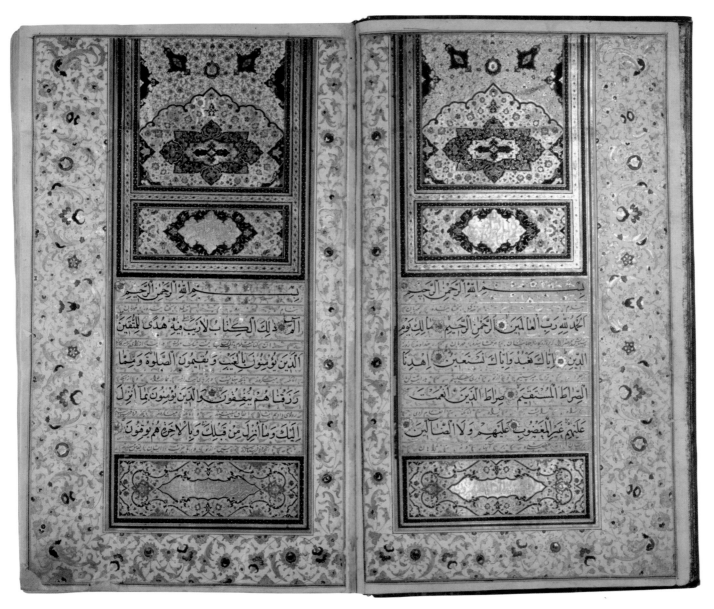

Illuminated opening written in black *naskh* with interlinear Persian glosses in red *shikaste* and *sura* headings in gold *riqa'*, from a single-volume Qur'an. Iran, probably Isfahan, 1689–90.

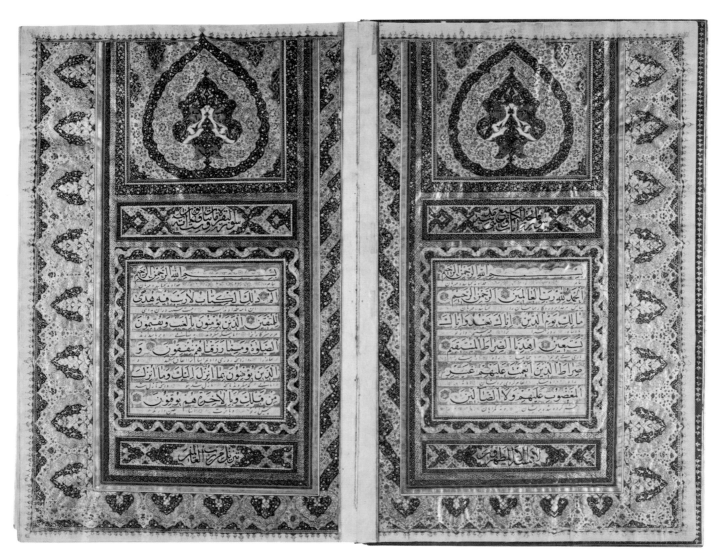

Two illuminated folios written in black *naskh*, with interlinear Persian glosses in red *nasta'liq* and *sura* headings in blue *thulth*, from a single-volume Qur'an. Iran, mid–19th century.

Illuminated
frontispiece from a
single-volume
Qur'an, copied for
Mercan Ağa.
Ottoman, Istanbul,
c. 1460–70.

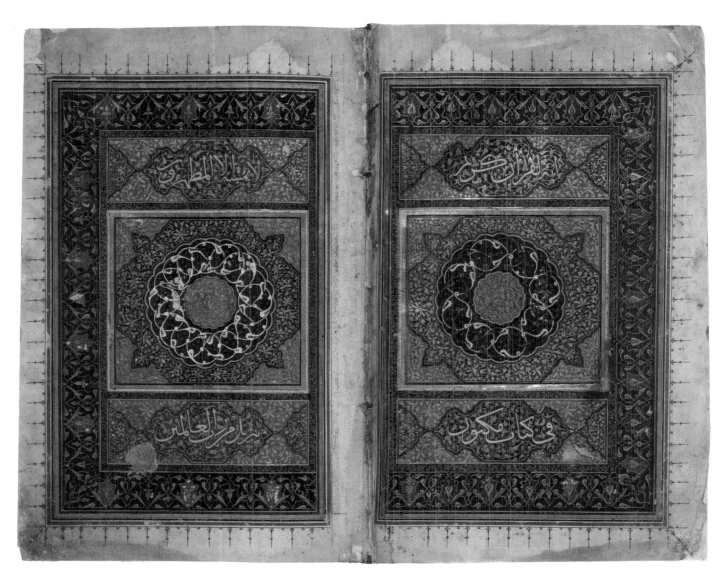

OTTOMAN QUR'ANS

Qur'ans in the early Ottoman period showed the influence of a number of diverse styles, but from the second half of the 15th century these increasingly gave way to Timurid and Turkmen influence (or more specifically, the style of Iranian Qur'ans developed at Shiraz, Tabriz and Herat during the 15th century). In particular, the Ottoman capture of Tabriz in 1514, and the subsequent deportation of a number of its artists and artisans to the Ottoman court at Istanbul, is associated with this phenomenon. The most widely used Qur'anic script was a style of *naskh* practised by the great Ottoman callig-

Right: Folio
written in *naskh*,
with an
illuminated *sura*
heading in *thulth*,
from a single-
volume Qur'an,
possibly copied by
Ahmed Karahisari.
Ottoman, Istanbul,
1550–60.

Far right: Folio
written in an
intermediate script
between *muhaqqaq*
and *rayhan*, with a
sura heading in
thulth, from a
large Qur'an.
Ottoman, probably
Cairo, 1561–2.

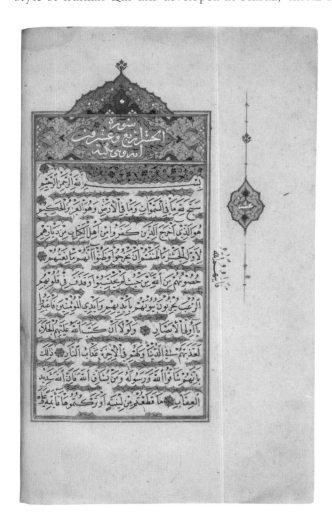

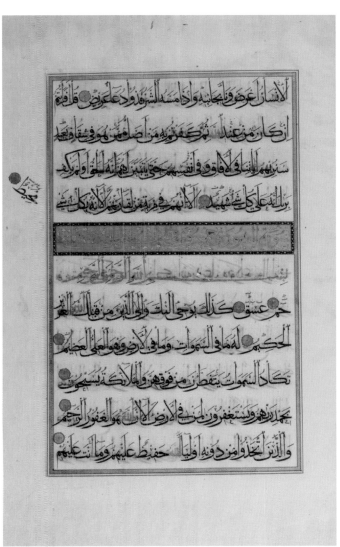

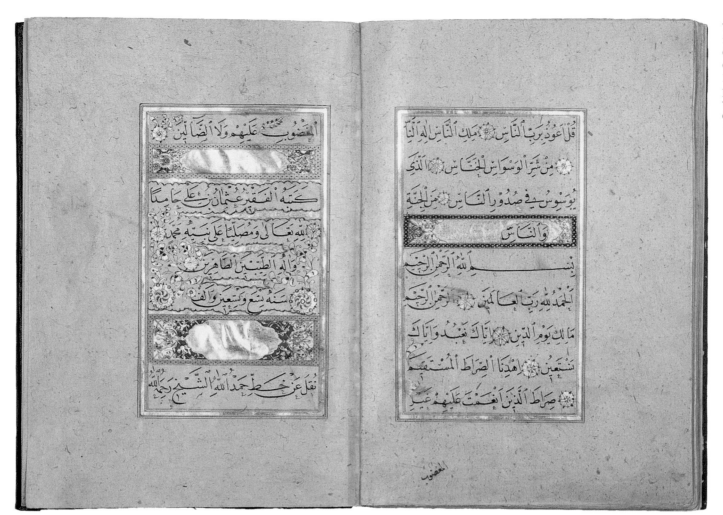

Two folios written in *naskh* by Hafiz Osman after a Qur'an by Shaykh Hamdullah, from part 30 of a multi-volume Qur'an. Ottoman Turkey, 1687–8.

rapher Shaykh Hamdullah (1429–1520). Derived from the *naskh* of Yaqut al-Musta'simi, it was to become the standard Qur'anic hand during the later Ottoman period.

Two of the finest surviving works by the Ottoman calligrapher Ahmed Karahisari (c. 1468–1556) are a Qur'an dated 1547, illuminated by the leading court illuminator, Kara Memi; and a Qur'an apparently begun for Süleyman the Magnificent, and completed after Karahisari's death by his adopted son, the master calligrapher Hasan Çelebi. A single-volume Qur'an in the Khalili Collection has been attributed to Karahisari, but this attribution remains only tentative as the manuscript is unsigned.

Ottoman Qur'ans of the 17th and 18th centuries demonstrate a continued preference for the *naskh* of Shaykh Hamdullah, with *sura* headings written in *riqa'*, often in white on a gold ground. Illumination is dominated by gold or blue-and-gold grounds, with scrolls and other floral motifs. It is at its most extensive in the double-page frontispieces, which often contain the opening verses of the Qur'an.

The introduction of lithography in the Ottoman Empire during the 19th century led to the production of some very high-quality facsimiles of Qur'ans in Istanbul. Nevertheless, fine hand-written and illuminated copies continued to be produced.

Illuminated closing pages written in *naskh* by Seyyid Mehmed Nuri, from a single-volume Qur'an. Ottoman, Shumen, Bulgaria, 1849–50.

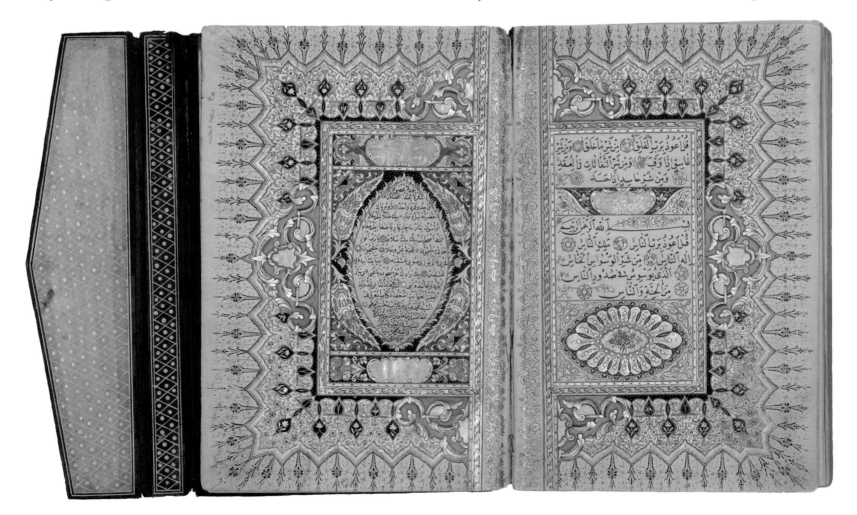

INDIA

Many particularly fine Safavid Qur'ans found their way to the courts of Mughal India, where they were copied profusely throughout the 16th century. The Mughal emperors Akbar, Jahangir and Shah Jahan showed a greater interest in *nasta'liq* calligraphy and miniature painting than in Qur'ans, and Akbar in particular favoured a policy of remarkable openness towards other religions. The result was that early Mughal Qur'ans were considerably more varied than they might have been had they been the priority of the royal workshop.

One of the more unusual Qur'ans to have survived from 16th-century India, and one of the few which does not follow entirely the Safavid style, is a Qur'an from Sind or northern India, which is datable to c. 1500–25. The script is a bold hybrid of elements of *naskh* and *muhaqqaq*.

A new period of Qur'an manuscript production was ushered in during the reign of Awrangzeb (1658–1707), whose more sternly pious character is associated with a preference for *naskh*, and a deliberate move away from the policy of religious tolerance instated by Akbar. A number of highly accomplished Iranian artists were

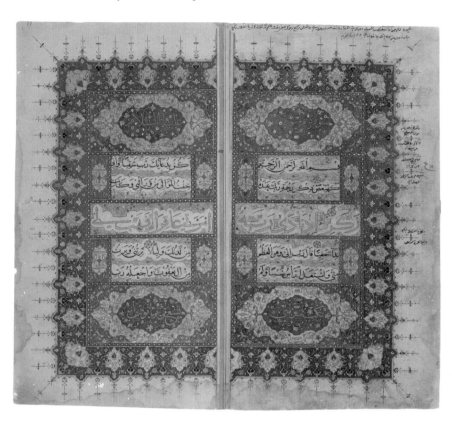

Above: Two folios from the second volume of a two-volume Qur'an, the main text written in a combination of *muhaqqaq, thulth* and *naskh*. Perhaps northern India, 1517.

Above right: Folio written in *muhaqqaq*, with an illuminated *sura* heading in gold *thulth*, from a Qur'an. Perhaps India, 15th century.

Right: Two illuminated folios with a prayer written in gold *naskh* and a Persian commentary in white *nasta'liq*, from a single-volume Qur'an. India, Deccan, perhaps Golconda or Hyderabad, before 1710.

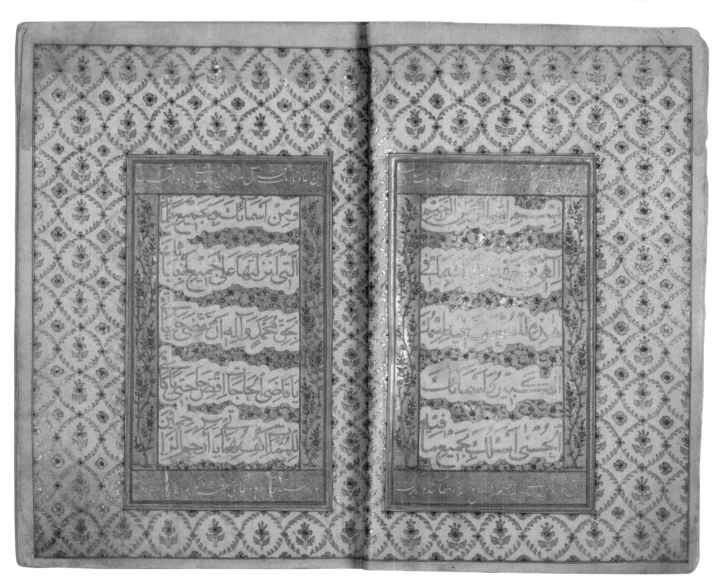

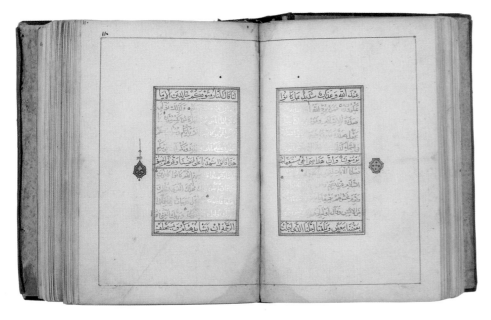

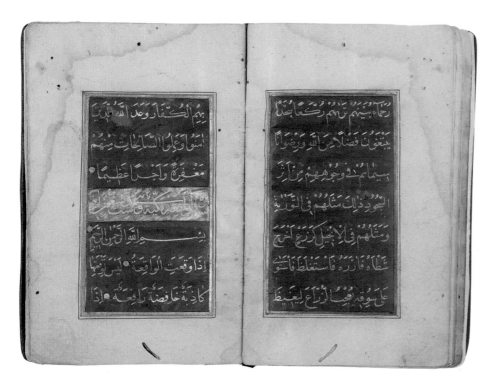

employed by the Mughal court, among them Amanat Khan who designed the inscriptions on the Taj Mahal. Another was Mevlana Muhammad Sa'id of Isfahan, who became the calligraphy tutor of one (or possibly two) of Awrangzeb's daughters. It is hardly surprising then, that many 17th-century Mughal Qur'ans contain elements characteristic of Iranian Qur'ans from the preceding two centuries, in particular Shirazi work of the 16th century, long after these styles had gone out of fashion in Iran itself. This often lends a somewhat archaic, though none the less attractive, element to the Qur'ans of 17th-century Mughal India.

A strong tradition of book production existed in Kashmir. Qur'ans in the so-called Kashmiri style often incorporate diagonal lines of Persian commentary in the margins, and lobed borders are frequently broken by large, hasp-shaped motifs.

During the 18th century a number of exceptionally fine copies of the Qur'an were produced in the Deccan – a territory wrested from the control of the Qutbshahi dynasty by the Mughals in 1703 – in particular the cities of Hyderabad and Golconda. The illumination in these examples is particularly rich, and sometimes includes a wide border decorated with flowers and leaves.

Above left: Two folios from a single-volume Qur'an written in *naskh* by Amanat Khan al-Shirazi, who designed the inscriptions on the Taj Mahal. India, probably Saray-i Amanat Khan, 1640–41.

Left: Two folios from a volume containing five *suras*, the main text written in *naskh*, and *sura* headings in *riqa'*. Northern India, first half 17th century.

Below: Two illuminated folios written in *naskh*, with *sura* headings in white *riqa'*, from a single-volume Qur'an copied by Princess Zinat al-Nisa', a daughter of the Mughal Emperor Awrangzeb. India, in or before 1669–70.

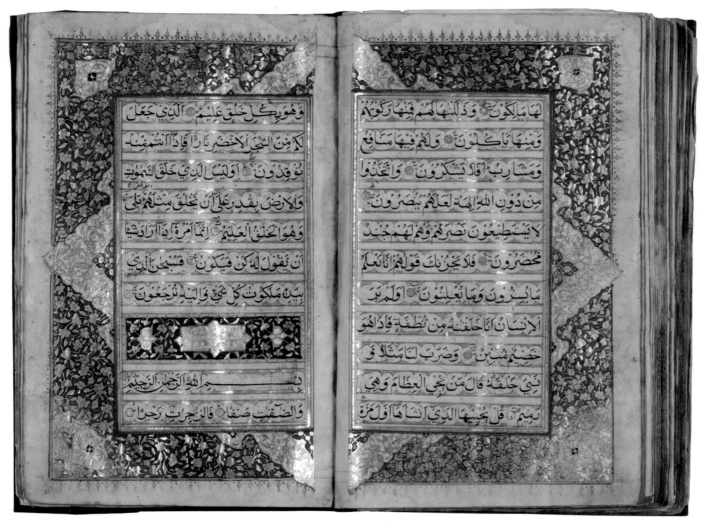

QUR'ANS FROM OTHER PARTS OF THE ISLAMIC WORLD

This overview of the development of Qur'an manuscripts has concentrated on the central and eastern Islamic lands under Umayyad and Abbasid rule, and in particular Iran, Asia Minor and the Indian subcontinent under later dynasties. Of course, Qur'ans of high quality were also copied in many other regions of the Islamic world, from Khanbaliq (Beijing) in China, to Indonesia, Western Sudan and the East African coast. While such examples clearly reflect a number of local traditions (with variations in ornament, script or the type of paper used), they nevertheless share many of the basic features of Qur'ans outlined in the preceding paragraphs.

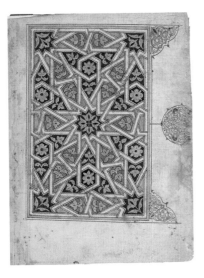
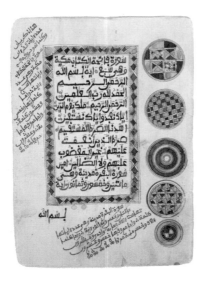
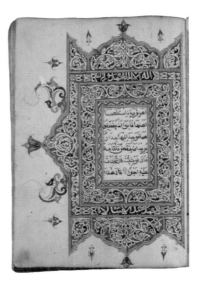
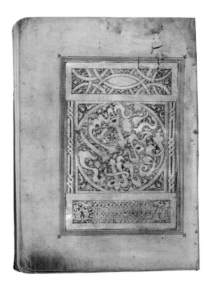

Illuminated frontispiece from a Qur'an in two parts. Morocco, 18th century.

Illuminated folio written in the *sudani* variant of the *maghribi* script, from a single-volume Qur'an. Western Sudan, late 19th century.

Illuminated folio written in a *Jawi* script similar to *naskh*, from a single-volume Qur'an. Indonesia, 18th or 19th century.

Single-page frontispiece with ornamental script, from a 30-part Qur'an. China, Khanbaliq (Beijing), 1401.

Two illuminated folios written in a regional hand, with alternative readings in *naskh* in the margins, from a single-volume Qur'an. East Africa, 1749.

Miniature Painting

The following overview of miniature painting in secular or non-Qur'anic manuscripts completes our brief survey of the arts of the Islamic book (see 'The Word of God: Qur'ans', 'The Written Word: Calligraphy' and 'Bookbinding'). The development of secular manuscripts in many ways paralleled that of Qur'ans, with one outstanding exception: the proscription against human and animal representation in Qur'ans did not extend to secular manuscripts, and consequently they frequently contain a wealth of figural imagery.

Globe thistle, fragmentary page from a herbal. Probably Iraq, 13th century.

Dimna was illustrated for the Samanid ruler Nasr ibn Ahmad at Samarqand during the 9th century, by Chinese artists; and the historian Mas'udi writes of a book in 10th-century western Iran which contained portraits of the Sasanian kings. A 'Book of Fixed Stars', produced during the 11th century in the Iranian province of Fars, contains some remarkable illustrations of the constellations; it is now in the Bodleian Library, Oxford.

EARLY MINIATURES

Miniature paintings have survived in far greater numbers from the early 13th century, when manuscript production appears to have flourished in the Middle East, in particular at Mosul, Diyarbakır and Baghdad. Favourite subjects for illustration included *Kalila wa Dimna*, the *Maqamat* ('Assemblies') of al-Hariri, and the volume on

A man riding an elephant, from a body of Fatimid drawings – the earliest known on paper from the Muslim world – discovered at Fustat. Egypt, 11th–12th century.

The earliest surviving Islamic painting is a schematic coloured drawing of a mosque, on parchment, dated c. 710–15. It was discovered among early Qur'an fragments found in San'a, and was probably produced in Damascus. A number of Fatimid drawings on paper have also survived. Otherwise, very few illustrated manuscripts have come down to us from the early centuries of Islam. Many of the great palace libraries, both in the central Abbasid lands and that of al-Hakam II at Cordoba, have been lost; and generally we must rely on wall paintings, such as those at the Umayyad desert palace of Qusayr 'Amra in Jordan (second quarter of the 8th century) and the decorated wooden ceiling of the Palatine Chapel at Palermo in Sicily (1140s), to provide a glimpse of what early Islamic painting may have looked like. Fragmentary wall paintings have also survived from Samarra and from Fatimid Egypt, and there are accounts of competitions between painters from the two centres.

Early historical references to book illustration in the eastern Islamic lands suggest links with pre-existing traditions. For example, it is claimed that a translation of the ancient Indian animal fables known as *Kalila wa*

Horsemen juggling lances while standing in their saddles, from a Mamluk instructional manual on *furusiyya* (horsemanship). Egypt, 15th century.

plants from Dioscorides' *De Materia Medica*. Byzantine influence is strong in these works, as is that of Syriac Gospels. The best-known *Maqamat* manuscript is now in the Bibliothèque Nationale, Paris; it was copied and illustrated in 1237 in Baghdad. An illustrated copy of the verse romance *Varqa u Gulshah* has also survived. It was probably produced in Konya c. 1240, and is now in the Topkapı Saray Library, Istanbul. One illustration is signed 'al-Khoyi'. Figures and animals in these miniatures are rendered in a style similar to that in which they appear in other contemporary media, such as *mina'i* pottery and 12th-century inlaid metalwork from Mosul.

Illustrated manuscripts such as *Kalila wa Dimna* and the *Maqamat* were also produced under the Mamluks, together with a new genre, *furusiyya*, instructional works on horsemanship. A copy of Qazvini's *'Aja'ib al-makhluqat* ('Wonders of Creation') has also survived, picturing animals similar to those depicted on the monumental inlaid brass basin known as the Baptistère de St Louis (now in the Louvre, Paris), described in the metalwork chapter. Many of these manuscripts are now attributed to Damascus.

MINIATURE PAINTING IN IRAN UNDER THE ILKHANIDS AND THEIR SUCCESSORS

Miniature painting attained a spectacular degree of refinement during the Ilkhanid period, in particular during the reigns of Ghazan Khan (1295–1304), Öljeitü (1304–16) and Abu Sa'id (1316–35). A bestiary produced c. 1297 or 1299, one of the earliest manuscripts which can be attributed definitely to Mongol court painters, is closely related to Arab manuscript painting of the 13th century. Perhaps anxious to legitimize their rule in western Iran, the Ilkhanids were responsible for the patronage of a large body of historical writing. The Persian national epic, Firdawsi's *Shahname* ('Book of Kings'), was also popular, and several lively illustrated copies of it have been attributed to the period 1300–1340.

Two of the greatest illustrated manuscripts to be produced under Ilkhanid patronage are the *Jami' al-Tawarikh* ('Compendium of Chronicles'), written and illustrated for the great Ilkhanid vizier Rashid al-Din in 1314; and the so-called 'Demotte' or 'Great Mongol' *Shahname* of c. 1335, named after the dealer who originally divided this manuscript.

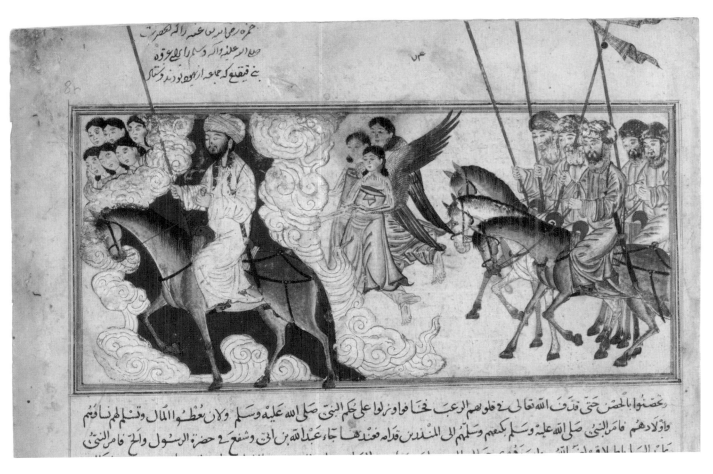

Muhammad leading Hamza and the Muslims against the Banu Qaynuqa' (top, folio 67a); *Four emperors of the Tang dynasty* (above left, folio 256b, detail); and *The mountains of India* (above right, folio 261a) from the *Jami' al-Tawarikh* ('Compendium of Chronicles') of Rashid al-Din. Iran, Tabriz, 1314.

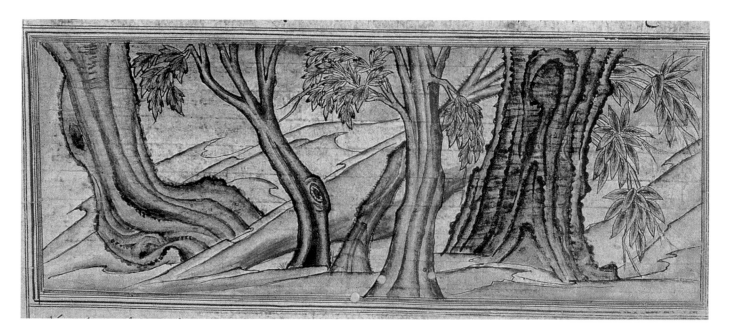

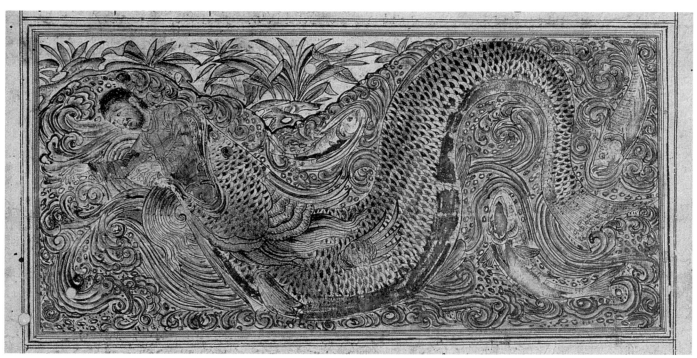

The grove of Jetavana (top, folio 276b) and *Jonah and the whale* (above, folio 299a) from the *Jami' al-Tawarikh* ('Compendium of Chronicles') of Rashid al-Din. Iran, Tabriz, 1314.

The *Jami' al-Tawarikh* is a large-format manuscript (the pages measure some 43 x 30cm), with predominantly horizontal illustrations. Landscapes generally contain only minimal detail but they show a highly developed level of observation, and elements of the setting often reflect or emphasize the pose of figures, contributing to the expressiveness of the image. Colours are sometimes thinly applied; the backgrounds usually remain unpainted. The manuscript is divided into sections on the ancient kings of Iran and Arabia; Muhammad and the Caliphate; post-Caliphal dynasties in Iran; China, India and the Jews.

The Demotte *Shahname* is also a very large manuscript and unquestionably one of the finest and richest to have survived from medieval Iran. Its illustrations are characterized by complex compositions in which figures are portrayed convincingly in rich and intense colours. Settings show spatial recession and contain more detail than those of the *Jami' al-Tawarikh*.

Miniatures produced under the Inju'ids of Shiraz (1335–53) are characterized by their bright colours, freedom of brushwork and large, unrealistic flowers. Compared to those in the Demotte *Shahname*, the compositions are simple. Chinoiserie elements, similar to those on Sultanabad pottery, began to appear with increasing frequency at this time. Extant manuscripts from this period include a large-format copy of *Kalila wa Dimna* (1333), now dispersed; and a number of copies of the *Shahname*, also dispersed among several private and public collections.

Under the Muzaffarids (1353–93), painted landscapes feature rounded hills and a high horizon line, and a wealth of natural detail. Figures are notable for their disproportionately large heads and the distinctive Muzaffarid turban which many of them wear.

One of the first figures to record the development of Persian painting was the mid-16th-century Safavid scribe and chronicler Dust Muhammad, who traced the genealogy of artists from those working during the reign of the Ilkhanid Abu Sa'id (1316–35), such as Ahmad Musa, to Shams al-Din, who worked under the Jalayirid Sultan Uways (1356–74). Although very few manuscripts have survived intact from the early Jalayirid period, a number of detached paintings still exist in album collections. These show that Jalayirid painting from the 1360s to the 1370s is distinguished by particularly rich colours, clearly showing the influence of the Demotte *Shahname*, a highly lyrical style and meticulous detail. Figures are reduced in scale somewhat in relation to their surroundings, and an attempt is made to show spatial recession in interiors, while landscapes echo the mood of scenes, as in the Demotte *Shahname*.

Jalayirid painting continued to be refined during the reign of Sultan Ahmad Jalayir (d. 1410). Manuscripts from Tabriz and Baghdad during this period have large, full-page illustrations, which are painted in a bright palette with areas of cool blue. The extension of the illustration into the margin, sometimes apparent in early Jalayirid works, became more developed under Sultan Ahmad. The slender, elongated figures are placed further back in the picture space than in Ilkhanid manuscripts, against a landscape of regular tufts of grass and flowers with characteristically high horizon lines. Sultan Ahmad himself was an accomplished poet who encouraged the marriage of poetic and mystical writings

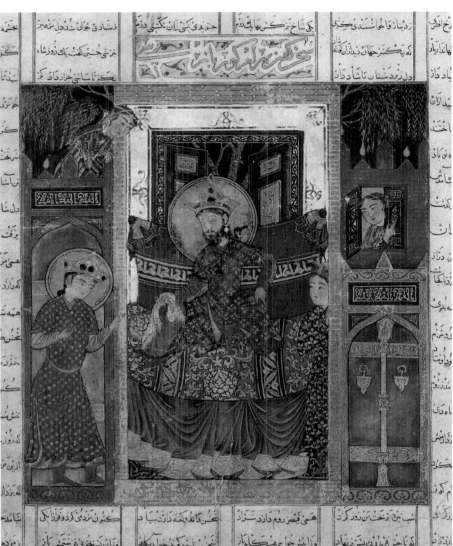

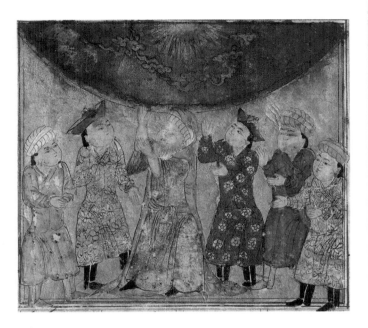

The end of the seven-year drought in the reign of Piruz Shah, from a *Shahname.* North-west Iran, 1310–35.

Bahram Gur sends his brother Narsi as viceroy to Khurasan, from the 'Demotte' *Shahname.* Iran, Tabriz, 1330s or later.

with illustrations. One of the first illustrated manuscripts known to have been produced in his reign is a *Khamse* ('Five Tales') of Nizami dated 1386 and 1388 – the earliest known illustrated example of this work; and a copy of the 'Three Poems' of Khwaju Kirmani (dated 1396) contains the earliest known signed Persian miniature, by the artist Junayd, a pupil of Shams al-Din. Both these manuscripts are now in the British Library, London. It would be fair to say that the style of the great classical period of Persian miniature painting, which would endure for the next two centuries, crystallized at the Jalayirid court.

MINIATURE PAINTING IN IRAN UNDER THE TIMURIDS

Following the campaigns of Timur in western Iran, many Jalayirid painters were taken back to Samarqand. Some no doubt also found their way to Baghdad, where Sultan Ahmad himself took refuge before fleeing to Egypt. 'Abd al-Hayy, a pupil of Shams al-Din and Ahmad's tutor in drawing, continued to work for Ahmad in Baghdad. The various Timurid princes who were installed as governors at Shiraz, Isfahan, Herat, Baghdad and Tabriz were able to call upon local artists of consummate skill who had served the Inju'id, Muzaffarid and Jalayirid courts.

In Shiraz between 1409 and 1414, artists working for Iskandar Sultan achieved a perfect synthesis of the Jalayirid and Muzaffarid styles, which is crystallized in two 'Anthologies', of 1410 and 1410–11 (now in the Gulbenkian Museum, Lisbon, and the British Library respectively), and a 'Miscellany' of 1410–11. The minute detail, distinctive rock formations and gold or deep-blue skies in these miniatures all foreshadow the great Timurid manuscripts produced a quarter of a

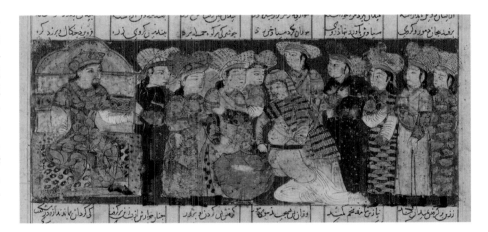

The murder of Siyavush, from a dispersed Inju'id *Shahname* that was commissioned for the library of the Inju'id vizier Hajji Qiwam al-Dawla wa-l'Din Hasan. Iran, Shiraz, February 1341.

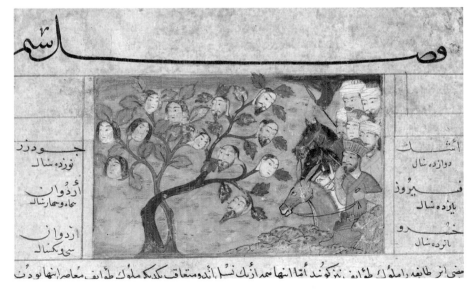

Alexander and the waq-waq *tree,* from a historical text. Iran, Shiraz, c. 1440.

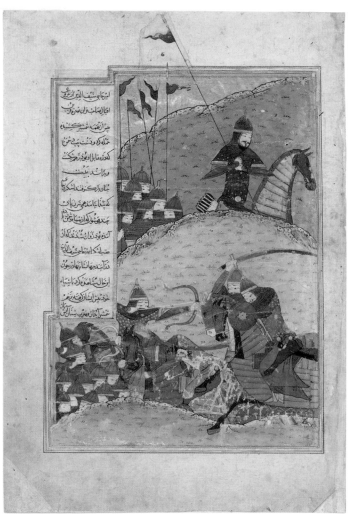
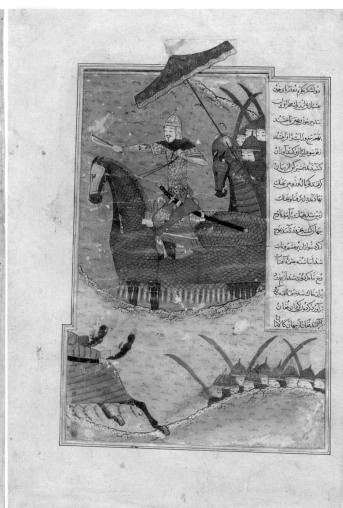

Timur defeats Tukhtamish in Khwarazm, double-page illustration from a copy of the *Zafarname* made for Ibrahim Sultan. Iran, Shiraz, 1436.

century later at Herat. However, Iskandar's various attempts at rebellion finally resulted in Shah Rukh removing him from his governorship in 1414 and having him blinded.

A highly accomplished group of artists was assembled at Herat by Shah Rukh, where they worked both for him and his son Baysunqur. They included many of those artists deported to Samarqand following Timur's campaigns in western Iran; artists brought from Shiraz in 1414 who had served under Iskandar Sultan; and more artists from Tabriz, who had worked under Ahmad Jalayir, discovered there by Baysunqur and brought back to Herat at his orders in 1421. Among the historical texts produced for Shah Rukh is the *Majma' al-Tawarikh* ('Assembly of Histories') of Hafiz-i Abru (c. 1425), a continuation of Rashid al-Din's great *Jami' al-Tawarikh*. But it is the superb illustrated manuscripts produced for Baysunqur, himself a noted calligrapher, that are considered by many the high point of Timurid painting, and one of the pinnacles of Persian miniature painting as a whole. These included illustrated copies of the *Shahname*, the *Gulistan* ('Rose Garden') of Sa'di, and *Kalila wa Dimna*. The large-scale illustrations in these manuscripts are rendered in meticulous detail, with complex compositions and an exquisite palette, and proved to be hugely influential on generations of Persian artists to come.

During the period of instability and power struggles which marked the two decades following Shah Rukh's death in 1447, a number of Timurid artists moved from Herat to the more settled environment of the Turkmen courts at Tabriz, Baghdad and Shiraz. 'Royal Turkmen' manuscripts follow the tradition of painstaking detail established in Timurid miniatures, showing fantastic rock formations in a bright palette, but less regard for proportion and spatial relationships. The disproportion of the figures in a *Shahname* dated 1494 has led to this manuscript being called the 'Big Head' *Shahname*. A large number of illustrated manuscripts were produced at

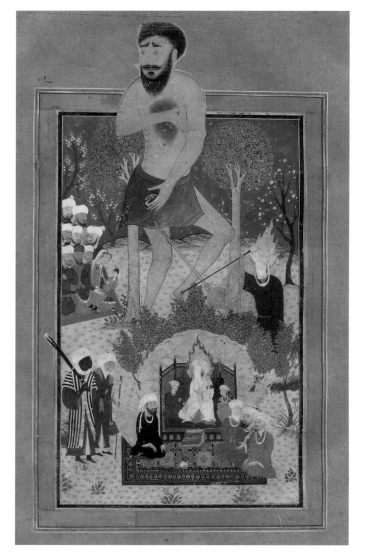

The giant Uj, and the Prophets Moses, Jesus and Muhammad, now mounted as an album page, but probably originally from a work on legends of the prophets. Jalayirid Baghdad or Tabriz, early 15th century.

Right: *Sultan Mahmud of Ghazna defeating Ilak Khan*, from a dispersed copy of the *Majma' al-Tawarikh* ('Assembly of Histories') of Hafiz-i Abru. Herat, possibly studio of Shah Rukh, c. 1425.

Far right: *Gustaham slaying Farshidward*, from the 'Big Head' *Shahname*. Iran, Gilan, 1494.

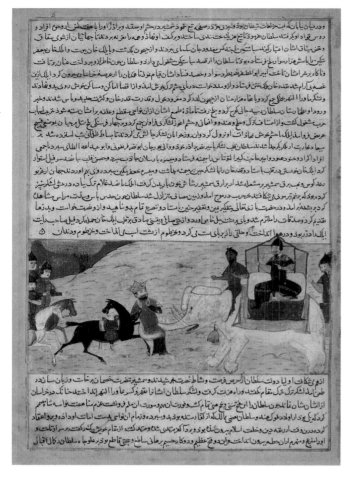

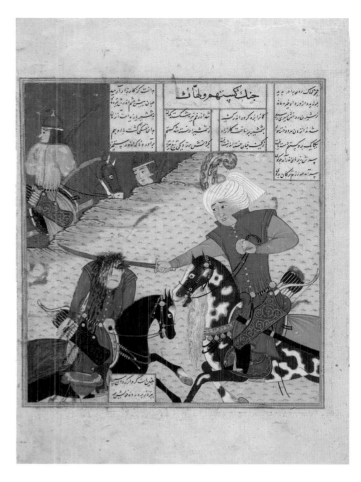

Right: *Isfandiyar and Rustam at their last feast*, from a Royal Turkmen copy of the *Shahname* made for Prince Baysunqur, son of the Aq Qoyunlu sultan Ya'qub. Probably Shiraz, 1485–6.

Far right: *The Caliph Harun al-Rashid at the hammam*, from a copy of the *Makhzan al-Asrar* (the first book of the *Khamse* of Nizami) in the style of the artist Bihzad. Iran, late 15th–early 16th century.

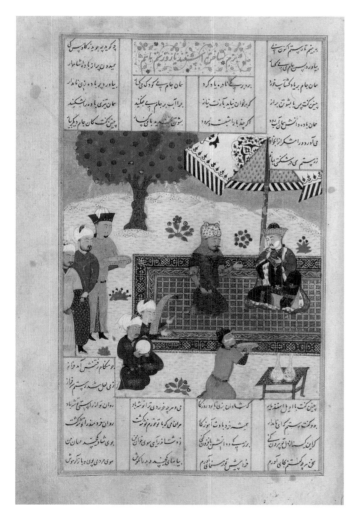

Shiraz during the second half of the 15th century, not for royal patrons but apparently for sale on the market. The miniatures in them show less variation in detail than their Royal Turkmen counterparts, and have more simplified, often pale landscapes, sometimes utilizing stock backgrounds; they nevertheless display considerable exuberance. The style of these manuscripts has been called 'Commercial Turkmen'.

The reign of the Timurid Sultan Husayn Bayqara (1470–1506) at Herat marked another great flowering of the arts in that city, which is highlighted in the work of Kamal al-Din Bihzad, acknowledged by successive generations as perhaps the greatest and most influential of all Persian painters. Bihzad's work is characterized by meticulous detail, exquisite colours and brilliant spatial relationships, and his figures show a great degree of individuality.

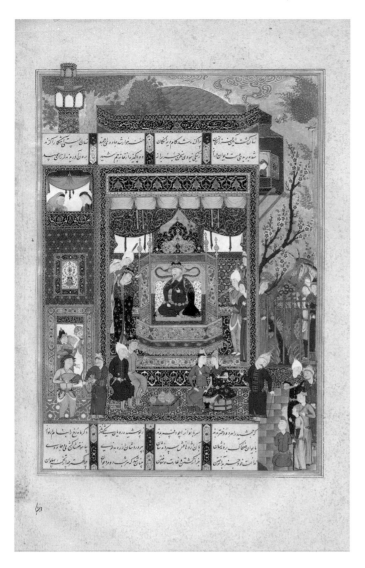

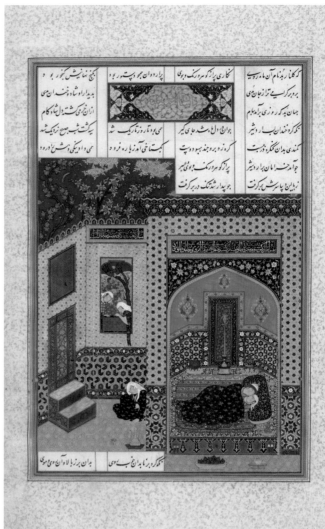

Far left: *Zahhak receives the daughters of Jamshid, whose throne he has usurped,* perhaps the work of the painter Sultan Muhammad, from the 'Houghton' *Shahname* made for Shah Tahmasp I. Iran, Tabriz, c. 1520s.

Left: *Ardashir and the slave-girl Gulnar,* perhaps the work of Mir Musavvir, from the 'Houghton' *Shahname* made for Shah Tahmasp I, the only illustration in the manuscript to bear a date. Iran, Tabriz, dated 1527–8.

Below: *The musician Barbad up in a tree,* perhaps the work of Mirza 'Ali, from the 'Houghton' *Shahname* made for Shah Tahmasp I. Iran, Tabriz, c. 1535.

MINIATURE PAINTING IN IRAN UNDER THE SAFAVIDS AND QAJARS

The traditions of both Timurid and Turkmen painting found their great synthesis under the Safavids. The degree of continuity between these styles is illustrated by a *Khamse* of Nizami, now in the Keir Collection, London, in which both 'Royal Turkmen' and Safavid illustrations appear side by side; and in 1522 Bihzad himself moved from Herat to work at Tabriz. Safavid miniatures are characterized by their brilliant colours, densely packed ornament and meticulous detail. Figures are often depicted wearing the distinctive turban with protruding bonnet known as the *taj-i Haydari*.

A magnificent *Shahname* (often referred to as the 'Houghton' *Shahname* after the owner who separated the manuscript) was commissioned by Shah Isma'il I at Tabriz. Work began c. 1522 and continued under his son Shah Tahmasp I; some paintings may not have been completed until the 1540s. This outstanding manuscript included some 258 miniatures and involved all the leading artists and craftsmen of the period. The large pages (approximately 47 x 31cm) are sprinkled with gold, the format of each illustration individually conceived. Shading is treated with extraordinary subtlety, and colours enhanced by the addition of gold, silver and mother of pearl. Among those artists to have worked on the 'Houghton' *Shahname* were Sultan Muhammad, one of the leading court painters under both Isma'il and Tahmasp; and Mir Musavvir and Mir Sayyid 'Ali, both of whom were invited to the court of the Mughal emperor Humayun in the 1540s. Due to the number of painters involved there is a degree of stylistic variation among the illustrations to the 'Houghton' *Shahname*: the illustrations of Shah Tahmasp's next major project, a *Khamse* of Nizami dated 1539–43 (now in the British Library), show a greater uniformity of style.

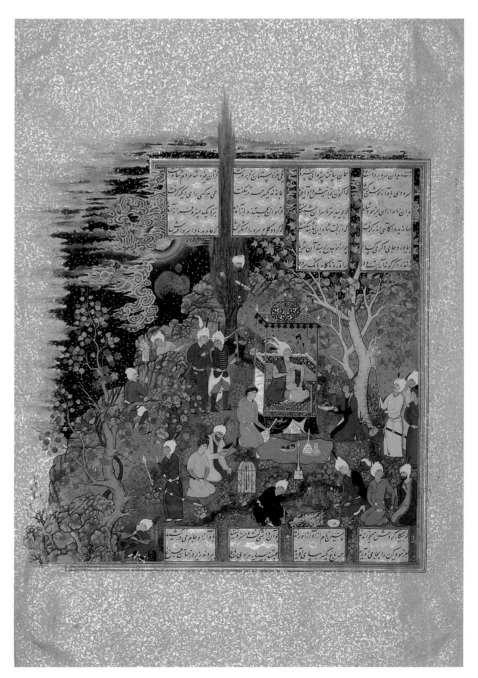

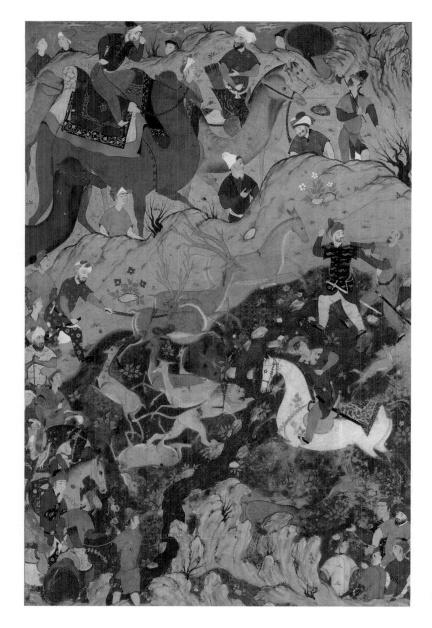
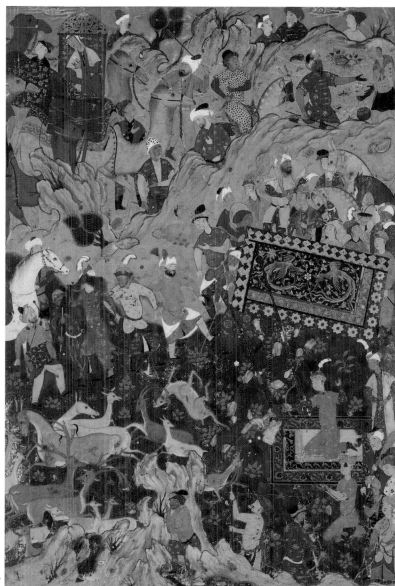

A princely hunt, double-page frontispiece, from a *Shahname* made for Shah Isma'il II. Iran, Qazvin, 1576–7.

'Commercial' style manuscripts continued to be produced at Shiraz under the Safavids, along with miniatures which emulated those made in the Safavid capital. The Safavid historian Budaq Qazvini, who visited Shiraz in the 16th century, wrote that 'Should one want a thousand books, they could all be produced in Shiraz within a year.' According to him, all the various aspects of book production, including calligraphy, illumination and binding, were carried out in private homes.

During the 16th century, Mashhad and Bukhara also emerged as thriving centres of miniature painting. The works produced by the court artists of Sultan Ibrahim Mirza (nephew of Tahmasp) at Mashhad are associated with a degree of mannerism; Bukhara produced miniatures in the style of Bihzad, and brightly painted images of lovers or other figures depicted within an ogival arch. Single-figure painting became popular at Qazvin and continued at Isfahan, which from the end of the 16th century became the new Safavid capital under Shah 'Abbas I (1587–1629).

The most celebrated artist at the court of 'Abbas I was the painter 'Aqa Reza, also known as Reza-i 'Abbasi (c. 1565–1635). Reza's early work is notable for his brilliant and apparently spontaneous use of line of varying thickness, and was widely imitated. His subjects included elegantly dressed youths and girls as well as numerous portraits of 'low-life' subjects such as scribes and dervishes, which show considerable expressiveness. Around the mid-17th century the artist Muhammad Shafi'-i 'Abbasi painted detailed and accurate studies of various species of birds and flowers.

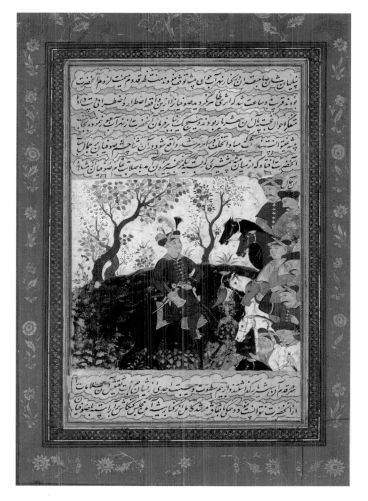

Shah Isma'il emerges from the forest with the sword given to him by the Twelfth Imam, from a dispersed history of the Safavid Shah Isma'il I. Isfahan, 1686–90.

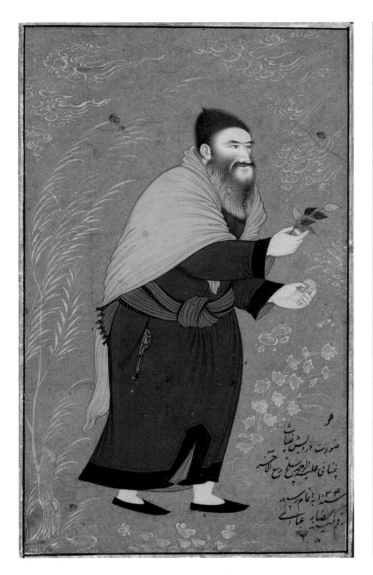

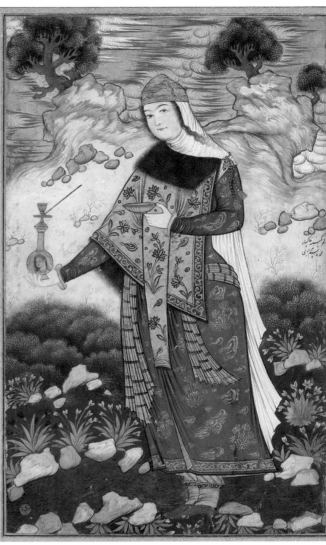

Far left: *Ghiyath the dervish*, by the painter Reza-i 'Abbasi. Iran, Isfahan, 1625.

Left: *Lady proffering a* huqqa *(water pipe)*, by the painter Muhammad Qasim-i Tabrizi. Iran, Isfahan, c. 1640–50

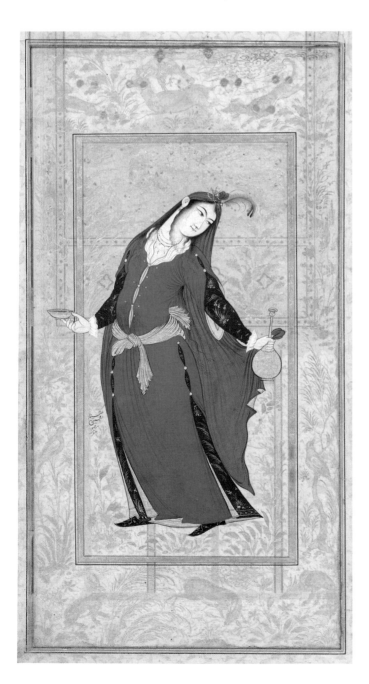

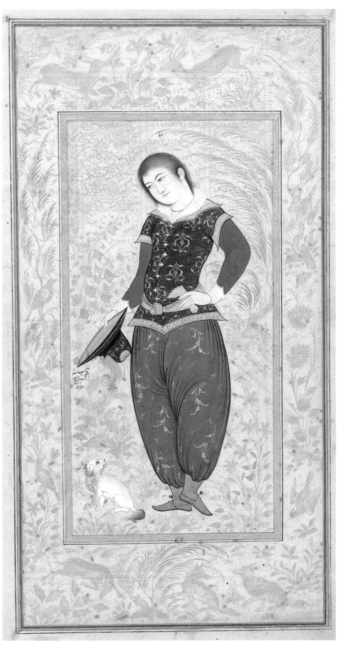

Girl with an Indian headdress (far left), and *European youth in Portuguese dress*, signed by Mu'in Musavvir, from a *Shahname*. Iran, Isfahan, 1648.

Far right:
Miniature enamel
portrait of Fath 'Ali
Shah. Iran, early
19th century.

From the late 17th century Safavid painting showed an increasing European influence, stimulated in part by prints brought to the Safavid court by European visitors. In turn these foreigners often commissioned paintings from local artists, frequently in European style. An example is the 45-page sketchbook of the Dutch traveller Engelbert Kaempfer, now in the British Museum.

This Western influence continued during the Qajar period. Oil painting became more and more common during the 19th century, along with printing and photography, and Persian miniaturists increasingly turned their attention to lacquer. Portrait miniatures, frequently in enamels, were also popular under the Qajars. Particularly notable during the mid-19th century are portraits by the Qajar court painter Abu'l-Hasan Ghaffari, who painted many of Nasir al-Din Shah's courtiers. Abu'l-Hasan also supervised the production of an illustrated Persian translation of the *Arabian Nights*, with over 1,100 pages of miniature painting.

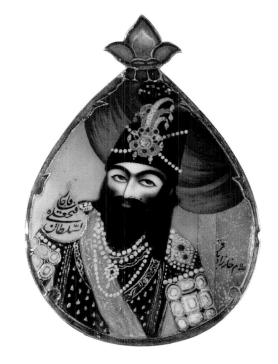

Right: Doublure
of a book cover, of
lacquered papier-
mâché board,
signed by the
painter, Muham-
mad Hadi. Iran,
Shiraz, 1815.

Far right: Portrait
of Husayn 'Ali
Khan, by the
painter Abu'l-
Hasan Ghaffari.
Tehran, 1853–4.

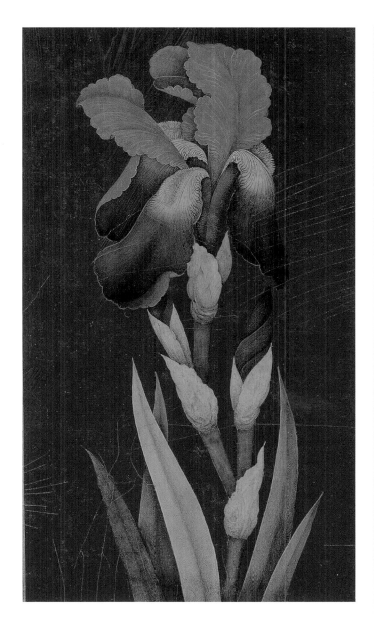

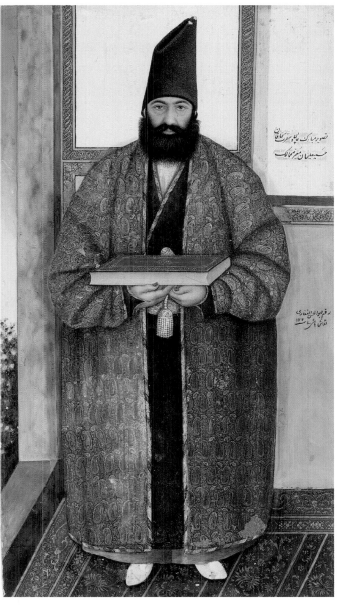

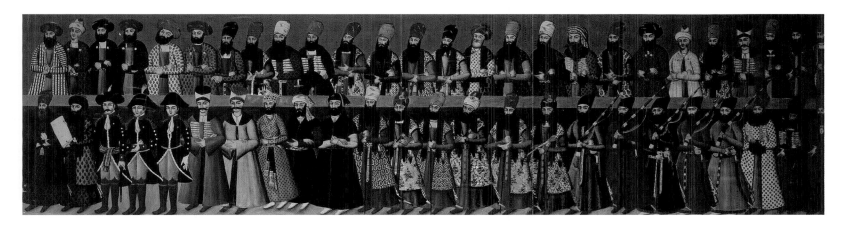

Panel from a frieze depicting a New Year reception at the court of Fath 'Ali Shah. Iran, c. 1815–20.

OTTOMAN MINIATURES

Ottoman painting drew its early inspiration from a variety of sources, and the royal studio of Süleyman the Magnificent (1520–66) included painters from such diverse backgrounds as Tabriz and the Balkans. Persian painters were brought back to Istanbul following the Ottoman capture of Tabriz in 1514, and the register of guilds from 1525–6 records pupils and masters of Albanian, Hungarian, Circassian, Anatolian and Persian origin in the royal workshop. Nevertheless, the primary influence on the Ottoman style was that of Persian manuscripts. Among the earliest dated miniatures from the Ottoman period are illustrations

to the *Dilsuzname* (a popular Persian romance), now in the Bodleian Library, Oxford.

One of the earliest accounts of the development of Ottoman painting is the *Menakib-i Hünerveran* ('Exemplary Deeds of the Virtuosi'), written by the Ottoman historian Mustafa Ali in 1587. The *Menakib* records that two of the most celebrated artists working at the Ottoman court during the 16th century were Şahkuli and Vali Jan, both of whom were originally from Tabriz, and had been pupils of Persian and Georgian masters respectively. Şahkuli, who headed the studio of Süleyman the Magnificent for ten years, is associated in particular with

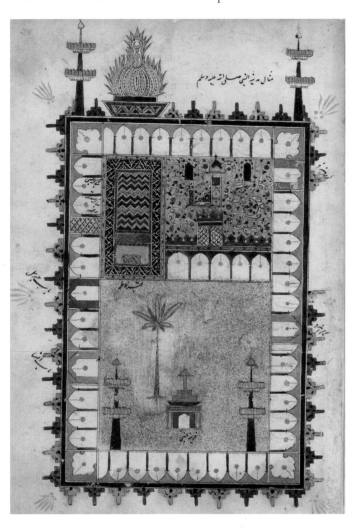

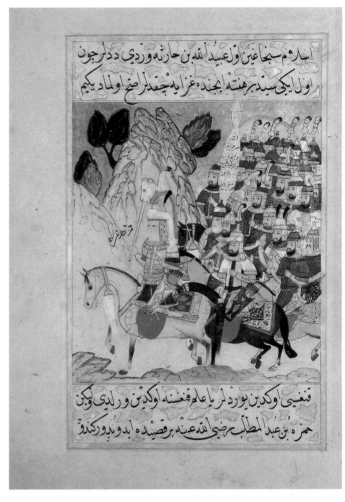

Far left: *The mosque of the Prophet at Medina*, from a copy of the *Futuh al-Haramayn*, a guide to pilgrimage. Mecca, June 1582.

Left: *'Ubayd and Hamza advancing at the head of a force against Abu Jahl*, a page from a copy of the *Siyer-i Nebi* of Erzurumlu Mustafa Darir, a version of the life of the Prophet Muhammad. Istanbul, c. 1594–5.

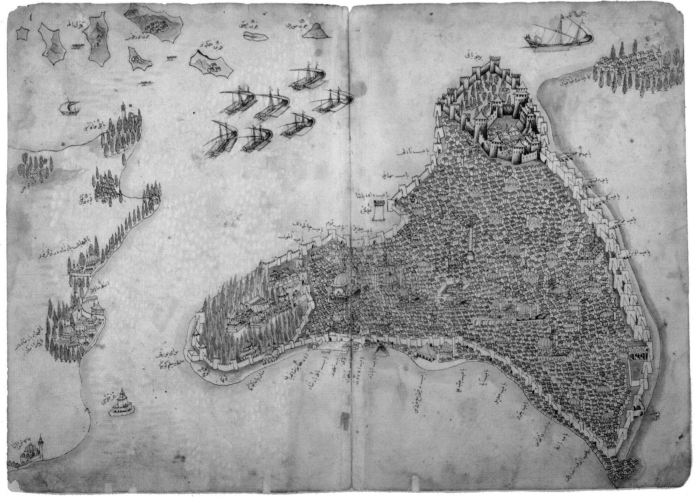

A topographic view of Istanbul, from the *Kitab-i Bahriye* ('Book of Seamanship') of Piri Reis. Ottoman Turkey, c. 1670.

drawings of dragons in the so-called *saz* style, much favoured by Aq Qoyunlu and Safavid painters, with characteristic foliage with lotuses and long, serrated *saz* leaves.

Particularly notable in Ottoman painting is the degree of realism. In addition to the verse romances so popular in Persian manuscripts (such as the *Shahname*), Ottoman painters were called upon to produce illustrated histories of the reigns of sultans – such as the great *Süleymanname* completed c. 1558 – together with accounts of various military campaigns, detailed topographical maps, and even scenes from daily Ottoman life. All such manuscripts required first and foremost a degree of accuracy, a quality which sets them apart from the idealized world of Safavid miniatures.

Perhaps the most famous Ottoman topographical manuscript is the *Kitab-i Bahriye* ('Book of Seamanship') by the Ottoman admiral and cartographer Piri Reis, which dates from the 1520s. It is a portolan chart (from the Italian and Catalan *Carta portolana* or *portolano*), a type of atlas the development of which was facilitated by increasing use of the compass for navigation; such charts are characterized by their network of rhumb-lines, divided into black, red and green for clarity. Two world maps by Piri Reis have also survived, the first dated 1513 and the second (a fragment only) dated 1528. Both bear his signature, and are now in the Topkapı Saray Library. Piri Reis is explicit in his annotation concerning his sources for the earlier map: 'the coasts and islands on this map have been copied from a map made by Columbus.' The accuracy of both is outstanding, in particular that of the later map, which is comparable to the famous Portuguese world map known as the Miller Atlas (1519).

A characteristic manuscript format in late Timurid Iran and in Ottoman Turkey was the *sefine* or *cönk*, a slim volume opening vertically and very often used for anthologies and poems. In 17th-century Ottoman Turkey these may have included figure studies or garden scenes as well.

Under Sultan Ahmed III (1703–30), a distinctive style was developed by the court painter Levni. Single female figures remained a popular subject. The lighthearted gestures of the figures and a pale palette are characteristic features of these works, which are prominent in Ottoman album collections of the 18th century.

Above: *Dragon amid foliage*, drawing in the style of Şahkuli. Istanbul, c. 1550.

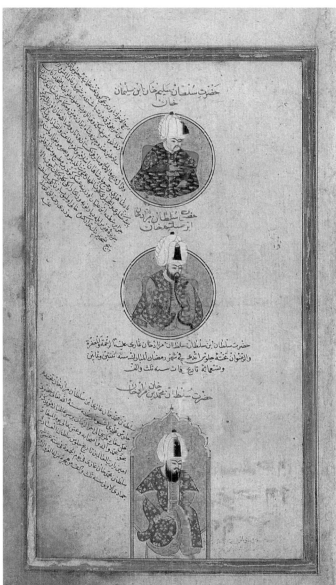

Left: Portraits of Selim II, Murad III and Mehmed III enthroned, from a copy of the *Silsilename*, an Ottoman royal genealogy up to the death of Mehmed III (1603). Ottoman Turkey, early 17th century.

MINIATURE PAINTING IN INDIA

Miniature painting in India during the Sultanate (or pre-Mughal) period was well established by the early 16th century, with a number of schools existing simultaneously in the various territories of the subcontinent. Their works are typically characterized by a mixture of Iranian and Indian elements, and are highly decorative. These styles, together with the so-called *Chaurapanchasika* style, with its bright primary colours and sinuous line, and the 'Western Indian' style associated with the Jain religion in Gujarat, were to play a key role in the development of Indian painting under the Mughals.

Indeed, Mughal manuscript painting is a remarkable synthesis of Persian, Indian and European elements. Under Humayun (1530–40, 1555–6), a more classically Persian style was favoured, and in 1549 the painters Mir Sayyid 'Ali and 'Abd al-Samad, both from Safavid Iran, came to work at Humayun's court-in-exile at Kabul. Both of these artists instructed Humayun, and later his son Akbar.

However, the accession of Akbar to the throne in 1556 marked a decisive change in style, largely brought about through Akbar's openness to Hinduism and other religions, and to European influence. While Mir Sayyid 'Ali and 'Abd al-Samad continued to manage the royal workshop, they were now joined by a large number of Indian artists from diverse backgrounds and different local schools. Humayun is not known to have hired any Hindu painters; in contrast, many of those working in Akbar's royal workshop bore Hindu names. These local artists rapidly assimilated the Persian style of their masters and integrated this with Indian elements, creating a manner which is remarkable both for its greater naturalism and for its energy. At the same time, European prints made a profound impression. Many had Christian subjects, including the Madonna and Child; the influence of Northern Renaissance landscapes, herbals and European costume is also apparent. Again local artists, born into the Indian sculptural tradition, proved highly adept at imitating the European illusion of three-dimensional form in manuscripts.

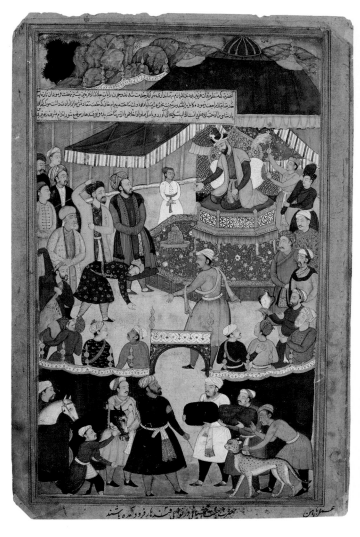

Bayram Khan doing obeisance before Humayun, a page from a copy of the *Akbarname*. Mughal India, c. 1595–1600.

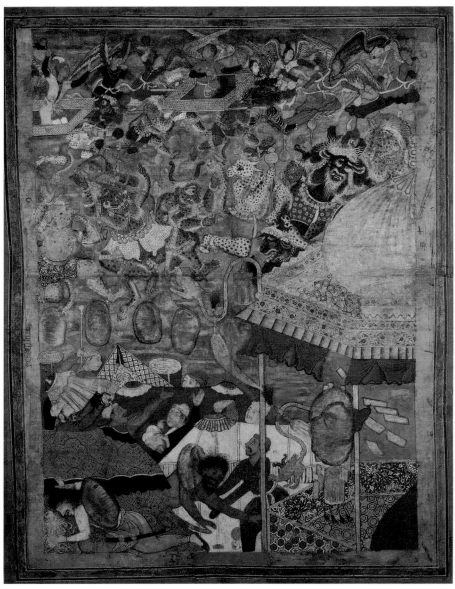

Peris (fairies) destroying an enemy camp, from a copy of the *Hamzaname*. Mughal India, c. 1562.

One of the most important manuscripts to be prepared by Akbar's royal workshop was a huge 14-volume copy of the *Hamzaname*, with some 1,400 illustrations, a project which lasted for approximately 15 years and clearly demonstrates the process of assimilation of a variety of diverse styles. Other major illustration projects included copies of the *Mahabharata* (the Hindu epics) with Persian translations; an *Akbarname*, a history of the emperor's own reign; and copies of the *Baburname*, written by the first Mughal emperor, Babur. Both Akbar and his mother Hamida Banu Begum commissioned copies of the collection of Hindu myths and legends known as the *Ramayana*.

Single-page compositions became more common during the reigns of Jahangir (1605–27) and Shah Jahan (1628–57), and were typically collected in albums. Single-figure paintings emerged as a popular genre, often characterized by a more contemplative mood, and sometimes framed by beautifully decorated borders. Shah Jahan's reign was chronicled in the *Padshahname* ('Book of the King of Kings'), which contains detailed scenes of court ceremonial in which the arrangement of figures is a clear reflection of the Mughal hierarchy.

A highly refined level of manuscript painting also developed in Kashmir, which was visited frequently by Jahangir, Shah Jahan and his intended heir, Dara Shikoh. Particularly fine is the work of the artist Muhammad Nadir Samarqandi, originally from Samarqand.

A distinctive style of painting also developed in the Deccan as early as the 16th century, in particular in Bijapur and Golconda, which were not conquered by the

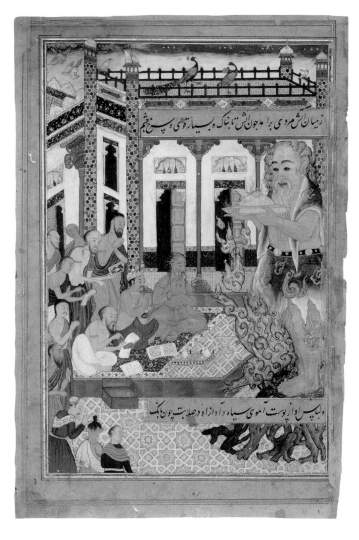

A giant messenger appears to King Dasaratha, from a manuscript of the *Ramayana* associated with Hamida Banu Begum, wife of the Emperor Humayun. Mughal India, c. 1594.

Right: *Hunting scene*, from a dispersed copy of the *Baburname*. Mughal India, c. 1589.

Far right: *Shah Jahan watches an elephant fight*, from the *Padshahname*. Mughal India, c. 1640–45.

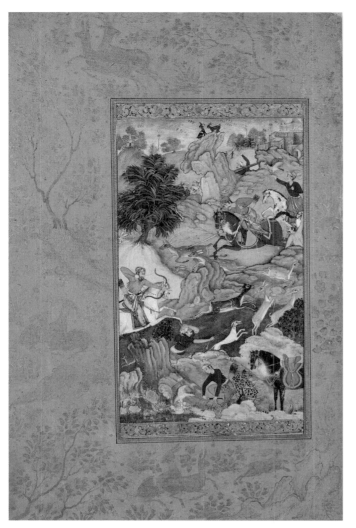

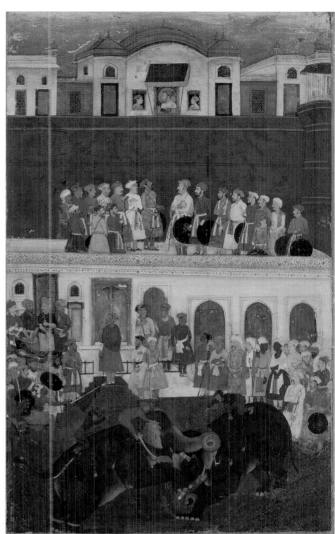

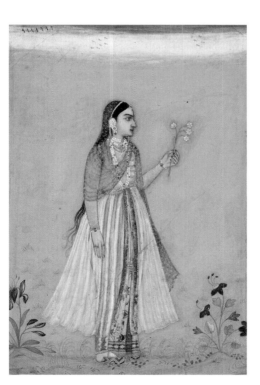

Lady in European dress, album page. Mughal India, c. 1615–35.

Court lady with a narcissus stem, album page. Mughal India, c. 1630.

Yusuf seated in a garden, double page from a copy of the *Divan* of Hafiz, with illustrations attributed to Muhammad Nadir Samarqandi and text in *nasta'liq*. Kashmir, 1653.

Mughals until the 1680s. Deccani painting is notable for its particularly subtle colour schemes and for the popularity of romances, which tended to be eschewed in favour of historical narratives under the Mughals further north. A number of single flower studies were also made, influenced by European herbals; many of these were produced for the Dutch East India Company.

The successive reigns of Akbar, Jahangir and Shah Jahan were all characterized by these rulers' greater interest in the production of secular manuscripts than of Qur'ans. In contrast Awrangzeb (1658–1707) shared neither the religious openness of his forefathers nor their love of miniature painting. Although he had commissioned manuscripts as a prince, Awrangzeb had the painters of the royal workshop expelled from Delhi in 1668, while his withdrawal of royal patronage from Kashmir marked the end of the area's prosperity and significance as a cultural centre. In the Deccan his devastating campaigns and protracted siege of Bijapur in 1686 all but extinguished the tradition of fine manuscript painting there. Painters from the imperial workshop in Delhi may have gone to work at the Rajput courts, or entered the service of the nobility. In

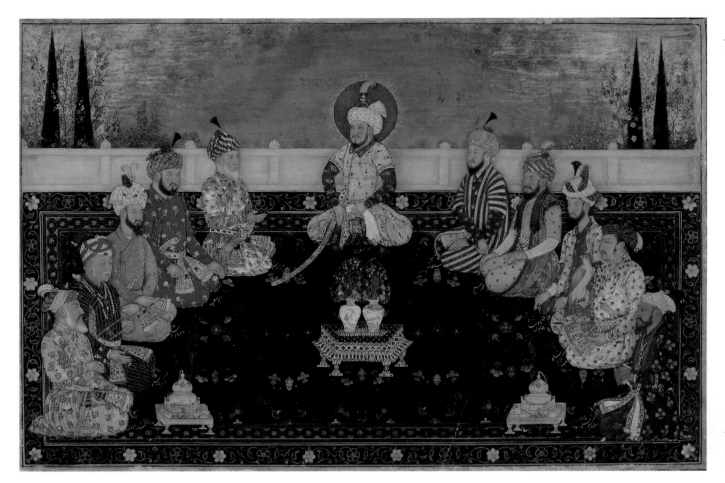

The Mughal dynasty from Timur to Awrangzeb. Mughal India, c. 1707–12.

Below: *Prince A'zam Shah hunting,* album page. Mughal India, c. 1685–90.

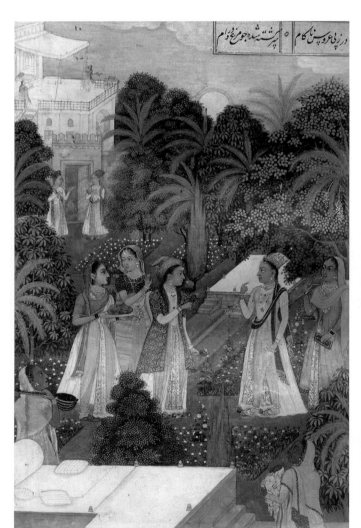

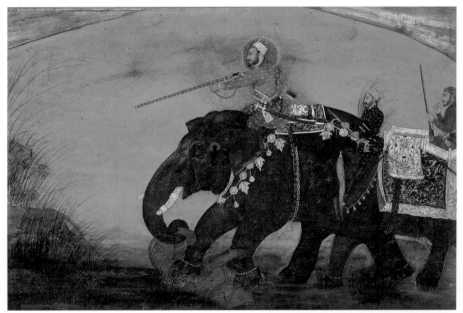

Layla and her companions in a garden, from a *Khamse* of Nizami that belonged to Awrangzeb. Mughal India, c. 1640–5.

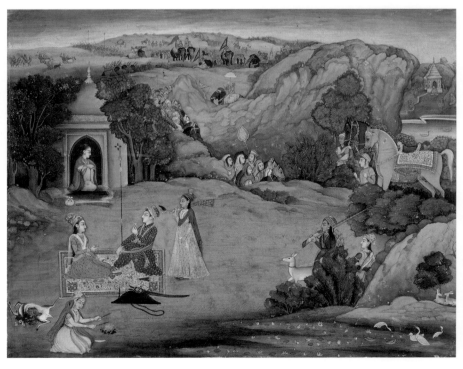

A prince and princess picnic in the country, attributed to Mir Kalan Khan. Mughal India, c. 1735–50.

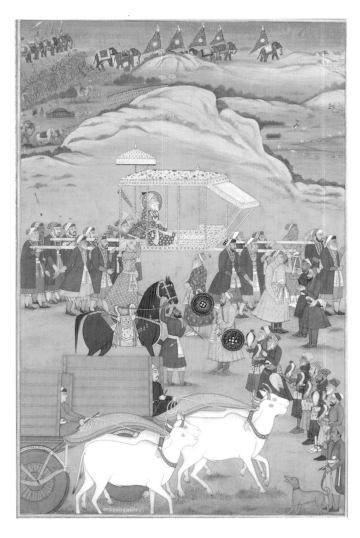

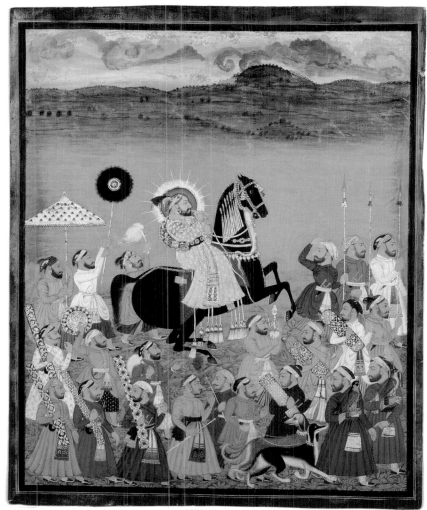

any case, the comparatively few examples which have survived from Awrangzeb's reign indicate that fine manuscripts did continue to be produced in India, but on a considerably reduced scale.

Mughal painting of the 18th century shows a degree of continuity with work produced in the reign of Shah Jahan, sometimes with a preference for flatter backgrounds. Many painters left Delhi following Nadir Shah's sack of the city in 1739, most going to work in Oudh and Bengal, both of which were flourishing through European trade. One such artist was Mir Kalan Khan. Hindu elements are particularly noticeable in the Provincial Mughal style associated with Lucknow, where various Hindu festivals were frequently depicted. Album paintings from Lucknow often feature floral trellis- or diaper-patterned borders.

The style of paintings produced for staff of the East India Company, often referred to as the 'Company Style', shows a marked European influence. Subjects included portraits, architectural studies, and studies of flora and fauna.

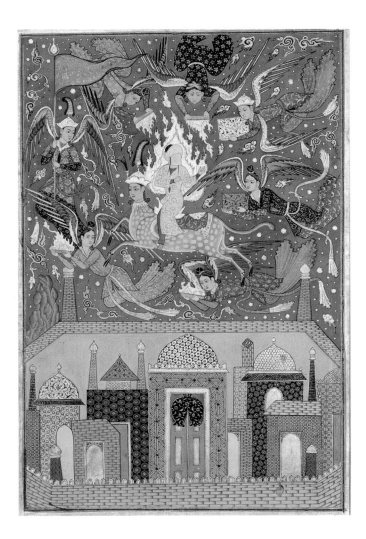

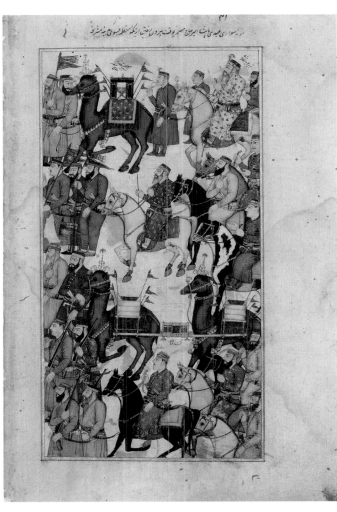

Above left:
Awrangzeb and his retinue in procession. India, 18th century.

Above right:
Maharana Sangram Singh of Mewar on his horse Jambudvipa. Udaipur, c. 1720–30.

Far left: *The Prophet Muhammad's night ride on Buraq, and the Aqsa mosque,* from a *Falname* manuscript (book of divination). Deccan, Golconda, c. 1610–30.

Left: *'Abdi Basha, the amir hajj of the Egyptian pilgrims, leaving Mecca on the way to Medina,* from a copy of the *Anis al-Hujjaj* ('Companion for Pilgrims'). Possibly Gujarat, c. 1677–80.

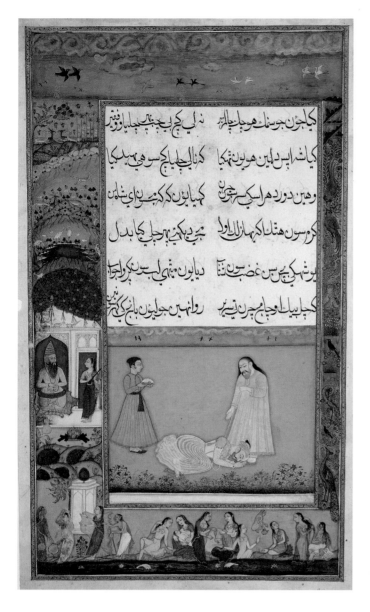

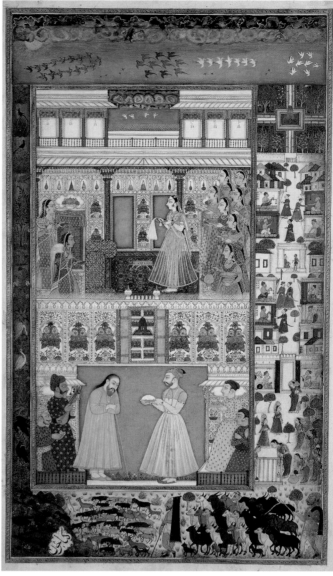

King Bikram offers food to the holy man, Roshan-i Dil, in the hope of gaining a boon, and is rebuffed, double page from a copy of the Gulshan-i 'Ishq ('The Rose Garden of Love') by the Sufi poet Nusrati. Deccan, Hyderabad, c. 1710.

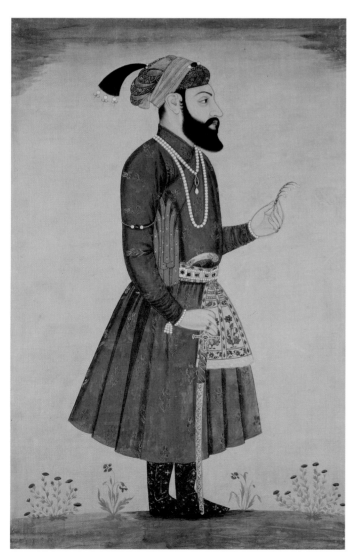

Portrait of Prince Shah 'Alam. North Deccan, c. 1695–1700.

A male comb duck, Company style. India, c. 1790.

Radha and Krishna in a boat, Company style. India, Rajasthan, possibly Udaipur or Bikaner, c. 1860.

Bookbinding

It is impossible to discuss the arts of the book in the Islamic world without mentioning, if only very briefly, the development of bookbinding.

A feature associated specifically with Islamic bindings is the flap, attached to the back cover, which when folded inside the front cover protects the fore-edge of the book, rather like a box. Books were traditionally stacked in piles rather than arranged side by side.

Very few early bindings have survived. They consist of wooden boards covered with leather, with leather straps to hold the book shut. The leather is usually decorated with tooling, a technique in which a pattern is carved or stamped into damp leather with a metal tool. By the 11th century wooden boards had been superseded by pasteboard, which was made up of sheets of paper glued together – sometimes including recycled pages from other manuscripts or even Qur'ans. Blind tooling (without gold infill) was still used to decorate the leather which covered these boards; stamps were also applied and sometimes the leather was engraved or gilded.

Blind and gold tooling is also found on bindings from the 15th century, which frequently feature medallions and cloud-scroll motifs, sometimes reflecting the design of illuminated pages within. Doublures – the inner face of the binding – were typically stamped. From the 16th century, designs were frequently sunk and stamped, and often brushed with gold. Decoration became increasingly complex, the doublures often receiving equally elaborate treatment. In bindings from Safavid Iran, the doublures are sometimes of coloured paper or of leather with filigree work.

Doublure from a Qur'an binding in leather with a stamped design of scrollwork incorporating human and animal heads, an extremely rare occurrence of figural imagery in a Qur'an. Anatolia or Jazira, c. 1250–1350.

Below: Qur'an binding in leather with moulded and stamped decoration. Iran, probably 13th century.

Right: Qur'an binding in leather with geometric designs in gold and blind tooling. Mamluk, probably Damascus, 1340–50.

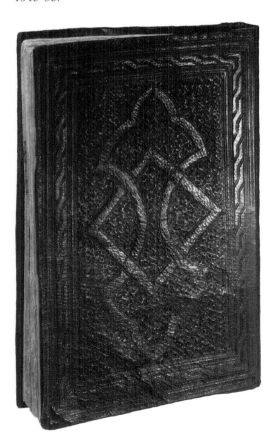

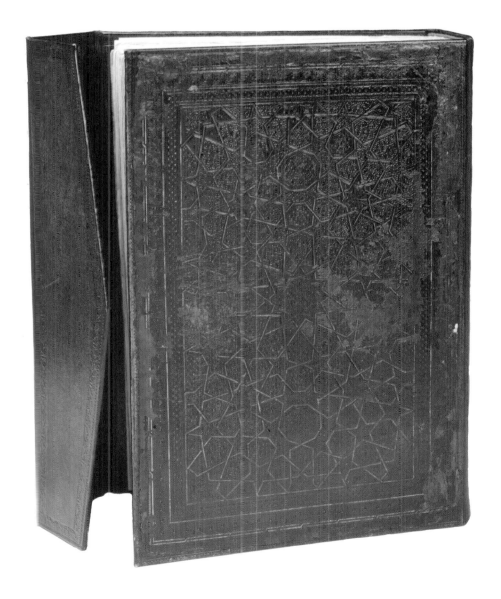

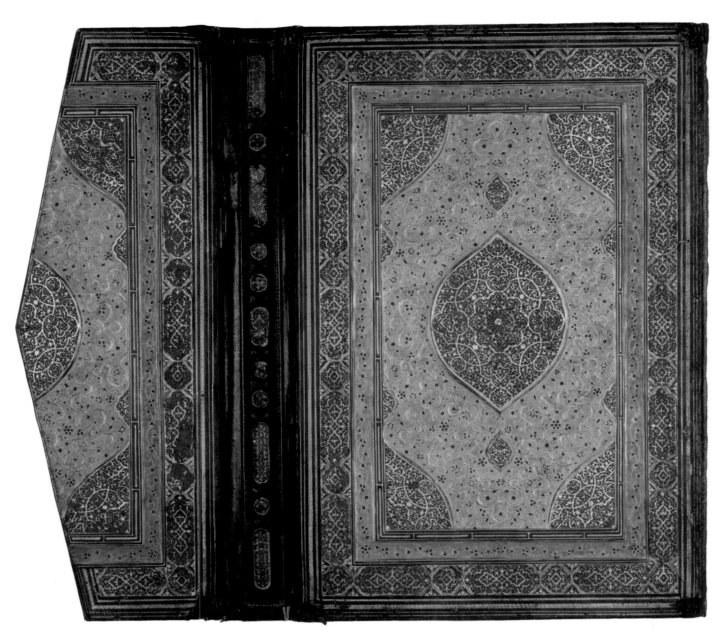

Inner back and flap of a Qur'an binding, with sunk and stamped decoration, and paper filigree. This Qur'an may once have belonged to the Safavid Shah Tahmasp I (1524–76). Iran, Qazvin, 1552.

The earliest known examples of lacquer-painted bindings (also known as 'bookbinder's lacquer') are from Herat, and are dated 1490–1510. They have a papier-mâché base, formed of sheets of paper pasted together, and are decorated with gold arabesques on a black ground, showing the influence of Chinese *qiangjin* lacquer, coated with a layer of brilliant varnish. Later examples of lacquer bindings from secular or non-Qur'anic manuscripts have miniature paintings featuring flowers and birds, landscapes, and figural compositions. Lacquer-painted Qur'an bindings are usually decorated with arabesque scrollwork or floral patterns. Lacquer bindings were popular in Safavid and Qajar Iran, in Ottoman Turkey, and in Mughal India (especially Kashmir). The restoration of 17th-century Safavid Qur'ans during the 19th century usually included rebinding, frequently in lacquer covers.

In the late 18th and 19th centuries, many Ottoman leather bindings were painted with gold and silver washes, in imitation of earlier stamped designs. Paper doublures became increasingly common, and were sometimes marbled (also known as *ebru*) or painted. Occasionally Ottoman bindings were decorated with jewels and metalwork; and some spectacular bindings embroidered with copper and silver wire have survived from the late 18th century. In Mughal India during the 18th century iron bindings decorated with exquisite gold inlay were produced.

Qur'an binding in leather with gold-brushed, sunk and stamped decoration. Iran, Shiraz or Qazvin, 16th century.

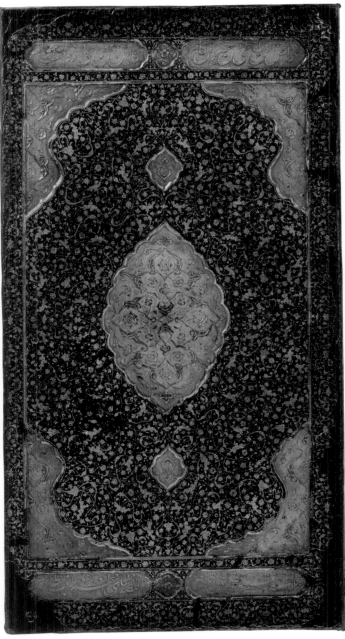

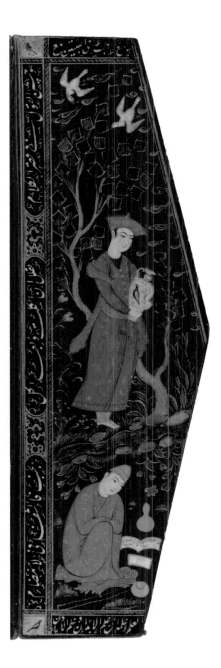

Far left: Book cover of lacquered papier-mâché board with sunken and gilded areas, reset within a later leather binding. Perhaps Herat, first half 16th century.

Left: Flap from a book cover of lacquered papier-mâché board. Isfahan, mid-17th century.

Below left: Album cover of lacquered papier-mâché board, probably the work of Muhammad Zaman, a court painter under Karim Khan Zand and Fath 'Ali Shah Qajar. Iran, late 18th century.

Below: Doublure of an album cover (one of a pair) of lacquered papier-mâché board, signed Razi Muzahhib. Iran, Tehran, 1881–2.

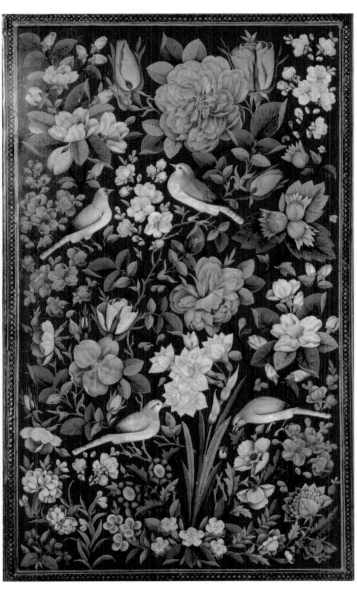

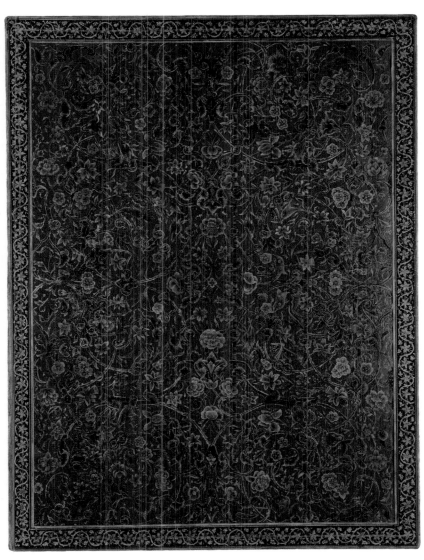

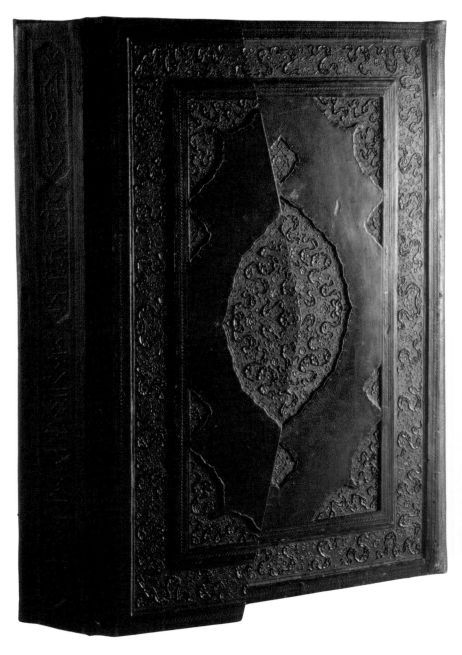

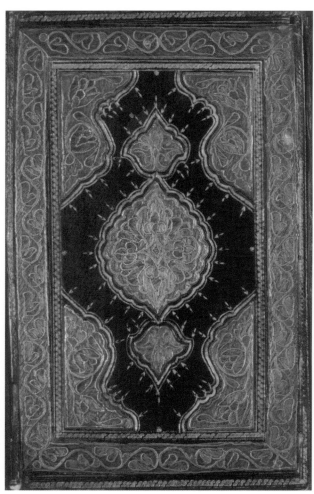

Left: Binding in pressure-moulded leather, from a copy of the *Mantiq al-Tayr* of Farid al-Din al-ʾAttar. Ottoman Turkey, c. 1540–50.

Above: Back cover of a single-volume Qurʾan in black morocco leather embroidered with copper and silver wire. Ottoman Turkey, 1677–8.

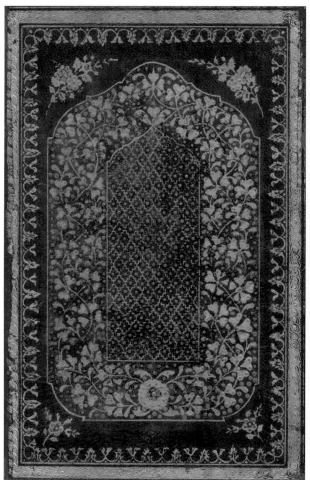

Back cover of a single-volume Qurʾan in dark-green morocco leather with gold-painted decoration. Ottoman, Balkans, mid-19th century.

Qurʾan binding in morocco leather with gold-painted and block-stamped decoration. India, Deccan, Hyderabad, 1780–82.

Lacquer

The term 'Islamic lacquer', or more specifically 'bookbinder's lacquer', refers to bookbindings, pen boxes and other objects with a papier-mâché base and painted and varnished decoration. The papier mâché was formed of sheets of paper pasted together, a practice found in bookbinding (hence the term 'bookbinder's lacquer'). It was painted with designs, usually in watercolours, and coated with a layer of varnish that imparted a beautiful sheen. In some examples the brilliance of the varnish was further enhanced by the use of powdered gold or powdered mother of pearl, an effect known in Persian as *marqash*.

Painted and varnished papier-mâché objects are associated in particular with Qajar Iran, but the art form was partly a continuation of an earlier tradition of Islamic lacquer painting on wood, leather or other bases (for example, a wooden Qur'an stand from Konya dated 1279–80). Another influence was that of the Iranian lacquer bow. This was coated with the same varnish – known as *rawghan-i kaman* or 'bow gloss' in Persian – as came to be used for bookbinder's lacquer. Mirak Naqqash, the head of the scriptorium of the Timurid ruler Sultan Husayn Mirza, was in fact a bow maker and illuminator by training.

Another important source of inspiration was Chinese lacquer (defined by the 15th-century Cairene historian al-Maqrizi as 'wares of varnished board ... brought from China'), which was being imported into the Middle East by the mid-15th century. Its influence, in particular that of gold-on-black *qiangjin* (or 'incised gold') lacquer and polychrome *tianqi* (or 'filled-in') lacquer, is clearly visible on the earliest surviving examples of Islamic lacquer, a

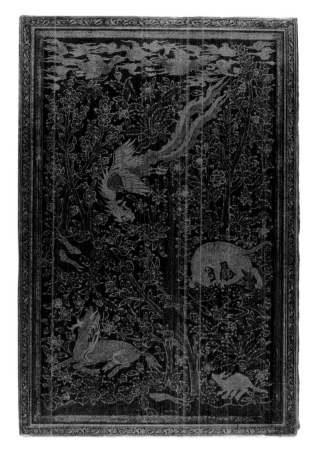

Binding of lacquered papier-mâché boards in *tianqi* style, from a copy of the *Divan* of Nava'i. Probably Herat, mid-16th century.

Lacquered wooden panel, probably from a door. Iran, Isfahan, second quarter 17th century.

Below left: Qur'an binding of lacquered papier-mâché boards in *qiangjin* style. Probably Herat, c. 1490–1510.

Below right: Binding of lacquered papier-mâché boards in *qiangjin* style, from a copy of the *Bustan* of Sa'di. Probably Istanbul, 1530s.

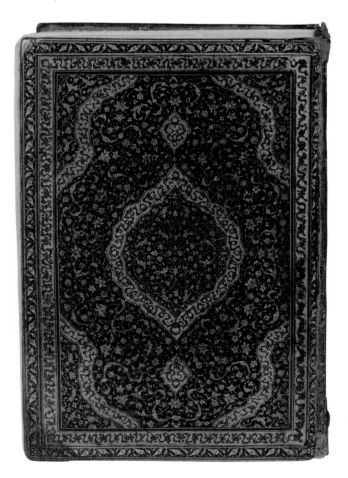

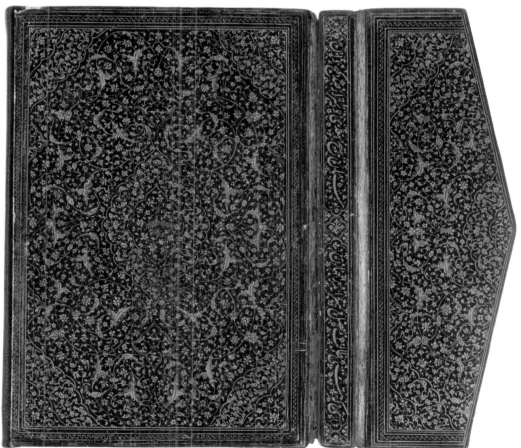

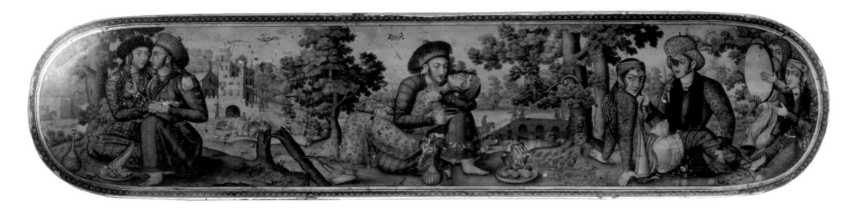

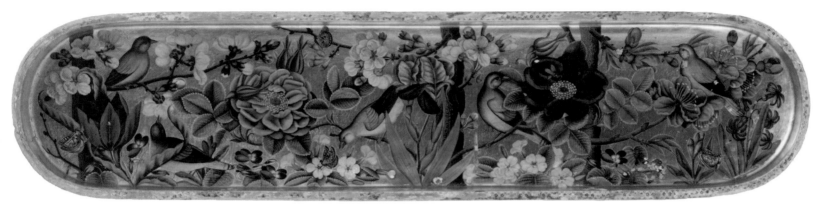

series of bookbindings made at Herat in the later 15th century. The decoration is predominantly fine gold arabesque and scrollwork on a black ground, which recalls *qiangjin*; polychrome figural designs appear on some examples along with inlaid mother-of-pearl, relating to *tianqi*. The influence of *qiangjin* is also evident on a set of leather bindings with lacquer decoration made for the Ottoman sultan Mehmed II in the late 1460s.

The lacquer bookbindings produced at Herat during the 15th century were to have a lasting influence on the development of Islamic lacquer over the following centuries, and even examples from late 19th- or early 20th-century Iran are clearly indebted to work from this

early period. From the 16th century colours other than black came to be used for backgrounds on lacquer book-bindings, and during the 18th and 19th centuries figural schemes similar to those found in miniature paintings were popular, while the use of solid grounds came to be restricted to non-figural decoration.

During the later 17th century in Safavid Iran a number of other painted and varnished papier-mâché objects gained popularity, most notably the pen box and the mirror case. Their decoration was characterized not by elements derived from Chinese lacquer painting, but by a new style featuring flowers and birds, and by figural scenes set in illusionistic landscapes showing the influence

Pen box lid of lacquered papier mâché, signed by Hajji Muhammad (outside and inside). Iran, Isfahan, 1712–13.

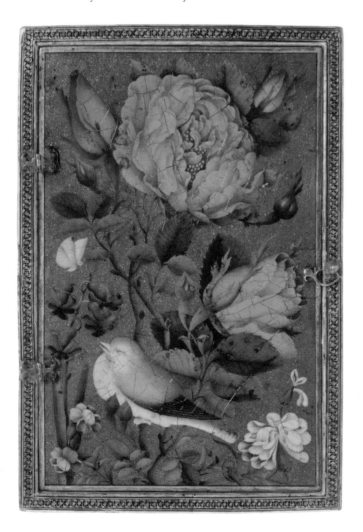

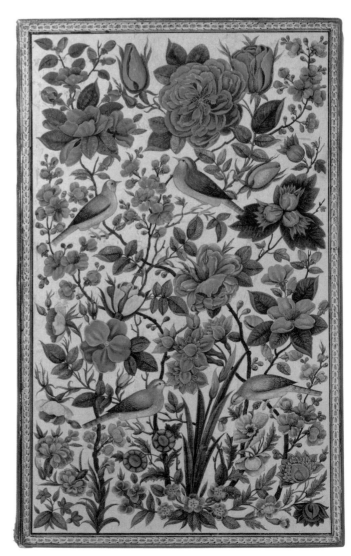

Far left: Mirror case with shutter of lacquered papier mâché (front). Iran, Shiraz, c. 1800.

Left: Qur'an binding of lacquered papier-mâché board. Iran, mid-19th century.

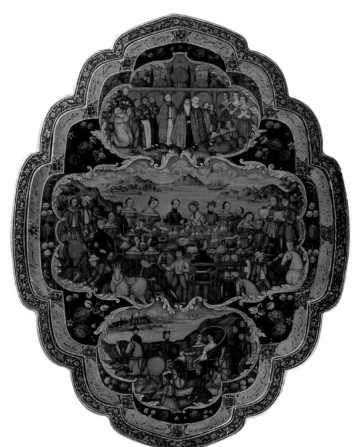

Left: Mirror case with shutter, painted by Muhammad Isma'il, of lacquered papier mâché (front). Iran, Isfahan, c. 1860.

Below: Binding of lacquer-painted boards with an image of Fath 'Ali Shah hunting. Iran, early 19th century.

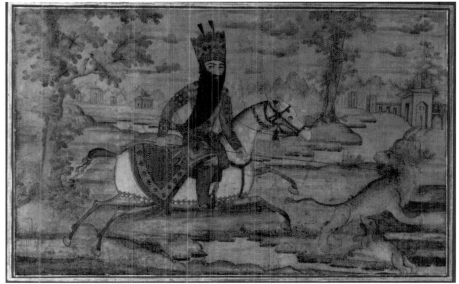

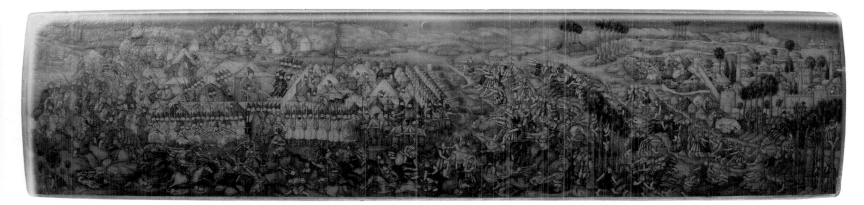

Pen box of lacquered papier mâché, signed by Muhammad Isma'il. Iran, Isfahan, 1849–50.

Mirror case with shutter of lacquered papier mâché. Iran, late 19th or early 20th century.

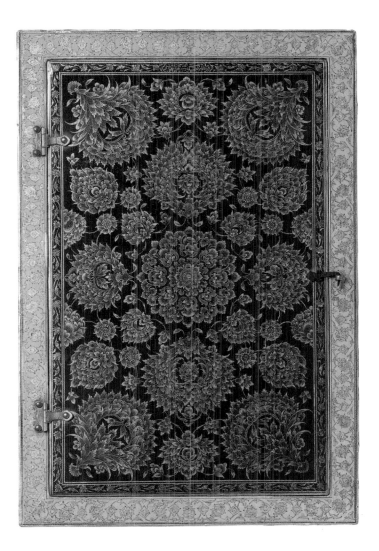

of European painting. These developments have been associated specifically with the work of the artists Hajji Muhammad and Muhammad Zaman, who may have been one and the same person. This style of decoration was to continue throughout the 18th century under artists such as 'Ali Ashraf and Muhammad Sadiq, who were responsible for transmitting it to painters of the early Qajar period. 'Ali Ashraf was celebrated for his flower and flower-and-bird paintings, Muhammad Sadiq for his figural decoration. At the same time, highly refined decoration in the tradition of *qiangjin* lacquer continued to be produced by such artists as the celebrated 18th-century illuminator Muhammad Hadi.

During the 19th century there were many centres of lacquer production in Iran, and several prominent family groups of makers. These included the Najaf family, headed by Najaf 'Ali, and the circle around them; the Imami family; and the Ghaffaris. One of the followers of Najaf 'Ali was Muhammad Isma'il, whose work includes spectacularly detailed battle scenes reduced in scale to the size of a pen box, portraits of his contemporaries, and

perhaps most distinctively, large groups of figures in European costume, including lay figures, courtiers, angels and Christian priests.

Other notable lacquer painters from 19th-century Iran included the artists Lutf 'Ali Shirazi, who made extremely detailed plant studies, and Abu Talib (flourished 1850s–60s), whose work is associated with pen boxes decorated with leaf-like forms or a type of 'engine-turned' pattern.

Two playing cards of lacquered papier mâché. Iran, third quarter 19th century.

Many pen boxes were decorated with portraits, including members of the ruling Qajar dynasty such as Fath 'Ali Shah. Other types of lacquer object from the Qajar period include musical instruments, Qur'an cases, folding fans, mirror cases, door panels and even playing cards.

Lacquer was also popular in Ottoman Turkey and Mughal India; lacquer bookbindings were especially favoured in Kashmir.

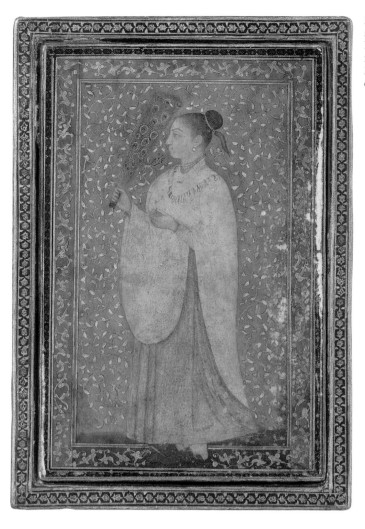

Mirror case with shutter of lacquered papier mâché, signed by Manohar. India, c. 1630.

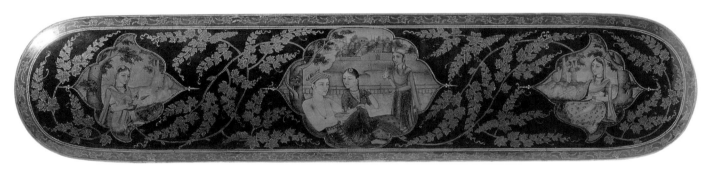

Pen box of lacquered papier mâché, signed by Rahim Dakani. India, c. 1700.

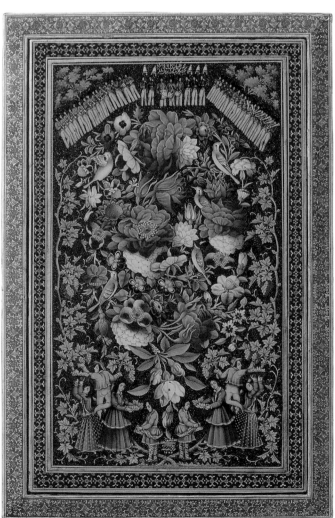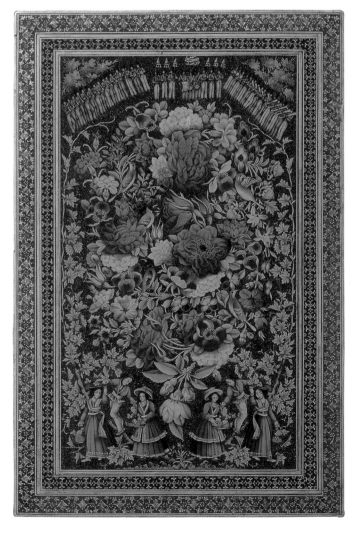

Left: Mirror case with shutter of lacquered papier mâché, signed by Lutf 'Ali Shirazi (front and back). Iran, Shiraz, 1865–6.

Folding
backgammon
board, wooden
base with lacquer-
painted decoration
(open and closed).
Iran, early 19th
century.

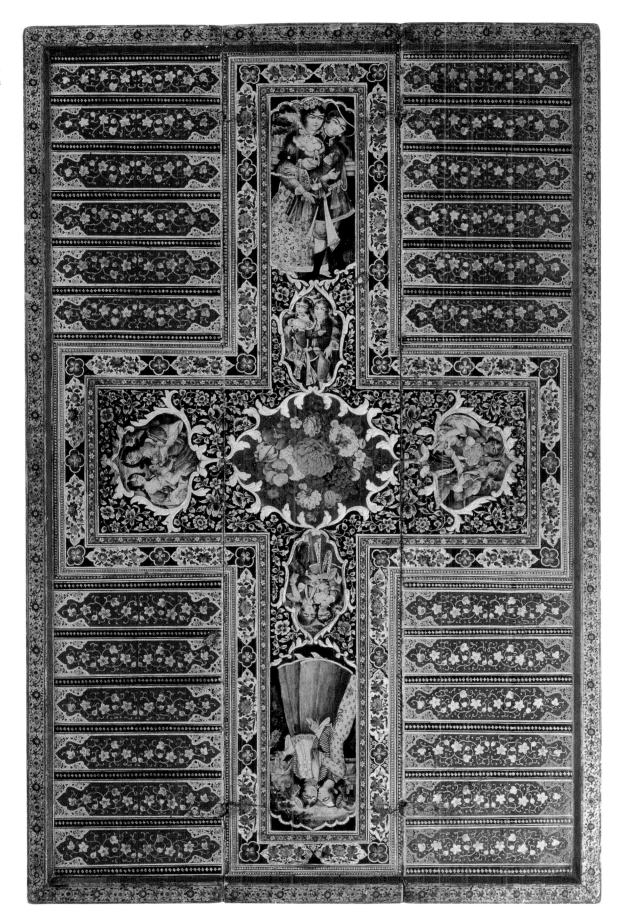

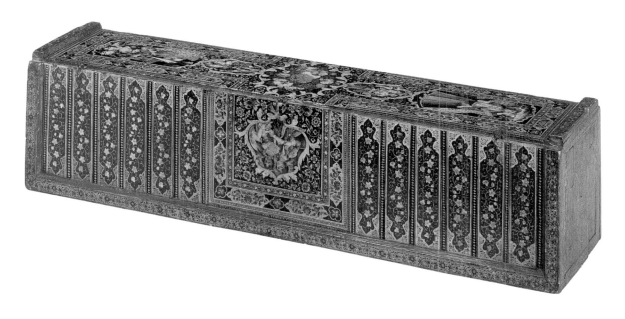

Pottery and Ceramics

Early Islamic pottery typically followed the traditions of Byzantium, Parthian and Sasanian Iran, and the Classical Mediterranean; and as with metalwork, it is often hard to distinguish between early Islamic objects and those of the preceding period. Indeed, through the conquest of Sasanian Iran Islamic pottery became the heir to a great Mesopotamian tradition stretching back to the 3rd millennium BC.

Earthenware related in both form and decoration to Sasanian pottery is found from the early Islamic period; examples include jugs and large storage vessels decorated with stamped geometric and animal designs. Moulded wares were also produced during the 8th century. Occasionally these pieces are unglazed; others are covered by a lead glaze, which was common in the Eastern Mediterranean in the pre-Islamic period.

A variety of wares were made in 9th-century Iraq, a time frequently referred to as the Samarra Period (Samarra was the Abbasid capital between 836 and c. 883). These feature a quite remarkable variety of glaze effects, and include the so-called Iraqi 'blue-and-white' pottery and white wares decorated with both polychrome and monochrome lustre.

Abbasid potters added tin oxide to the otherwise transparent lead glaze, thus making it opaque, in order to imitate the brilliant white of Chinese porcelain. Geometric and floral patterns, together with inscriptions, were then painted on the vessel in cobalt blue.

Lustre decoration involved painting metallic pigments onto a fired, glazed surface and then firing the object a second time to leave a thin metallic film adhering to the glaze; it is this which imparts a lustrous sheen. Lustre had been used on Egyptian glass in the 8th century but its adaptation to pottery was to prove especially popular in the Muslim world – and later (via Islamic Spain) in Renaissance Italy. Three types of lustreware are associated with the Samarra Period: polychrome lustre, with two or

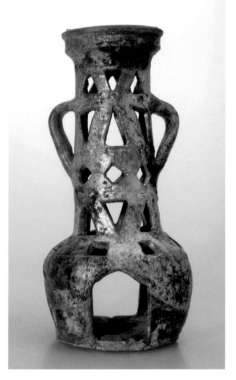
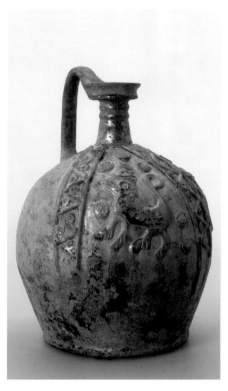

Turquoise-glazed earthenware lantern with incised and pinched decoration. Iran, 7th–8th century.

Green-glazed earthenware jug with applied and stamped decoration. Iran or Iraq, 8th century.

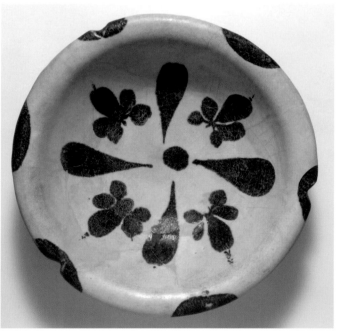

Blue-and-white bowl with opaque white glaze. Iraq, 9th–10th century.

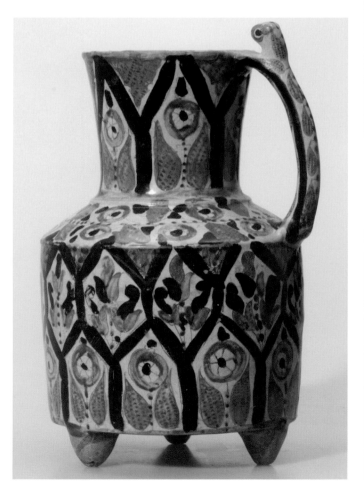

Far left: White-glazed jug with polychrome lustre decoration. Iraq, 9th century.

Left: Green-glazed earthenware dish with moulded decoration. Iraq, 9th century.

Plate with splashed decoration and calligraphy over an opaque white glaze. Iraq, 9th–10th century.

White-glazed plate with monochrome lustre decoration. Iraq, 9th–10th century.

Fragment of Fatimid lustre-painted bowl with figural decoration. Egypt, 10th–11th century.

Fragment of Fatimid lustre-painted dish with figural decoration. Egypt, 10th–11th century.

three tones of ochre and brown; the more luxurious polychrome ruby lustre; and monochrome lustre, featuring a single brown tone. Although non-figural designs predominate on polychrome examples, monochrome lustre is often decorated with human and animal figures. Bowls and plates are the most commonly found objects but lustre tiles were also produced, including those on the *mihrab* of the Great Mosque at Qayrawan, which were probably made in Baghdad in 862. These bear palmettes in geometrical compartments, in brown and yellow tones; examples from the late 9th and 10th centuries include greenish monochrome tiles decorated with stylized human and animal figures, outlined in white.

Splashed wares were also produced during the Samarra period. These are decorated with splashed colours over a white glaze. Chinese influence is apparent in these pieces, in particular that of T'ang polychrome stoneware of the 8th century.

Early Islamic pottery from North Africa and Spain is characterized by coloured glazes (typically yellow, green, brown and purple), either applied under a clear glaze or over opaque white. *Cuerda seca* (or 'dry cord') technique was introduced in Umayyad Spain during the 10th century. This involved painting lines of manganese purple pigment, mixed with a greasy substance that disappeared in firing, between areas of different coloured glazes to prevent them running into one another. A number of examples have been found at Madinat al-Zahra. Lustre

was probably introduced from the central Abbasid lands through Qayrawan and Fustat; however, the palette of Moorish lustre wares is sometimes very different from that found in Iraq.

Lustre technique was to became particularly refined under the Fatimids. In the 10th century the decoration of their pottery bore some similarities to the lustre developed at Samarra, but was characterized both by its greater attention to naturalistic detail and by its remarkable figural style. The roots of this style appear to lie in large-scale wall paintings (these are known to have existed from the beginning of the Fatimid period in Egypt, and it is recorded that painters from Iraq travelled to Egypt) and ancient local tradition (a Classical or late Hellenistic source has been proposed for this phenomenon). Notable developments in the Fatimid figural repertoire include the appearance of the hare, cheetah and griffin; among human figures, as well as the usual court scenes lay characters such as workmen were introduced. Examples from this period show a pleasing balance between clearly drawn motifs and the undecorated lustre ground, and also the use of foliated Kufic script.

In Spain, lustre reached spectacular levels of achievement with the famed 'Alhambra' vases of the 14th century. These are large, amphora-shaped vessels, ornately decorated, with inscription bands in Kufic or *naskh*; the tradition continued after the *Reconquista* among the *mudéjars* (the Muslim population of Christian Spain).

Bowl with polychrome lustre decoration. Perhaps North Africa, 9th century.

In Khurasan and Transoxania, Nishapur and Samarqand emerged as the main centres of pottery production under the Samanids. During the 10th and 11th centuries, this region was responsible for producing some of the most strikingly beautiful pottery of the medieval Islamic period. Medium-sized to large bowls predominate. A white slip was used over the reddish local clay and decorated with superb bands of calligraphy, typically in black but also sometimes in earthy brown. In some instances the slip itself is a deep purple-black. In many examples the inscription stands alone, the ascenders of the letters sometimes bursting into foliate terminals; in others, it is combined with geometric elements. Although the best-known examples of pottery from this period are epigraphic in their decoration, figural examples are also found. The remarkable diversity of this figural decoration

Right: Slip-painted bowl with figure of a seated ruler. Iran, Nishapur, 10th century.

Far right: Slip-painted bowl with human-headed quadruped. Iran, Nishapur, 10th century.

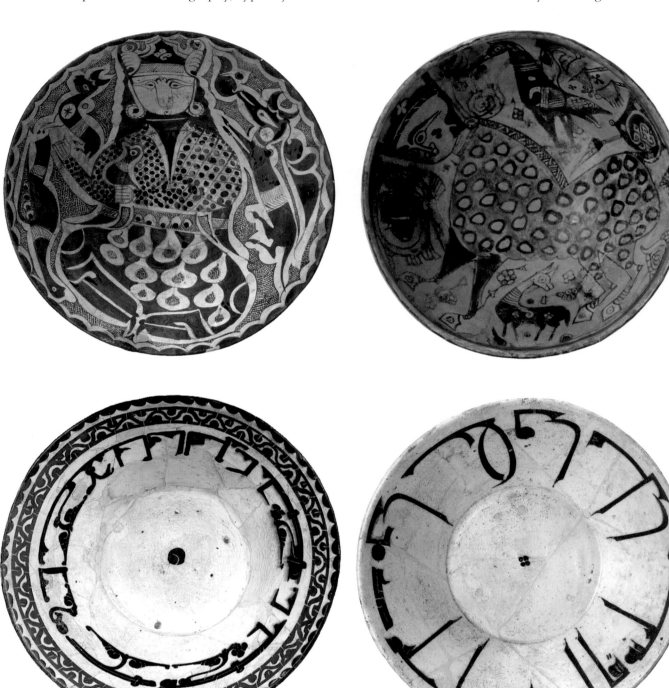

Right: Slip-painted bowl with an inscription that translates as 'Generosity is the disposition of the dwellers of Paradise.' Iran, Nishapur, 10th century.

Far right: Slip-painted bowl with an inscription that translates as 'Generosity is the disposition of the dwellers of Paradise. He said.' Iran, Nishapur, 10th century.

Right: Slip-painted bowl with stylized lion. Iran, Nishapur or Mazanderan region, 10th–11th century.

Far right: Earthenware bowl with white slip and *sgraffiato* decoration. Iran, 10th–11th century.

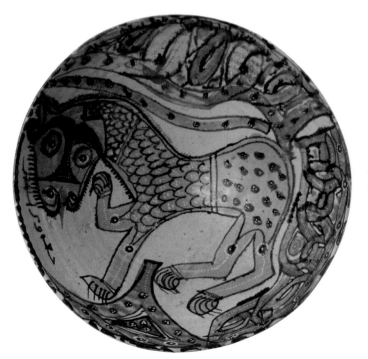

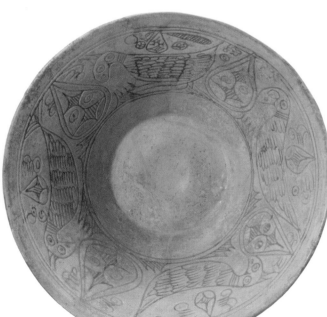

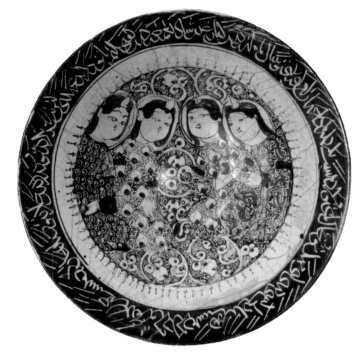

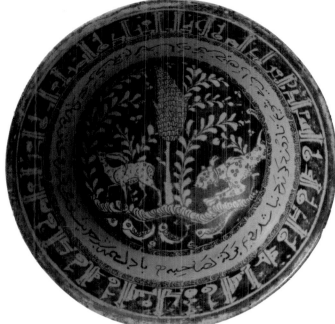

Far left: Lustre-painted dish with four seated figures. Iran, Kashan, early 13th century.

Left: Lustre-painted conical bowl with a leopard stalking a gazelle in a landscape. Kashan, 13th century.

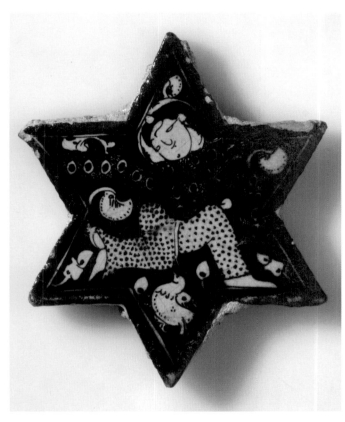

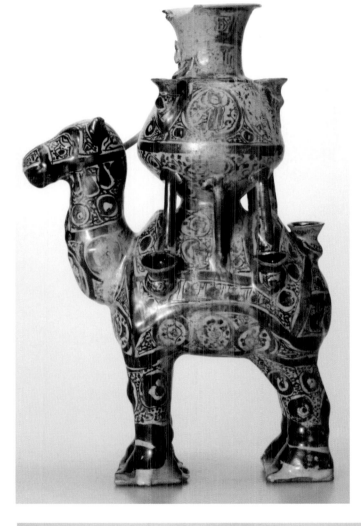

Far left: Star-shaped, lustre-painted tile with figure of a dancer. Iran, Kashan, early 13th century.

Left: Lustre-painted figurine of a camel. Iran, Kashan, 13th century.

may have its roots in the Sasanian past of Khurasan, in the myths and folklore of Iran and Central Asia, or in local codes of chivalry.

Other types of pottery were also produced in Khurasan during this period, including 'Nishapur buff ware' and *sgraffiato* ware (from the Italian verb, 'to scratch'). *Sgraffiato* ware typically has a reddish body, with a white or cream slip through which designs were incised. Sometimes the technique was combined with coloured glazes. In the pottery type known as 'plain *sgraffiato* ware' a light-coloured body was used, giving a more subtle effect in which the incisions are less prominent. Meanwhile the Mazanderan region of northern Iran, around the Caspian littoral, produced a more provincial, though none-the-less distinctive style of pottery, decorated with expressively rendered birds and animals. Monochrome-glazed wares from this period and later show the influence of Sasanian and pre-Islamic Central Asian prototypes in their iconography; the form of these objects sometimes suggests the influence of metalwork.

Great developments in pottery production occurred under the Seljuks in Iran during the 12th and 13th centuries, most importantly with the introduction of fritware (or 'stonepaste pottery'), which was probably developed at Kashan, although later it seems to have been

Below: Interior of a fragment of a *mina'i*-ware bowl, decorated with scenes from the *Shahname*. Iran, 12th or 13th century.

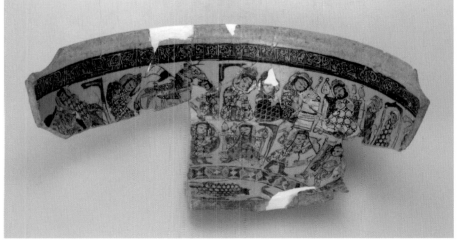

produced throughout Iran. Fritware has a hard white body, which is composed of quartz, white clay and glaze frit (itself a mixture of ground quartz and soda heated until partially fused); it was frequently formed in

Right: Underglaze-painted figurine of a seated man, identified on his hat as Sultan Tughril; perhaps a chess piece. Iran, Kashan, late 13th century.

Far right: *Mina'i*-ware bottle with seated figures and horsemen in medallions. Iran, Kashan, late 12th or 13th century.

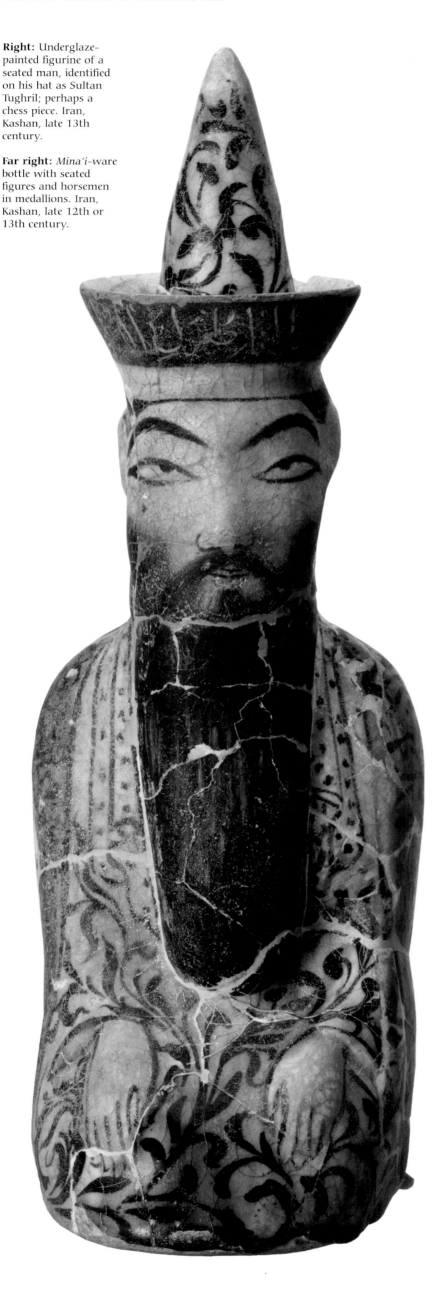

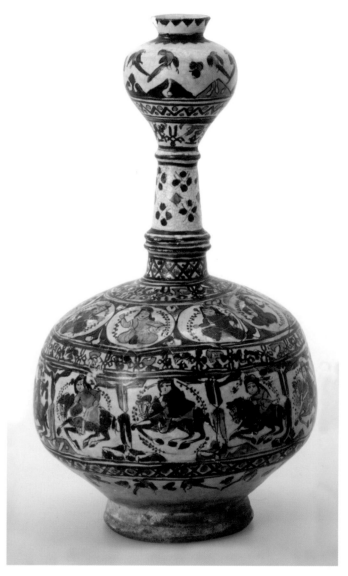

moulds. The technique facilitated the production of finer shapes and thinner walls than had previously been common. Furthermore, as the glaze used on fritware was made of similar compounds to the body material itself, it adhered much better than to the earthenware bodies of earlier periods.

A range of fritware objects was produced, with a variety of decorative techniques, including monochrome-glazed wares and monochrome lustre-painted objects. Bowls, vases, jugs and other vessels were made, with designs ranging from decorative floral and geometric patterns to complex figural and narrative schemes, sometimes recognizable as scenes from Persian epics. The development of this style may be divided into an early period (known as the 'Rayy Period'), in which examples are closer to Fatimid wares in their balance between

clearly defined designs and the solid lustre ground; and a mature or later period (known as the 'Kashan Period'), in which the relationship between background and motif becomes considerably more complex. Lustre tiles of various shapes were also produced and used in friezes or panels, including the decoration of *mihrabs*. A number of sculptural pieces have also survived, including small objects in the form of buildings, and human and animal figures which range from the small to the monumental.

That Kashan was, and continued to be, the major production centre of pottery during the Seljuk (and even into the Mongol) period is confirmed by the number of pieces bearing the signatures of the artists who produced them, ending with the epithet al-Kashani ('of Kashan'); and by a treatise on pottery written by Abu'l-Qasim al-Kashani, from one of the preeminent families of Kashani potters, completed in 1301.

The late 12th century saw the development in Seljuk Iran of enamel ware, known as *mina'i* or *haft rang* (meaning 'seven colour'). The production of this sump-

Right: Underglaze-painted double-shell or 'reticulated' jug, decorated with animals, harpies and sphinxes in a waterweed pattern. Iran, c. 1215.

Below: Underglaze-painted bottle with slip-carved stripes. Iran, 12th century.

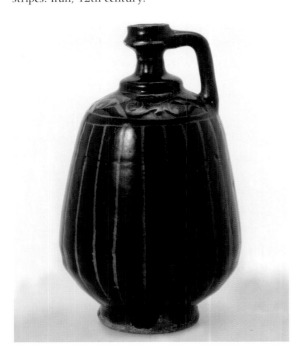

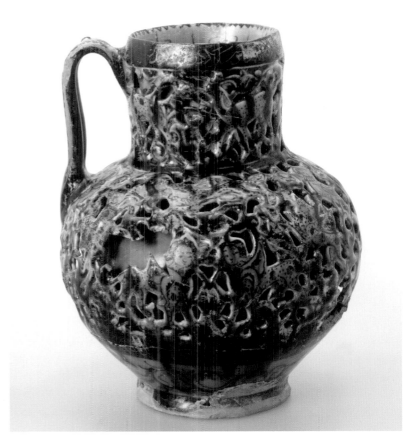

Right: Underglaze-painted jar with 'waterweed' scroll. Iran, 13th century.

Far right: *Mina'i*-ware bowl with royal couple seated under a tree. Iran, 12th or 13th century.

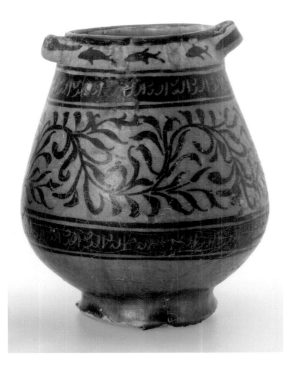

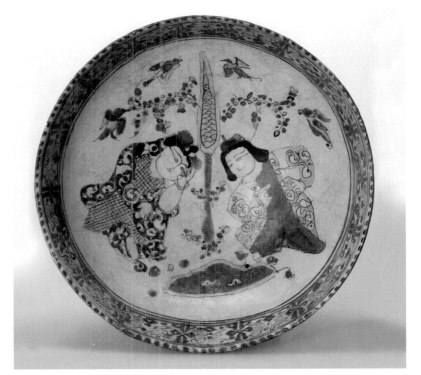

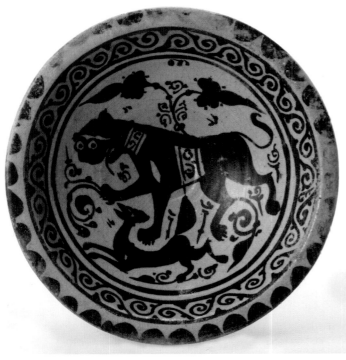

Above: 'Tell Minis'-ware dish with lustre-painted lion. Syria, 12th century.

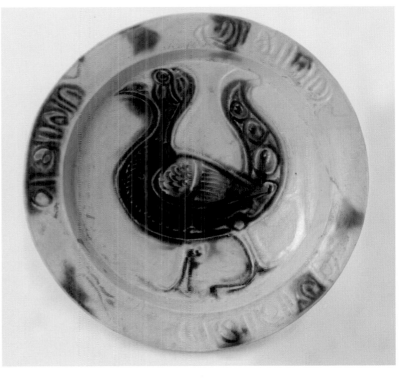

Above: *Laqabi*-ware dish with the figure of a bird. Syria, 12th century.

tuous polychrome ware involved two firings, with decoration applied both under and over a colourless or pale-blue glaze. Gilding was sometimes used to enhance the decoration. As with lustre-painted pottery, figural designs are common on *mina'i* ware. These may have parallels with large-scale figural wall paintings of the period, which are now lost. Geometric and floral designs are also found. *Mina'i* pottery was also produced in Anatolia, and *mina'i* tilework was used on the Anatolian Seljuk palace of Kubadabad near Konya.

Underglaze-painted wares were also produced by the potters of Seljuk Iran, featuring abstract floral designs – in particular the distinctive 'waterweed' scroll – and elaborate figural compositions. These designs may be in black on a white ground, under a colourless or turquoise glaze; the black is sometimes combined with cobalt blue, and *sgraffiato* may also be used. The most spectacular types, however, are double-shelled vessels where parts of the outer wall have been cut away, leaving an openwork pattern through which the inner vessel can be seen. Examples of this 'reticulated pottery' are extremely rare: two of the finest are the Macy Jug in the Metropolitan Museum of Art, New York, and a comparable piece in the Khalili Collection.

The manufacture of stonepaste pottery with lustre decoration had also spread to Ayyubid Syria by the 12th century. The best-known types include 'Tell Minis ware', named after an alleged find-site between Hama and Aleppo; and 'Raqqa ware', produced at Raqqa and other sites on the Euphrates. The quality of the hard, pure white body of Tell Minis pottery is particularly fine; that of Raqqa ware is usually yellowish or greenish, and is somewhat more friable. In both types lustre painting was the most popular form of decoration, although underglaze painting and relief moulding are also common in Raqqa ware.

Polychrome carved pottery or *laqabi* ware is also thought to have been produced in Syria during the 12th century. Painted decoration in different colours is combined with areas of carved decoration, the latter helping to prevent the colours from running into one another. *Laqabi* ware is typically decorated with a single animal figure, a bird being the most common motif.

Pottery manufacture in Iran continued under the Ilkhanids. Sultanabad ware, named after a site in northwest Iran at which it was first discovered, dates from the first half of the 14th century, and was probably made at Kashan. Its vegetal ornament is notably less stylized than that of earlier periods, and typically provides a background to birds or phoenixes. Occasionally two levels of greyish slip were used, resulting in a unique surface texture which creates an illusion of spatial recession. The pottery known as *lajvardina* (meaning 'from lapis lazuli') also dates from the beginning of the 14th century, and is characterized by its cobalt-blue glaze.

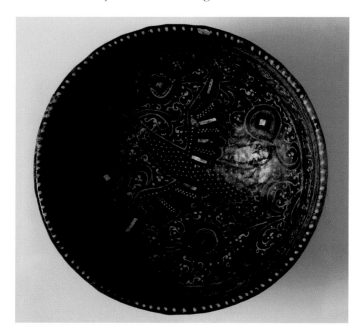

Left: Small *lajvardina* bowl. Iran, dated 1376.

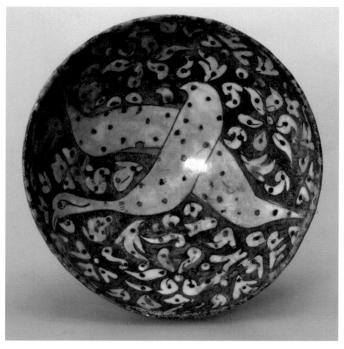

Left: Sultanabad-ware dish. Iran, 14th century.

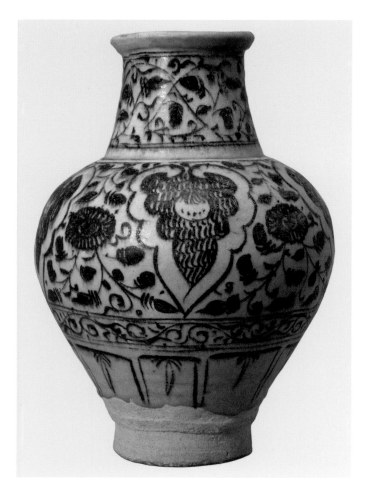

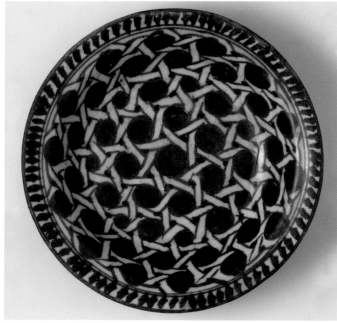

Far left: Large Mamluk underglaze-painted jar or vase. Egypt or Syria, 15th century.

Left: Mamluk underglaze-painted plate. Egypt or Syria, late 13th–14th century.

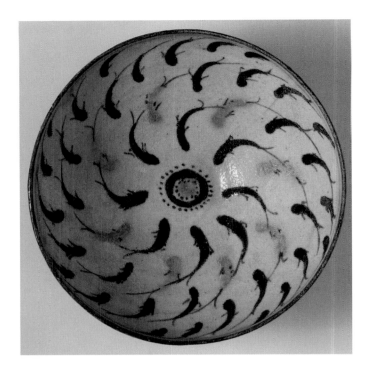

strength in cursive designs, such as arabesques, floral sprays and *thulth* inscriptions; for massive exterior inscriptions, an arrangement of glazed bricks known as *banna'i* was often used.

In Iran during the Safavid period, Kirman emerged as a major production centre of pottery. Kirman wares are characterized by decoration in cobalt blue and brownish-red under a clear glaze. A distinctive type of flower vase produced in Kirman features an opening for each individual flower stem; this form is also found in earlier Iranian pottery. During the Safavid period it was exported to Europe, where it came to influence Delft tulip vases of the late 17th century. Blue-and-white wares were produced at a number of sites including Kirman, Mashhad and Yazd; those from Kirman sometimes feature sprays of blue flowers reminiscent of 15th-century blue-and-white pottery, while the drawing on examples from Mashhad appears much closer to Chinese prototypes. Lustreware was also produced under the Safavids, characterized by a hard, thin body and a rather thick, greenish glaze, decorated with predominantly floral motifs and scrollwork. Tiles were also made for large decorative panels, sometimes including figural elements.

'Kubachi' wares were produced from the 15th to the 17th centuries in northwest Iran, probably at Tabriz, and include bowls and other large vessels with an outturned rim. They are named after the village in Daghestan where many examples had been collected, and it has been suggested that they were acquired with the proceeds of the trade in arms and armour from this region of the Caucasus. Kubachi wares are typically covered with a white slip; decoration may be in black under a turquoise or greenish glaze, or in blue and white.

Left: Underglaze-painted bowl. Iran, 14th century.

Underglaze-painted pottery was still produced in Iran during the Timurid period but it is the spectacular tile-work decorating the architecture of Iran and Central Asia, sheathing domes, façades and minarets in a glittering shell, which is among the finest ceramic production of the 15th century. A variety of techniques were employed in this decoration, including underglaze-painted tiles, *cuerda seca*, mosaic-faience (a patterned arrangement of closely fitted, small pieces of tile with different coloured glazes), and inset technique (in which patterns are composed of a series of 'plaques', themselves made up of mosaic-faience, *cuerda seca*, etc.) Mosaic-faience reveals its greatest

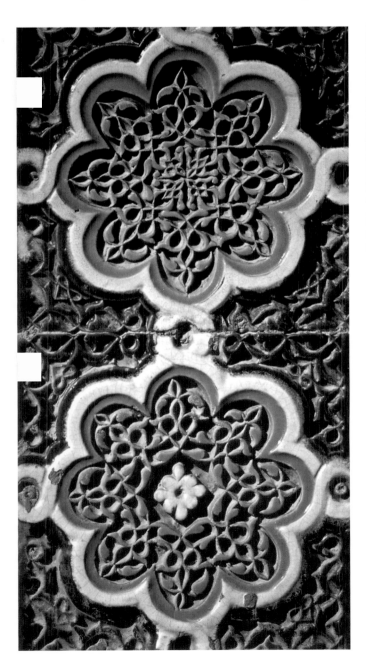

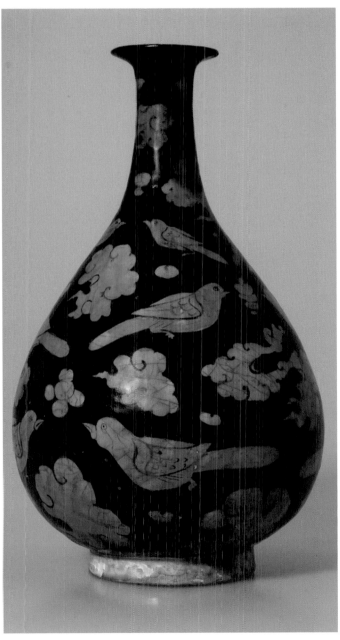

Far left: Timurid carved terracotta tiles. Iran, 15th century.

Left: Underglaze-painted jug. Iran or Central Asia, second half 15th–early 16th century.

'Gombroon' ware (named after the port on the Persian Gulf from which it was exported to Europe, the modern Bandar-i 'Abbas) was produced from the 17th to the 19th centuries. It has a particularly thin white body, which in some examples appears almost translucent, and features painted decoration in blue and black together with pierced openwork.

The revivalist movement of the second half of the 19th century in Qajar Iran saw the imitation of types of pottery that had gone out of fashion or even ceased production altogether, such as lustreware. Perhaps the greatest exponent of Qajar lustre was 'Ali Muhammad of Isfahan, who moved to Tehran in 1884. In other types of pottery, figures are depicted in a painterly style. Tilework panels were also produced.

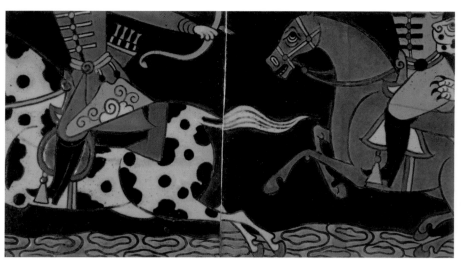

Above: Two Safavid *cuerda seca* tiles. Iran, 17th century.

Far left: Safavid blue-and-white plate. Iran, late 16th century.

Left: Kubachi-ware plate. Iran, 17th century.

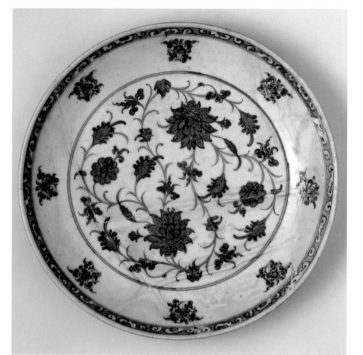

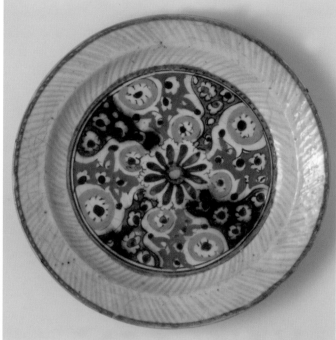

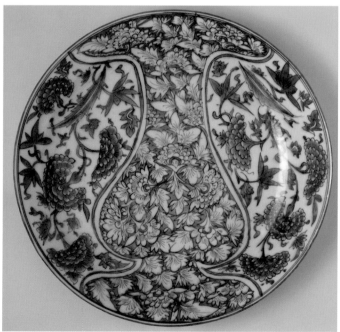

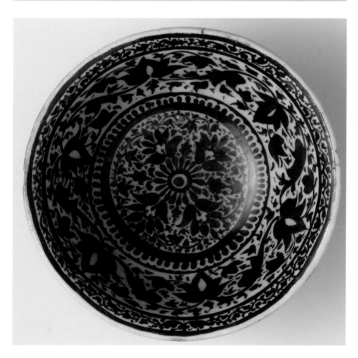

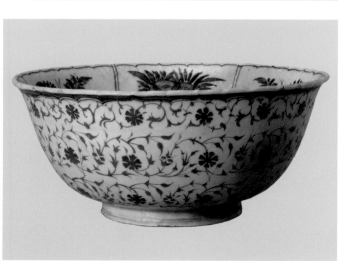

Above left: Large Safavid blue-and-white plate. Iran, 17th century.

Above right: Lustre-painted bowl, perhaps from the workshop of 'Ali Muhammad. Iran, second half 19th century.

Left: Large underglaze-painted bowl. Iran, Kirman, 17th century.

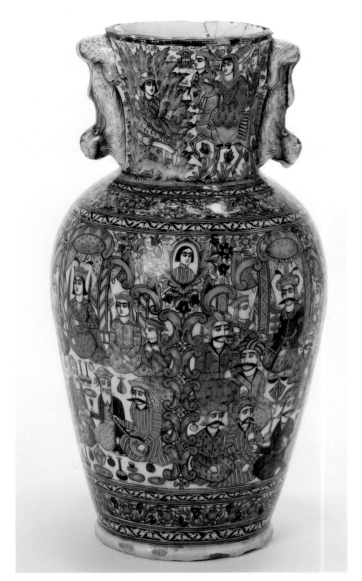

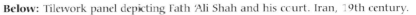

Below: Tilework panel depicting Fath 'Ali Shah and his court. Iran, 19th century.

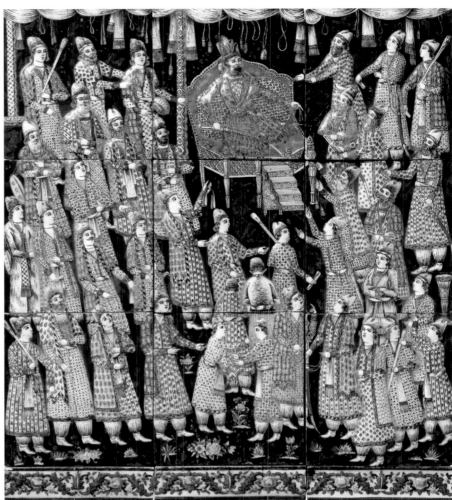

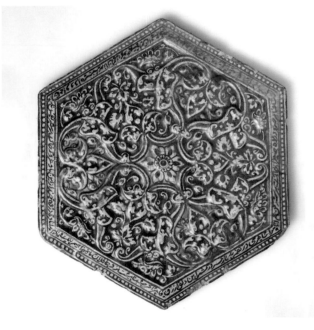

Above left: Under-glaze-painted vase with court scenes. Iran, Tehran, late 19th century.

Left: Hexagonal lustre-painted tile. Iran, Tehran, second half 19th century.

The interiors of many Ottoman mosques are well-known for their beautiful tile decoration. Superb mosaic and polychrome *cuerda seca* tiles decorate the early 15th-century interior of the Yeşil Cami or Green Mosque and Tomb at Bursa (1412–24), and *cuerda seca* tiles appeared in other buildings in Bursa and Edirne until the 1470s. Similarities between these and *cuerda seca* tilework in Samarqand have led to this style being termed 'International Timurid'. The city of Tabriz, in northwest Iran, appears to provide the link between Ottoman Turkey and Timurid Central Asia: Tabrizi craftsmen were taken back to Samarqand by Timur in 1402 and are known to have worked on the Green Mosque (the *mihrab* of the mosque is signed 'the masters of Tabriz'). By the mid-15th century the reddish body material of the tiles at Bursa had been superseded by the white body of those at the Muradiye Mosque in Edirne. Red body material was also used in

the pottery known as Miletus ware, which was made at Miletus and Iznik during the early 16th century.

Perhaps the most familiar aspect of Ottoman art is the pottery and tiles produced at Iznik in western Anatolia, and later at Kütahya, known as 'Iznik' pottery. Iznik wares are characterized by their rich, deep colours offset against a brilliant white ground. The hard white body of Iznik ware was overlaid with an additional wash of white body material; designs were then painted over this, and finally a shiny, transparent glaze was applied.

The earliest Iznik pieces are fine blue-and-white wares, decorated with chinoiserie and arabesques, dating from the last quarter of the 15th century. From the 16th century floral designs predominated, including carnations, *saz* (a serrated leaf, derived from the reed), roses and, especially during the second half of the 16th century, tulips. A distinctive group with thin blue floral scrolls is known as 'Golden Horn ware'. The most common colours on Iznik pottery are deep blues and greens, aubergine, and later a strikingly bright red (made from bole) which stands up in slight relief under the glaze. During the late 16th and early 17th centuries, a distinctive group of Iznik jugs and tankards were decorated with fleets of ships. Sometimes, but comparatively rarely, animal grotesques of a type associated with those found in Armenian gospels appear in the decorative repertoire of Iznik pottery.

In architectural decoration, Iznik tiles superseded the International Timurid style during the 16th century, and gradually tile production came to surpass pottery in terms of workmanship. Large-scale panels of square or rectangular tiles, with elaborate floral schemes, were produced. Some of the finest Ottoman tiles are to be found in the mosques of Rüstem Paşa (Istanbul, c. 1561–2) and Sokollu Mehmed Paşa (Kadırga, Istanbul, 1571–2).

During the 1550s, when Süleyman the Magnificent ordered the restoration of the Dome of the Rock in

Right: Ottoman underglaze-painted flask with repeated floral sprays. Turkey, Iznik, c. 1560–80.

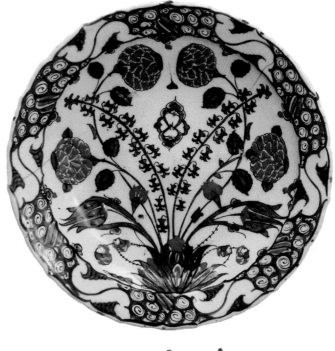

Left: Ottoman underglaze-painted dish with symmetrical floral design. Turkey, Iznik, later 16th century.

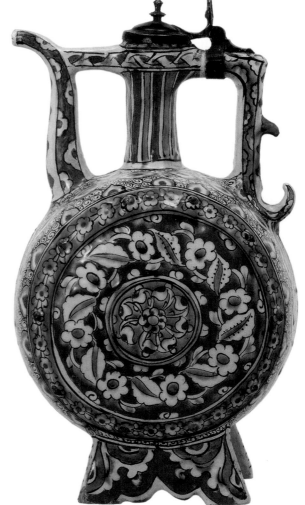

Left: Ottoman underglaze-painted ewer. Turkey, Iznik, 17th century.

Far left: Ottoman underglaze-painted tile from a decorative panel. Turkey, Iznik, c. 1570–80.

Left: Ottoman underglaze-painted tile from a decorative panel. Turkey, Iznik, later 16th century.

Jerusalem, *cuerda seca* tiles were fired on site under the direction of one Abdallah al-Tabrizi. Syria was also an important production centre for Ottoman pottery, in particular Damascus. From the late 1560s, tiles produced in Damascus featured a characteristic palette of blue, turquoise, bright green and manganese purple; the bole red of Iznik and Kütahya wares is notably absent. Damascus pottery followed the distinctive palette set by its tiles, but in quality was markedly inferior to Iznik and Kütahya wares.

During the 18th and 19th centuries the town of Çanakkale in western Anatolia emerged as an important provincial centre for the production of Ottoman pottery. Çanakkale pottery was made from a coarse local clay, and decorated with coloured slips under a yellowish glaze. A variety of white wares were produced in Istanbul during the 19th century, including stamped pottery and moulded porcelain.

Tin-glazed pottery and other wares were produced in Morocco well into the 19th and even 20th centuries. A number were brought back to France by the painter Eugène Delacroix, who visited Morocco in the 1830s.

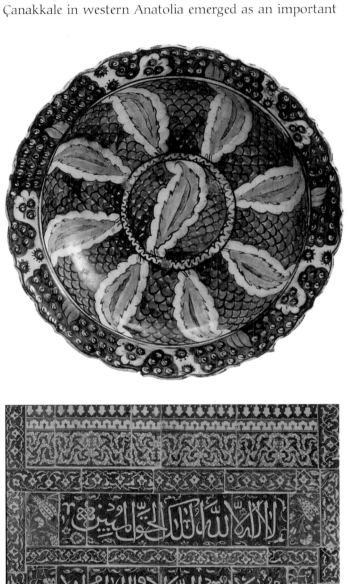

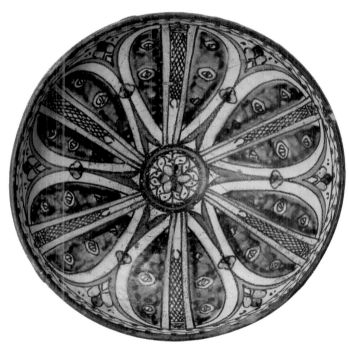

Top left: Ottoman underglaze-painted dish with *saz* leaves. Syria, Damascus, later 16th or 17th century.

Left: Large Ottoman underglaze-painted tile panel. Syria, Damascus, later 16th or 17th century.

Top right: Ottoman glazed earthenware bowl with splashed decoration. Turkey, Çanakkale, 19th century.

Above: Glazed earthenware bowl. Morocco, Fez, early or mid-19th century.

Glass and Rock Crystal

As with pottery and metalwork, there is a long and highly developed tradition of glassmaking in the Middle East. Glass production had been widespread in Egypt since Pharaonic times, and in Syria the technique of glass blowing was developed during the 1st century AD. The flourishing glassmaking industries of Byzantine Syria and Sasanian Iran provided prototypes and production continued almost uninterrupted into the early Islamic period. New forms and techniques were soon developed by Islamic glassmakers, and glassmaking attained new levels of refinement.

It is particularly difficult to establish the date and provenance of glass objects. This is due not least to the fragile nature of the material itself, to which we must ascribe the loss, through breakage, of many representative pieces; and also to the fact that glass was often melted and reused. The study of glass is further complicated by the lack of documentary evidence (in the form of inscriptions on the objects themselves), and the extent to which the objects were traded across the Islamic world and beyond.

Glass objects are formed and decorated using one of two main techniques, or a combination of both: hot-worked glass is blown, shaped or moulded while molten; and cold-worked glass is cut, ground or incised with wheel-mounted tools or by hand.

Mould-blown vessels are some of the most common glass objects to have survived from the early Islamic period. The ball of molten glass (known as a 'parison' or 'gather') was inflated through a long metal tube (known as a 'blowpipe'), directly inside a patterned wooden or clay mould which left a decorative design impressed upon its surface. Moulds were of two basic types: hinged (or 'full sized'), which as well as impressing a pattern gave the final desired shape to the vessel; and cylindrical (or 'dip'), into which the parison was first blown or dipped, usually to impart a pattern, before being removed and further blown to the desired shape. The former left a deeper and more distinct pattern on the glass, while the latter technique typically resulted in some distortion of the moulded pattern. Ribbed and fluted designs are common on mould-blown vessels, but geometric and vegetal patterns are also found, and sometimes inscriptions. Plain, free-blown bottles and other vessels – which were inflated on a blowpipe without being shaped or decorated in a mould – were also produced for everyday use.

Simple 'pinched' decoration was adopted from Sasanian glass during the early Islamic period. During the 9th and 10th centuries in Egypt metal tongs with carved designs were used to impress patterns on glass vessels – a technique more suited to open shapes, such as cups or bowls. Designs included geometric and animal motifs, which were typically repeated across the surface of the vessel.

Trail-decoration, a technique developed in pre-Islamic times and very common on Byzantine glass, was popular, in particular in Syria and Egypt from the 10th century. Vessels were decorated with threads of molten glass, of the same or a contrasting colour or both, sometimes spiralling around the body of the vessel, sometimes applied in zig-zags. Thick threads were also

Square, sandwich-glass tile, with gold leaf between two layers of glass. Syria, 7th–8th century.

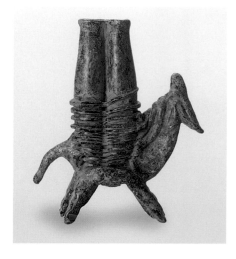

Camel-shaped flask, blown and tooled, with trail-decoration. Probably Syria, 7th–9th century.

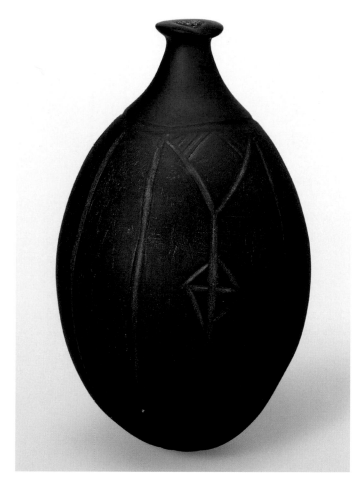

Melon-shaped bottle, free-blown with tooled and wheel-cut decoration. Iran or Iraq, 5th–early 7th century.

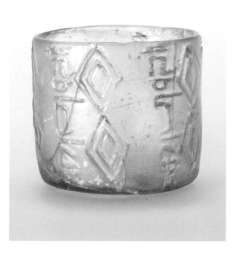

Cylindrical beaker with pincered lozenges and inscriptions; the vertical inscriptions read – from the inside of the vessel – 'Blessing to its owner.' Eastern Mediterranean, Iraq or Iran, 9th–10th century.

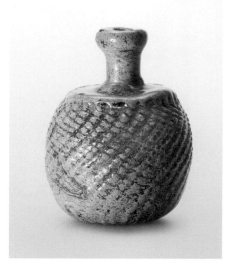

Small flask, the hobnail pattern produced in a 'dip' mould. Probably Iran, 10th–11th century.

Right: Bell-shaped flask, mould-blown and tooled. Iran or Egypt, 10th–11th century.

Far right: Long-necked flask with mould-blown, tooled and trailed decoration. Eastern Mediterranean or Iran, 11th–12th century.

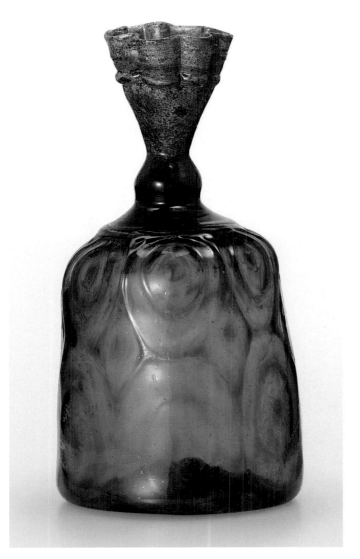

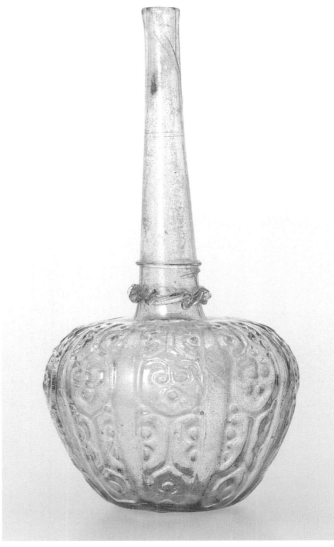

Right: Footed jug with mould-blown decoration and trailed handle with pinched thumb-rest. Iran or Iraq, 10th–11th century.

Far right: Long-necked ewer with trail-decoration. Iran or Afghanistan, 11th–early 13th century.

formed into stylized shapes, and glass discs (also adopted from Byzantine Syria) might be applied, sometimes with stamped designs. Vessels such as jugs typically have a trailed handle, sometimes with a folded or pinched thumb-rest. Free-blown vessels with an animal-shaped base and a 'cage' of wavy trailed glass have also survived.

In a variation of trail-decoration known as 'marvering', the vessel was turned against a flat stone or metal surface called a 'marver', so that the trails became flush with the vessel's surface. This type of decoration is typically in white, on a vessel of dark glass, and frequently features combed patterns created using a toothed implement. One of the most celebrated examples of marvered glass is the so-called 'Durighiello Bottle', produced in Syria during the 13th century and now in the British Museum, London.

Mosaic glass had been produced in Egypt since the 2nd millennium BC, and was later common during the Roman

Right: Long-necked flask with trail-decoration, thick glass threads tooled in the form of stylized horses, and applied discs. Iran, 12th–early 13th century.

Far right: Cylindrical beaker, lustre-painted with stylized palm branches; the inscription reads 'Drink with enjoyment and pleasure in its excellent qualities. Blessing to its owner.' Probably Egypt, 8th–9th century.

Right: Small marvered bowl with a unique double-wall construction. Egypt or Syro-Palestine coast, 13th–14th century.

Far right: Large flask with facet-cut decoration. Iran or Iraq, 9th–10th century.

Boat-shaped vessel in mosaic glass (*millefiore*). Iraq, or possibly Egypt, 8th–10th century.

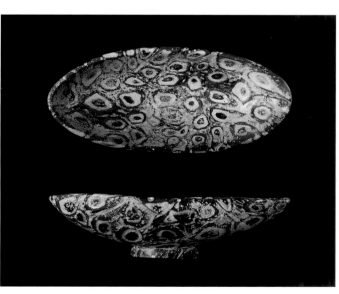

period. Under Islam, mosaic glass was popular between the 8th and 9th centuries, and a number of mosaic-glass tiles have been found at Samarra. Mosaic-glass vessels were formed from small glass discs sliced horizontally from narrow rods, themselves made from various coloured glass threads grouped vertically. These discs were arranged in a pattern, heated until they fused, and shaped in a mould. The surface was sometimes ground and polished. The technique is also known as *millefiori* (meaning 'a thousand flowers' in Italian).

Painted lustre decoration was probably developed in pre-Islamic Egypt, and its use in the Islamic period soon spread from glass to pottery with spectacular success. Designs were painted on the surface of the blown vessel

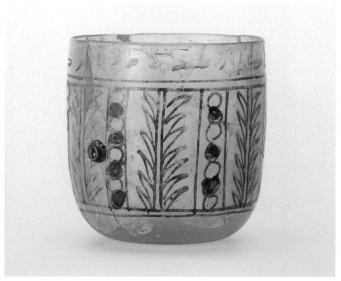

in metallic pigments containing either silver or copper, or both, and fired at a moderate temperature so that the coloured metallic film became fused with the glass itself, permanently staining it. Pale glass was favoured for vessels with lustre decoration, with monochrome designs in yellowish, brownish or reddish tones (the former two from silver, the latter from copper). Common motifs include palmette leaves and other vegetal elements, inscriptions, and bird and animal motifs.

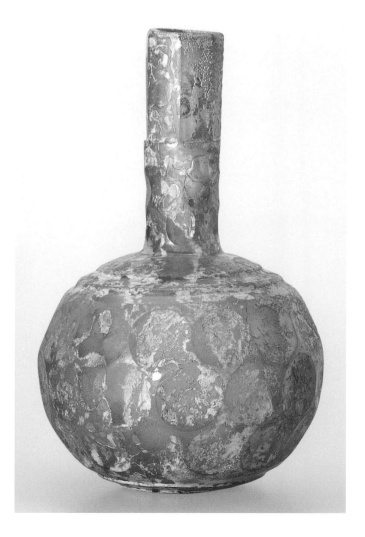

Right: Jug with bevel- and linear-cut decoration. Iraq or Iran, possibly Nishapur, 9th–10th century.

Far right: Mallet-shaped flask with linear-cut decoration, including pairs of confronted birds. Mesopotamia or Egypt, or possibly Nishapur, 10th–11th century.

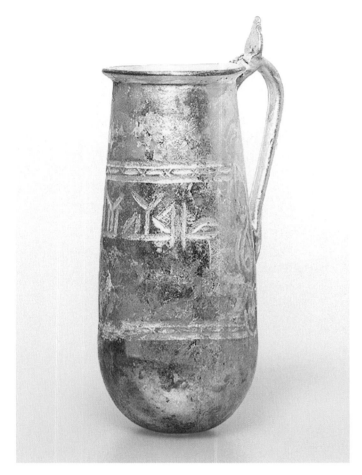

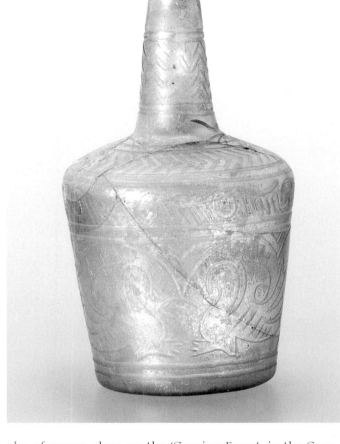

Molar flask, drilled and facet-cut. Eastern Mediterranean or Iran, 9th–11th century.

Right: 'Hedwig' beaker, with wheel-cut decoration of animals including an eagle, a griffin and a lion. Syria or Egypt, 12th–13th century.

Far right: Footed beaker with relief-cut decoration, including running ibexes. Iran or Egypt, 9th–10th century.

Early cut-glass decoration followed the faceted designs of Sasanian prototypes, but by the 9th century the ornamental repertoire had expanded to include linear-cut inscriptions, geometric and vegetal motifs, and various plants and animals. By the 10th and 11th centuries, cut-glass objects in Iran and Egypt had reached outstanding levels of refinement, and are often a technical *tour de force*. One of two main techniques was used: engraving or cutting a design into the surface of the vessel, known as hollow-cutting; or cutting the entire background away, leaving the design to stand out in high relief, known as relief-cutting. The latter, by far the more technically difficult of the two, allowed the production of some spectacular pieces decorated with highly stylized animals, either depicted individually, in groups, or in bands. The walls of relief-cut objects may be exceptionally thin in some areas (in one example in the Khalili Collection, as little as 0.1mm). Sometimes the glass vessel was dipped in a second layer of coloured glass before the background was cut away, leaving a raised design in a different colour. This is known as cameo cutting. Two well-known exam-

ples of cameo glass are the 'Corning Ewer', in the Corning Museum of Glass, New York, and the 'Buckley Ewer', in the Victoria and Albert Museum, London.

'Hedwig' beakers were probably made in Fatimid Egypt or in Syria between the 10th and the 12th centuries; they are named after the Silesian princess Saint Hedwig (1174–1245) who is said to have owned one of them. These smoky glass beakers or cups feature wheel-cut facets, highly stylized animals and geometric motifs. There is a fine example in the British Museum. Small, four-footed scent flasks were cut from blocks of glass, and a cavity drilled into the interior. These form a distinctive group of vessels, and are known as 'molar' flasks from their shape. They have been found widely across the Islamic world,

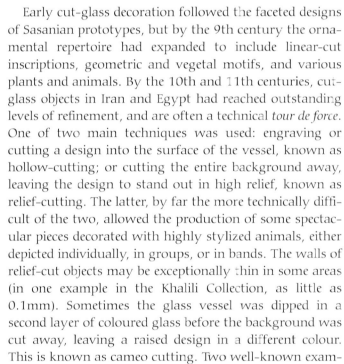

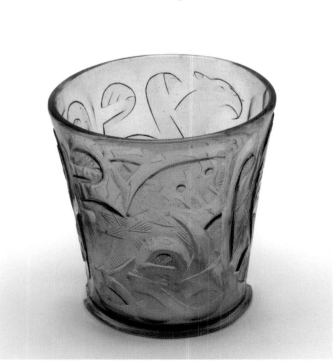

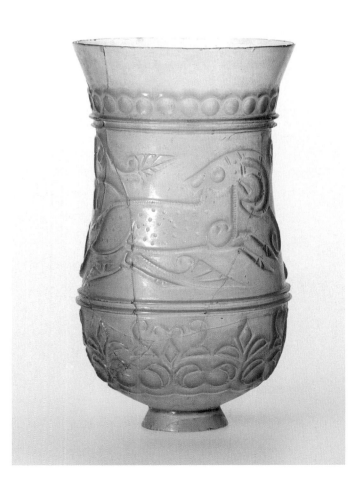

Rock Crystal

Rock crystal objects, such as a dish in the Bibliothèque Nationale, Paris, were produced in Sasanian Iran and these provided models for craftsmen during the early Islamic period. In particular Egypt, Iran and Iraq produced some superb examples of carved rock crystal during the 10th and 11th centuries. Cut from flawless blocks of quartz, these objects were decorated with acanthus leaves and other vegetal designs, together with lithe bird and animal forms, and included ewers, lamps, seals and even chess pieces. Many pieces later found their way into church treasuries in Europe, where they were often remounted and incorporated into reliquaries and ecclesiastical vessels. There are some exceptionally fine examples in the Hermitage Museum, St Petersburg, in the Victoria and Albert Museum, London, and in the Treasury of San Marco, Venice. Many cut-glass objects resemble rock crystal.

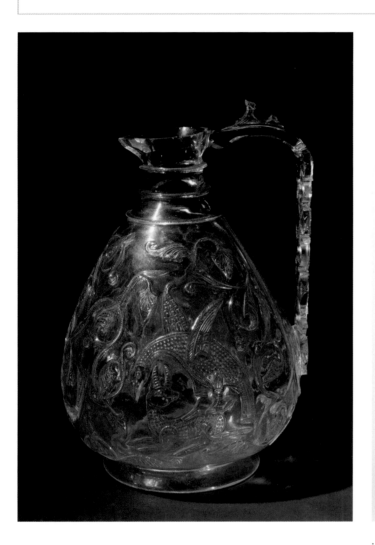

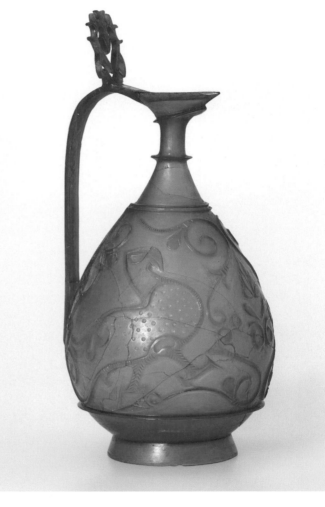

Far left: Rock-crystal ewer with relief-cut decoration, including birds of prey attacking gazelles. Egypt, early 11th century.

Left: Pear-shaped ewer with relief-cut decoration, including confronted birds of prey. Iran or Egypt, late 10th–early 11th century.

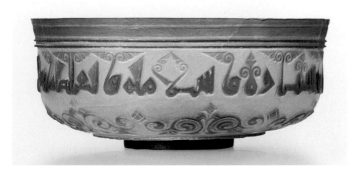

Far left: Large, footed bowl with relief-cut decoration in cameo technique, including a benedictory inscription. Iran or Egypt, 10th–11th century.

including Egypt, Iraq and Iran; their production is often attributed to the 9th and 10th centuries.

The technique of decorating glass objects with gold and enamels was developed in Syria and Egypt. Gilded glass has survived from the first half of the 12th century, when northern Syria was under Zangid rule, and the technique had reached a considerable level of refinement by the end of the Ayyubid period (1171–1260). One of the best-known pieces is the 'Luck of Edenhall', a 13th-century gilded and enamelled drinking glass with a flared rim, now in the Victoria and Albert Museum; another spectacular piece from the late 13th century, known as the 'Cavour Vase', is in the Museum of Islamic Art, Qatar. However, it was perhaps in the superb examples of gilded and enamelled glass from Mamluk Egypt that the technique reached its apogee. Clear glass was first gilded and decorated with coloured glass paste, and then heated, causing the enamels to fuse to the surface and leaving the decoration to stand out in relief against the flat gilding. The technique requires exceptional skill, as the gilding and the various enamels fuse to the glass vessel at different temperatures. Among those gilded and enamelled glass objects which have survived, mosque lamps are particularly impressive; beakers, bottles and pilgrim flasks – the shape of which derives from the leather water flasks used by medieval travellers – were also produced. The decorative repertoire on these objects includes bold calligraphy, figural representations and geometric motifs which find a parallel in the illuminated frontispieces of Mamluk Qur'ans.

Flask with gilded and enamelled decoration, including human figures, pelicans, and medallions with interlace patterns. Syria, mid-13th century.

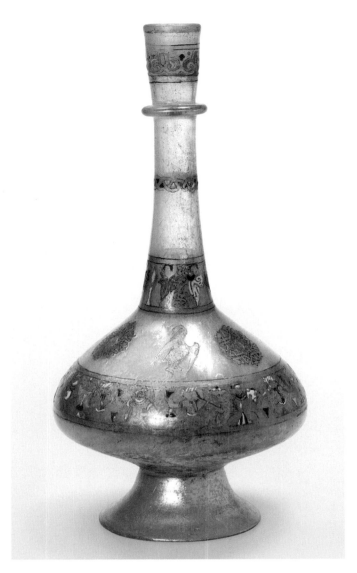

By the later Mamluk period enamelled glass was no longer produced, and glassmaking largely went into a decline after the 15th century, in part the result of increased imports from Venice. However, some glass was made in the Middle and Near East during the Ottoman and Safavid periods, and in Mughal India too. Notable are the rosewater sprinklers from late Safavid and Qajar Iran. These mould-blown vessels are typically in blue glass, and have long, slender and curving necks. Gilded and enamelled glass was produced in Mughal India, where elegant wheel-cut decoration was also applied to vessels. There is a fine example of such wheel-cut decoration in the Cleveland Museum of Art. New shapes during the later period included the *huqqa* or water pipe, which appeared following the introduction of tobacco.

During the 19th century, enamelled glass in the Mamluk style was produced in Austria, Bohemia and France, both for the European market and for export to the Islamic world itself. One of the most highly skilled European glassmakers producing objects inspired by medieval Islamic glass was Philippe-Joseph Brocard of Paris. At the same time, European influence was often apparent in glass produced in the Islamic lands themselves, and at least one 19th-century Ottoman glassmaker is known to have trained in Vienna.

Three stacking beakers with gilded and enamelled decoration. Syria or Egypt, mid-13th century.

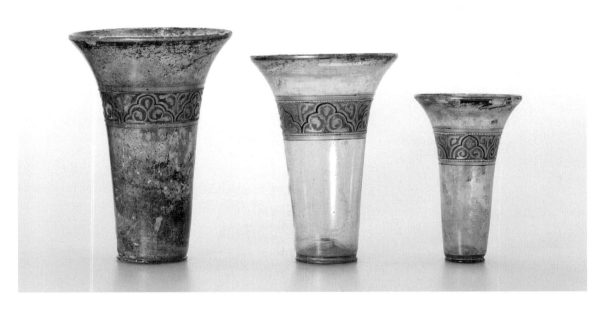

Right: Case bottle (a square shape derived from Dutch gin bottles) with gilded and enamelled decoration. India, 18th century.

Far right: *Huqqa* (water pipe) base with gilded and enamelled decoration. India, 18th or early 19th century.

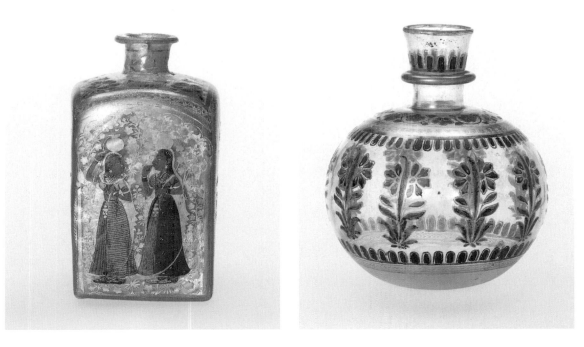

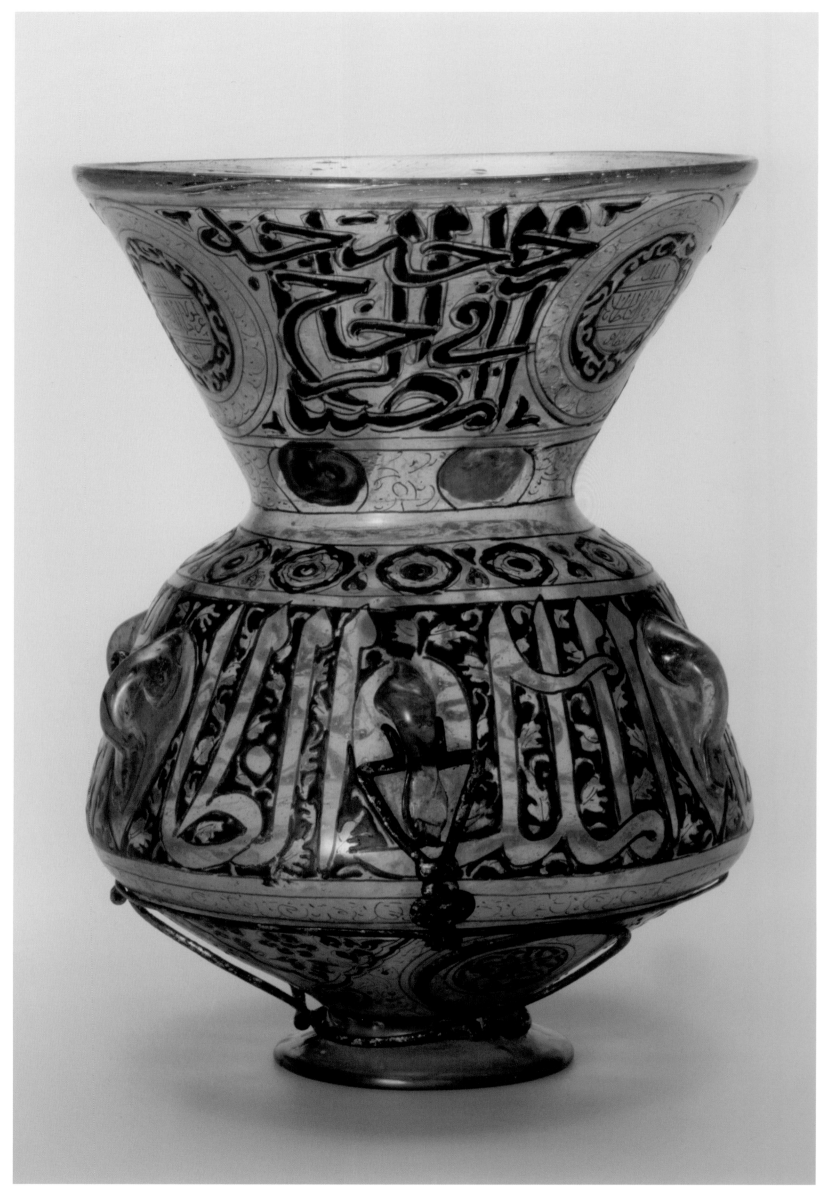

Mosque lamp with gilded and enamelled decoration, including blazons of the Mamluk Sultan Barquq and a
Qur'anic inscription, the 'Verse of Light', taken from *sura* XXIV. Egypt, c. 1385.

Right: Rosewater
sprinkler with gilt
filigree mounts.
Ottoman Turkey,
18th century.

Far right: Swan-
necked flask with
pattern-moulded
decoration. Iran,
probably Shiraz,
18th or 19th
century.

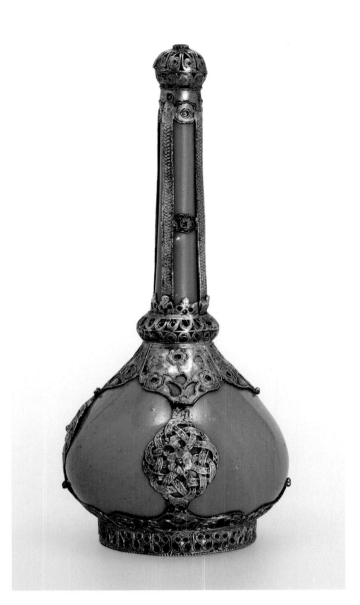

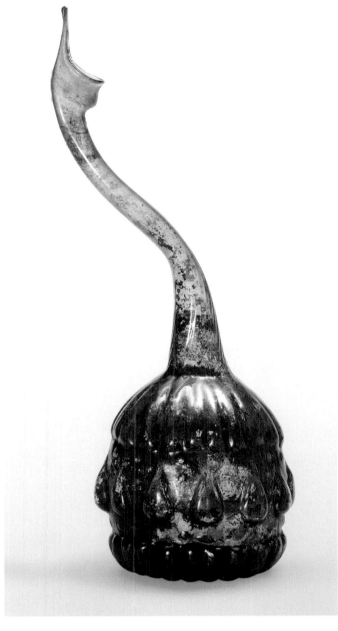

Right: Mosque
lamp and
suspension ball
with gilded and
enamelled
decoration, made
for the Egyptian
Khedive ʾAbbas
Hilmi II. Austria or
Bohemia, 1910.

Far right:
Amphora-shaped
vase with gilded
and enamelled
decoration, by
Philippe-Joseph
Brocard. Paris,
France, 1874.

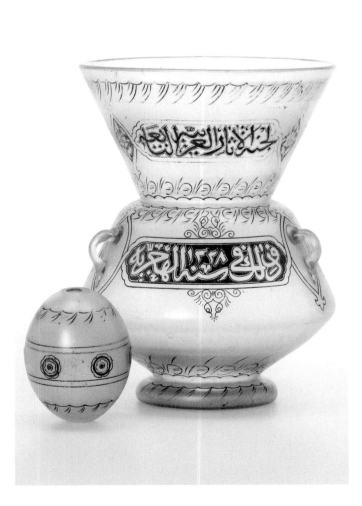

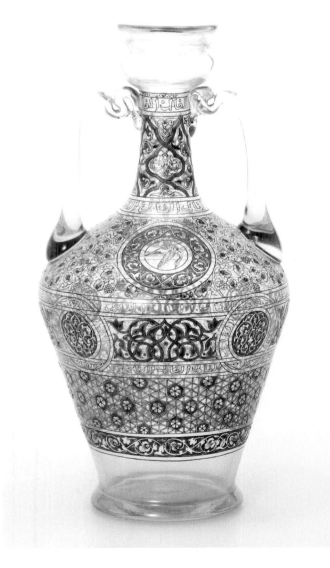

Metalwork

Metalwork has a long and distinguished tradition in the Middle East, stretching back to bronzes made in Luristan in western Iran (2nd to 1st millennium BC), and encompassing the fine silver vessels of Byzantine Syria and Sasanian Iran. The eastern Mediterranean was an important producer of metalwork for the Roman and later the Byzantine empires; and Egyptian metalwork was exported as far afield as England, where one Egyptian-made piece forms a part of the Sutton Hoo treasure. Many of the metals used were mined within the region, the mineral wealth of Khurasan being particularly rich.

The study of metalwork is complicated by the fact that metal objects (and in particular those made of precious metals) were often melted down and re-used – which obviously affects what has survived to the present day.

As in pottery, there was a great deal of continuity from late Sasanian metalwork into the early Islamic period. Following the Islamic conquest of Iran, metalwork was taken back to Damascus and Baghdad as booty, and work was commissioned from local craftsmen by their new Arab governors. Quite probably the same craftsmen continued to work for these new rulers, who in turn adopted many aspects of local artistic taste. As a result, it is often hard to distinguish between Sasanian and early Islamic pieces – not least because the forms of the earlier objects were deliberately imitated.

The earliest dated piece of Islamic metalwork is an aquamanile (water pourer) in the form of a bird, now in the Hermitage Museum, St Petersburg. It is of copper alloy inlaid with silver and copper, and was discovered in the north Caucasus. Although its form is clearly related to Sasanian prototypes, the complex ornamentation applied to much of the surface, with no obvious connection to the form of the bird itself, and the inscription around its neck, are distinctly Islamic. The inscription dates the piece to 796–7.

The decoration on early Islamic metalwork is characterized by geometric and arabesque ornament, together with inscriptions in Kufic. Typically it is engraved, although some examples of inlaid decoration are known (as on the aquamanile described above). Other pieces, such as a brass ewer in the Hermitage, with a round body and a high cylindrical neck, feature openwork.

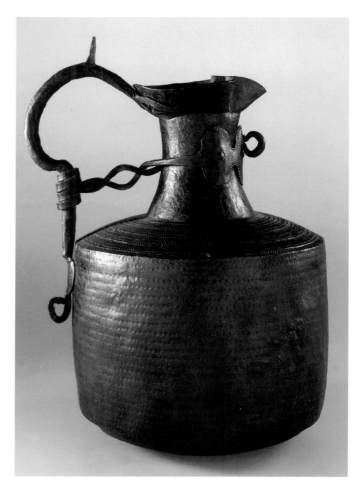

Left: Large ewer of copper alloy sheet with punched decoration. Eastern Iran, perhaps Nishapur, 9th century.

Below left: Ewer of silver with niello and traces of gilding, decorated with two griffins and a double-headed eagle. Iran or Central Asia, 7th or early 8th century.

Below: Incense-burner of copper alloy, piece-cast with openwork and engraved decoration. Syria, 8th–9th century.

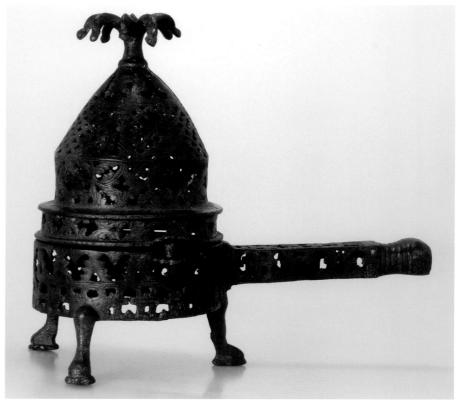

Flask of gilded silver with repoussé, chased and punched decoration and incised details. Iran, 10th–11th century.

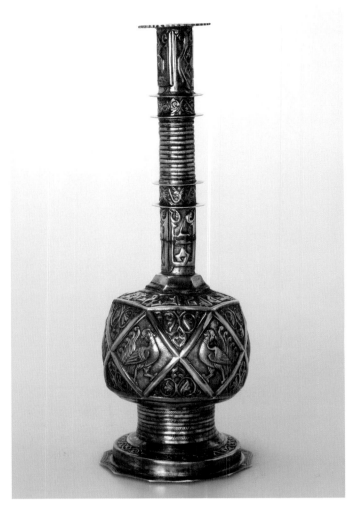

is also recorded from Fatimid Egypt. The 11th-century traveller Nasir-i Khusraw visited the Fatimid court and described the caliph's huge gold throne, which was decorated with hunting scenes and inscriptions. No such pieces have survived, however, and simpler objects in brass or copper alloy were far more common. Incense burners and aquamaniles in the form of both real and fantastic animals such as lions, birds and griffins are also known. The animals are highly stylized, with engraved decoration and, frequently, zoomorphic handles. Once again, the form of these pieces seems to derive from the animal figures of late Sasanian Iran; in their turn, these Fatimid pieces may have influenced later Romanesque metalwork in Europe.

During the 10th century Khurasan emerged as the most important metalworking region in the Islamic world. The Samanid and Ghaznavid courts, at Bukhara and Samarqand and at Ghazna respectively, were major artistic and cultural centres during this period, with access to the vast metal resources of the region. Among those objects to have survived are vessels decorated with animals such as lions and ibex, in gold, silver and silver-gilt, together with cast brass bottles decorated with almond-shaped bosses. In particular, the cities of Ghazna and Balkh (both in modern-day Afghanistan) were important silverworking centres at this time. The silversmiths of Balkh inhabited a separate quarter of the city with their own mosque, and Nasir-i Khusraw reports that Ghazna supplied silver furnishings for the Ka'ba at Mecca.

Far right: Bowl of high-tin bronze with engraved decoration. Iran, 10th–early 11th century.

Some examples of silverwork survive from the early Islamic period – dishes, ewers and other vessels, frequently with repoussé work (in which a design is beaten out from the inner surface) and parcel (partial) gilding. Flourishing trade routes, both within the Islamic lands and across Russia, resulted in examples being carried as far away as Sweden.

The richness of precious metal objects during the Abbasid period is indicated in a description made in 917 by a Byzantine diplomatic mission, of a gold and silver tree with mechanical birds, produced during the reign of the caliph al-Muqtadir (908–32). Luxurious metalwork

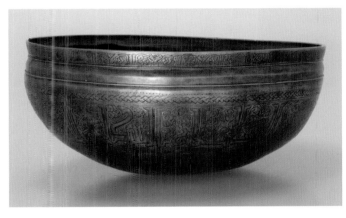

Right: Ewer of cast copper alloy with a spout in the form of a lynx's head. Iran, 12th century.

Far right: Aquamanile (water-pourer) of copper alloy, cast in the form of a goose, with traces of black compound and eyes inlaid with turquoise-glazed pottery; signed by Abu'l-Qasim ibn Muhammad al-Haravi. Iran, Khurasan, 12th century.

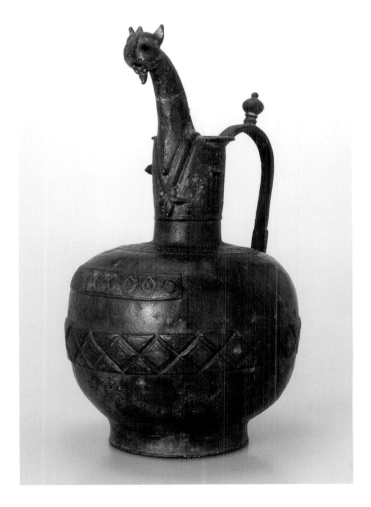

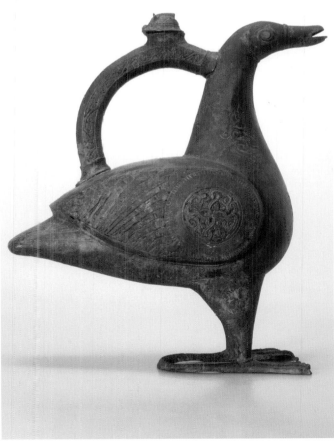

Far right: Incense-burner or pomander of copper alloy, cast in the shape of a lynx. Iran, late 12th or early 13th century.

Lidded bowl of high-tin bronze with silver-inlaid decoration, known as the Vaso Vescovali. Khurasan, possibly Herat, c. 1200.

Far right: Interior and exterior of bowl in hammered sheet silver with repoussé and chased decoration. Perhaps Anatolia, first half 13th century.

Squatting lion of cast copper alloy, probably one of the supports for a flat object such as a tray. Iran, 12th–13th century.

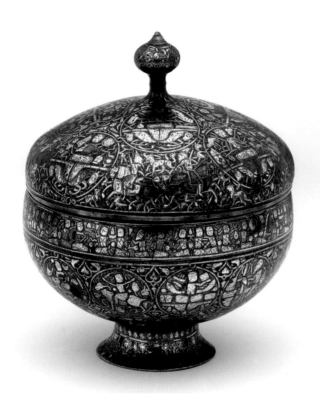

The majority of surviving examples of metalwork from 12th-century Iran are brass objects inlaid with silver, gold and copper. The technique of metal inlay had been employed by Roman, Sasanian and Chinese metal-workers, and its use had continued into the early Islamic period; now it was much more extensively employed, with an increased use of inscriptions. Inlay raised the value and status of brass objects to rival that of silver and gold pieces, and became extremely fashionable. The decorative repertoire of these objects included human and animal figures – involved in princely pursuits such as hunting, depicted at court, or representing signs of the zodiac – together with inscriptions, arabesque and vegetal ornament. According to the 13th-century cosmographer Zakariyya al-Qazvini, the centre for the production

a poisonous green patina which develops on ordinary brass and bronze. Thus it was particularly suitable for vessels used to contain food and drink. High-tin bronze can become very brittle as a result of hammering, however, and production was largely restricted to open-shaped vessels such as cups, bowls and trays. Earlier examples are often decorated with ring-and-dot ornament arranged in geometric designs, while inscriptions and arabesque feature increasingly in the decoration of later objects. Some carry figural decoration but this is rare in this material.

Mosul emerged as a prominent centre of metalwork production in the early 13th century, possibly with the arrival of craftsmen from Khurasan who had fled their

of inlaid brass was the city of Herat, which was then under Ghurid rule.

Two outstanding examples of inlaid metalwork from the 12th century are the Vaso Vescovali (now in the British Museum, London) from Khurasan, and the Bobrinsky Bucket (now in the Hermitage Museum), from Herat. Both are magnificently decorated. The former features rows of astrological symbols in human form, together with other human and animal figures, and decorative vegetal scrolls sprouting animal heads; the latter has medallions containing enthroned princes, bands of horsemen and of musicians, and inscriptions with ascenders in the form of human torsos and the terminals of some letters in the form of dragons' heads.

Some examples of inlaid brass are spectacular piece-cast works, such as an aquamanile in the form of a zebu (or cow), dated 1206, now in the Hermitage Museum. Hammered sheet brass also came to be used, possibly in an attempt to imitate fine silver wares, with engraved decoration and silver inlay.

Openwork incense burners and pomanders in the shape of felines, in particular lynxes, were a common form in 11th- and 12th-century Iran. They are typically of brass or bronze, and often have expressive facial features. Birds were another popular form for such incense burners. This type of vessel largely disappeared in the 13th century following the Mongol invasions.

High-tin bronze vessels were produced in Iran between the 10th and the 12th centuries, especially in Khurasan. High-tin bronze was valued for its rich golden colour, and for its resistance (due to the high tin content) to verdigris,

homeland in the face of the Mongol invasion. Mosul was at this time under Zangid rule, and the inscriptions on a small number of pieces state that they were made for Badr al-Din Lu'lu' (1210–59), the last Zangid vizier, who went on to rule independently. Perhaps the most spectacular piece to have survived, however, is the 'Blacas Ewer', made in 1232 and now in the British Museum. The Blacas Ewer is the only known object which categorically states that it was made at Mosul, and is signed by Shuja' ibn Man'a al-Mawsili. It was made from hammered sheet brass, and its faceted body was engraved and inlaid with silver and copper. The magnificent decoration includes scenes of court life, hunting and everyday activities, both in bands and medallions, together with fine, animated inscriptions, on a ground of small fret patterns typical of the work of Mosul. This decoration is paralleled in a silver inlaid stem-cup and a silver-inlaid brass casket with a combination lock, both in the Khalili Collection. The development of the spinning technique – in which a metal object is formed on a high-speed lathe, rather than by casting or hammering into shape – is also attributed to 13th-century Mosul.

Following the Mongol sack of Mosul in 1261, many of its metalworkers were dispersed to surrounding areas. It was thus through Mosul that developments in inlaid metalwork were passed from Khurasan to Egypt, Syria, western Iran and Asia Minor, where the signatures of many later metalworkers include the epithet al-Mawsili (meaning 'of Mosul'). Despite this interchange of developments in technique, the form of objects generally continued to follow local tradition.

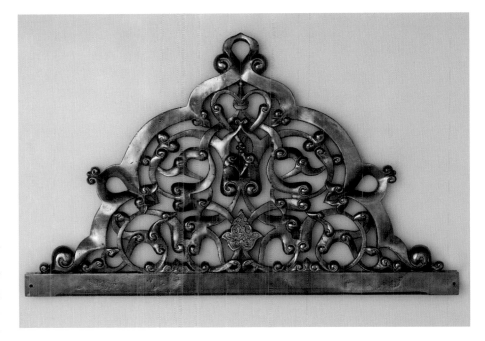

Large brass decorative attachment, cast in openwork; signed by Shakir ibn Ahmad. Jazira, probably Mosul, 13th century.

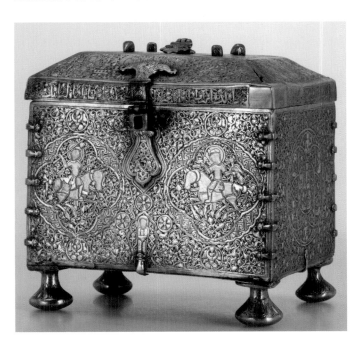

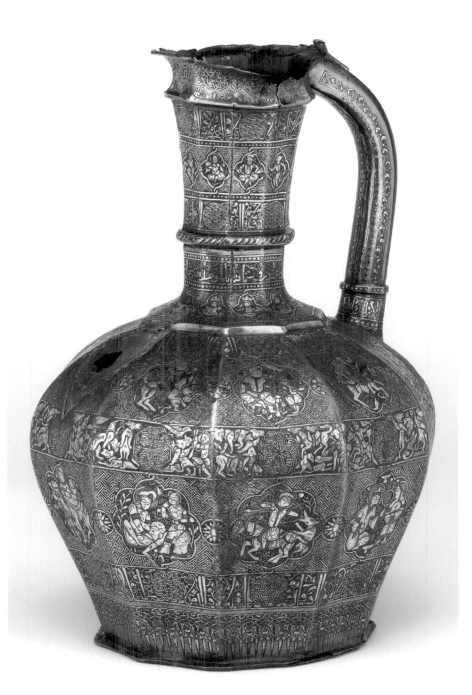

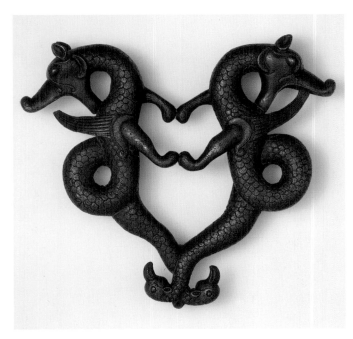

Above left: Casket of brass with silver-inlaid decoration. Jazira (northern Mesopotamia), first half 13th century.

Left: Door handle of copper alloy, cast in the form of two dragons, one of a pair. Jazira (southeast Turkey), early 13th century.

Above: Ewer of brass with silver- and copper-inlaid decoration, known as the Blacas Ewer, signed by Shuja' ibn Man'a al-Mawsili. Jazira, Mosul, 1232.

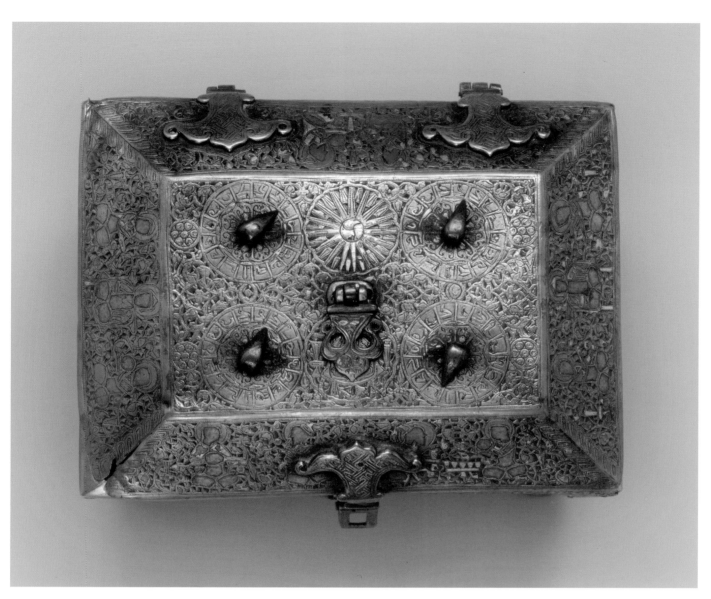

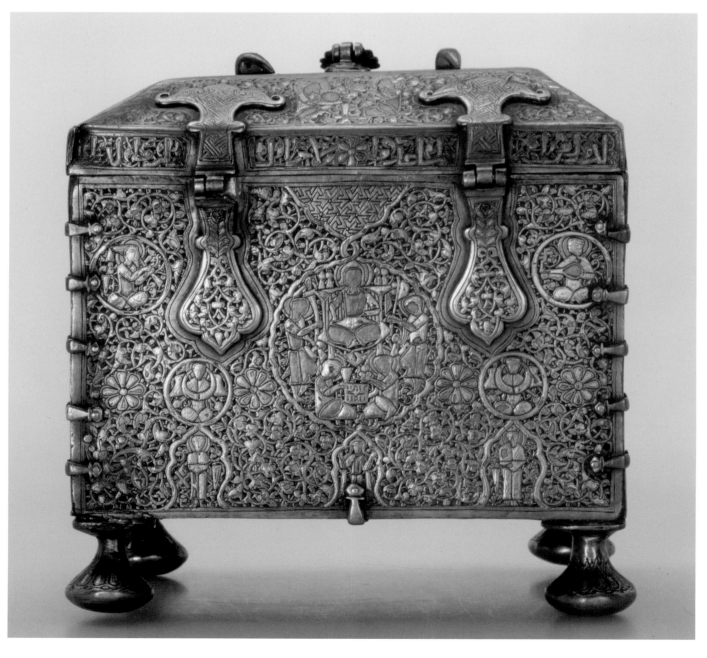

Lid and back of a casket of brass with silver-inlaid decoration, the lid with four dials from a combination lock. Jazira (northern Mesopotamia), first half 13th century.

Cast brass objects from the 13th century include some remarkable dragon-shaped door-handles from the Jazira (an area roughly corresponding to modern southeast Turkey and northern Iraq), which are described in 'The Book of Knowledge of Ingenious Mechanical Devices', written by al-Jazari in the late 12th century. A number of objects made in Syria and northern Iraq during the 13th century include Christian images. The decoration of an inlaid brass canteen in the Freer Gallery, Washington, DC, features a central roundel with a representation of the Virgin and Child, surrounded by scenes from the life of Christ, floral ornament and inscriptions. It was made in Ayyubid Syria during the mid-13th century. Such pieces may have been made for wealthy Christian patrons.

Perhaps the greatest heirs to the Mosul tradition were the Mamluks. Initially figural images featured prominently in the decoration of Mamluk metalwork, but from the end of the 13th century these were superseded by arabesques and chinoiserie elements such as lotus and peony blossoms (influenced by Ilkhanid and Chinese imports), supporting the increasingly broad and monumental inscription bands characteristic of Mamluk art. A basin in the British Museum, datable c. 1320–41, is decorated with a bold inscription band containing the name and blazon of Sultan al-Nasir Muhammad, amid lotus flowers and arabesque. The interior is decorated with swimming fish, suggesting that among other things such basins may have been used for ablutions. Although Cairo or Damascus have been established as their place of production, this and other pieces continued the style and tradition of inlaid metalwork developed at Mosul and brought to the Mamluk capital by metalworkers who had fled the Mongol invasion.

The most famous piece of metalwork produced under the Mamluks, however, is the large brass basin known as the Baptistère de St Louis. Datable c. 1290–1310, it was later used in the baptism of the kings of France, and is now in the Louvre Museum, Paris. Rather than the predominantly epigraphic decoration which became one of the hallmarks of later Mamluk art, the spectacular silver- and gold-inlaid decoration of this early piece features large medallions with mounted figures, groups of servants and amirs, and bands of running animals. It is also signed, in no fewer than six places, by Muhammad ibn al-Zayn, whose signature appears on another small basin in the Louvre.

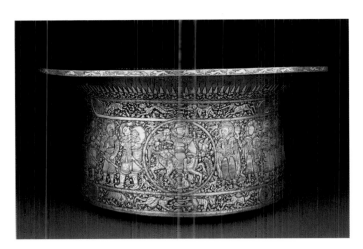

Basin of brass with silver-inlaid decoration, the so-called Baptistère de St Louis; signed in six different places by its maker, Muhammad ibn al-Zayn. Mamluk Egypt or Syria, 1290–1310.

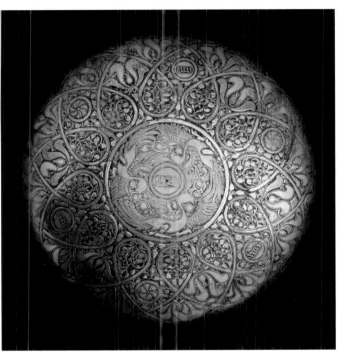

Base and side of a brass bowl with silver-inlaid decoration, bearing the name of Sultan al-Nasir Muhammad ibn Qalawun. Mamluk Egypt, early 14th century.

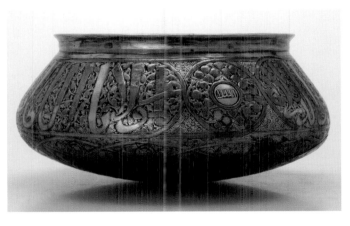

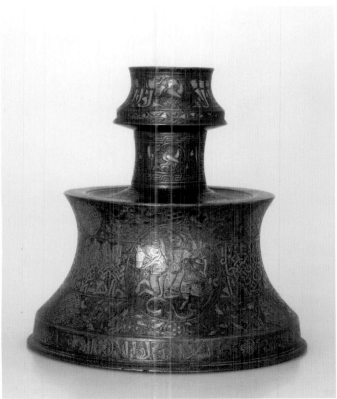

Far left: Candlestick of cast copper alloy with gold- and silver-inlaid decoration. Iran, early 14th century.

Left: Candlestick of cast copper alloy with silver-inlaid decoration. Southeastern Turkey (Siirt), late 13th–early 14th century.

Mirror of cast high-tin bronze, decorated with two dragons. Iran, late 13th–early 14th century.

Cup of silver with a dragon-shaped handle, gilded and with incised decoration. South Russia (period of the Golden Horde), late 13th–early 14th century.

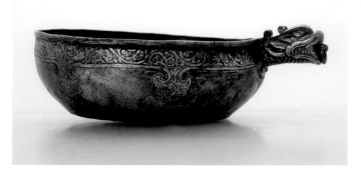

Examples of metalwork made in the Caucasus during the 14th century include large bronze or brass cauldrons with four flanges projecting from their rim. They are decorated with bold floral motifs and figural representations and are thought to have been produced in Daghestan.

The metalwork of Shiraz in the 14th century, successively under the Inju'id and Muzaffarid dynasties, is distinguished by bold inscriptions and representations of courtly scenes, with figures in the style of contemporary Persian miniatures. On later pieces the style is characterized by a degree of miniaturization, which is paralleled in 15th-century metalwork from western Iran, especially that of the master inlayer Mahmud al-Kurdi, which features inlay in fine silver wire on a field of intricately engraved arabesque and scrollwork and a hatched ground.

Far right: Candlestick of cast brass, with entwined dragons. Iran or Central Asia, 15th century.

Right: Jug of copper alloy with gold- and silver-inlaid decoration. Northeastern Iran, late 15th century.

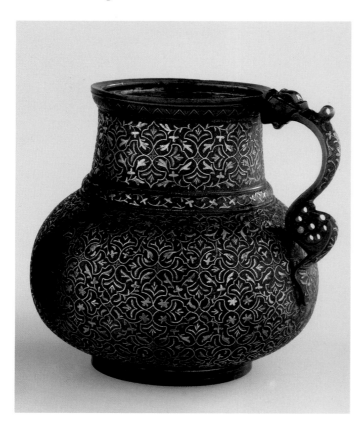

The Spanish traveller Ruy Gonzalez de Clavijo, who visited the Timurid court in 1404, wrote of a gold tree filled with birds and decorated with jewels and enamel. Sadly, as with earlier fantastic pieces described by visitors to the Abbasid and Fatimid courts, nothing like this has actually survived.

One of the most characteristic forms in 15th-century Timurid metalwork is the globular jug with a cylindrical neck and S-shaped dragon handle; the form itself is traceable to the 13th century, and is also found in jade – for example a white jade jug bearing the name of Ulugh Beg (1420–50), now in the Gulbenkian Museum, Lisbon. These and other examples of Timurid metalwork are characterized by all-over surface decoration with chinoiserie and floral scrollwork. This style, characteristic throughout the decorative arts of the Timurid period, was to prove highly influential in Ottoman Turkey and Mughal India. Another form characteristic of Timurid and Turkmen metalwork from the 14th and 15th centuries is bronze or brass candlesticks with candleholders in the form of dragons' heads. These generally have bell-shaped bases, some of which are decorated.

Among the most remarkable surviving pieces of Timurid metalwork is the huge cast bronze cauldron commissioned by Timur in 1399 for the shrine of Ahmad Yasavi at Turkistan. It has a diameter of almost 2.5m and weighs about 2 tons, and is signed 'the work of 'Abd al-'Aziz ibn Sharaf al-Din Tabrizi'. The decoration includes inscription bands and arabesque scrolls; the form, however, parallels a slightly earlier (and smaller) bronze cauldron from Herat, dated 1373/4. A number of large brass oil lamps (approximately 0.9m high) are also associated with the shrine of Ahmad Yasavi but, despite bearing the titles of Timur, their exact date and provenance remain uncertain. Three intact lamps remain in the shrine itself, while two other complete examples are now in the Hermitage. They feature silver- and gold-inlaid decoration, with inscriptions and arabesque, cartouches and various knots, and may be the work of craftsmen brought back to Samarqand following Timur's campaigns in Mamluk Syria.

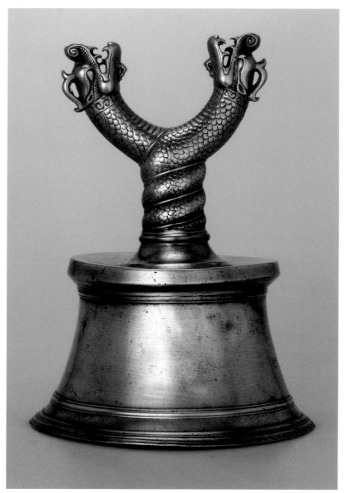

Far right: Jug or mug of silver, beaten and engraved, with chased detail. Ottoman Turkey, late 15th century.

In Safavid Iran, from the later 16th and 17th centuries brass torchstands increasingly came to replace brass candlesticks. These have a distinctive, pillar-shaped form with a faceted mid-section and a removable upper section; this was the reservoir, which could be carried separately. The decoration of these and other examples of 16th- and 17th-century Safavid metalwork features vegetal arabesque, cartouches with inscriptions in *nasta'liq* and, sometimes, figural scenes. The inscriptions include verses by Sa'di and other poets. Decoration in precious metal inlay became increasingly rare, and was largely replaced by engraved decoration.

Objects in pierced steel, ranging from the finials on military standards to various tools and other household items, were produced in Iran during the Safavid and Qajar periods, and the technique continues to be practised in Iran to the present day. Isfahan was a particularly important centre of steel production during the 19th century. In some cases, steel vessels were decorated with gold damascening. In this technique, gold or silver was hammered into slightly undercut grooves or cavities in the metal object and burnished flush with the surface. Alternatively, gold or silver foil was applied to areas prepared by hatching. The decoration of gold objects with bright, multicoloured enamels also became popular, and was used on such items as trays, cups and water pipes.

The prestige attached to fine metalwork during the Ottoman period is illustrated by the fact that Selim I

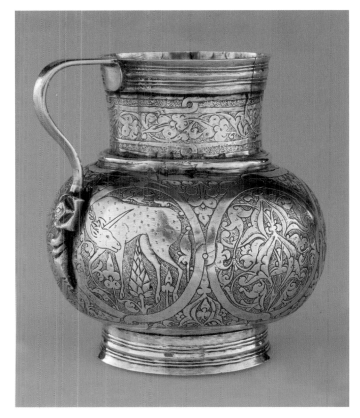

Silver mugs were produced widely during the 15th and early 16th centuries in the Ottoman territories, both in major urban centres and in provincial workshops. Their engraved or chased decoration varies considerably, and sometimes includes figural imagery, such as stags or rabbits. Some are stamped with the sultan's *tuğra*, a feature of silverware which does not appear to pre-date the reign of Bayazid II (1481–1512). A number of Ottoman metal jugs with globular bodies and cylindrical necks follow the shape of 15th-century Timurid vessels and, like them, some have dragon-shaped handles. The style of decoration is clearly Ottoman, however, and includes floral scrollwork and medallions, together with rubies, turquoises and other gems mounted in flower-shaped collars.

Pairs of monumental candlesticks with bell-shaped bases often flank the *mihrab* of Ottoman mosques; they are also found in mausoleums, such as that of Süleyman the Magnificent in Istanbul. They are typically made of cast brass or bronze, or of beaten copper, which was

Right: Back of a fountain ladle of silver, engraved and gilded, with a nielloed inscription, the handle set with precious stones; the Qur'anic inscription reads 'In the name of God, the Compassionate, the Merciful; and [we made] from water every living thing.' Ottoman Turkey, 1577–8.

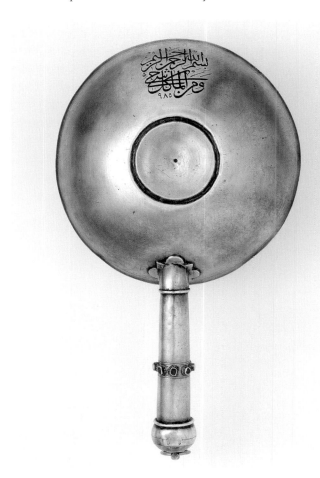

Far right: Large candlestick of gilt copper (*tombak*), one of a pair. Ottoman Turkey, perhaps late 16th century.

(1512–20) and Süleyman the Magnificent (1520–66) were both trained in the art of goldsmithing, following the custom that every sultan should learn a craft. Ottoman metalwork is characterized by highly patterned surfaces, encrusted with jewels and precious stones. This opulent style reached its peak under Murad III (1574–95), when the application of jewelled metalwork even extended to bookbindings. Elaborate filigree work with silver and silver-gilt wire was also produced.

The only precisely dated piece of Ottoman silverware from the 16th century is a ladle in the Khalili Collection. It has an engraved inscription, inlaid with a black composition, which includes the date 1577–8 and bears traces of gilding. The tubular handle is decorated with a band of semi-precious stones.

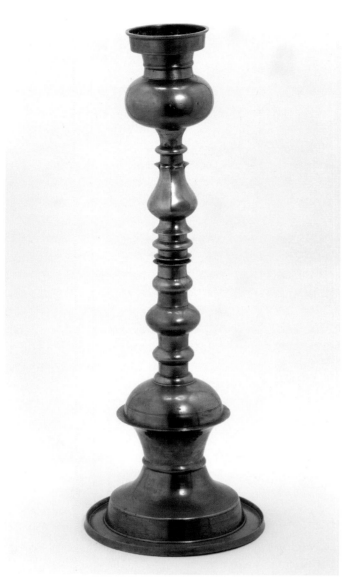

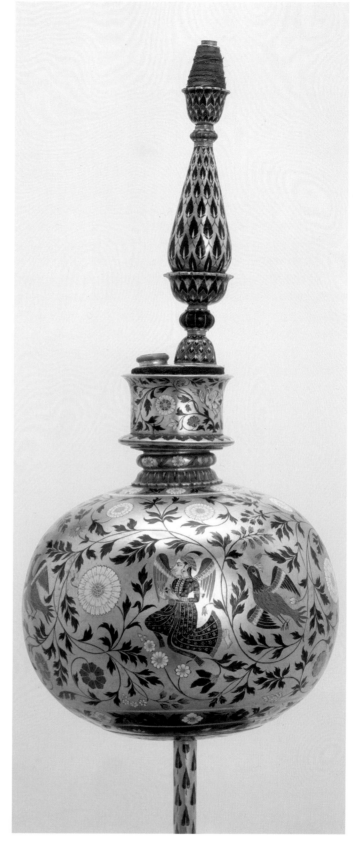

Far left: Large candlestick or torchstand of brass, cast in five sections. Ottoman, mid-16th century.

Left: *Huqqa* (water-pipe) of gold decorated with translucent and opaque enamels. India, Mewar (Rajasthan), early 18th century.

sometimes gilded (gilded copper is known as *tombak*). Another form of candlestick or torchstand is characterized by a tall, slender neck with various rings and bosses. Sometimes the socket is in the shape of a tulip.

In India, base metal objects continued earlier (pre-Mughal and local) traditions, and reflected a strong influence from Safavid Iran. Gold objects decorated with bright enamels and precious stones were produced in Mughal India from the 17th century onwards. These and other innovations reflected the influence of European jewellers and other craftsmen at the Mughal court. The Hermitage Museum contains some spectacular examples, including a small table taken, along with a vast quantity of other booty, by Nadir Shah following his sack of Delhi in 1739 and given by him to Tsar Ivan VI in 1741.

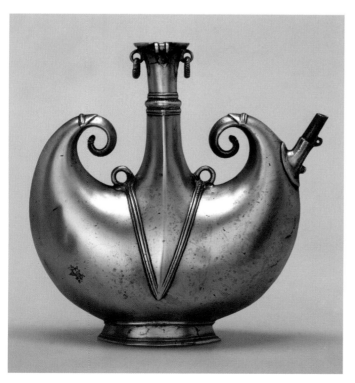

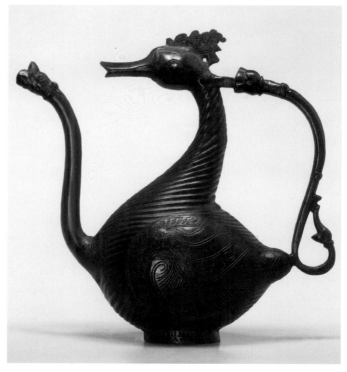

Far left: Two-handled 'pilgrim flask' of cast brass with gilding. India, Deccan, 16th century.

Left: Ewer of brass or bronze, cast in the shape of a goose with a dragon's-head spout. India, Deccan, 16th century.

Bidri ware is peculiar to the metalwork of Mughal India. The technique is thought to have originated in the Deccan, probably in the early 17th century, but production later spread to other centres including Lucknow and Purnea. Vessels made from an alloy containing mainly zinc were inlaid with silver, brass and occasionally gold; they were then coated with salts mixed with mud. This blackened the vessel but not the inlay, throwing the flowers, leaves and cartouches of the inlay into greater contrast. Among the most characteristic forms associated with *bidri* ware are spherical or bell-shaped bases of *huqqas* (water pipes).

The 19th century saw the revival of a number of earlier styles and techniques of metalwork. Some superb pieces were produced in Egypt and Syria during the Mamluk Revival, in part a response to the increasing interest in Islamic art and architecture in the West, and to meet the new demand from the increasing number of European travellers. The techniques employed often differed from those of the Mamluk craftsmen, however. Examples include a copy of an inlaid bronze lamp made for Sultan Baybars II in 1309, commissioned by Lord Curzon as a gift to the Taj Mahal. A similar movement, known as the Safavid Revival, emerged in Iran, from which objects in steel in the Safavid style have survived.

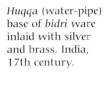

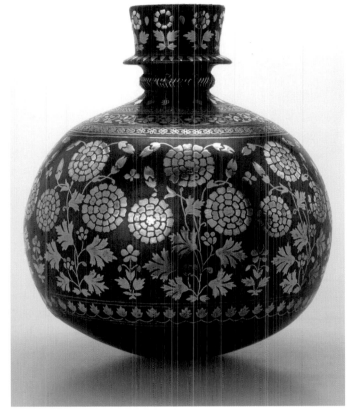

Huqqa (water-pipe) base of *bidri* ware inlaid with silver and brass. India, 17th century.

Below: Binding of steel, with gold and silver damascening, and panels of gold filigree, set with gold-inlaid ivory plaques and enamelled rosettes. Caucasus, 19th century.

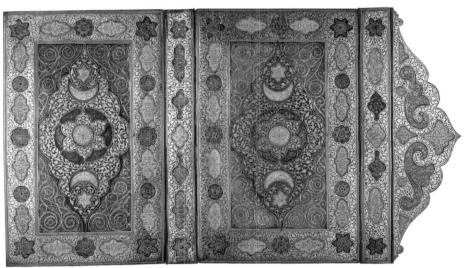

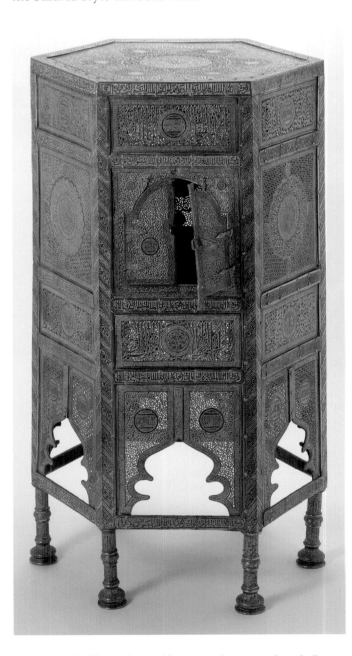

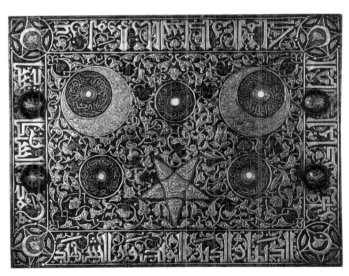

Plaque of brass sheet with engraved and silver- and copper-inlaid decoration, silver appliqué and niello. Damascus, 1912–13.

Qur'an stand of brass sheet with engraved, openwork and silver-inlaid decoration. Cairo, late 19th century.

Scientific Instruments

Considering the remarkable achievements of its mathematicians, geographers, physicians and astronomers, it is hardly surprising that the medieval Islamic world's production of fine metalwork also extended to scientific instruments such as astrolabes and celestial globes. Along with manuscripts such as medieval Arab and Persian geographies, topographical maps and portolan charts, anatomical treatises and herbals, these instruments reveal a profound interest in the surrounding world and are evidence of exacting scientific discipline.

The Islamic lands became heirs to the astrological and cosmological traditions of the Hellenistic world and Hindu India, and much of this knowledge was then

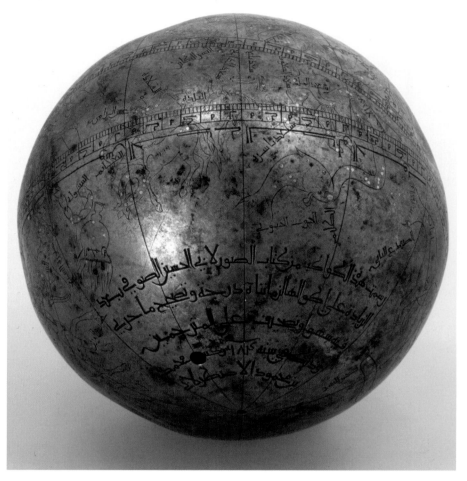

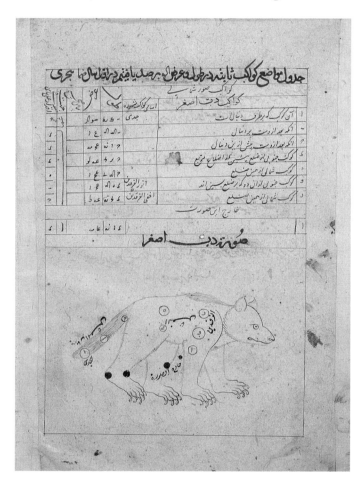

transmitted to Christian Europe through Islamic Spain. In turn, from the 17th and 18th centuries, increased contact with Europe led to Western innovations in astronomy being transferred back to the Islamic world.

Of particular interest among surviving astronomical instruments are a Judaeo-Arabic astrolabe (used to make astronomical measurements and in navigation), inscribed in Arabic which has been written in the Hebrew script, produced c. 1200 in Islamic Spain; and a celestial globe with a full set of constellation figures and the positions of some 1024 stars. Both these pieces are in the Khalili Collection; a copy of the latter is in the Louvre. Celestial globes are metal spheres on the exterior surface of which the stars and constellations are marked as if seen from the centre of the sphere; thus their position is the reverse of what would actually be seen in the night sky. Such globes continued to be produced in India into the 19th century, in some cases with bogus dates alleging earlier manufacture.

Qibla compasses are instruments designed for determining the correct direction of Mecca, towards which Muslims must face when praying. The bases and lids

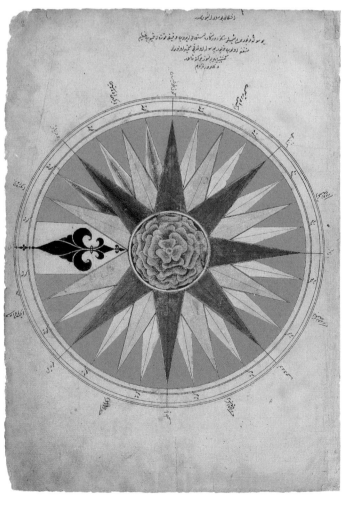

Above: Celestial globe of brass, cast in two pieces, with engraving and silver inlay; dated, and signed by Muhammad ibn Mahmud ibn 'Ali al-Tabari al-Asturlabi, this is the sixth oldest surviving celestial globe. Iran, 1285–6.

Far left: Folio from an illustrated star catalogue, showing Ursa Minor as seen on a globe. Iran, 15th or 16th century.

Left: Compass-card, the frontis-piece from a portolan atlas, the *Kitab-i Bahriye* ('Book of Seamanship') of Piri Reis. Ottoman Turkey, c. 1670.

were sometimes inscribed with the azimuth of the *qibla* at certain locations (that is, its compass-bearing relative to true north measured along the horizon) or with poetical verses explaining the instrument's correct use. In some cases, such as on the type of *qibla* compass known as *da'irat al-mu'addil* (invented by the Egyptian astronomer al-Wafa'i), a sundial was incorporated.

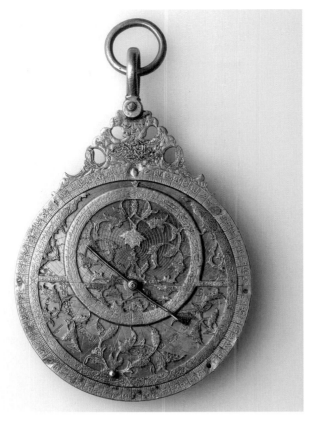

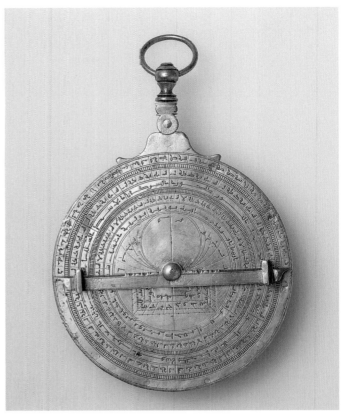

Planispheric astrolabe of sheet and cast brass with cut and engraved decoration. Iran, 1650.

Back of planispheric astrolabe of brass, cut and engraved. Probably Morocco, perhaps 18th century.

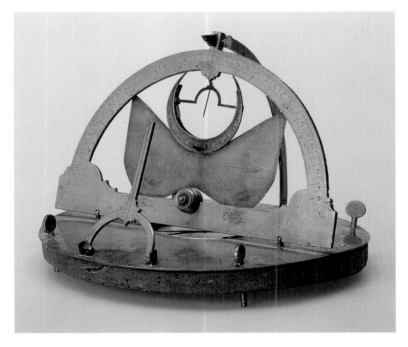

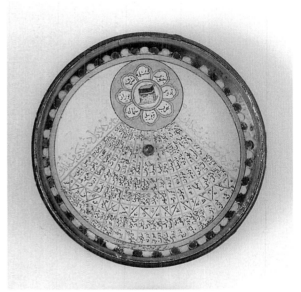

Da'irat al-mu'addil (a type of *qibla* compass) of brass with engraved decoration; signed 'the work of 'Ali, time-keeper of the Ebülfeth Sultan Mehmed Han' (the Fatih Mosque, Istanbul). Istanbul, 1748.

Qibla compass, brass case with inscribed cardboard; signed by Ahmad, timekeeper of the 'Osmaniye' Mosque (probably the Nuruosmaniye Mosque in Istanbul). Istanbul, 1808–9.

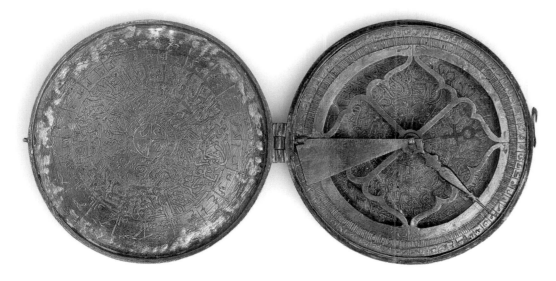

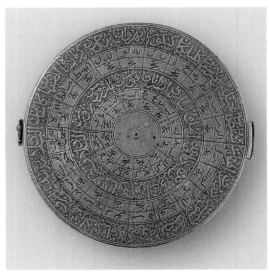

Two *qibla* compasses, one open (left) and the other showing the base (right), of brass sheet with engraving. Iran, late 19th or early 20th century.

Arms and Armour

The military prowess of medieval Muslim powers, combined with the remarkable achievements of Islamic metalworkers, favoured the production of some magnificent arms and armour. This ranged from the functional to the ceremonial and was sometimes exquisitely decorated, in a style reflecting that of other contemporary metalwork.

Arms and armour were frequently taken as booty following military campaigns, and so a good deal of material has been well preserved. For example, a considerable amount of Turkmen, Mamluk and Safavid weaponry was captured by the Ottomans during their various military campaigns of the 15th and 16th centuries and taken back to Istanbul, where it was kept in the imperial arsenal; much of this is now displayed at the Topkapı Saray Museum and the Military Museum. Among this weaponry is material from the Mamluk arsenal at Alexandria, itself taken as booty from the Crusaders (and the source of much of what is known about Western medieval arms). Later, Ottoman arms and armour were captured at the siege of Vienna in 1683 and preserved in various European collections.

Our knowledge of Islamic arms and armour is greatly augmented by manuscripts and miniature paintings, which frequently depict warriors in ceremonial or combat scenes. Illustrations in Rashid al-Din's *Jami' al-Tawarikh* ('Compendium of Chronicles') of 1314, for example, make a clear distinction between Turkic and Arab military traditions.

SWORDS AND DAGGERS

The two most commonly used swords in the Islamic lands were the Arab straight sword and the sabre. The former has a straight, double-edged blade, a rounded pommel and down-turned quillons (cross-pieces between the hilt and the blade). Its basic form is known from the pre-Islamic period, and is similar to that of the Roman *gladius*. The sabre has a long, single-edged, backward-curving blade, sometimes slightly broader towards the tip, and a hilt which generally curves slightly to one side. It is thought to have been introduced into the Islamic world from Central Asia by Turkic slave warriors during the 8th century. The earliest datable Islamic sword with a curved blade bears the name and blazon of the Mamluk sultan Baybars (1260–77). The single-edged blade has a deep groove below the tang (the extension of the blade that is enclosed in the hilt) and is gold-inlaid; later inlay work on the blade dates from the Ottoman period. The different shapes of these blades lent themselves to different forms of combat. The Arab straight sword was most effective when used on foot at close quarters, while the sabre was particularly well suited for fighting on horseback. The *yataghan* was a long scimitar with inward-curving blade. A weapon known since antiquity, it was adopted by the Turks from at least the 11th century.

The manner in which a sword was worn was of considerable significance: the Arab straight sword was usually worn from a baldric slung across the shoulder; the sabre was worn in a scabbard. Scabbards were typically carried on a belt, which had been a mark of tribal authority from pre-Islamic times. Girding with a belt and sword formed part of the inauguration of the later Ottoman sultans, and belts were frequently given as ceremonial gifts. Belts were also used to distinguish between different military ranks.

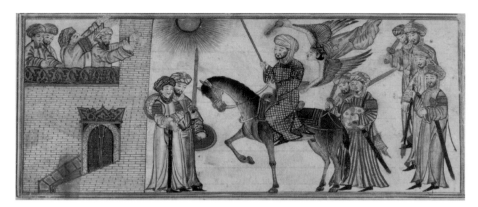

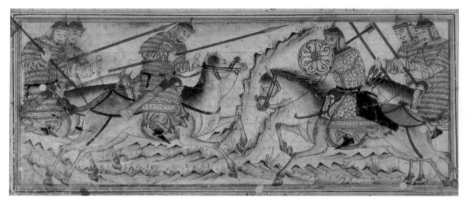

Dhu'l-Faqar

Probably the most famous sword in the Islamic world is Dhu'l-Faqar, one of the Prophet Muhammad's swords. It is said to have been given to 'Ali – with whom it therefore has a particular association – and to have been later used in the inauguration of caliphs, but at some date it was lost. From the 15th century it was frequently depicted on banners, where it is recognizable by its bifurcated blade.

Above left: Painting of *Dhu'l-Faqar*, from a book of prayers. Ottoman, 17th–18th centuries.

Above right: Central section of a silk banner with the motif of *Dhu'l-Faqar*: the curving quillons in the form of dragons' heads and the almost human shape of the sword are characteristic of its appearance in Ottoman art. Ottoman Turkey, 17th century (or 19th-century facsimile).

Opposite page:
Two illustrations from the *Jami' al-Tawarikh* ('Compendium of Chronicles'): *Muhammad receiving the submission of the Banu'l-Nadir* (above) and *Battle of the Pandavas and Kauravas* (below). The standing figures in the first carry Arab straight swords suspended from baldrics slung across the shoulder. Iran, Tabriz, 1314.

Right: Belt plaques of gold and silver sheet and wire with repoussé, chased and engraved decoration, and suspension loops for swords. Central Asia, perhaps Samarqand, c. 1200–50, and Eastern Iran, 13th century.

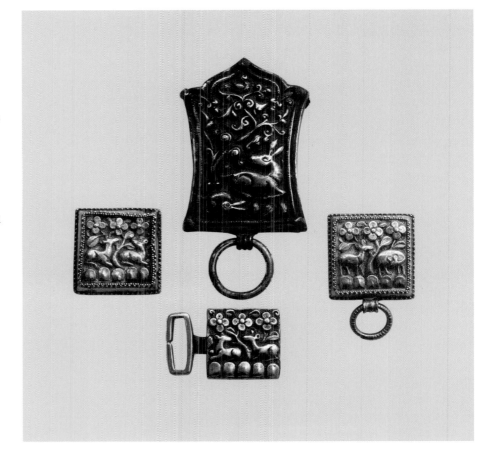

Left to right:

Sword with a double-edged straight blade of steel, and a hilt of silver gilt. Oman, 19th century, the blade perhaps 16th century.

Sword with a single-edged curved blade of watered steel with gold-inlaid decoration and later gold damascening. Egypt, c. 1270 (blade), and Ottoman Turkey, c. 1520 (additional decoration).

Sword with a single-edged curved blade of watered steel with gold damascening, and a hilt made of horn. Ottoman Turkey, 17th century.

Yataghan (scimitar) with a single-edged curved blade of forged steel decorated with gold damascening, a hilt of walrus ivory, and a wooden scabbard covered in silver gilt and decorated with a grape-vine motif, the bunches of grapes formed from seed pearls. Ottoman Turkey or the Balkans, 1863–4.

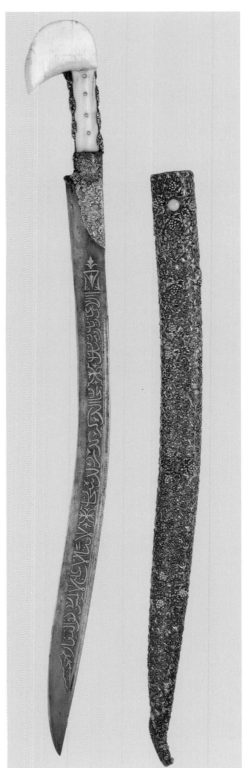

From the 15th century onwards Islamic swords and other weapons commonly had blades of high-carbon, 'watered' steel. This 'watered' pattern was achieved through particular forging techniques and may have been enhanced by etching with acid. Examples were often referred to in Western inventories as 'Damascus steel', following the belief that the technique had originated in Mamluk Syria. Blades were frequently decorated with inscriptions and arabesque in gold or silver inlay, a quite different technique confusingly known as damascening. From the 16th century hilts were often encrusted with jewels, a style particularly associated with Ottoman metalwork. Enamelling was especially popular in Mughal India from the 17th century, during the later Ottoman period and in Qajar Iran. Scabbards and sheaths of wood and leather were also richly decorated. (In some cases they are obviously of different date and provenance from the associated sword or dagger – and the blades themselves were frequently reset or remounted.)

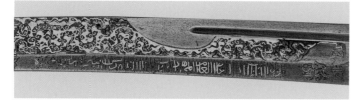

Detail of sword with a curved blade of watered steel with inlaid decoration in (below) gold wire, and (above) gold damascening (the complete sword is shown on the previous page). Egypt, c. 1270 (blade and gold inlay), and Ottoman Turkey, c. 1520 (damascening).

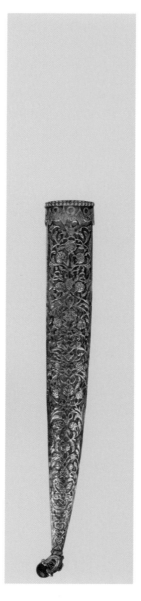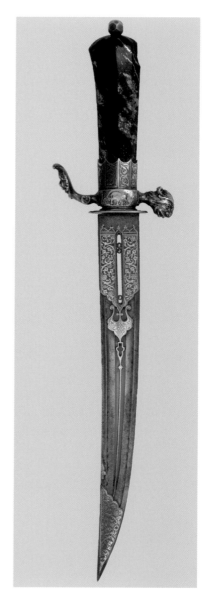

Far left: Dagger scabbard of silver sheet worked in repoussé with chased and engraved detail; at the tip, a dragon's head holds a coral bead. Ottoman Turkey, late 16th or early 17th century.

Left: Dagger with a blade of pierced steel with gold damascening, and a later hilt of lapis lazuli. Ottoman Turkey, 16th century (blade) and probably Germany, 17th century (hilt).

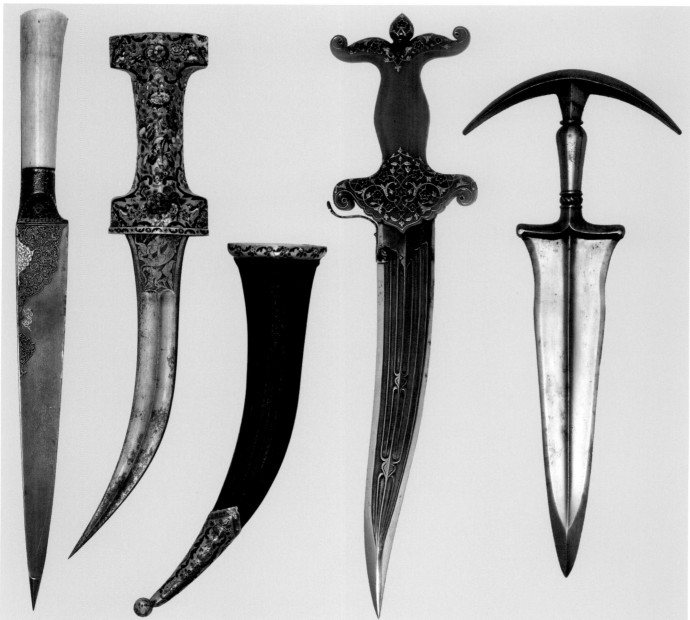

Left to right:

Dagger (*kard*) with a straight, single-edged blade of forged steel with gold damascening and chiselled decoration, and a hilt of walrus ivory. Iran, 1800–01.

Dagger with a double-edged curved blade of forged steel with chiselled decoration, and an I-shaped enamelled hilt. Iran, early 19th century.

Dagger with a double-edged blade of steel, and a hilt of nephrite jade with a splayed pommel. India, late 17th or early 18th century.

Steel dagger with a double-edged blade, and crescent-shaped pommel. Northern India, 17th or 18th century.

Daggers (*khanjar*) were made in a number of different forms. That with a long, straight, one-sided blade and slightly tapering hilt is known as a *kard*. The earliest known example of a *kard* is probably a piece in the Treasury of St Mark's, Venice, which is thought to date from the 12th century. Another type of dagger has a curved, two-sided blade and an I-shaped hilt. Daggers with a curled or splayed pommel – the latter form known in India before the Mughal period – were also common. Many surviving daggers have hilts of jade, sometimes carved in the form of an animal's head, a treatment also extended to ivory and metal hilts. These were especially popular in Mughal India during the 17th century. A distinctive group of all-metal daggers, thought to be from northern India, has a two-sided blade and a crescent-shaped pommel. Daggers with pierced steel blades were made for the Ottoman and Safavid courts during the 16th century.

OTHER WEAPONS

The mace had been carried both as a weapon and as a symbol of authority since pre-Islamic times, and some surviving examples were clearly intended for purely ceremonial use. Mace heads of various types are known, some elongated, others squat and cut in flanges. The shaft might be of metal or of wood.

Axes typically have crescent-shaped blades, and the back is often shaped as a hammer or a spike. The blades sometimes bear inscriptions or arabesque ornament. On a superbly decorated example bearing the blazon of the Mamluk sultan Qaytbay (1468–96), now in the Kunsthistorisches Museum, Vienna, a flange protects the hand from the sharply curving blade. Shafts are usually wooden. Long-handled 'saddle axes' were attached to a horse's saddle, below the rider's thigh. The heads of Ottoman saddle axes are generally broader than those of Iranian examples.

Short, composite bows were used, made of wood reinforced with horn or sinew. They were typically of the recurve form, that is, the arms curve forwards at the tips when the bow is in a relaxed state, adding extra tension when the bow is drawn. Steel bows were popular in 19th-century India. Archer's thumb-rings or *zehgir* were worn on the thumb of the right hand, that is, the hand which pulled the string taught. Many examples, perhaps intended to be worn only at court, are of jade and are beautifully decorated with gold inlay and precious stones. The quiver was generally carried at the waist, on the right-hand side of the body. A number of Ottoman examples from the 17th century, in tooled leather with silver mounts, were taken as booty following the siege of Vienna. More luxurious examples made from inlaid wood, or jewelled and faced with brocade, have also survived.

Below: Axe head of forged steel with engraved decoration. Ottoman, perhaps 16th century.

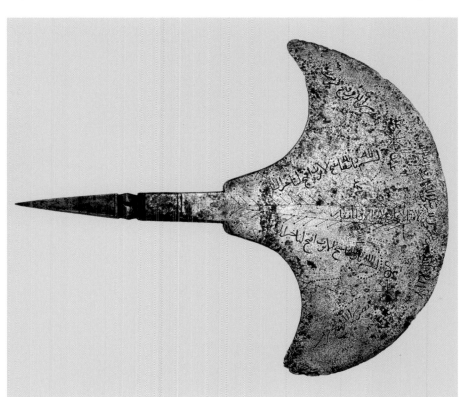

Archer's thumb-ring of hippopotamus ivory, with a leather pad inside the lip. Anatolia, 15th century.

Archer's thumb-ring of nephrite jade. Anatolia 16th or 17th century.

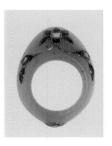

Thumb-ring of jade set with diamonds, rubies and emeralds in gold mounts. India, 18th century.

Far left: Mace with a head and collar of iron or steel with gold damascening, rubies and turquoises, and a wooden haft. Ottoman Turkey, early 16th century.

Left: Saddle axe of cast steel with chiselled and engraved decoration and gold damascening, and a painted wooden haft. Iran, late 18th century.

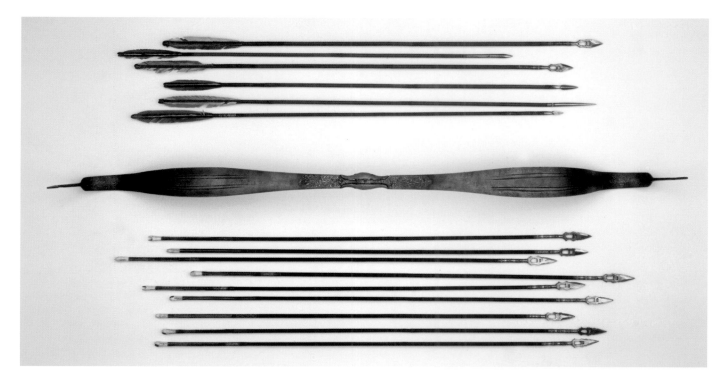

Bow of steel with an ivory grip and gold damascening, and steel-tipped bamboo arrows. India, 19th century.

ARMOUR

The Caucasus region boasts a long and distinguished tradition of arms and armour manufacture. The armourers of Derbend and of Daghestan are referred to in the 10th-century geographical treatise, the *Hudud al-'Alam* ('Regions of the World'); and in some areas of the Caucasus armour was still being worn at the beginning of the 20th century. Armour from the North Caucasus appears in Ottoman inventories as *derbendi*, that is, 'from Derbend'.

During the medieval Islamic period armour of the type known as lamellar (from Latin *lamella*, meaning 'thin plate') was generally worn (see the painting shown on p.122). Lamellar armour consisted of small plates of leather, bone or metal sewn together or attached to fabric, and sometimes covered with an outer layer of fabric. During the 14th and 15th centuries lamellar armour was superseded by metal armour made from plates joined by small rings of steel or iron (known as 'mail'), or made entirely from such rings. The plates were often inscribed with passages from the Qur'an. Sometimes flat rings were used for the mail, and the individual rings stamped with an inscription. Mail shirts were augmented by other elements such as leg- and shoulder-plates. Although arm guards and full breast plates sometimes appeared at a later date, the preference remained for lighter mail armour.

Early helmets were of the type known as *Spangenhelm*, composed of a number of metal plates held together with rivets or wire. The type is known from Sasanian Iran and is also depicted on Turkic stone figures known as *balbals* from the 7th and 8th centuries. Later helmets were in one piece, made from forged steel; sometimes additional elements such as nasal- and cheek-pieces were riveted to the bowl. The most commonly known helmets are conical, and fall into a number of categories. Some are fluted and slightly bulbous – a type known as 'turban helmets' and associated especially with the Ottomans and with the Aq Qoyunlu in Iran. Many of these entered European collections following the 'spring cleaning' of the Istanbul armoury by Sultan Abdülmecid in 1839. Others have a more elongated, tapering bowl, the most famous example being a helmet made for the Mamluk sultan Barsbay, now in the Louvre, Paris.

War masks are depicted in 13th-century manuscripts and 15th- and 16th-century examples have survived from western Iran. They were worn attached to a helmet, and often have realistic facial features, with broad eyebrows and an upturned moustache, and are decorated with inscriptions.

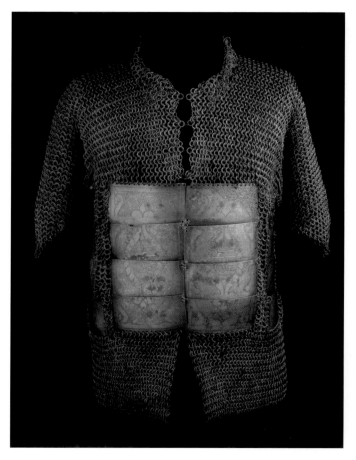

Left: Mail and plate shirt of forged iron or steel with engraved and punched decoration and silver inlay. Northern Caucasus, for the Ottoman or Persian market, late 15th or early 16th century.

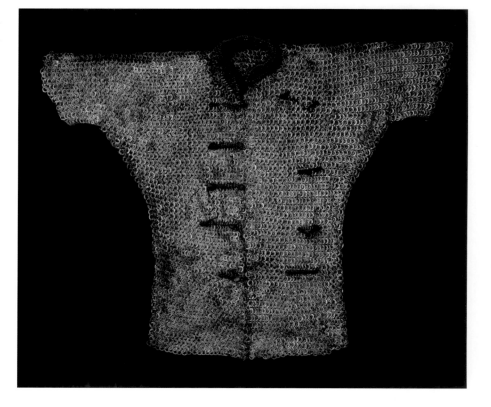

Below: Mail shirt of forged steel, the rings riveted and stamped with inscriptions and interlace designs. Probably Iran, 15th century.

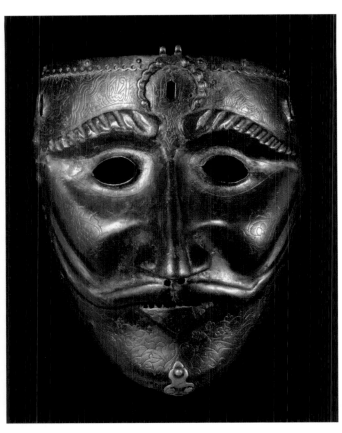

Left: War mask of iron and steel with beaten and engraved decoration. Possibly made for an Aq Qoyunlu ruler, late 15th century.

Below left: Helmet of forged iron plates with gilded decoration, held together with bronze rivets. Iran, 7th or 8th century.

Below centre: Conical helmet of forged steel with riveted elements. Possibly Mamluk, early 16th century.

Below right: 'Turban' helmet of iron or steel with engraved ornament and silver damascening. Northern Caucasus, made for the Ottoman or Persian market, later 15th century.

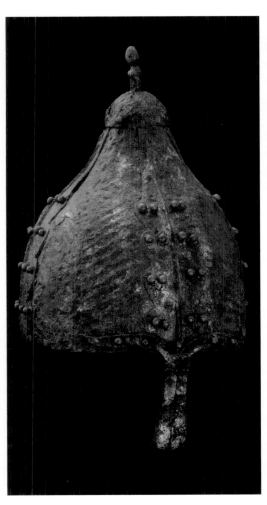

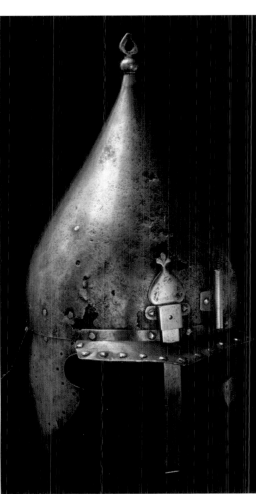

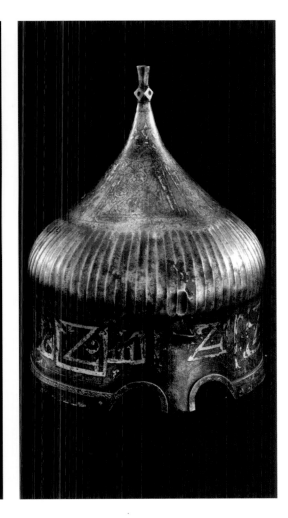

Two views of a helmet of steel forged and engraved to resemble a type of turban worn in India during the late 17th century. India, the Deccan, late 17th century.

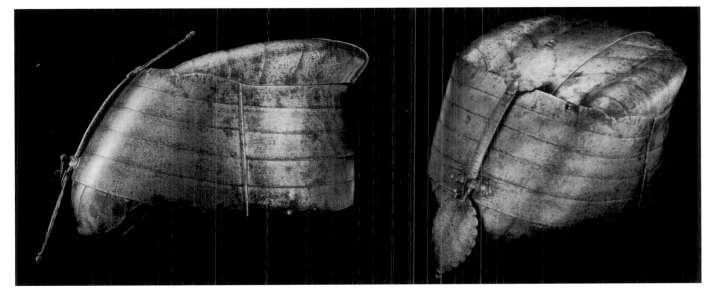

Shields of various shapes and sizes are known from the Islamic world. Small round metal shields known as 'bucklers' were common from the 11th to the 13th centuries, and were also used during later periods. Larger shields were also in use by the 13th century. Cane shields were also common. These were made from spirals of cane wound with silk thread, around a central wooden disc covered with a metal boss. Different coloured threads were used to create decorative patterns. Examples have survived from the Ottoman and Safavid periods but they were probably used in earlier times.

Below left: Cane shield. Ottoman Turkey, c. 1650–84.

Below right: Large shield of forged steel. India, c. 1500.

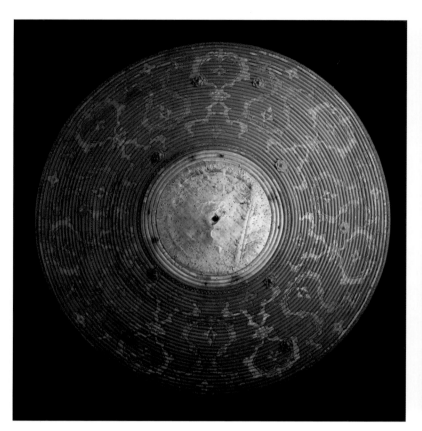

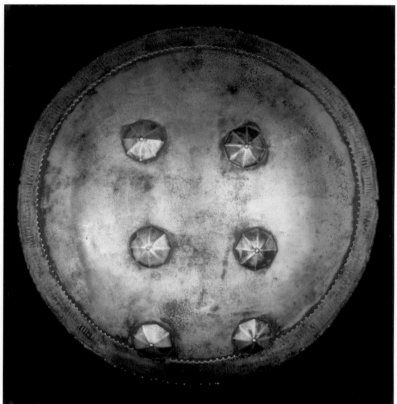

The prestige attached to the horse resulted in the production of equestrian armour and trappings of considerable richness. The metal plate that protects a horse's forehead and nose, known as a chamfron, was often decorated with vertical flutings which tapered towards the animal's nostrils, and fine engraving. Cheek and neck guards were attached to it with iron rings. Saddles were sometimes decorated with beautiful metal fittings; even stirrups might be finely ornamented and the bridle and other straps embellished with decorative trappings. Examples from 13th- and 14th-century Iran and Anatolia are often of cast or sheet silver or gold, with repoussé decoration. Later examples, from the Turkmen of northeast Iran and Turkmenistan, feature stamped appliqués and are similar to contemporary Turkmen jewellery.

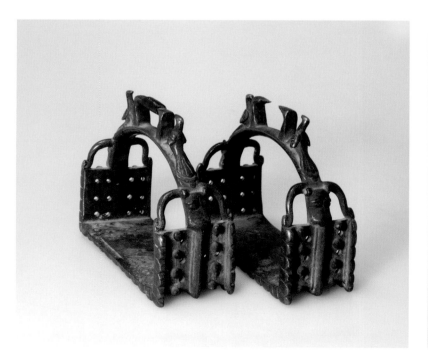

Stirrups of cast bronze with punched and engraved decoration. Probably Ghaznavid, Northeast Iran, 11th or 12th century.

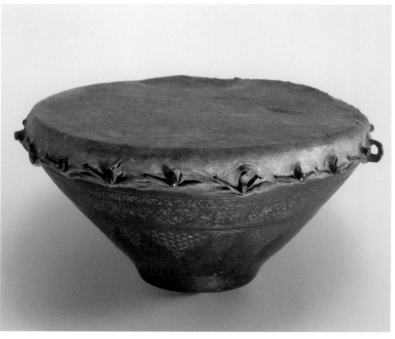

Drum of engraved bronze with a leather skin. Mamluk, perhaps Egypt, 15th century.

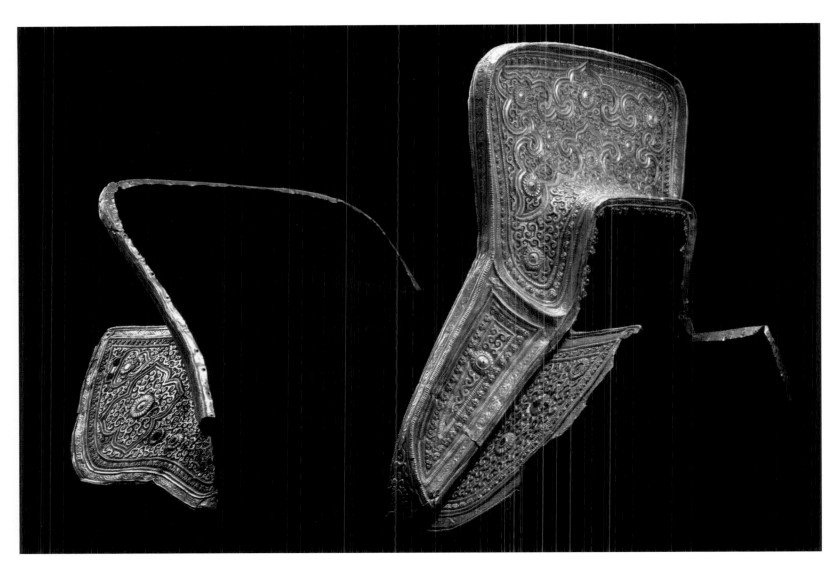

Above: Fittings for a saddle, of gold sheet worked in repoussé and chasing, with engraved details. Inner Asian frontiers of China, probably 13th century.

Left: Set of horse trappings of silver sheet and wire, worked in repoussé and chasing, engraved and gilded. Probably Iran, 13th century.

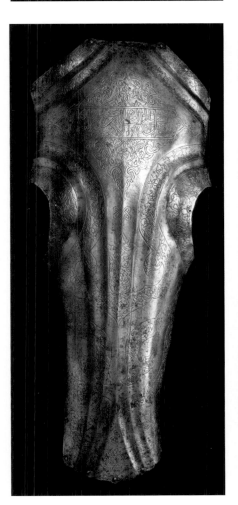

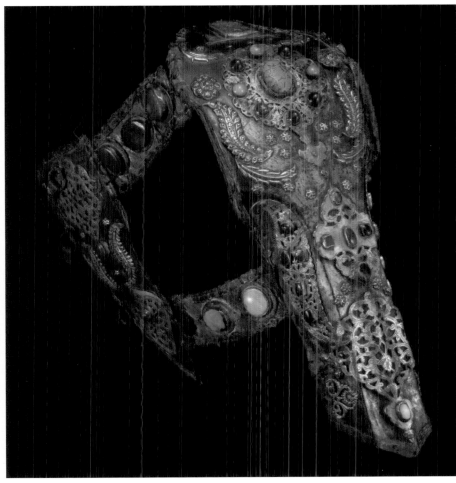

Far left: Chamfron of iron or steel with engraved and dot-punched decoration and an Arabic inscription bearing the name of Husayn ibn ʿAlikhan ibn Jahangir, grandson of the brother of the great Aq Qoyunlu ruler Uzun Hasan. Iran or Anatolia, late 15th century.

Left: Chamfron and cheek pieces, characteristic of the decorative armour of a parade horse, of forged iron or steel, leather, silver-gilt appliqués, cornelian, agate, coloured glass and jade. Ottoman Turkey or Egypt, 18th century.

Banners and Standards

Banners and standards were important accoutrements of war. They bore invocations to God, Muhammad and the *Rashidun* (or 'Rightly Guided') caliphs, together with appropriate verses from the Qur'an. Banners seem to have been prepared for individual campaigns and in the 19th century may have been woven in batches for different Ottoman regiments. From the 15th century or perhaps earlier, the finials on standards were typically made of fretted steel. Metal drums were also carried into battle. These were of bronze or steel, and many were engraved or inlayed. The skin was stretched over the rim and attached to a series of metal nodes.

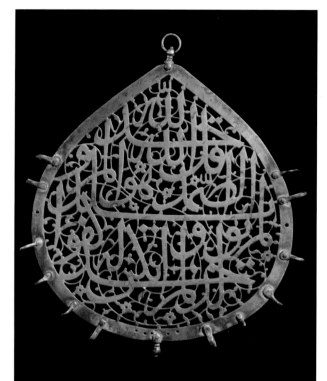

Left: Part of a standard of pierced steel carrying a *sura* from the Qur'an. Iran, probably 17th century.

Below: Large silk banner with invocations and Qur'anic verses. Ottoman Turkey, 1819–20.

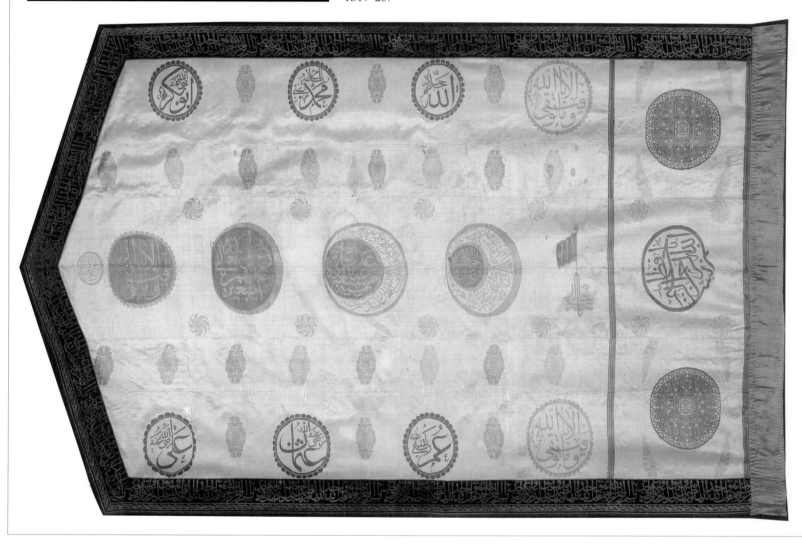

FIREARMS

The introduction of firearms and gunpowder irrevocably changed the face of warfare in the Islamic world. The Ottomans were one of the first Islamic dynasties to adopt the use of guns and cannon, which gave them a powerful advantage over their rivals the Mamluks and the Safavids, who were at first more reluctant to abandon traditional weaponry. (It should be pointed out that, at first, the Ottoman Janissaries themselves frowned on muskets, recognizing in them an erosion of traditional fighting skills and codes of chivalry.) Artillery played a key role in the Ottoman conquest of Constantinople in 1453, and was used by the Mughals in their conquest of India in 1526.

Firearms basically followed 17th-century European prototypes in their form, and in some cases used locks of European manufacture. Their lavish decoration was distinctly Islamic, however. The wooden stocks of guns were often inlaid with ivory and decorated with gold, silver or brass plaques and studs, and bands of mother of pearl. Sometimes the wood was carved. Gun barrels were often inlaid with gold. Stocks with a fish-tail shape are characteristic of 19th-century manufacture in Sind. Cannon were also sometimes decorated; a type with a muzzle cast in the form of a tiger's head is associated specifically with Tipu Sultan, ruler of Mysore in India during the late 18th century.

Powder flasks were made of ivory, of wood covered with leather and metal plaques, or of metal only. Ivory powder flasks decorated with carved animals were popular in Mughal India from the late 16th century.

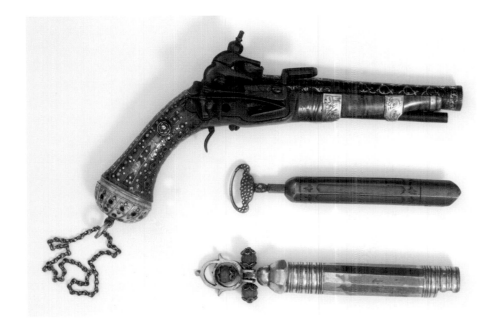

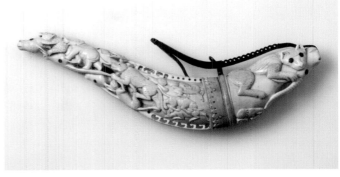

Above: Powder flask of carved hippopotamus ivory. India, 17th or 18th century.

Left: A rare early Ottoman pistol, with a barrel of steel inlaid with gold inscriptions and arabesques, and a wooden stock inlaid with gold, silver and stained ivory. Ottoman Turkey, 17th century. Shown with two powder measures, forged steel and forged steel with silver gilt. Iran, possibly 17th or 18th century (upper), and Ottoman Turkey, 17th or 18th century (lower).

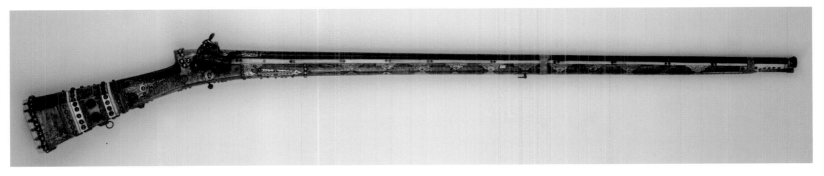

Flintlock gun with a barrel of steel inlaid with gold, and a wooden stock inlaid with ivory (much of which is stained green) and set with bands of mother-of-pearl, engraved brass plaques, copper and brass studs, and glass-paste gems. Ottoman Turkey, 18th century.

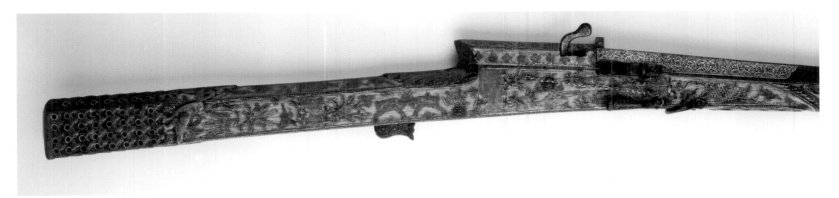

Detail of matchlock hunting rifle with a barrel of steel, and a carved and painted wooden stock. India, probably 18th century.

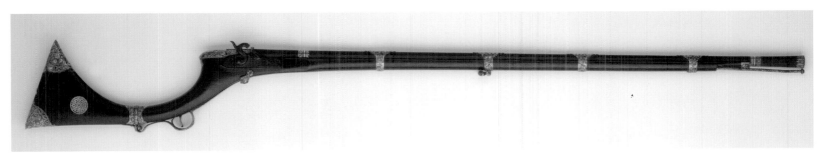

Gun with an English percussion lock, and a wooden stock in the shape of a fish tail with enamelled gold fittings. England (lock), and India, Sind, c. 1835.

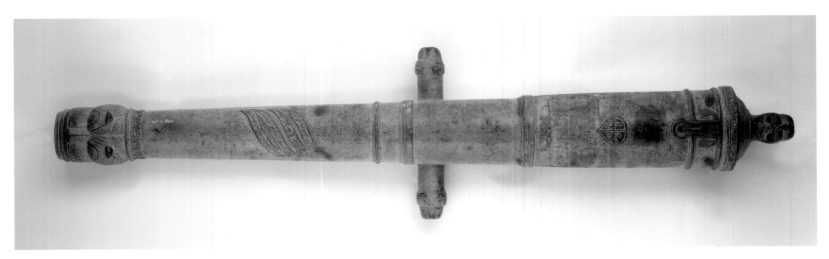

Cannon of cast bronze. India, 1781.

Jewellery

The wearing of jewellery by both men and women has a long tradition in the Middle and Near East, and early Islamic jewellers were able to draw on a broad range of influences, including the jewellery of India, Sasanian Iran, the Graeco-Roman world and in particular Byzantium. In addition, the fantastic wealth of gold and precious stones across the territories conquered by Islam undoubtedly favoured the production of fine jewellery.

Jewellery, like other precious metal objects, was frequently melted down and the gold or silver re-used. Stones and gems were re-set. This obviously affects what has survived and complicates our picture of what was typical of a particular period. Furthermore, with the exception of seal stones, most known examples of Islamic jewellery lack the inscriptions necessary to establish their precise date or provenance.

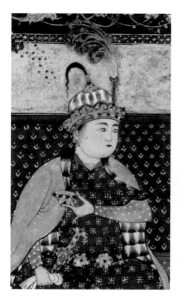
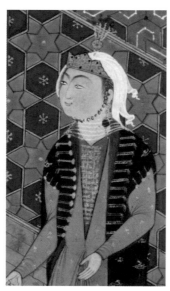

Two details from the 'Houghton' *Shahname* made for Shah Tahmasp I: Faridun wearing a jewelled gold crown with plume, earrings, a pendant or amulet case on a short chain, a jewelled belt and dagger (left) and the Princess of Kabul, wearing a jewelled diadem and head ornament, long pendant earrings with a large ruby and a string of pearls framing her face. Iran, Tabriz, 1520s.

TECHNIQUES AND FORMS

The work of Islamic jewellers included pendants and necklaces, earrings, beads, pins, bracelets, rings, head ornaments (such as crowns and diadems), arm bands and anklets; it also encompassed belt trappings and fittings, seals, talismans and amulet cases. Jewellery was typically made of gold, silver or bronze, either cast or in the form of metal sheet. The most common types of decoration included repoussé (relief decoration, worked from the back of the sheet); full or partial gilding; plain or twisted wire filigree; granulation (attaching tiny metal spheroids to a surface, usually by hard soldering); and niello (a black metallic compound, usually applied to engraved areas and other depressions, and then fused to the surface by heating). Niello was mostly used on silver, although it sometimes appears on gold. Enamels were also popular. In this technique coloured glass is ground to a powder, then applied as a paste to the surface of a precious metal object – usually into depressions (champlevé enamel) or compartments created by wire or strips of sheet metal (cloisonné enamel). Sometimes it is painted over larger areas with chased or engraved decoration, variations in thickness giving a translucent or more opaque finish (basse taille enamel), or painted in layers onto undecorated sheet, giving an opaque effect (painted enamel).

The object is then heated until the coloured enamels fuse to the surface.

Necklaces usually consisted of sets of cylindrical or spherical beads, or rosette-shaped elements. Earrings were often crescent-shaped, or took the form of animals

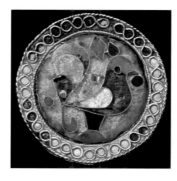
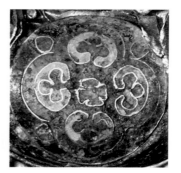

Details of cloisonné enamel from Egypt or Syria, 11th century (above, left), and Spain, 12th century (above, right); and granulated filigree from Egypt or Syria, 11th century (left).

such as lions or birds. Sometimes they were simple hoops to which beads and other elements were attached. Bracelets were either open (the ends sometimes overlapping, and sometimes with dragon- or lion-headed terminals), or closed (usually with a clasp). Rings were typically set with semi-precious stones, including almandine garnets, carnelian and other agates, lapis, jade, rock crystal and turquoise. All of these were thought to be imbued with talismanic properties of one kind or another, as various treatises on gemstones show, and often the choice of stone may have been guided not only by its aesthetic qualities but also by the protective powers it was believed to embody. Sometimes the stones bore inscriptions. Pearls were widely used in earrings and necklaces; their popularity is confirmed by the writings of al-Biruni (973–1050). This repertoire was enriched by new forms and techniques during the modern period, but Islamic jewellery has nevertheless held tenaciously to many older traditions.

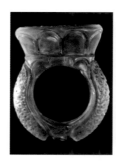
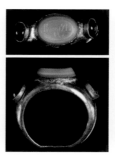
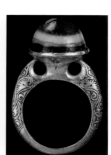
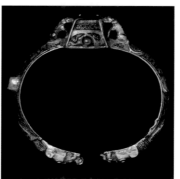

Above left: Sasanian rock-crystal seal ring. Iran or Iraq, 4th–6th century.

Above centre: Gold ring, set with garnets and an onyx seal stone inscribed, 'Al-Hasan son of Bilal'. Iraq or Iran, 9th–10th century.

Above right: Ayyubid gold ring, inlaid with niello and set with an eye-agate. Egypt, late 12th century.

Left: Gold bracelet with lion's-head terminals, decorated with lion appliqués and niello and once set with stones. Iran, late 12th–13th century.

THE EARLY PERIOD

Comparatively little jewellery has survived from the early Islamic period, and that which has is difficult to distinguish from Sasanian and Byzantine pieces. Most of what we know of early Islamic jewellery is in fact derived from pictorial and sculptural references – the jewellery worn by figures in the wall paintings at Qusayr 'Amra in Jordan (second quarter 8th century) and the palace of al-Mu'tasim at Samarra (833–42), for example – and this, too, has close Classical, Byzantine and Sasanian parallels. This is hardly surprising, as early Muslim goldsmiths and silversmiths adopted the techniques, forms and motifs of earlier civilizations: filigree work, granulation, cloisonné enamel, crescent-shaped earrings and bracelets with dragon- or lion-headed finials are all known from the work of Byzantine goldsmiths.

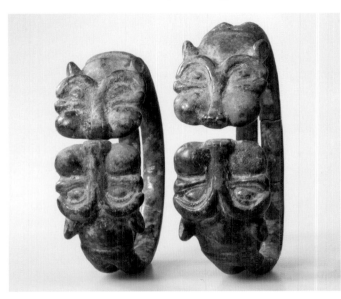

FATIMID JEWELLERY

Fatimid jewellery is some of the finest from the medieval Islamic world. Much of what we know of it derives from the discovery in 1952, in Tunisia, of an earthenware jar containing a number of pieces of jewellery, along with 82 gold coins bearing the names of Fatimid caliphs ruling between 1003/4 and 1044/5, by which the jewellery could be dated.

Fatimid jewellery was usually made of gold sheet, and characterized by its decoration in elaborate filigree and granulation. Objects were typically of box construction, and featured arabesque and openwork designs – in particular S-scrolls and figure-of-eight motifs – together with small loops for stringing pearls or semi-precious stones. Some surviving examples are set with cloisonné enamel. Rings were typically stirrup-shaped, with a high circular or rectangular bezel; one of the most popular shapes for earrings, pendants and other pieces was a crescent (*hilal*). Bi-conical beads were typical of necklaces from the Fatimid period. Pendants and earrings were usually double-faced – that is, with decoration on both sides. Figural imagery, including rabbits, sphinxes and birds, appeared on some jewellery.

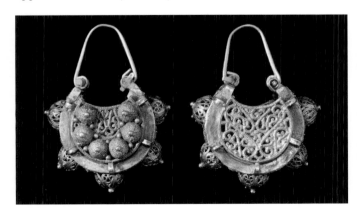

Pair of Fatimid gold crescent-shaped granulated filigree earrings (front and back). Egypt or Syria, 11th century.

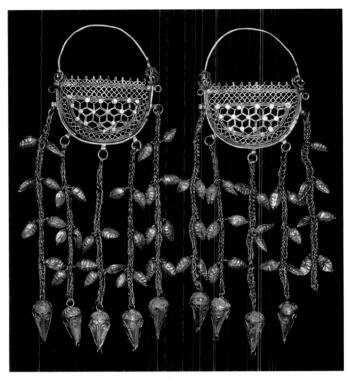

Pair of gold filigree earrings. Syria, 10th–11th century.

Far left: Pair of cast bronze bracelets with lion's-head terminals. Central Asia, 8th century.

Left: Gold crescent-shaped earrings from Byzantium, 8th–9th century (top); and Iraq, Iran and Syria, 11th–12th century (bottom, left to right).

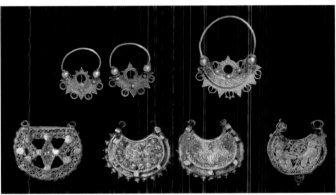

Pair of gold twisted-wire filigree earrings in the shape of paired birds. Syria or Iran, 11th–12th century.

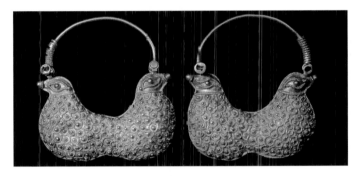

Elements from a Fatimid gold bracelet or necklace, decorated with wire filigree and cloisonné enamels. Egypt or Syria, 11th century.

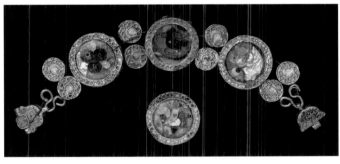

Bracelet of knitted gold wire, the clasp of gold sheet with a benedictory inscription in Kufic script. Syria, 11th–12th century.

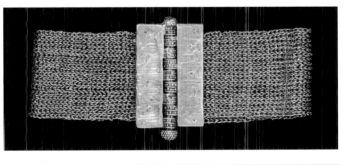

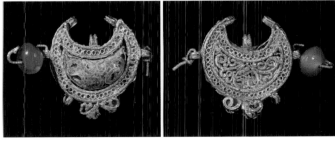

Gold crescent-shaped filigree pendant with cloisonné enamels (front and back). Probably Egypt, 11th–12th century.

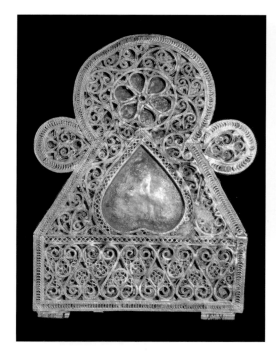

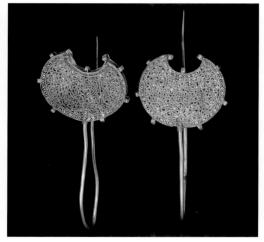

Above: Two Fatimid gold filigree crescent-shaped pins, the wires later bent to convert them into earrings. Egypt or Syria, 11th century.

Left: Fatimid gold filigree plaque, probably from a belt. Egypt or Syria, 11th century.

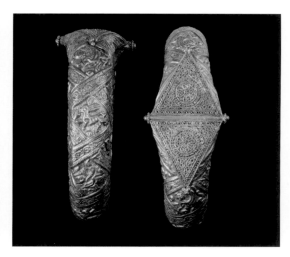

Above: Pair of Fatimid gold bracelets decorated with repoussé animals, with the clasp in granulated filigree. Egypt or Syria, 11th century.

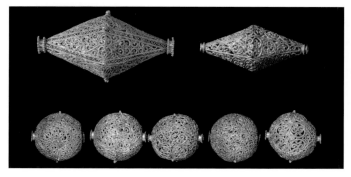

Fatimid biconical and spherical gold beads, in granulated filigree. Egypt or Syria, 11th century.

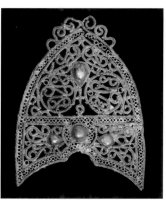

Left: Small gold bird, probably once part of an earring, decorated with granulation. Syria, 11th–12th century.

Left: Fatimid gold plaque, probably from a belt, in granulated wire filigree. Syria or Egypt, 11th century.

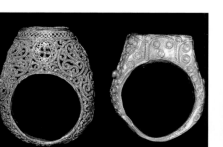

Fatimid gold stirrup rings, in granulated filigree. Egypt, 11th century.

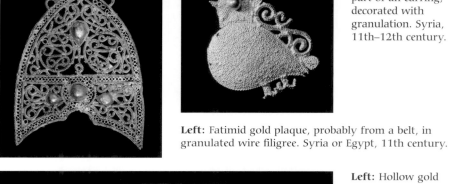

Left: Hollow gold bracelet (one of a pair), the clasp decorated with granulation. Iran, 12th century.

JEWELLERY OF THE LATER MEDIEVAL PERIOD

There are a number of similarities between surviving examples of Seljuk jewellery from Iran and Fatimid pieces, including ornamentation with palmette and scroll motifs. Earrings in the form of lions and birds, and rings with elongated bezels, are associated in particular with jewellery from 12th-century Iran. A large quantity of silver jewellery has survived from this period. It provided a less expensive imitation of or alternative to gold, especially when the latter was in short supply, and is often decorated with repoussé work, granulation, niello or gilding. Some of the most significant archaeological excavations in which jewellery from this time has been discovered were in eastern Iran and Central Asia, in particular at Nishapur and Rayy.

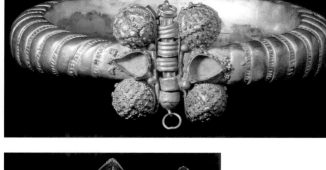

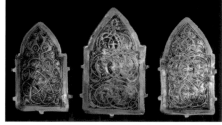

Left: Three gold elements, perhaps from a necklace, the backs engraved and inlaid with niello. Iran, 12th–early 13th century (the stones are later replacements).

Below left: Two gold earrings in the shape of lions, with twisted wire filigree. Iran, 12th century.

Below right: Silver locket in the shape of a lion with niello and gilt decoration. Iran, 12th century.

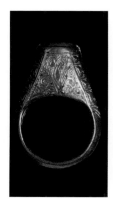

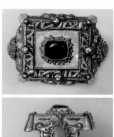

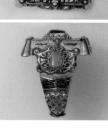

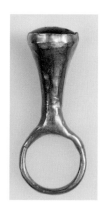

Far left: Ring of sheet gold with engraved and niello-inlaid decoration. Iran (Rayy), 12th century.

Centre: Gold ring, with gold appliqués, turquoises, a red glass cabochon, and niello decoration. Iran, late 13th–early 14th century.

Left: Gold ring set with an almandine garnet seal inscribed, 'Abdallah son of Ahmad'. Iran, 12th–13th century.

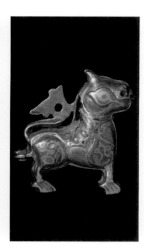

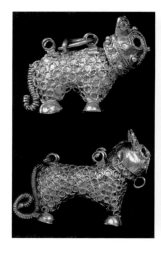

Right: Two gold beads of sheet and granulated wire filigree, originally set with stones. Iran, 12th century.

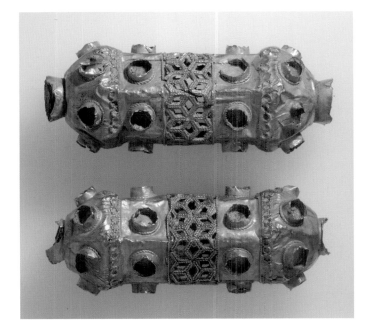

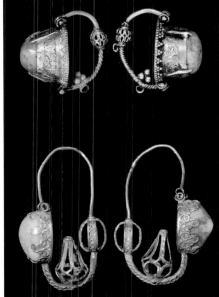

Left: Two pairs of gold earrings, one set with turquoises (top), the other with glazed quartz cabochons. Iran, 12th century.

Below: Set of six gold filigree and pearl buttons, once decorated with enamels or coloured paste. Syria or Spain, 13th–14th century.

Similar techniques to those used in Fatimid jewellery are found in surviving jewellery from Mamluk Egypt and Syria, and from Nasrid Spain. These include box construction, granulation and filigree work, and cloisonné enamel. For example, the Metropolitan Museum of Art in New York contains a particularly fine set of elements from a gold necklace, decorated with granulation and cloisonné enamel, from 15th- or 16th-century Granada. The quality of known Mamluk jewellery is not as fine as that of the Fatimid period, however, and most pieces are single- rather than double-faced. Heraldic designs were a typical feature of Mamluk jewellery.

Right: Gold crescent-shaped pendant decorated with cloisonné enamels and granulation (front and back). Spain, 12th century.

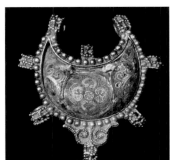

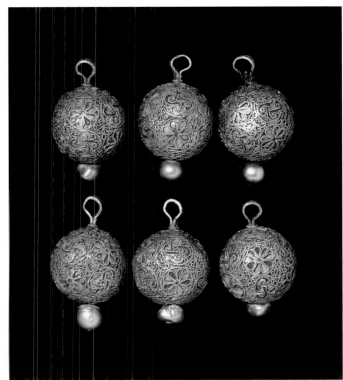

Right: Mamluk gold filigree pendant set with a jet cabochon. Syria, early 14th century.

Centre right: Two gold filigree beads and a double-drum element from a necklace, once decorated with cloisonné enamels. Spain, 12th century.

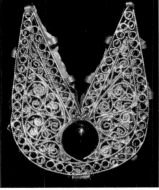

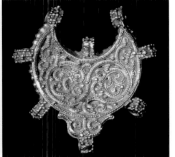

Below: Nasrid gilded bronze belt fittings, with cloisonné enamels. Spain, 15th century.

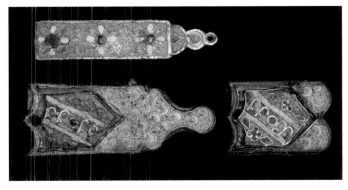

Right: Mamluk silver amulet case, decorated with engraved inscriptions and green enamel. Syria, 14th century.

Below left: Bezel of a cast silver ring with 'heraldic' lion. Anatolia or Syria, late 13th century.

Below right: Detail of a page from the 'Demotte' *Shahname*, showing a youth wearing a gold hoop earring with a large pearl. Iran, Tabriz, 1330s or later.

With the exception of rings and belt trappings, little jewellery has survived from Iran during the Ilkhanid and Timurid periods but miniature paintings once again provide a clue to jewellery fashions from that time. In the 'Demotte' *Shahname* (1330s and later), for example, male figures are depicted wearing gold earrings of a simple, hoop design. Persian miniatures from the late 14th century onwards show female figures whose faces are framed by strings of beads worn attached to a headcloth. Bracelets with dragon-headed finials have survived from Timurid Iran and Central Asia; the form of serpent- or dragon-headed finials is paralleled on the shanks of rings from this period. Jade became popular as a seal stone in rings from the 15th–16th century. A large quantity of jewellery has survived from the period of the Golden Horde (13th–15th centuries) in southern Russia.

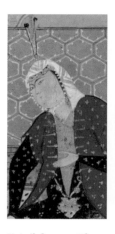

Detail from a *Khamse* of Nizami, showing a lady wearing a necklace with a jewelled gold pendant, a gold head ornament and a string of pearls framing her face. Iran, Shiraz, 1557.

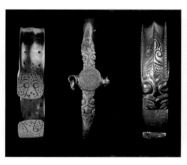

Gold filigree pendant or headdress ornament. Golden Horde (South Russia), mid-13th century (the stones are later replacements).

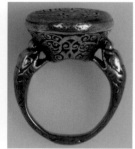

Gold pendant with twisted wire filigree. Syria or Golden Horde (South Russia), early 14th century.

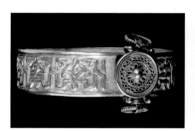

Gold bracelet, decorated with a repoussé pseudo-inscription and a filigree clasp. Western Iran or Anatolia, early 14th century.

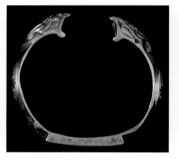

Gold bracelets with stylized lion's-head terminals, Golden Horde (South Russia, left and centre), and Iran (right), 13th–14th century.

Timurid silver bracelet with dragon's-head terminals. Iran or Central Asia, 15th century.

Silver seal ring with dragon's-head buttresses. Anatolia or Iran, 14th–15th century.

OTTOMAN, MUGHAL AND QAJAR JEWELLERY

The Ottomans had a great taste for jewel-encrusted objects, which can be seen on a wide variety of examples ranging from jugs to weapons to bookbindings. However, they wore comparatively little jewellery apart from belts and turban ornaments; medals were popular from the 19th century onwards. Turban ornaments were attached to the headgear by a pin or prong, and used to hold feathers and plumes, the most treasured being those of the

Ottoman silver-gilt belt buckle, set with a jade plaque and turquoises, coral beads, rubies and glass paste. Turkey, c. 1700.

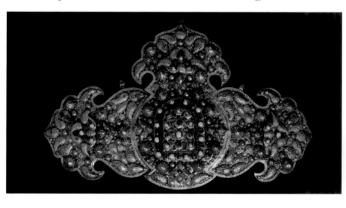

black heron. Examples from the 16th and early 17th century are often bud-shaped, while those of the late 17th or early 18th century are typically in the form of a medallion and encrusted with gems. Belts were sometimes made from densely plaited or knitted wire. Pocket watches, their cases decorated with jewels or enamels, were also popular during the later Ottoman and Qajar periods.

Mughal jewellery is some of the most opulent ever produced, and the Mughal emperors and other figures at their court were decked out in an abundance of jewellery – far more than was worn during any other period across the Islamic world. Strings of pearls formed both necklaces and bracelets, and pearl earrings were worn around the edge of the ear as well as in the lobe. Precious stones including rubies, emeralds and sapphires were used in profusion, the rich mines of the Indian subcontinent being complemented by emeralds from the New World. The Mughal emperors were great collectors of precious stones – according to the 17th-century French traveller Jean-Baptiste Tavernier, Shah Jahan (1628–57) was a particularly fine connoisseur of jewels – and often had their names engraved on them. An auspicious nine-stone combination known as the

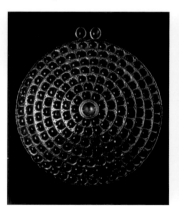

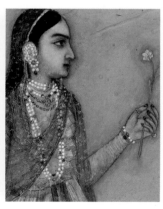

Miniature portrait of Sultan Abdül-mecid I wearing a jewelled aigrette and two medals, set into a mount with diamonds and made into a brooch; signed by Sebuh Menas. Istanbul, dated 1854–5.

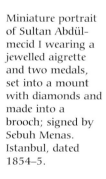

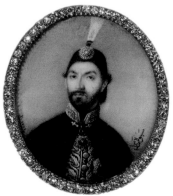

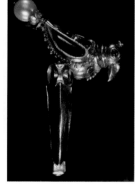

Above left: Mughal gold pendant set with rubies and a diamond. India, 17th–early 18th century.

Above right: Detail of an album painting, showing a court lady wearing jewelled and pearl-strung ear ornaments, necklaces, bracelet and several rings, including a thumb ring similar to those worn for archery. Mughal India, c. 1630.

Left: Front and side views of a gold ring with a bezel in the shape of a hawk or a parakeet, set with rubies, turquoises, New World emeralds and a pearl. India (Mysore) 17th century.

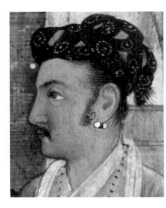

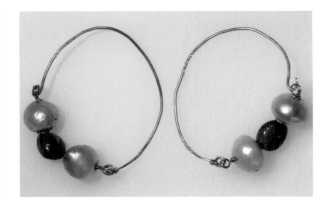

Far left: Large spinel bead, engraved with the names and titles of the Mughal emperors Jahangir and Shah Jahan. India, dated 1615 and 1632–3.

Centre: Detail from a *Khamse* of Nizami, showing the young Jahangir wearing hoop earrings with pearls and a ruby. India, c. 1640–45.

Left: Pair of Mughal gold hoop earrings with pearls and spinels. India, 18th century.

navaratna was a Hindu tradition which was often used in Mughal jewellery.

Nadir Shah melted down the gold from a large quantity of Mughal jewellery when he sacked Delhi in 1739 but the stones themselves survived, including pieces which now form part of the Crown Jewels of Iran, and examples in the Hermitage. Our knowledge of pieces before this date is once again supplemented by miniature paintings and literary references.

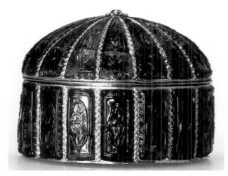

Mughal gold box and cover with 103 perfectly matched emeralds; the base (right) is engraved under translucent enamel. India, c. 1635.

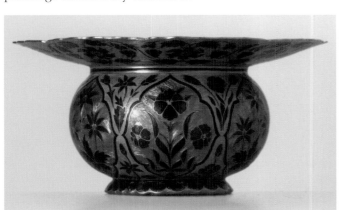

Gold spittoon, with translucent and opaque basse taille enamels. North India, c. 1700.

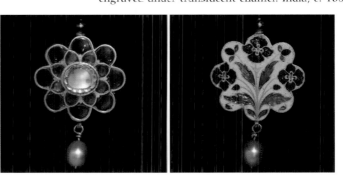

Mughal gold pendant set with rubies, emeralds, a diamond and a pearl, the back enamelled with a stylized poppy plant. India, c. 1640.

Mughal emerald pendant (weighing 164.33 carats), carved with a flowering plant on one side and a double rosette on the other. India, c. 1650.

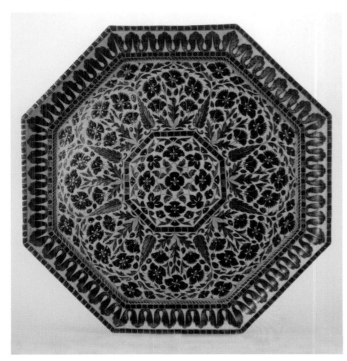

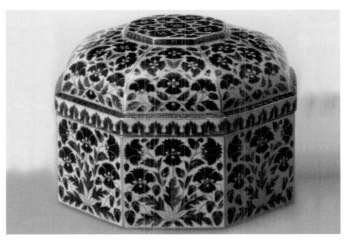

Far left and left: Mughal enamelled gold tray and casket (*pandan*). India, Jaipur, c. 1700.

As with the Ottomans, turban ornaments were a prominent feature of the jewellery worn by men during the Mughal period. They were made from gold or jade and set with precious stones. Some were plume-shaped. Richly decorated thumb-rings, similar to Ottoman archers' rings, were also worn at the Mughal court. They were usually made of jade, although other materials such as agate or rock crystal were sometimes used and thumb-rings of silver and gold, set with stones and enhanced with enamels, were also quite common. Arm bands, which had been worn from the Safavid period, were very popular among the Mughals and Qajars. They were made from a variety of materials and were often set with semi-precious stones carved with religious or talismanic inscriptions. Some include a small box that housed a miniature Qur'an.

From the 17th century the work of Islamic jewellers was increasingly influenced by European forms and techniques. European jewellers were present at the Mughal court during this period, and Tavernier himself traded jewels at the Safavid court. The use of enamelled decoration (predominantly basse taille, but also sometimes cloisonné) is a distinctive feature of Mughal jewellery, and was probably introduced by European craftsmen. It was often combined with the use of precious stones. Painted enamels were particularly common in Qajar Iran, and Qajar enamelled jewellery frequently includes portraiture, similar to large-format paintings produced for the court.

Carved Ivory and Jade

Carved ivory featured in a number of Islamic art forms. Some of the most beautiful examples are carved ivory pyxes and caskets from Umayyad Spain, which have survived in some number from the 10th century. Many were made at Madinat al-Zahra. Their decoration typically includes confronted birds and animals amid intertwined foliage, with an inscription band in Kufic, and sometimes figural groups are depicted within lobed cartouches.

The Muslim territories in Central Asia were particularly rich in jade, which was greatly treasured. The surface of jade objects is usually highly polished, and carved decoration typically restricted to small areas, in order to highlight the beauty of the stone itself.

Among the jade objects most closely associated with Timurid, Turkmen and Ottoman taste during the 15th century are cups with dragon handles. Some are inlaid with gold. Ottoman and Mughal jade vessels from the 16th and 17th centuries are relatively heavy, with more formal carving or inlaid and jewel-encrusted decoration. In contrast, later Mughal pieces, especially from the mid-17th century onwards, tend to be more thinly carved and highly polished. An exquisite cup in pale nephrite jade made for Shah Jahan, the base of which is shaped as a lotus flower and the handle in the form of the head of an ibex, is now in the Victoria & Albert Museum, London.

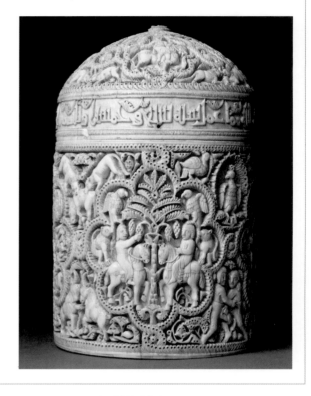

Box (pyx) of ivory carved with figural groups, the so-called Pyx of al-Mughira. Umayyad Spain, 960s–70s.

Gold-inlaid jade cup with dragon handle. Ottoman Turkey or Aq Qoyunlu Tabriz, 15th century.

Gold turban ornament (*sarpech*), set with diamonds, rubies and emeralds, the tip in the shape of a dragon's head holding an emerald between its jaws. South India, early 19th century.

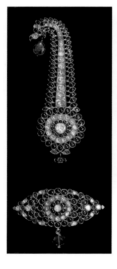

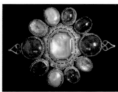

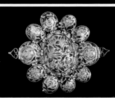

Qajar enamelled gold element from an arm band, the stone setting reminiscent of the Indian *navaratna*. Iran, 19th century.

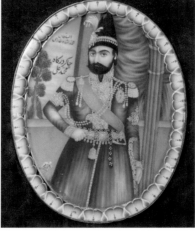

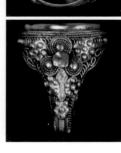

Left: Pair of enamelled gold bracelets. Sind, 19th century.

Below left: Enamelled gold miniature portrait of Muhammad Shah Qajar wearing a frock coat with diamond-set collar, front, cuffs, epaulettes and armbands, an astrakhan cap with a jewelled aigrette, and a similar medallion with a portrait of his grandfather, Fath 'Ali Shah; signed by Muhammad 'Ali. Iran, c. 1834–48.

Left: Gold ring, set with an emerald seal of Fath 'Ali Shah Qajar reading, 'Glory be to God. The king of the kings of the world, Fath 'Ali'. Iran, dated 1822–3.

JEWELLERY OF THE 19TH AND 20TH CENTURIES

During the late 19th and early 20th century the influence of Art Deco appeared in Islamic jewellery – for example, in the large claws which feature on Qajar rings from this period – and modern techniques such as 'engine-turning' (which gives a hatched texture) were introduced. Nevertheless, many centres across the Islamic world maintained older traditions. Particularly noteworthy is the large, heavy Turkmen jewellery of eastern Iran and Central Asia, and the jewellery of the Arabian peninsula.

Champlevé enamelling became a feature of Moroccan jewellery from the 17th century onwards, and the fibula, a type of brooch which holds clothing in place, is an ancient form which remains typical of the jewellery of North Africa.

Right: Gold filigree pendant in the shape of a double-headed eagle, set with emeralds and rubies. Morocco, 17th century.

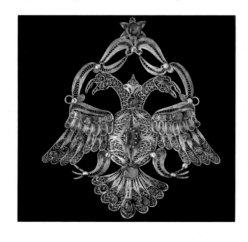

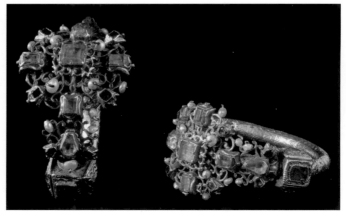

Left: Pair of gold ear ornaments, set with emeralds, rubies and pearls. Morocco, 18th century.

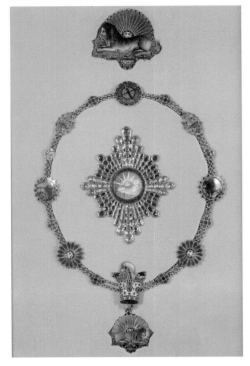

Enamelled gold insignia of the Order of the Lion and the Sun, comprising a badge signed by Muhammad Ja'far, a star and a collar, presented by Fath 'Ali Shah Qajar to Sir John Kinneir MacDonald, the envoy of the East India Company to Iran between 1824–30. Iran, Tehran, dated 1826–7.

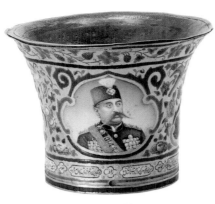

Enamelled gold water-pipe (qalyan) cup, painted with the portrait of the Qajar ruler Muzaffar al-Din Shah; signed by Ghulam Husayn Mina-kar Bashi ('Chief Enameller'). Iran, dated 1901–2.

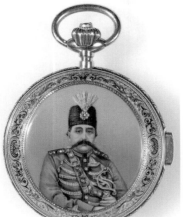 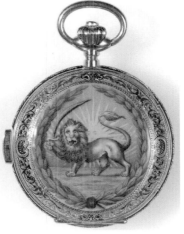

Enamelled gold watch, painted with the portrait of the Qajar ruler Muzaffar al-Din Shah (front) and the Qajar lion-and-sun device (back). Switzerland, late 19th–early 20th century.

Qajar enamelled gold earrings. Iran, 19th century.

Far left: Silver cast and engraved ring, set with a carnelian seal of the commercial agent of the Russian government in Yazd. Iran, dated 1888–9.

Centre left: A massive silver ring inspired by European styles of the 1930s, set with a 15th-century jade seal stone. Iran, 20th century.

Left: Pair of silver-gilt bracelets (covering the arm from the wrist to the elbow), each made of eight bands set with carnelians. Turkmen, late 19th century.

Seals

Seals – which functioned as a personal signature, and were applied to wax, clay and paper – have a long tradition in the Near East. They were typically carved in semi-precious stones, in particular carnelian, although examples in metal have also survived. These stones were associated with magical or talismanic properties. An example in the Khalili Collection, the seal of Shah Tahmasp I dated 1555–6, is cut from flawless rock crystal. Seal stones were most commonly set in rings. From the Mongol period onwards the use of Chinese-style ink seal rings – on which a wire or metal inscription stands in relief – also became common.

Left: Lapis lazuli pendant engraved with a Qur'anic *sura* in Kufic script, and set in gold. Iran, 10th century.

Below: Seal of the Safavid Shah Tahmasp I, wheel-cut in flawless rock crystal, with his name in the centre and four lines of Persian verse in the corners. Iran, dated 1555–6.

Below left: Fatimid cast gold seal ring, inscribed with a woman's name, Zubayda. Egypt, 12th century.

Below right: Gold ink seal ring with a wire inscription reading, 'Ali. Iran, 14th century.

Right: Safavid carnelian seal stone inscribed with an invocation to 'Ali, around a central inscription reading, 'He who is content earns respect'. Iran, 16th century.

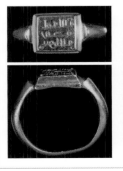 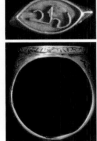 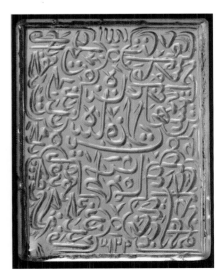

Carpets and Textiles

Carpets have become almost synonymous with Islamic art, although the history of fine rugs and other textiles is of course much older than the beginning of the Islamic period. The earliest known woollen rug was discovered in the Pazyryk burials of southern Siberia, and was probably made in eastern Iran in the 5th–4th century BC. Egypt has a long tradition of textile manufacture, and was producing woven tapestries at least as early as the 2nd millennium BC. Silk had been imported from China for centuries, and its production is said to have been introduced into the West by the Byzantine emperor Justinian (527–65). And Iran has a long and highly distinguished association with silk manufacture. Historical sources refer to a huge carpet – depicting a lush garden with irrigation channels – in the audience hall of the Sasanian palace at Ctesiphon, which was found by the invading Arab armies in 642 AD. (Whether this was indeed a carpet or in fact a tapestry or wall hanging remains uncertain.)

Surviving examples of textiles from the early Islamic period are rare. One such piece, a woollen tunic in the Khalili Collection, probably survived only because it was used as a shroud and buried in the hot, dry Egyptian sand. Large prayer rugs with multiple niches, known as *saff* (from the Arabic for 'row'), were certainly manufactured from this time. Fragments of carpets have been unearthed at Fustat and dated to the 9th or 10th century, although their provenance remains uncertain. Silk fragments from the late 7th to mid-8th century, perhaps made in Tunisia and now in the Victoria and Albert Museum, London, feature large roundels that clearly follow Sasanian tradition. A well-known silk fragment associated with the relics of St Amon in the cathedral at Toul, France (now in the Musée Historique Lorrain, Nancy) bears roundels with confronted lions. It may have been made in Transoxania, perhaps near Bukhara, in the 8th or 9th century.

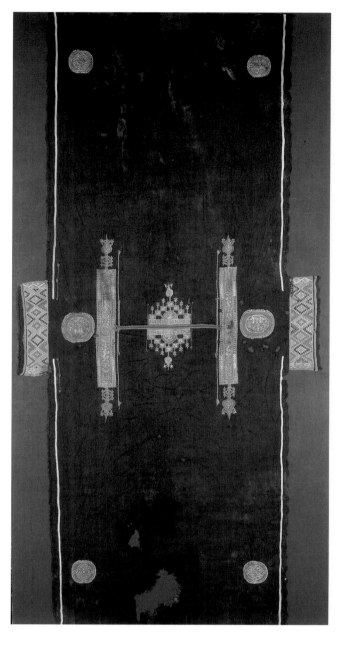

Left: Woollen tunic (not sewn), plain and tapestry weave. Upper Egypt, 8th–9th century.

Left: Fragment of textile with bird, in Sasanian style. Iran, 7–8th century.

Warp, Weft and Knots

Carpets are made on vertical or horizontal looms, over which threads, usually made of cotton and known as the warp, are stretched lengthways. A second, transverse set of threads, known as the weft, is then woven over and under the warp. Short lengths of wool or silk looped (or, less accurately, 'tied') around pairs of the warp threads are called 'knots', and form the pile. Two different types of knot are used: symmetrical, also known as the 'Turkish' or 'Ghiordes' knot; and asymmetrical, known as the 'Persian' or 'Sehna' knot. In the first case, the length of wool is looped symmetrically around two pairs of warps; in the second, the end is wound around only one pair of warps, and passes behind the other. As a very general rule, the symmetrical knot is favoured in Turkish rugs, in rugs from the Caucasus, and in some Persian rugs including those from Tabriz and Herat; the asymmetrical knot is favoured in most Persian rugs, in rugs from Central Asia and from Mughal India, and also in Mamluk carpets. However, both types of knot can also appear on the same carpet. The density of knots can vary considerably, from less than 50 to over 1,000 per square inch.

Flat-weave carpets or *kilims* are woven rather like a tapestry: that is, the weft itself forms the design as well as being integral to the structure, without the use of 'knots' to create a pile. The weft of each coloured area of the design is woven back on itself at the border with a different colour, and does not necessarily pass across the whole width of the loom. A slight division or slit is thus discernible between adjacent colours, from which the technique is sometimes termed 'slit-tapestry' weave.

CARPETS

Illustrations from the 'Demotte' *Shahname* suggest that during the 13th and 14th centuries floor coverings in Ilkhanid Iran had fields of chevrons or knot-motifs, borders with Kufic inscriptions, and sometimes animal motifs; whether or not these were actually pile carpets remains uncertain. Carpets produced in Anatolia at this time feature repeating designs of well-spaced geometric motifs, including stars and interlace patterns.

Below: Ottoman wool and cotton 'prayer rug' with plain niche. Cairo, 16th–early 17th century.

In contrast, Mamluk rugs have complex, centralized designs based on octagonal or star-shaped medallions, surrounded by flanking bands which often contain cartouches. The colour scheme is dominated by a highly saturated red (which owes its depth to the use of lac, imported from India), along with green and blue and, later, yellow. Other distinctive features include the use of the papyrus motif; the absence of monumental inscriptions, so characteristic of Mamluk art in other media; and the use of the asymmetrical or Persian knot. An outstanding piece from the later 15th century, the 'Simonetti' carpet (approximately 9m long), has been extremely well preserved. It was probably made during the reign of Qaytbay (1468–96), and is now in the Metropolitan Museum of Art, New York. The exact

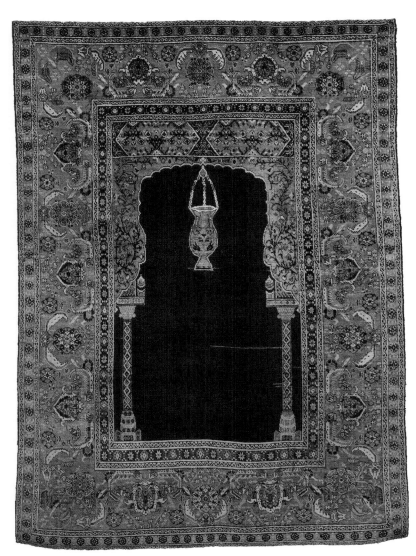

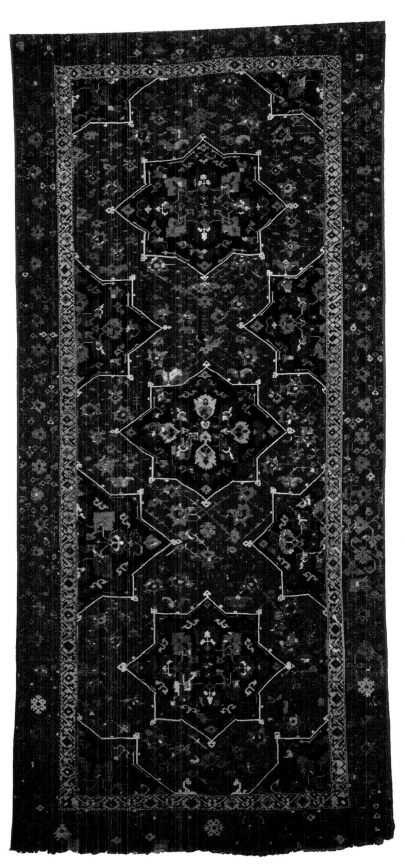

Above: Woollen star-medallion carpet. Western Anatolia, Uşak, late 15th–16th century.

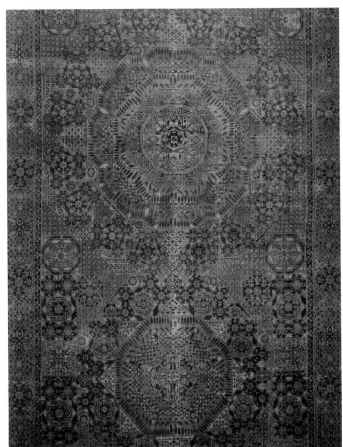

Left: Detail of Mamluk woollen pile carpet. Egypt, 16th century.

Far right: Ottoman wool and cotton 'prayer rug' with floral niche. Cairo, 16th–early 17th century.

Below left: Woollen pile 'Ardabil' carpet. Iran, probably Kashan, 1535–6.

Below right: Wool and metal thread medallion carpet, from the same workshop as the 'Ardabil' carpets. Iran, Kashan, 16th century.

provenance of Mamluk carpets remains a matter of some dispute among scholars.

The luxurious Ottoman rugs known as 'Uşak' carpets were produced in the town of Uşak in western Anatolia, which was an established centre for carpet weaving from at least the late 15th century. A number of different types of Uşak carpet were made, the majority characterized by their bold star or medallion motifs. The former are generally eight-pointed, the latter usually ogival. Variants on these patterns are also found, and may in fact be slightly earlier than the better-known eight-pointed star designs. The production of 'star' and 'medallion' Uşaks continued for over 200 years, and many examples have survived, particularly in Italy.

Ottoman carpets were imported into Europe in considerable quantities, and they appear in a number of paintings by European artists, often depicted in minute detail. The paintings have thus played an important role in dating surviving Ottoman rugs. One group in particular

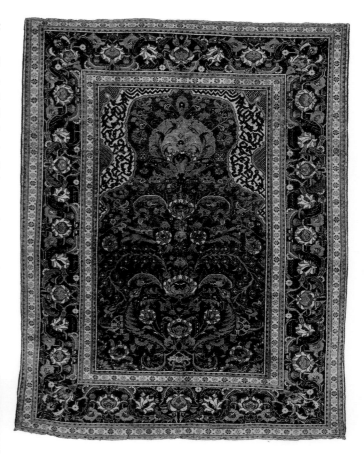

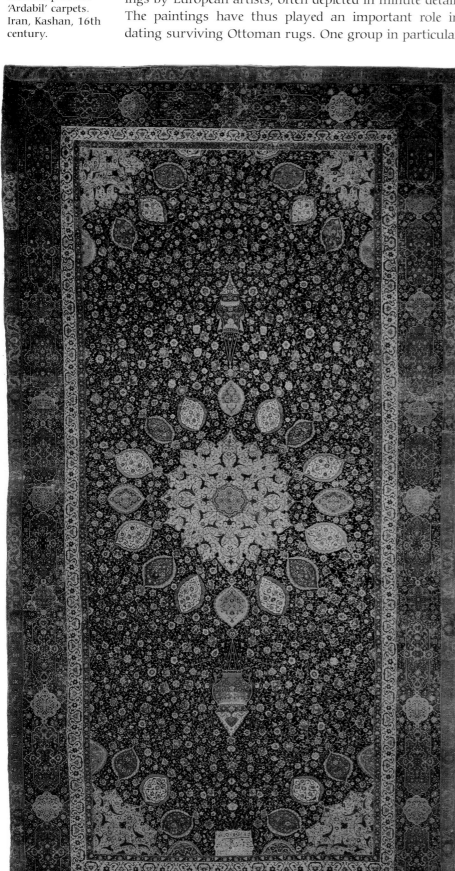

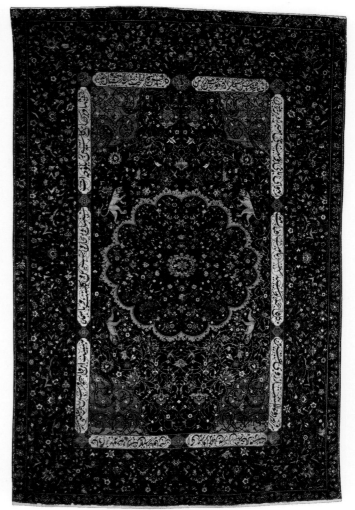

are known as 'Holbeins' after the painter Hans Holbein the Younger (1497–1543), in many of whose works they feature prominently.

'Court' carpets were produced from the 16th century, originally in Cairo, although later some of the finest examples may have been produced in Bursa or Istanbul. They are characterized by the *saz* style popular at the Ottoman court around the mid-16th century. Many incorporate in their design a *mihrab*-like niche on the longer axis. These niche rugs are often referred to as 'prayer' rugs, although there is no evidence that they were in fact used for prayer. Some examples have plain fields, typically red, the most famous being that in the Museum für Islamische Kunst, Berlin; others have floral fields, the best-known example being a piece in the

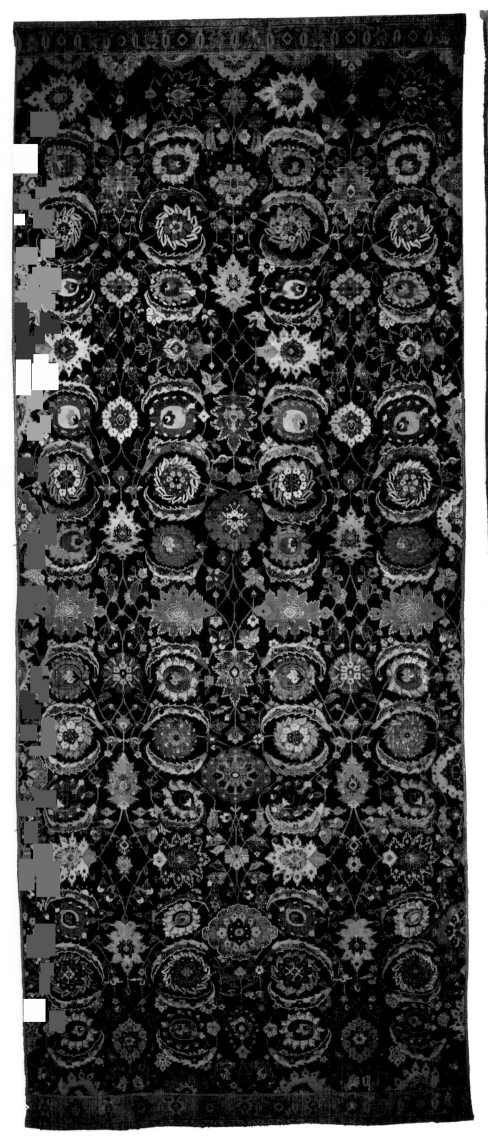

Safavid wool pile carpet with all-over pattern of flowers and leaves.
Iran, perhaps Kirman, 17th century.

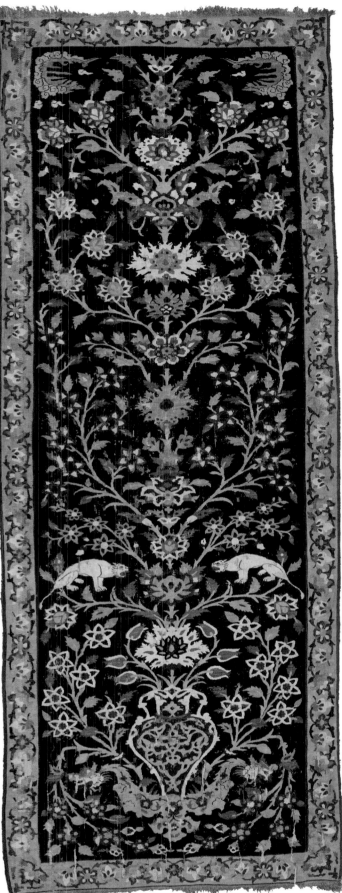

Silk *kilim* with flowers, chinoiserie clouds and two felines.
Iran or Turkey, 16th century.

Museum für Angewandte Kunst, Vienna.

'Village' rugs and *kilims* (see 'Warp, Weft and Knots') were produced in the villages of western Anatolia and feature strong colours, stepped lines, and various zoomorphic motifs drawn largely from the repertoire of nomadic and steppe art. A number of *kilims* were also produced in the 'Court' style. A remarkable example in the Khalili Collection has a composition dominated by chinoiserie elements.

Other types of rug produced during the later Ottoman period include 'Shield' carpets made in the eastern Caucasus during the 17th and 18th centuries, which bear motifs of large, shield-like palmettes; and 'Transylvanian' carpets, some of which have niche designs with various numbers of columns. A large number have survived in

churches in Transylvania, although they were almost certainly produced within Turkey.

Some magnificent carpets were produced in Safavid Iran. Best known among these are the two 'Ardabil' carpets, now in the Victoria and Albert Museum, London, and the Los Angeles County Museum of Art. These huge works (over 10.5 x 5m) were commissioned by Shah Tahmasp I for the mosque-mausoleum of Shaykh Safi at Ardabil. They are signed 'the work of Maqsud of Kashan', and dated 1535–6. They were probably woven at Kashan. The central 'medallion' designs of the Ardabil and other carpets – with a sun-disc (*shamsa*), rosette or star within framing bands – mirror the format of book covers and illuminated frontispieces. The main field of a related carpet in the Khalili Collection, smaller in size but exquisitely preserved, is surrounded by verse inscriptions in lobed cartouches and, as on the Ardabil carpets, has four corner pieces shaped as 'cloud collars'.

Other important centres of Safavid carpet production

were the cities of Yazd, Kirman and Isfahan. One group of carpets has an all-over design of vegetal motifs, such as vines with lotus blossoms and sickle-shaped leaves, or palmette scrolls. 'Vase' carpets are thought to have been woven in Kirman, and feature a one-directional design of spiralling vines which emanate from vases. One of the most commonly exported types of Safavid carpet was the so-called 'Polonaise' carpet, characterized by a main field of arabesques of flowers and leaves, with central medallions and quarter medallions at the corners, enclosed by borders. They have a vivid palette (although in most cases this has now faded), and were typically knotted in silk, often with silver and gold brocading.

Carpets were probably introduced into the Indian subcontinent during the Delhi Sultanate (1206–1555); under the Mughals their production attained great refinement, and during the reign of Akbar (1556–1605) weavers were brought from Iran and carpet factories were established in a number of cities including Fatehpur Sikri, Lahore and Agra. Carpets with pictorial designs were produced at this time, their fields inhabited by naturalistic plants and animals drawn from the world of contemporary Iranian and Indian miniatures. From the reign of Shah Jahan (1628–57) onwards, one group of Mughal carpets was characterized by extremely detailed and naturalistic portrayals of individual plant species, framed within a niche.

TEXTILES AND EMBROIDERIES

A number of linen pieces with inscription bands (*tiraz*) in silk have survived from the Fatimid period. Some include caliphs' names and can thus be dated with considerable accuracy. Perhaps the best-known example is the 'Veil of St Anne', dated 1096–7, now in the Church of St Anne at Apt, in southern France.

Silk manufacture was introduced to Spain following the Muslim conquest, and Coptic textile workers were brought there from Egypt in the 10th century. According to records from Cairo, Spain was a leading textile

Below: Part of a woollen pile carpet with cypress trees, birds and plants. Iran, 18th century.

Below left: Part of a painted-cotton 'summer carpet'. India, Deccan, 1730–40.

Below right: Silk and metal thread 'Polonaise' prayer rug. Iran, early 17th century.

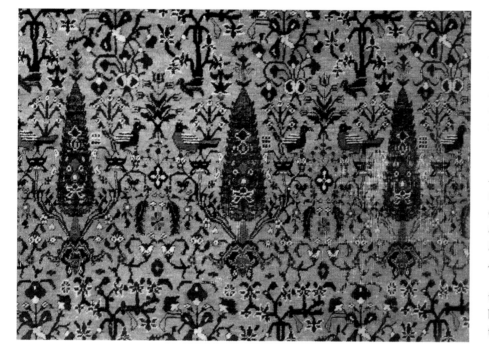

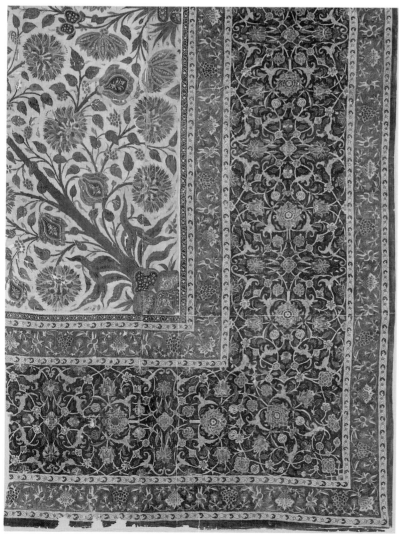

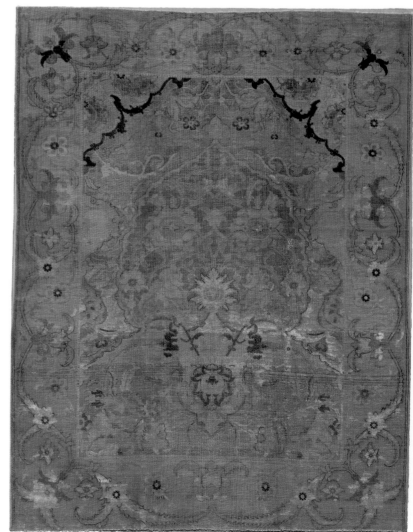

Right: Part of a woollen pile carpet. Iran, Isfahan or Herat, early 17th century.

Bottom right: Silk pile prayer rug. India, 17th century.

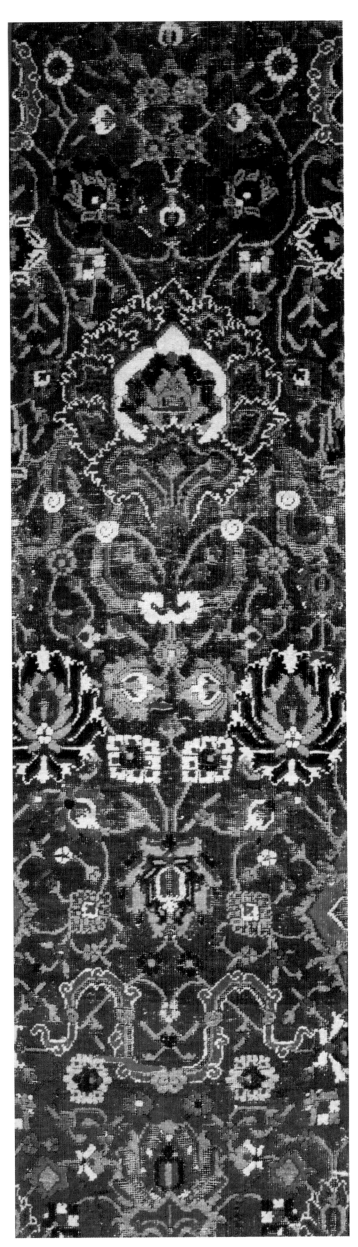

producer during the 12th century, under Almoravid and subsequently Almohad rule. Of particular importance was the town of Almería, which had almost 3,000 looms for the production of silk garments, precious brocades and other textiles. Granada, Seville and Malaga were also key centres of silk production. Many examples have survived because, like the silk fragment from Toul Cathedral (see above), they were used to wrap the relics of various Christian saints. Others were used as church vestments. The designs feature rows of octagons, bands of Kufic script, and human and animal figures including peacocks, lions and bears. It is possible that, following the expulsion of a large part of the Muslim and Jewish population from Spain, many of the textile workshops moved to Morocco.

The few surviving silk textiles from 12th-century Iran feature the arrangement of circular medallions, each enclosing representations of animals, familiar from Sasanian textiles but the overall designs show greater density and detail. The medallions alternate with vegetal designs or smaller animals, and sometimes lines of Kufic script. Silks have also survived from 13th- and 14th-century Anatolia, decorated with double-headed eagles or paired lions in roundels. There is a fine example in the Musée Historique des Tissus, Lyons.

Among the surviving silks from the Mamluk period, a number bear a lattice design formed from a repeating almond-shaped motif and derived from a stylized chinoiserie lotus. This 'ogival lattice' was to prove extremely popular during the Ottoman period. Chinoiserie elements are also found. Other Mamluk textile fragments include garments in striped silk, and cotton or linen with block-printed designs.

Silk weavers were transferred to Isfahan from Julfa in Azerbaijan by Shah 'Abbas I (1588–1629) to revive the Iranian silk industry. The silks made in Safavid Iran during the late 16th and 17th centuries show a remarkable degree of naturalism in their designs, with many parallels to Safavid miniature painting. In some cases,

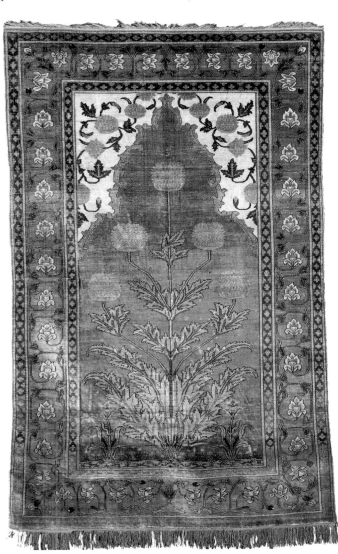

miniature painters actually designed the patterns for the silk weavers. Typical subjects include birds and animals placed among elaborate foliage and flowers, and figural subjects derived from illustrated manuscripts.

Silk brocades and velvets were highly prized by the Ottomans. Floral designs predominate, with many parallels to those found on Iznik pottery, but in contrast to the naturalism that characterizes Safavid textiles they remain comparatively formal and stylized. The designs are typically in red, blue, black and gold; backgrounds are usually blue, green and yellow. The 'ogival lattice' design popular under the Mamluks is also found on many Ottoman silks. Bursa was probably the main production centre, although the island of Chios may also

have played an important role. Velvets with repeating designs were also produced in Bursa. These were made as yardage, and used for a variety of purposes, including cushion covers.

Other kinds of textile were of course produced in many regions of the Islamic world. Among them are exceptionally beautiful batik designs from Java, which continue to be produced to the present day; silk embroideries probably used as bridal coverlets in Ottoman Turkey; and the *suzanis* of 19th-century Uzbekistan. *Suzanis* are large, silk-embroidered cotton or linen wall-hangings, bedspreads and other furnishings. They were particularly associated with wedding ceremonies, and formed an integral part of a dowry. Algeria also produced embroideries from the early 17th century.

Opposite page, left: Timurid silk brocade with ogival medallions. Iran or Central Asia, 15th century.

Opposite page, top right: Safavid silk brocade with gold thread. Iran, late 16th–17th century.

Opposite page, bottom right: Safavid silk brocade with gold and silver thread. Iran, 17th century.

Left: Linen cloth with silk inscription (*tiraz*). Egypt, 11th century, probably period of al-Mustansir.

Linen cloth with tapestry-woven bands in silk, and inscription reading 'help from God'. Egypt, 12th century.

Silk textile with signature of maker, 'the work of Abi Muti''. Iran, 11th century.

Mongol or Ilkhanid silk and gold brocade with confronted parrots. Iran, 13th–early 14th century.

Ilkhanid brocade with palmettes in lattice. Iran, second half 13th century.

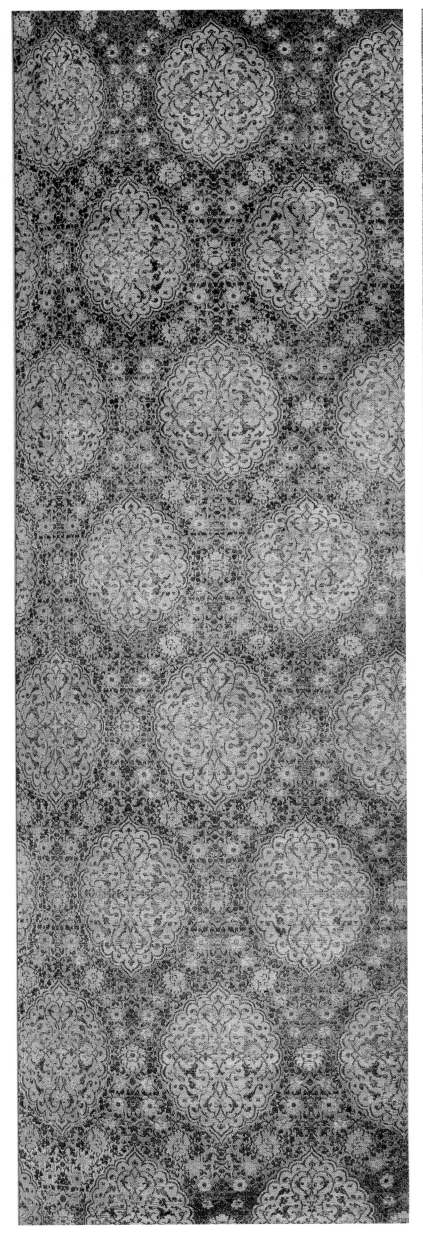

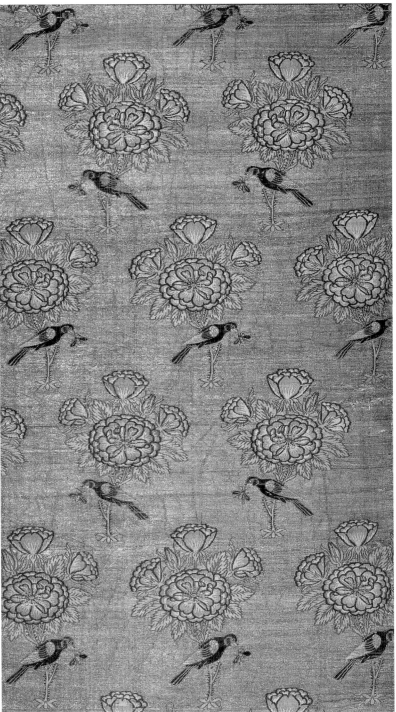

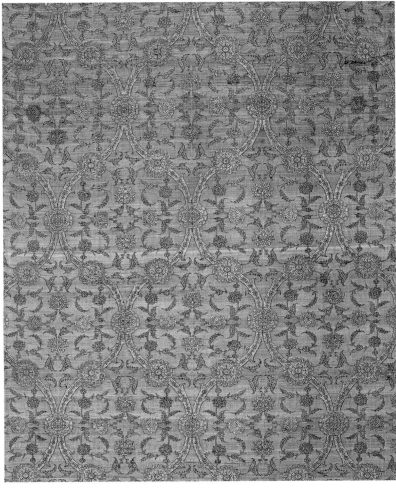

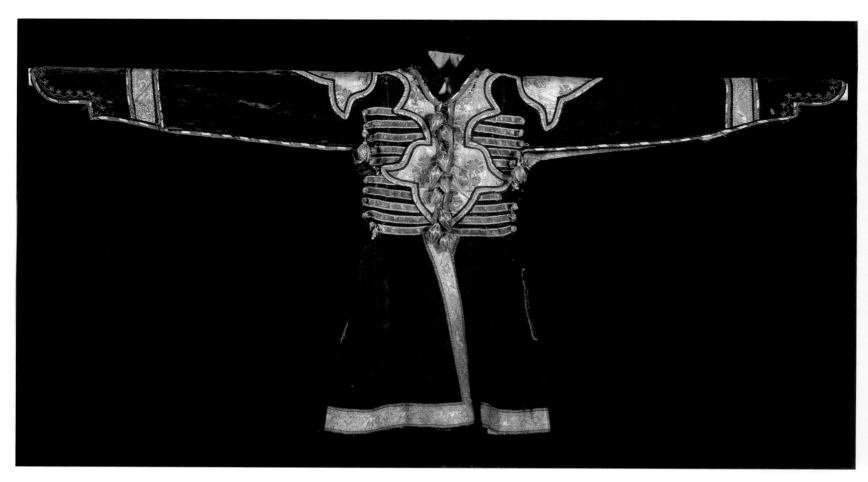

Safavid velvet coat with gold brocade appliqués. Iran, 17th century.

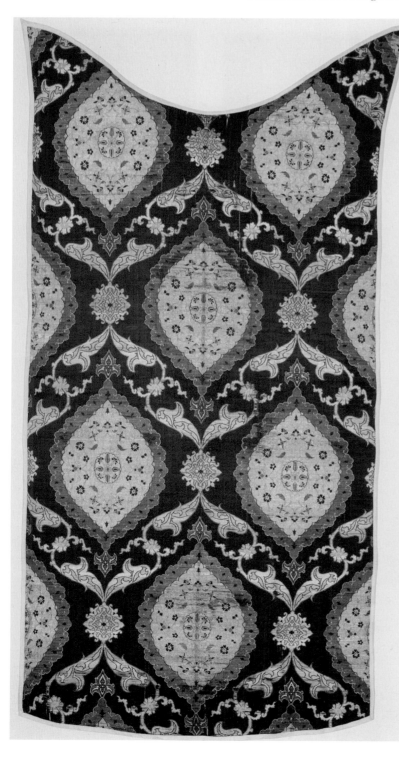

Left: Ottoman silk brocade with silver thread: section from a chasuble. Turkey, Bursa, 16th century.

Above: Ottoman silk brocade. Turkey, Bursa, 16th century.

Calligraphic silk textile, with repeating word, 'God'. Possibly North Africa, 18th century.

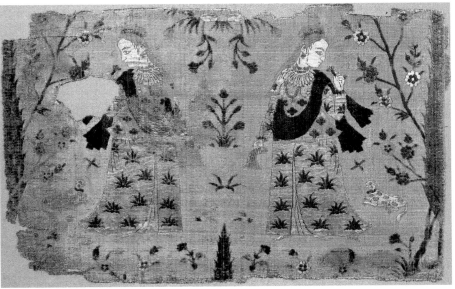

Above: Silk velvet, with two figures among cypress trees and flowers. Iran or India, 16th–17th century.

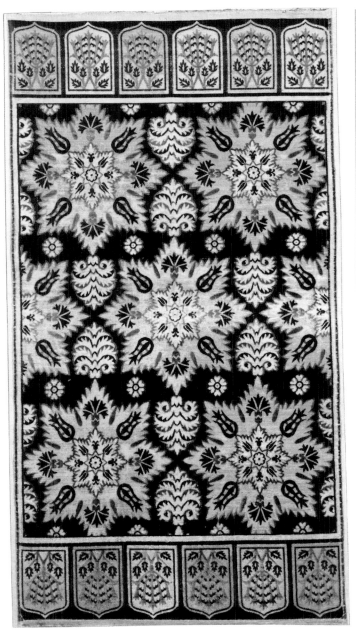

Left: Ottoman silk velvet cushion cover. Turkey, Bursa, 16th or 17th century.

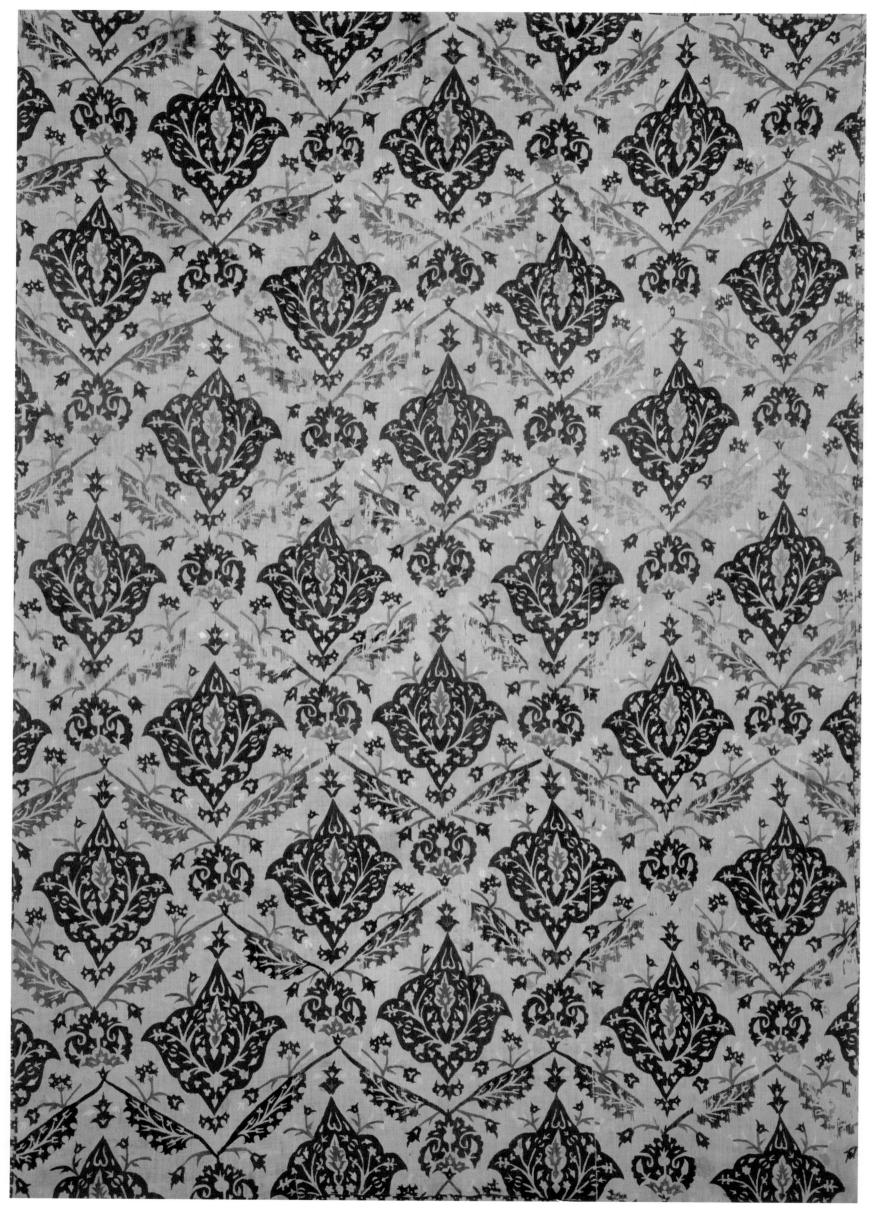

Ottoman silk–embroidered linen bridal coverlet. Possibly Epirus region of northern Greece, 16th or 17th century.

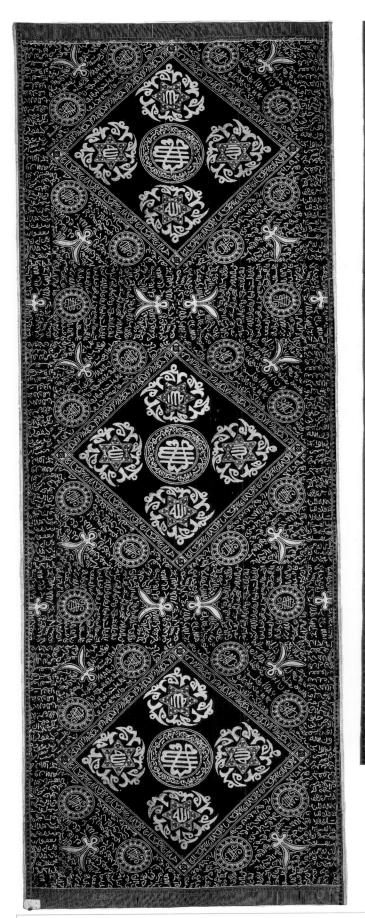

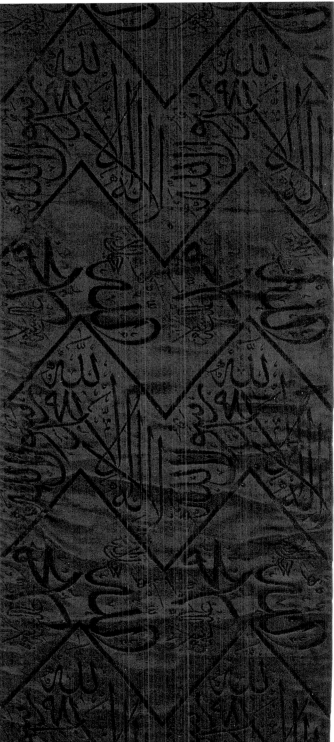

Far left: Cotton batik cloth. Java, early 20th century.

Left: Section from an Ottoman black silk cenotaph cover. Ottoman provinces, 18th century.

The Hizam

The *hizam* is a band formed from eight large textile panels decorating the upper part of the *kiswa* ('veil') of the Ka'ba. Together with the *kiswa* and the *sitara* (the curtain which covers the external door of the Ka'ba), it is replaced each year during the pilgrimage to Mecca. Under the Mamluks, the *hizam* was a woven textile, and was made in Cairo; following the Ottoman conquest of Egypt in 1517, it was made in Istanbul or Damascus, and during the later period it was embroidered. In the 19th century production seems to have taken place in Cairo once more.

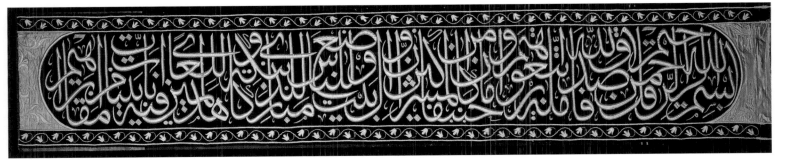

Silk panel embroidered with gold and silver thread, from the *hizam* of the *kiswa*. Egypt, 19th century.

Tents

The tent has maintained its importance both as a dwelling and for ceremonial occasions throughout the history of Islam. The Ilkhanid ruler Ghazan Khan (1295–1304) is reported to have had a tent made from gold cloth, so elaborate that it took a month to pitch; and the Spanish ambassador Ruy Gonzalez de Clavijo, who visited Timur's court in 1404, writes of vast tents with silken walls which imitated castles in their design. Magnificent hangings of brocaded silk are thought to have formed the walls of Ottoman campaign tents at the siege of Vienna in 1683.

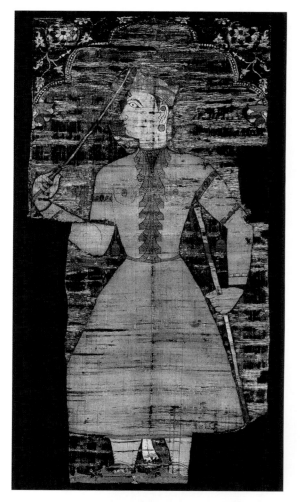

Right: Silk panel from a tent with a standing female figure. Mughal India, late 16th century.

Below: Silk brocade *saff* or wall-hanging. Probably Morocco, 16th or 17th century.

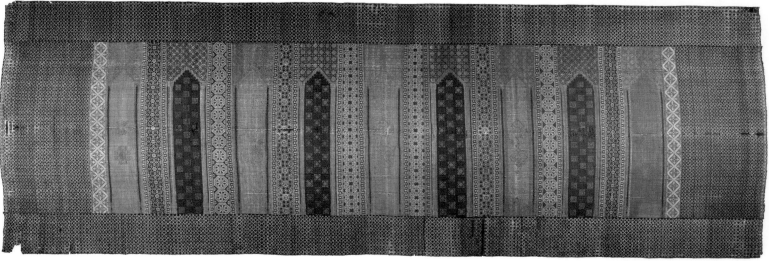

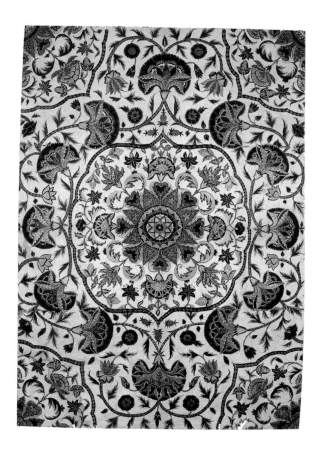

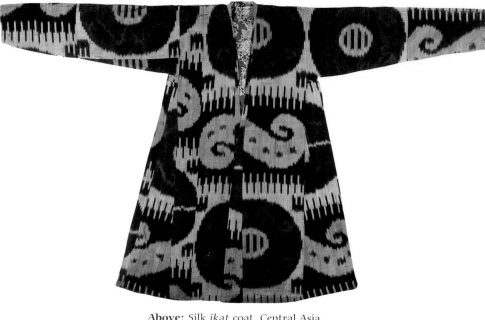

Above: Silk *ikat* coat. Central Asia, 19th century.

Left: Silk embroidery. India, Goa, 17th century.

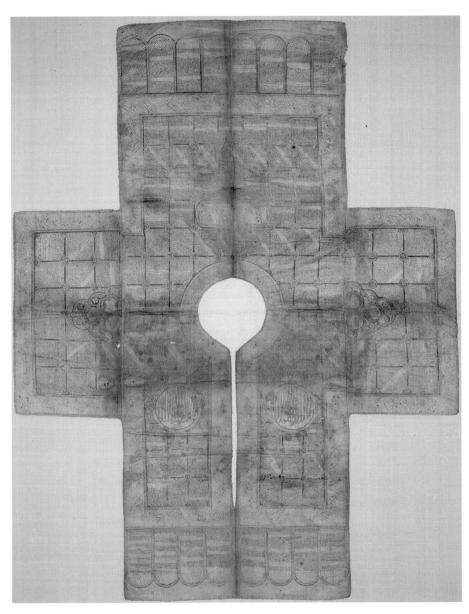

PRINTED AND PAINTED TEXTILES

Textiles were also decorated with printed and painted designs. Among the latter are shirts, usually of cotton, inscribed in ink with verses from the Qur'an, prayers and the attributes of God, together with *vefk* (talismanic squares containing letters and numerals) and other geometric and floral decoration. Such talismanic shirts were believed to protect the wearer and appear to have been worn on military campaigns by both Ottoman and Safavid rulers. Talismanic coats were also worn by dervishes. An example in the Khalili Collection belonged to a member of the Yasavi order (founded by Ahmad Yasavi during the 12th century, at Yasi, the modern city of Turkistan in Kazakhstan). It is decorated with large medallions and inscriptions.

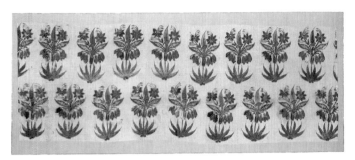

Above: Painted cotton textile showing rows of flowering plants. Mughal India, 17th–18th century.

Left: Inscribed cotton talismanic shirt (not sewn). India, Sultanate or early Mughal period, 15th–16th centuries.

Below: Painted and printed cotton calligraphic coat for a *shaykh* of the Yasavi order. Bukhara, 18th century.

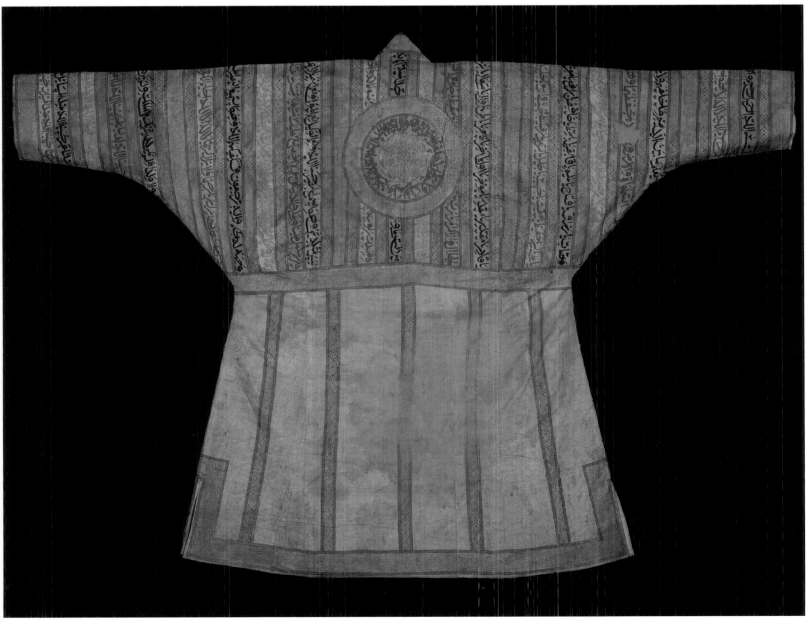

Coins

The earliest of all coins were probably those introduced by the Lydians in western Asia Minor during the 7th century BC. They were made from electrum, an alloy containing gold and silver, but by about 550 BC the Lydians were producing pure gold and silver coins. The use of electrum and then of gold and silver coinage was soon adopted by the Greeks, and with the Persian defeat of Lydia in 547 BC gold and silver coinage spread to Iran. Thereafter, the use of coinage spread throughout most of the Graeco-Roman world and the Near East. The coinage current in the Hijaz at the beginning of the Islamic era was in fact that of Byzantium and Sasanian Iran, and the new Muslim rulers soon found a need not only to mint their own coins, but also to develop their own, distinctly Islamic, style of coinage.

Coin Terminology
Coins are made by placing a heated, blank metal disc – known as a 'flan' – between a pair of bronze or iron devices with engraved or sunk designs – called 'dies'; the upper die is then struck with a hammer. In some cases, the flan was incorrectly placed between the dies, resulting in only a portion of the design or inscription being transferred to the coin; such coins are described as 'off-flan'. Coins were also sometimes re-struck with a different design at a later date. Die-making developed into a considerable art, and die-makers sometimes signed their dies. The front and back of a coin are described as the 'obverse' and 'reverse', respectively.

The Umayyads initially adopted the local currency of the areas under their control, together with its nomenclature: the gold *dinar* and the copper *fals* (from the Byzantine *denarion* and *follis*), and the silver *dirham* (from the Sasanian *drachm*). At times during the early period, coins even included a portrait bust of a Byzantine or Sasanian monarch. In other cases, Byzantine or Sasanian prototypes were closely followed, but modified in certain ways – for example the replacement of Byzantine figures with Arab ones, and of Greek inscriptions with Arabic. During the administrative reforms of 'Abd al-Malik (685–705), however, a purely epigraphic coinage was introduced. Gold dinars struck in 696–7 featured an Arabic inscription written horizontally across the 'field' (that is, the centre of the coin), surrounded by circular legends. The inscriptions were drawn entirely from the Qur'an, the standard message being the *shahada* or Muslim profession of faith: 'There is no God but God, Muhammad is the messenger of God.' The date on which the coin was struck was also included. This was to remain, with very few exceptions, the standard pattern for Umayyad coinage.

The Abbasids continued to issue coinage in the style of that introduced under 'Abd al-Malik, although the lettering of the Kufic inscriptions across the centre of the coin tended to become more elongated during the second half of the 8th century, and greater emphasis was given to the second part of the *shahada*, 'Muhammad is the messenger of God.' The caliph al-Ma'mun (813–33) introduced the names of mints on gold and silver coins, along with an additional marginal inscription, 'God's is the command, past and future, and on that day the believers will rejoice in the victory granted by God.' Furthermore, al-Ma'mun forbade the naming of subordinate officials and local governors on gold and silver coinage. This style

Silver *dirham* (*drachm*) of 'Ubaydallah ibn Ziyad, with a Sasanian monarch on the obverse. Basra, AH 57 (AD 676–7).

Anonymous Arab-Byzantine copper *fals*, with a standing emperor holding a cross on the obverse. Damascus, no date.

Anonymous Umayyad silver *dirham*. Damascus, AH 79 (AD 698–9).

Abbasid gold *dinar* of al-Ma'mun, reform type, with a second marginal inscription introduced on the obverse. No mint name, AH 207 (AD 822–3).

Gold *solidus*, with two imperial portrait busts on the obverse and Latin marginal inscriptions. Ifriqiyyah (probably Carthage), no date, c. AD 699–705.

Almohad gold 'double' *dinar* of Abu Hafs 'Umar al-Murtada (AD 1248–66), square-in-circle type. No mint name or date.

Anonymous Arab-Byzantine gold *solidus* from the reign of 'Abd al-Malik (685–705), with three standing imperial figures on the obverse. No mint name or date, but almost certainly struck in Damascus.

Anonymous gold *dinar* from the reign of 'Abd al-Malik, the first truly Islamic type of coinage. No mint name, but almost certainly struck in Damascus, AH 77 (AD 696–7).

Abbasid gold *dinar* of al-Mahdi. No mint name, AH 160 (AD 776–7).

Abbasid silver *dirham* of the reign of al-Muqtadir (908–932), with his name and a bull on the obverse. This is a unique example in silver of a type otherwise known only in gold. No mint name or date.

Almoravid gold *dinar* of Abu Bakr ibn 'Umar al-Lamtuni. Madinat Fas (Fez), AH 472 (AD 1079–80).

Gold *dinar* (or *morabitino*) of Alfonso, 'son of Sancho', King of Castile and Leon. Tulaytula (Toledo), AD 1251.

The Right of *Sikka*

A ruler's entitlement to place his name on coins issued under his authority was known as the right of *sikka*. Along with his right to be named in the *khutba* – that part of Friday prayers acknowledging the ruler, sultan or caliph – the right of *sikka* became one of the most important emblems of independent sovereignty during the medieval Islamic period.

Fatimid gold *dinar* of al-Mustansir, with three circular inscription bands. Tarabulus (Tripoli), AH 444 (AD 1052–3).

Fatimid gold *dinar* of al-Amir bi-Ahkam Allah, with the Shi'a *kalima* on the obverse. Misr (Cairo), AH 503 (AD 1109–10).

was to remain largely unchanged throughout the Abbasid period.

North Africa and Islamic Spain, as so often in their history, remained an exception to some of the changes in the eastern Abbasid realms. Latin legends (often the *shahada*, or one section of it, written in Latin) and imperial portrait busts featured on many of the Umayyad coins of North Africa, even after the reforms of 'Abd al-Malik; and the Umayyads of Spain continued to issue coinage in the Umayyad style until the 10th century.

The Almoravids produced some highly refined gold coinage that was later imitated by the Christian rulers of Toledo. The gold *morabitino* of late 12th-century Christian Spain was modelled on the Almoravid dinar, and features Christian legends written in Arabic, together with the Christian cross. Later the Almohads adopted a square-in-circle design, with a refined *naskh* script and subsidiary inscriptions in the outer segments. This design remained current in Morocco until the 17th century.

Fatimid coinage from the reign of al-Mansur (946–53) onwards had particularly refined calligraphy, and a greater emphasis on the circular rather than the horizontal inscriptions. In some instances, beginning with coins issued during the reign of al-Mu'izz (953–75), horizontal inscriptions were abandoned altogether. This circular emphasis was adopted in the coinage of the Anatolian Seljuks, and even the Crusaders. In Sicily during the Norman period, Roger II (1130–54) issued gold coins known as *tari* (from the Arabic meaning 'pure'). These were based on Fatimid dinars, and featured legends in both Latin and Arabic. Central horizontal inscriptions regained their importance in Syria and Egypt during the late Ayyubid and Mamluk periods.

Cartouches containing inscriptions gained popularity from the reign of Saladin (1174–93) onwards, and coins from Aleppo during his reign feature a six-pointed star. Cartouches, often lobed, also became the hallmark of Ilkhanid coinage. Square Kufic appears on some Ilkhanid coins, while others feature ornamental calligraphy shaped like a *mihrab* (prayer niche); inscriptions in Mongolian are also a common feature of Ilkhanid coins. Ilkhanid coinage was influential on the early coinage of both the Ottomans and the Safavids.

The coinage of some of the dynasties in Anatolia, western Iran and northern Mesopotamia did not follow the standard patterns developed by the central Islamic powers. Instead, their relatively large copper coins featured a variety of images drawn from Graeco-Roman, Byzantine, Parthian and Sasanian tradition. Early Seljuk coins in Iran included tribal emblems alongside inscriptions, the mace and the bow featuring on the coins of Tughril Beg (1040–63), and silver and copper dirhams issued by the Anatolian Seljuks sometimes bearing the motif of the lion and the sun. Particularly striking, however, are the copper dirhams of the Artuqids and Zangids. Figural designs were also featured on the late 14th-century coins of the Rasulid dynasty in Yemen.

Coins issued by the early Mamluk sultan Baybars (1260–77) featured the motif of a prancing lion alongside horizontal inscriptions, but later rulers restricted themselves to purely epigraphic coins. During the reign of

Ayyubid silver *dirham* of Salah al-Din (Saladin), square-in-circle type. Damascus, AH 579 (AD 1183–4).

Ayyubid silver *dirham* of Salah al-Din (Saladin), star-in-circle type. Halab (Aleppo), AH 579 (AD 1183–4).

Ilkhanid gold double *dinar* of Abu Sa'id, with a *mihrab*-like cartouche on the obverse. Qays, AH 720 (AD 1320–21).

Ilkhanid gold double *dinar* of Abu Sa'id, with the Sunni *kalima* in square Kufic on the obverse and Abu Sa'id's name in Mongolian on the reverse. Bahrazan, dated 'in the year 33 Ilkhani' (AD 1333–4).

Artuqid copper *dirham* of Najm al-Din Alpi. No mint name, AH 558 (AD 1162–3).

Zangid copper *dirham* of Nasir al-Din Mahmud and the Abbasid caliph al-Mustansir, with a crowned figure holding the crescent moon on the reverse. Mosul, AH 627 (AD 1229–30).

Anatolian Seljuk silver *dirham* struck in the name of the Abbasid caliph al-Nasir li-Din Allah and the Anatolian Seljuk Sultan Suleyman Shah II, with a figure on horseback on the obverse. Konya, AH 579 (AD 1183–4).

Anatolian Seljuk silver *dirham* struck in the name of the Abbasid caliph al-Mustansir and the Anatolian Seljuk Sultan Kay Khusraw II, with a lion and sun on the obverse. Konya, AH 639 (AD 1241–2).

Anatolian Seljuk gold *dinar* struck in the name of the Abbasid caliph al-Nasir li-Din Allah and the Anatolian Seljuk Sultan 'Izz al-Din Kay Kawus I, square-in-circle type. Sivas, AH 614 (AD 1217–18).

Sultan al-Ashraf Barsbay (1422–37), the gold *ashrafi* was introduced in an attempt to compete with the strength of the Venetian gold ducat, also known as the *sequin*. The Mamluk *ashrafi* weighed the same as the Venetian coin (3.5g) and featured decorative, cable-like bands dividing the lines of horizontal inscription. The *ashrafi* was to prove highly successful and was adopted by a number of other dynasties, including the Aq Qoyunlu – who imitated the coin's design as well as its weight – the Safavids and the Ottomans.

The Ottomans adopted the standard weight, although not the design, of the Mamluk *ashrafi*, through Genoese copies of the Venetian ducat. The Ottoman ducat went under a number of different names at different times, including *filuri* (from the *florin*, the gold coin of Florence) and *sultani*. The *sultani* had horizontal inscriptions in bold *thulth*, and from the end of the 17th century the sultan's *tuğra* became a central feature of the design. Some coins from the reign of Süleyman the Magnificent (1520–66) featured panegyric titles of the Sultan, together with the mint and the date, but no religious inscriptions. The standard Ottoman monetary unit was the silver *akçe*, this later being superseded by the *guruş* and the *para* (the Turkish word for 'money'), and in the 19th century, the *lira*. Large, heavy gold coins were also issued to be worn as jewellery.

The weight of the gold *ashrafi* was also adopted in Safavid coinage. One of the most common silver coins was the *'abbasi*. Safavid coins bore inscriptions in *nasta'liq*, *thulth* and *naskh*, and these typically included the Shi'ite proclamation of faith, and the names of the twelve imams. The Safavid *larin*, an unusual, hairpin-shaped silver coin, was introduced in Iran during the 16th century. It gained considerable popularity in trade and was later imitated in other areas, including Turkey, Sri Lanka and the Maldives. Gold portrait medallions and other ceremonial coins were issued during the Qajar period, featuring the shah, or the royal Persian emblem of the lion and the sun. Another denomination of coinage, the *toman*, was introduced during the mid-19th century. A special set of square *tomans* was struck during the late 19th century.

In Afghanistan and in India, the coinage of the Ghurids and the Delhi Sultanate was considerably heavier (from approximately 11g up to 14g) than that of the central and western Islamic lands. Early Ghurid coins struck at Delhi retained the motif of the Hindu goddess Lakshmi, together with the local *nagari* script. Square coins were also issued, following local custom, and the traditional Indian denominations (though not the weights) of coinage such as the *tanka* and *muhur* were also maintained. Nevertheless, the Delhi Sultans often struck their coins in the name of the Abbasid caliph. During the 19th century, both *ashrafis* and *muhurs* were struck in Afghanistan, depending on whether they were for trade with Iran or India.

Mughal coinage attained great refinement, with highly original designs, and like the coinage of Safavid Iran had adopted *nasta'liq* for its inscriptions by the beginning of the 17th century. One of the more unusual Mughal coins from the 16th century is shaped like a *mihrab*. Coins dating from the reign of Jahangir (1605–27) are particularly impressive, and include a spectacular series based on signs of the zodiac. Jahangir also ordered the production of gold portrait medallions, the weight of a *muhur* and bearing his likeness, to be presented as gifts to favourite amirs. The practice of striking portrait medallions was continued by later rulers.

From 1844, Ottoman coins were minted on steam-powered machines imported from Europe, and by 1879 the production of hand-struck coins had been discontin-

Mamluk gold *dinar* of Baybars I, with a lion or leopard on the reverse. Cairo, AH 657 or 659 (AD 1258–9 or 1260–1).

Mamluk gold *ashrafi* of al-'Aziz Yusuf. Cairo, AH [8]4[2] (AD 1438–9, date off flan).

Ottoman gold *sultani* with the name and titles of Süleyman the Magnificent on the obverse. Qustantiniyya (Constantinople/Istanbul), AH 926 (AD 1520–1).

Ottoman gold *ashrafi* with the *tuğra* of Mustafa II on the obverse and his titles on the reverse. Edirne, AH 1106 (AD 1694–5).

Ottoman silver *akçe* with the name of Ahmed III on the obverse and his titles on the reverse. Qustantiniyya (Constantinople/Istanbul), AH 1115 (AD 1703–4).

Ottoman 5 *lira* (500 *guruş*) with the *tuğra* of Abdülhamid II on the obverse. Qustantiniyya (Constantinople/Istanbul), AH 1293 (AD 1876–7).

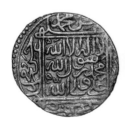 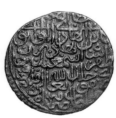

Safavid silver coin with the Shi'i *kalima* and names of the twelve imams (some off flan) on the obverse and the names and titles of Shah Isma'il I on the reverse. Herat, AH 911 (AD 1505–6).

Safavid gold *ashrafi* with the Shi'i *kalima* and names of the twelve imams on the obverse and the names and titles of Shah Isma'il I on the reverse. Mint name off flan, AH 918 (AD 1512–13).

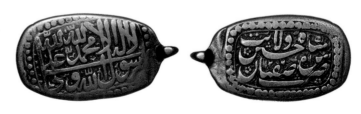

Safavid silver 5 *shahi* (an oblong issue, with loop attached) with the Shi'i *kalima* on the obverse and the name of Shah Sultan Husayn I on the reverse. Isfahan, AH 1126 (AD 1714–15).

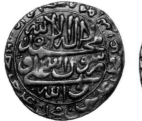 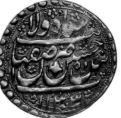

Safavid silver *'abbasi* with the Shi'i *kalima* and names of the twelve imams on the obverse and the name of Shah Husayn on the reverse. Isfahan, AH 1133 (AD 1720–1).

ued in Iran. With the fall of the Ottoman Empire after the First World War, and later the emergence of modern independent states in areas of the Middle East previously under European rule, the design of coins in the Middle East often came to reflect national aspirations.

Paper Money

The first Ottoman banknotes were introduced in 1840. Known as *kaime*, these were effectively debt certificates or treasury bonds rather than banknotes. The first *kaime* were hand-written, but these were soon replaced by printed versions. From 1863 the Ottoman Imperial Bank issued its own printed bank notes. During the late 19th century banknotes were also issued in Iran.

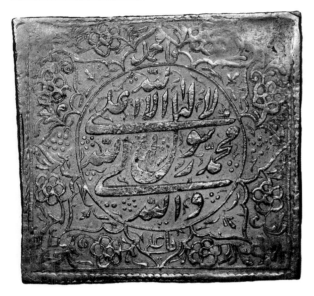

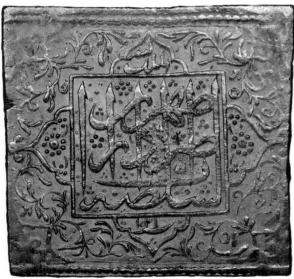

Qajar gold 50 *toman* of Agha Muhammad. Tehran, AH 1201 (given in error as 1021. AD 1786–7).

Qajar gold *toman* of Fath 'Ali Shah. Yazd, AH 1228 (AD 1813–14).

Qajar gold *toman* of Fath 'Ali Shah, with his portrait enthroned on the obverse and the mint name and date in an ornamental cartouche on the reverse. Isfahan, AH 1249 (AD 1833–4).

Ghaznavid silver *dirham* struck in the name of the Ghaznavid Yamin al-Dawla Mahmud and the Abbasid caliph al-Qadir, with a *nagari* inscription on the reverse. Mahmudpur (Lahore), AH 418 (AD 1027–8).

Samanid or Ghaznavid gold *dinar* struck in the name of the Ghaznavid Sayf al-Dawla Mahmud, with a sword to the left, on the obverse, and the name of the Samanid Nuh ibn Mansur on the reverse. Nishapur, AH 385 (AD 995–6).

Ghurid gold half-*dinar* of the reign of Muhammad ibn Sam (probably Muizz al-Din, ruler in Ghur and India 1203–06), with a *nagari* inscription around a horseman on the reverse. No mint name or date.

Mughal gold *muhur* with a portrait of Jahangir on the obverse. No mint name, AH 1020 (AD 1611–12).

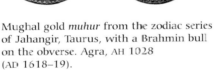

Mughal gold *muhur* from the zodiac series of Jahangir, Taurus, with a Brahmin bull on the obverse. Agra, AH 1028 (AD 1618–19).

Mughal gold *muhur* from the zodiac series of Jahangir, Cancer. Agra, AH 1029 (AD 1619–20).

Architecture

The dramatic early expansion of Islam in the 7th and 8th centuries AD brought the adherents of the new religion into contact with the architectural traditions of the Classical Mediterranean, and most importantly of the Byzantine and Sasanian empires. From the relatively simple, utilitarian buildings of the Arabian peninsula, Islamic architecture evolved into a highly sophisticated, clearly recognizable style, within which there developed a number of regional variations.

EARLY ISLAMIC AND UMAYYAD ARCHITECTURE

The earliest mosque, and the main centre for prayer in the city of Medina, appears to have been the Prophet Muhammad's own house (AD 624). Although nothing of this building has survived to the present day, it is nevertheless described in detail in a number of early sources. Built of sun-baked bricks, it was roughly square in plan, each side measuring approximately 56m. Nine rooms were arranged along the east wall, facing inwards. Soon short colonnades of palm trunks supporting palm branches were added to the north and south, to provide shade from the heat of the sun, and the orientation of the *qibla* (that is, the direction of prayer) changed from Jerusalem to Mecca. This relatively simple arrangement was to be repeated in subsequent, non-secular Islamic architecture, and became the basic plan of the mosque. The mosque at the newly founded Muslim town of Kufa (637, rebuilt 670), for example, was a simple square with supports along all four sides, and a deep portico on the *qibla* wall functioning as a prayer hall.

The form and structure of early Islamic architecture were conditioned by the availability of good local stone and wood, and elements such as columns often re-used from existing Classical architecture. The decoration of these buildings included mosaic, carved stone and stucco, ornamental brickwork, and sometimes wall paintings. Two of the finest monuments from the Umayyad period are the Dome of the Rock in Jerusalem (691–2) and the Umayyad Mosque or 'Great Mosque' in Damascus (705–14/15). Although both clearly reflect the influence of Byzantine tradition, they are evidence of an emerging, distinctly Islamic style.

The Dome of the Rock is the earliest Islamic monument to have survived in its original form to the present day. Standing near the centre of the artificial platform known as the Haram al-Sharif ('the Noble Sanctuary'), it is an octagonal structure, above which rises a high drum pierced by 16 windows, supporting a large central dome. The dome is double-shelled, with wooden ribs; the outer shell is made of sheets of lead and gilded copper. The interior is lavishly decorated with mosaics; those on the exterior were replaced with Ottoman tiles on the orders of Süleyman the Magnificent. The form of the building is largely derived from Byzantine church architecture, and the marble columns and many of the capitals were taken from earlier monuments. The decoration includes a number of motifs from the late antique period and from Sasanian Iran. But the Qur'anic inscriptions, together with the absence of figural imagery and overall application of decoration, clearly identify the building as Islamic.

The Great Mosque in Damascus was built on the orders of the caliph al-Walid I (705–15) at a time of great political expansion, and was a clear expression of the power and prestige of the Umayyads. The courtyard was

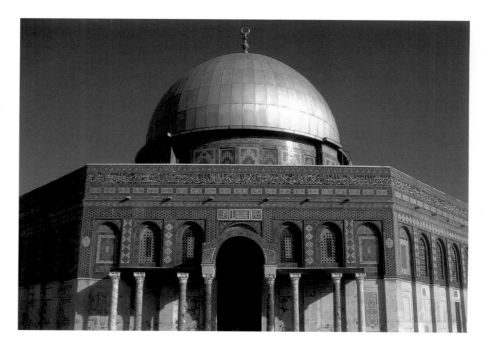

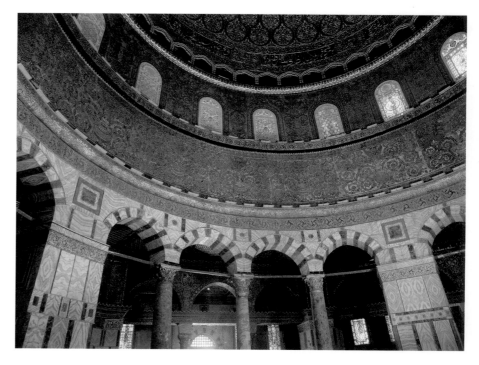

Top and above: Exterior and interior of the Dome of the Rock, Jerusalem, 691–2.

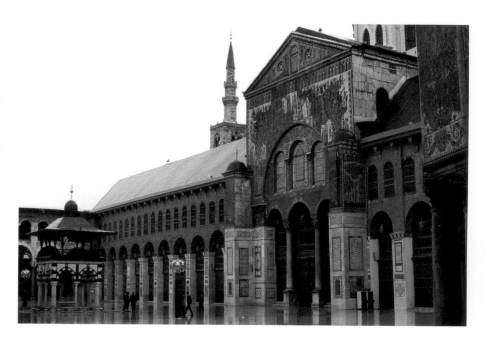

Above: Courtyard of the Great Mosque, Damascus, 705–14/15.

originally the enclosure of a Roman temple, later converted into a Byzantine church; it is surrounded on three sides by covered porticoes with two levels of arcading, the lower level showing the beginnings of the form of the horseshoe arch. The fourth (*qibla*) wall is occupied by the covered part of the mosque, which follows the form of a classical basilica, but with the axis changed, and contains the earliest surviving concave *mihrab* (prayer niche). Some superb mosaics remain on the upper levels of the courtyard façade; they depict plants and trees in great detail, as well as clusters of buildings against a gold background. These mosaics would once have covered most of the walls.

A number of desert palaces found in modern Syria and Jordan represent the secular architecture of the Umayyads. They typically formed the centre of agricultural estates or provided hunting retreats for the new ruling elite. They are often square in plan and have a fortress-like exterior, although Qusayr 'Amra in Jordan

consists of a large open court surrounded by covered arcades, those of the *qibla* wall being the deepest – a form clearly derived from the earliest mosques and described as 'hypostyle'. The arcades feature massive brick piers with engaged columns and the huge *mihrab* was decorated with marble columns and mosaics. The buttressed walls give the exterior a fortress-like character. The minaret, a distinctive construction with a spiral ramp on its exterior, was built outside the walls.

This formula was repeated, on a slightly smaller scale, in the mosque of Abu Dulaf (c. 860), also at Samarra, of which only parts have survived. The arcades feature rectangular and T-shaped brick piers, the latter forming the north and south façades of the courtyard. However, the arcades stop short of the *qibla* wall, which is isolated by a broad transverse aisle running parallel to it. The resultant form is known as 'T-plan'. These developments giving greater emphasis to the *qibla* wall were to prove highly influential. The Great Mosque of Qayrawan (836,

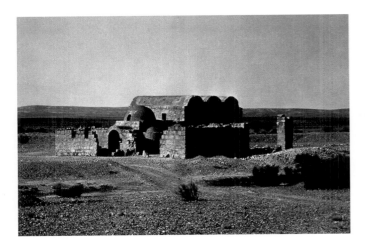

Above: Qusayr 'Amra, Jordan, second quarter 8th century.

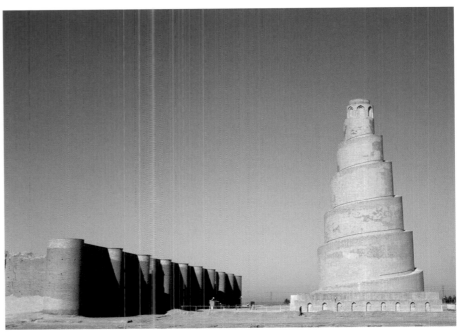

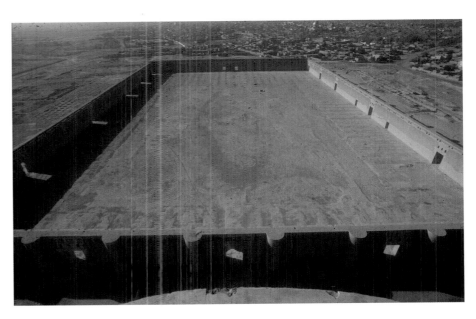

Top and above: Two views of the Great Mosque, Samarra, completed 852.

(second quarter 8th century) is much less austere in appearance, being a small cluster of domed and vaulted rooms. In contrast to the decoration of religious architecture in major centres such as Damascus, Qusayr 'Amra contains some remarkable figural wall paintings, among them hunting and zodiac scenes, and a group of standing figures which have been identified as the kings of Byzantium, Iran and Abyssinia. The building may have been constructed for the pleasure-loving al-Walid II (743–4) in the years before he attained the caliphate. Whereas the majority of surviving desert palaces have plain exterior walls, those of the palace at Mshatta (c. 743) in Jordan are exceptional for their elaborate sculptural decoration: classically influenced acanthus leaves and swirling vine scrolls are joined by lions and other animals, often confronted (face to face) as in late antique precedents.

THE ABBASIDS
During the Abbasid period, architecture continued to develop according to the pattern established under the Umayyads, and a number of Umayyad structures were either rebuilt or substantially altered. Just as Umayyad architecture in Syria drew upon the availability of fine local stone, so the shift of the Abbasid capital eastwards to Baghdad and then Samarra conditioned a preference for the baked and unbaked brick typical of the architecture of Iraq. Nothing of 8th-century Baghdad remains, its site having been buried beneath later developments, and it is largely to the ruins of Samarra that we must turn to gain a picture of early Abbasid architecture.

The Great Mosque at Samarra (completed 852), built during the rule of the caliph al-Mutawakkil (847–61), is the largest known mosque of the Islamic world. It is rectangular in plan and measures some 240 by 156m. It

862 and 875), built on an earlier Umayyad mosque dating c. 670, of which only traces remain, took these innovations further. Here not only did the arcades stop short of the *qibla* wall, they flanked a wide central aisle (or axial nave) running from the court to the *mihrab* area. This central aisle was raised higher than the surrounding arcades, and had two domes, one in front of the *mihrab* and one at the entrance to the court. The domed area in front of the *mihrab* was richly decorated with marble and tiles.

The palace at Ukhaidir (c. 775), roughly 120 miles southwest of Baghdad, features an early use in Islamic architecture of the *iwan*, a large vaulted chamber, which opens onto the central court. The most remarkable local precedent for the *iwan* is the enormous vault at the Sasanian palace of Ctesiphon (6th century AD). The decoration at Ukhaidir features elaborate ornamental brickwork.

Excavations at Samarra have revealed fragments of wall paintings and extensive stucco decoration. The former, from the palace of al-Mu'tasim (833–42), include figures, and birds and animals in medallions, which clearly follow Classical and Sasanian traditions. The stucco decoration has been divided into three categories: an early, moulded style characterized by five-lobed vine scrolls; a second, moulded style characterized by vine clusters; and a later, carved and moulded style.

The mosque of Ibn Tulun at Fustat or Old Cairo (879) was strongly influenced by the architecture of Samarra, where its founder Ahmad ibn Tulun had spent a number of years, and marked a clear departure from local Egyptian precedents. It is built of brick, and features rectangular piers with engaged columns. It is one of the earliest surviving examples of the extensive use of pointed arches, the outlines of which are emphasized by narrow bands of stucco decoration. At the centre of the rectangular court is a large fountain, which originally had a gilded dome. The original minaret was very probably a spiral, like those at Samarra; the present structure dates to the late 13th–14th century. The exterior walls are pierced by grilled windows and niches.

Similarly, the mosque of Al-Hakim, Cairo (990 and 1012), built under the Fatimids, successfully blends elements from North Africa (such as a higher central nave) with features from Samarra (such as the large brick piers already seen in the mosque of Ibn Tulun). The decoration of the minarets and the façades is in stone. The Al-Azhar Mosque, Cairo (969–72), founded by the Fatimids at the same time as the city of Cairo, features lavish stucco decoration in its interior, including wall panels and a particularly impressive *mihrab*. It was during the Fatimid period that *muqarnas* (or 'stalactite vaulting') was introduced into the architecture of North Africa.

Fatimid architectural decoration also included wall paintings, fragments of which have survived. Much better preserved, however, is the painted decoration of the Palatine Chapel in the royal palace of the Norman king Roger II in Palermo, Sicily (1140). Though the walls and dome were decorated by Byzantine artists and show Christian subjects, the *muqarnas* of the wooden ceiling is believed to have been decorated by Muslim painters working in the Fatimid style, and features Kufic inscriptions and representations of animals and humans set among vine scrolls and floral compositions.

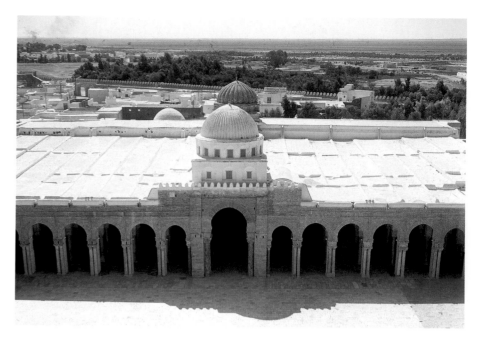

Above: Great Mosque, Qayrawan, 836, 862, 875.

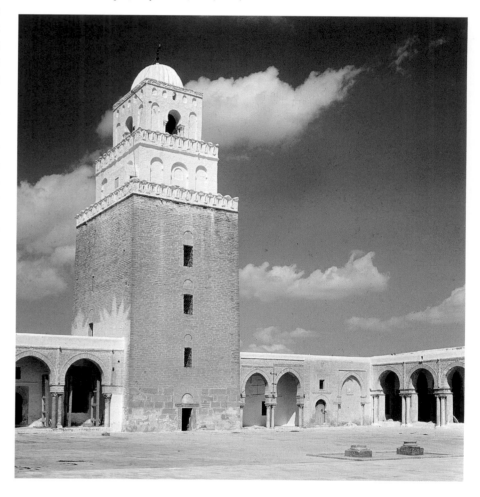

Above: Minaret of the Great Mosque, Qayrawan, 836.

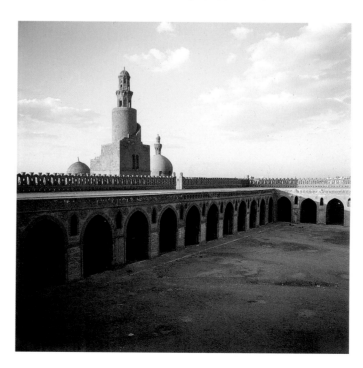

Left: Courtyard of the mosque of Ibn Tulun, Cairo, 879.

SPAIN AND NORTH AFRICA

As in the decorative arts, the architecture of Islamic Spain and North Africa developed along its own lines, at once deeply rooted in the style of Umayyad Damascus, yet highly distinctive and refined in its own right.

Undoubtedly the most important building to have survived from Umayyad Spain is the Great Mosque at Cordoba. Although the original building dates to 784–6 during the reign of 'Abd al-Rahman I, it was enlarged considerably by successive rulers: by 'Abd al-Rahman II in 833–52, and most notably by al-Hakam II in 961–76 and the chief minister al-Mansur in 987. The mosque consists of a large hypostyle hall with aisles running perpendicular to the *qibla* wall. One of the most innovative features is the use of two-tiered arches –somehow reminiscent of Roman aqueducts, of which Spain has many – as a means of raising the height of the ceiling despite the use of relatively short columns from older, existing buildings. These arches, maintained through all later additions, are further emphasized by the use of alternating red brick and white stone. The lower tier of arches are horseshoe-shaped – a form that existed in Spain under the Visigoths. Al-Hakam II added a spectacular *mihrab* in the form of a circular room, and directly in front of this a magnificent bay of polylobed arches, while al-Mansur widened the building by eight bays. The decoration of the *mihrab* area is particularly fine, featuring glass mosaics, carved marble panels, and carved stucco. Many of the same decorative features are present in the ruins of Madinat al-Zahra, the palace founded near Cordoba in 936 during the reign of 'Abd al-Rahman III.

In mosques built under the Almoravids and the Almohads, the number of domes over the transverse aisles and the axial nave increased, and the interiors of these domes often featured elaborate *muqarnas*. Minarets were square constructions, following the form of the minaret at Qayrawan, but considerably higher. They had extensive exterior decoration, including repeating or overlapping horseshoe or polylobed arches, and an interior spiral ramp instead of a staircase. The finest surviving examples of such minarets are those at Seville (1171, all that has survived of the Great Mosque in that city), the Kutubiyya Mosque at Marrakesh (c. 1160), and the mosque of al-Hasan, Rabat (c. 1195). A horseshoe arch is typical of city gates – for example the Oudna Gate at Rabat (late 12th century); elsewhere, as in the *mihrab* chamber of the Great Mosque at Tlemcen (1136), we find variations on the polylobed arches developed at Cordoba. The decoration of this architecture also features some quite spectacular carved stucco work, such as a doorway from the Aljaferia, Zaragoza (11th century), now in the National Archaeological Museum, Madrid.

The Alhambra in Granada is one of the best-preserved palaces of the medieval Muslim world. Its most significant features – including the Court of the Myrtles (1347–8) and the Court of the Lions (begun 1377) – date from the 14th century, and were built during the reigns of the Nasrid rulers Yusuf I (1333–54) and Muhammad V (1354–9, 1362–91). The lavish decoration of the numerous courtyards, colonnades, pools and fountains includes intricate stucco, tilework in mosaic and *cuerda seca* (dry cord) technique, carved stone and polished marble.

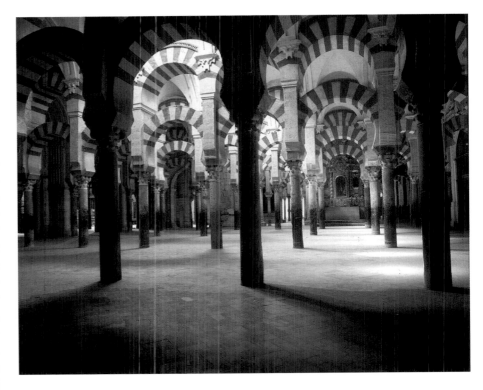

Above: Two-tiered arches in the Great Mosque, Cordoba, 784–6.

Above: Bay of polylobed arches in front of the *mihrab*, added by al-Hakam II, in the Great Mosque, Cordoba, 961–76.

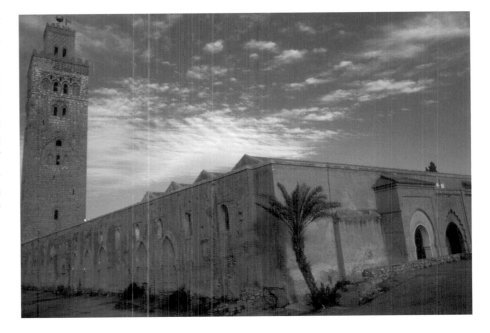

Above: Kutubiyya Mosque and minaret, Marrakesh, c. 1160.

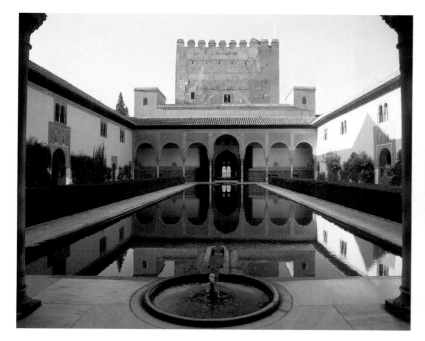

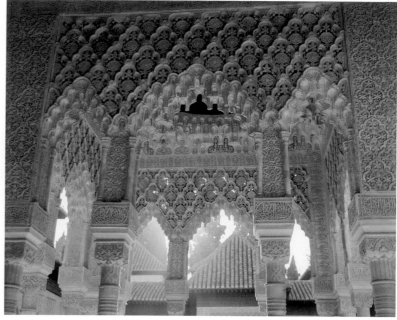

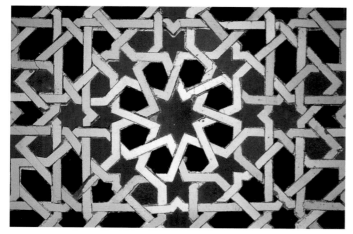

Above left: Court of the Myrtles in the Alhambra Palace, Granada, 1347–8.

Above right: Detail of stucco decoration in the Court of the Lions, Alhambra Palace, Granada, begun 1377.

Left: Tiles – the work of *mudéjar* craftsmen (Muslim inhabitants of Christian Spain) – at the Alcazar Palace, Seville, second half 14th century.

IRAN AND CENTRAL ASIA
UNTIL THE 12TH CENTURY

Early mosques in Iran and Central Asia generally followed Abbasid tradition and, like their counterparts in Iraq, were predominantly of brick. The mosques at Damghan and Nayin (probably 8th and 10th century respectively) feature hypostyle plans with heavy-set, round columns. Those in Nayin are largely sheathed in elaborate stucco decoration, together with the arches and the *qibla* area.

The basic plan of the Masjid–i Jami' (Friday Mosque) at Isfahan consists of a large central courtyard surrounded by arcades, probably built during the 9th century and enlarged by the Buyids in the 10th century. The mosque underwent a major transformation during the late 11th and early 12th centuries, when Isfahan was the Seljuk capital. The largest dome bears an inscription with the name of the great Nizam al-Mulk, vizier of the Seljuk ruler Malik Shah, and the date 1072–92. It may have functioned as a *maqsura* – a private area for prayer, for a ruler or other important figure. A further domed chamber, some 10m square, bears the name of Taj al-Mulk, vizier of Malik Shah's wife, and the date 1088. This would originally have been freestanding. In both cases the zone of transition between chamber and dome features a complex arrangement of *muqarnas* niches. Four *iwans* opening onto the courtyard were added, probably some time after a fire in 1120–21, the largest and most prominent of these being the *qibla iwan*. The court façade between the four *iwans* consists of arched chambers arranged in two storeys. Most of the vaults of the surrounding covered areas are domed. This distinctive form, with four *iwans* facing onto a central court, is known as a cruciform plan. It became the standard for mosques in Iran, and was also extended to other building types such as *madrasas* (religious colleges) and caravanserais.

During the 11th century, the form of minarets evolved into a tall, tapering cylinder frequently covered with decorative brickwork. The type is exemplified by the minarets at Damghan (mid-11th century), and the Kalan Minaret at Bukhara (1127) – all that remains of the original 12th-century Qarakhanid mosque on this site, now replaced by a 15th-century structure. The Kalan Minaret has a height of more than 51m. The entire surface of the shaft is covered with broad decorative bands of geometric

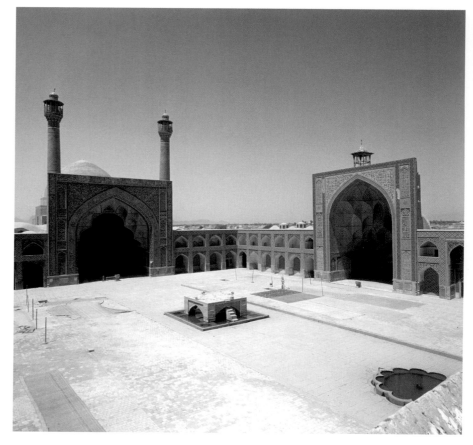

Above: Courtyard and *iwans* of the Masjid-i Jami' (Friday Mosque), Isfahan, late 11th and early 12th centuries.

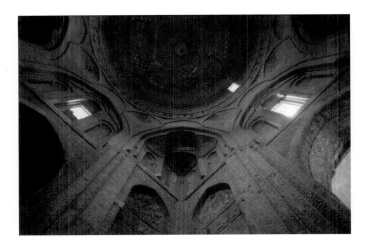

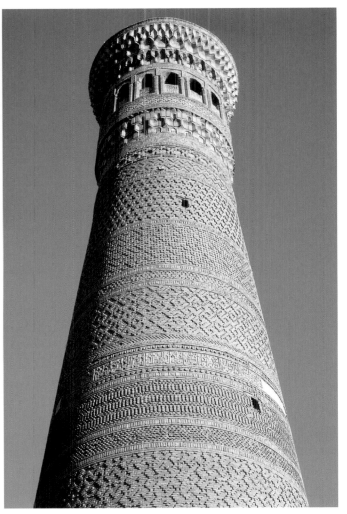

Far left: Interior of north dome of the Masjid-i Jami' (Friday Mosque), Isfahan, dated 1088.

Left: Kalan Minaret, Bukhara, 1127.

brickwork, each one different, and interspaced with inscription bands.

Towers of Victory

Although they usually form part of a mosque and are typically associated with the call to prayer, minarets may also have functioned as monuments to the victories of a particular ruler, or to the victory of Islam. The 'Minaret of Mas'ud' at Ghazna was erected by the Ghaznavid ruler Mas'ud III in the early 12th century. It is a tapering brick structure, the lower section in the form of an eight-pointed star decorated with panels of carved terracotta; its upper cylindrical section has now fallen.

Some remarkable mausoleums, again in brick, have survived in Iran and Central Asia. One of the earliest and best-preserved of these is the so-called Samanid Mausoleum at Bukhara, datable before 943. Its basic form is a square chamber with a dome carried on four arches – a structure known as *chahar-taq* in Persian, and based on a Sasanian fire temple. The walls feature engaged columns at each corner and a small gallery running around the top. The decoration is achieved entirely with the imaginative use of baked bricks, which are laid both horizontally and vertically to form zigzags and rows of circles, creating a lattice effect.

Mausoleums in the form of tall tomb towers, known as *gunbad* in Persian, have also survived, particularly in northern Iran. The Gunbad-i Qabus, near Gurgan (1006–7), was built for a local Ziyarid prince, Qabus ibn Vashmgir. The exterior takes the form of a tapering ten-pointed star capped by a conical roof. In contrast to the Samanid Mausoleum the decoration is restricted to two inscription bands in Kufic. The interior of the tower is smooth and circular, with a hemispherical dome.

The largest surviving mausoleum from the Seljuk period is that of Sultan Sanjar at Merv (1152). The soaring double dome, some 14m high, rests upon an octagonal drum; this in turn sits upon a square chamber, the walls of which are particularly thick and unbroken by any major decorative scheme. A gallery runs around the upper zone. It is the only remaining part of a large complex, including a palace and a mosque, and is therefore the earliest dated example of a mosque-mausoleum.

Of the numerous *madrasas* known to have been built by the Great Seljuks, none has survived in its original form or can be identified with any certainty. A ruined

Below, left to right:

Samanid Mausoleum, Bukhara, before 943.

Gunbad-i Qabus, near Gurgan, 1006–07.

Mausoleum of Sanjar, Merv, 1152.

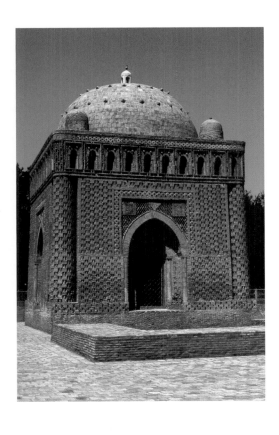

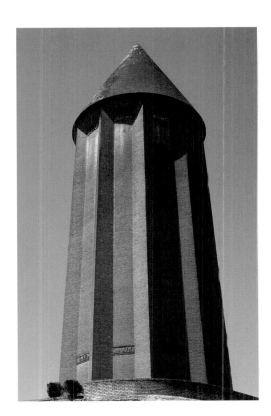

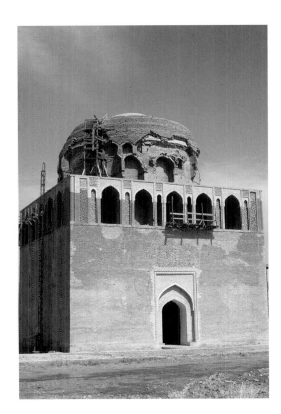

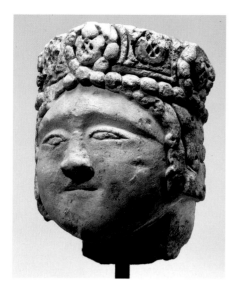

Far left: Stucco head with crown. Iran, 12th century. Stucco figures such as this were often used to decorate the audience halls of palaces in 12th-century Iran.

Left: Panel from a marble calligraphic frieze. Eastern Iran, 13th century.

structure at Khargird (datable before 1092) bears an inscription with the name of Nizam al-Mulk himself, but whether this was indeed a *madrasa* or a mosque remains open to question.

SELJUK ANATOLIA

In contrast to the architecture of Iran, that of the Seljuks in Anatolia was primarily of stone, reflecting a long local tradition. In many Seljuk mosques the central court was considerably reduced in size or the building entirely roofed, a feature perhaps conditioned in part by the colder, wetter climate of the Anatolian highlands.

A new *madrasa* form was developed by the Seljuks in Anatolia, first at the Karatay Medrese (1252) and then at the Ince Minareli Medrese (1265), both in Konya. This new type consisted of a domed square or rectangle with side chambers and an entrance complex, and effectively transformed the *madrasa* into an enclosed building planned around a central domed court, with a prominent exterior façade or portal. This closed form recurred under the 14th-century emirates in northwest Turkey, and the basic type was later taken up by the Ottomans. More common, however, were open *madrasas*, with *iwans* facing onto an open central

court, such as the Çifte Minareli Medrese at Erzurum (1253). A number of *madrasas* – including the Çifte Minareli Medrese and the Gök Medrese at Sivas (1271) – feature twin minarets above the main portal, a form which probably had its origin in the earlier Seljuk architecture of Iran.

Flourishing trade routes across Anatolia led to the establishment of numerous caravansarais (in Turkish, *hans*), a number of which are remarkably well preserved. These were typically enclosed within austere walls, and usually consisted of an entrance leading to an open courtyard flanked on two sides by an arcade and storerooms, with a long, covered hall on the third side used as the stable area. A small, raised pavilion in the courtyard functioned as a mosque.

Also distinctive of Seljuk architecture in Anatolia are the numerous mausoleums known in Turkish as *kümbed* or *türbe*. These carried on the tradition of the Iranian and Central Asian tomb tower, and occurred both independently and within the context of *madrasas* and other buildings. The great majority are cylindrical or octagonal structures on raised plinths, with conical or pyramidal roofs, although a number of local variations on this basic form also exist.

Right: Portal with twin minarets, Gök Medrese, Sivas, 1271.

Far right: Mausoleum (*türbe*) of Sitte Melik, Divriği, 1195–6.

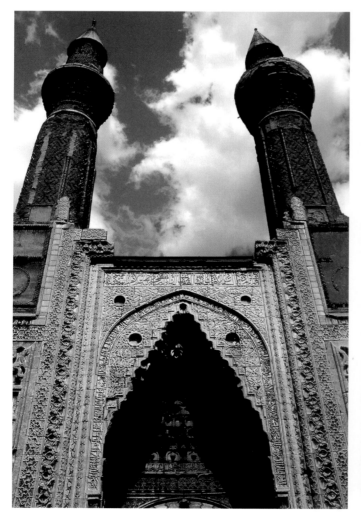

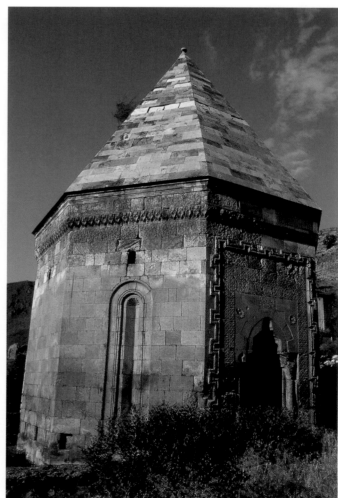

Above and right: Seljuk architectural decoration in Anatolia: carved stonework at the Great Mosque, Divriği, 1228–9 (above left, above right); carved stonework at the Çifte Minareli Medrese, Erzurum, 1253 (above centre); tiles at the hospital and mausoleum of Kay Kawus I, Sivas, 1217–18 (right).

The decoration of these buildings is characterized above all by its exceptional stone carving, including geometric interlace patterns and vegetal ornament, together with figural sculpture such as birds of prey and heraldic lions. This sculpture was typically concentrated around portals and windows. A particularly fine example is the Great Mosque and hospital at Divriği (1228–9). Underglaze-painted and lustre-painted tiles also played a role in this decoration. Eight-pointed star- or cross-shaped glazed tiles, sometimes with a wealth of figural imagery, have been excavated in considerable numbers at Kubadabad, the Seljuk palace on the shore of Lake Beyşehir.

Right: Complex of Salar and Sanjar al-Jawli, Cairo, 1303–4.

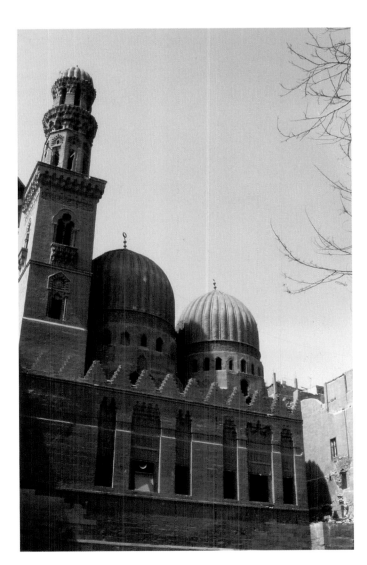

MAMLUK EGYPT AND SYRIA

As in Anatolia, the architecture of Mamluk Egypt and Syria was primarily of stone. Buildings increasingly gained composite functions, the mosque, mausoleum, madrasa and khanqa (a lodge or centre for dervishes or Sufis) frequently being combined into a single complex. Mamluk architecture was strongly conditioned by its urban setting: Cairo was already highly populated, and except in cases where existing buildings were torn down to make way for a new structure, the form of much Cairene architecture had to adapt to what was already there. Perhaps partly in reaction to this, a greater emphasis was placed on elements such as the mausoleum dome, the minaret and the façade, all of which had to be visible from the narrow streets. In addition, interiors were often set at a markedly different angle to the façade in order to achieve correct qibla orientation.

During the earlier, Bahri period, Mamluk architecture was often highly eclectic, but this is not to say that it was any less distinctive, as it fused numerous influences into its own, easily recognizable style. As had been common in earlier periods, many buildings featured re-used columns. The tall façade of the Mausoleum-Madrasa of Sultan Qalawun in Cairo (1284–5) has recesses with pointed arches containing double windows surmounted by a smaller round window. These elements were a clear departure from local tradition, and give the impression of a Romanesque cathedral. They were probably influenced by Christian architecture in Palestine, or even Sicily. The minarets of the mosque of Sultan al-Nasir Muhammad at the Citadel in Cairo (1318–35) are decorated with blue and green faience mosaics, and have been associated with the work of Tabrizi craftsmen working in Cairo at this time; the bulb-shaped tops of the minarets have also been linked with the architecture of Tabriz.

Mamluk domes have a relatively steep profile, and a number are double-shelled. Some are ribbed, while a number of others were originally sheathed in tiles. Contemporary descriptions indicate that some Mamluk domes may originally have been slightly bulbous. The earliest surviving stone dome in Mamluk architecture appears to be a small, undated dome at the complex of Salar and Sanjar al-Jawli (1303–4).

Minarets built at this time took the distinctive form of a three-tiered structure with balconies, initially with a square base rising to an octagonal shaft, then later octagonal throughout, or octagonal and cylindrical. The earliest surviving occurrence of the wholly octagonal type is at the mosque of Altinbugha al-Maridani in Cairo (1340). Minarets were typically crowned by a *mabkhara*, a structure resembling an incense burner, or later a small, open pavilion supporting a pear-shaped bulb with a finial.

One of the most imposing buildings from the Bahri Mamluk period is the mosque of Sultan Hasan in Cairo (1356–61), which also contains a mausoleum and four *madrasas* for the four schools of Islamic law. This huge building was the largest in medieval Cairo. The mausoleum protrudes from the rather austere façade, and is crowned by an enormous dome. Remarkably, the mausoleum is behind the *qibla* wall, that is, in the direction of prayer. This highly unconventional arrangement gave the mausoleum greater prominence when viewed from the royal palaces of the Citadel. A monumental portal, which shows strong Anatolian influences, stands at an angle, perhaps to make it, too, more visible from the Citadel. Four *iwans* surround the inner court, the *qibla iwan* being one of the largest vaulted halls of the medieval Islamic world. Although architecturally one of the most significant buildings of the Mamluk period, it was in fact never completed.

Mamluk architecture was richly decorated. A distinctive feature was the use of *ablaq*, that is, two contrasting shades of stone. Others included polychrome inlaid marble, carved stone, carved and inlaid wood, and glass mosaic. The use of carved stucco was widespread, from the minaret of the mausoleum-*madrasa* of Sultan al-Nasir Muhammad (1295–1303) to the large inscription band in the *qibla iwan* of the mosque of Sultan Hasan. Pierced carved stone screens were a feature of a number of buildings, including the complex of Salar and Sanjar al-Jawli. A limited use of mosaic tilework is found from the reign of al-Nasir Muhammad.

Later Mamluk architecture reached its highpoint in the carved masonry domes of the late 15th century, in the

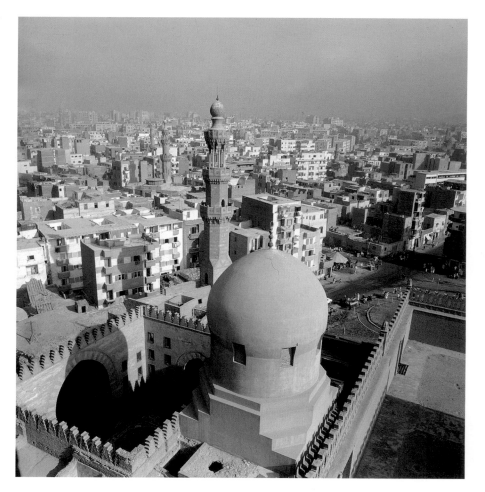

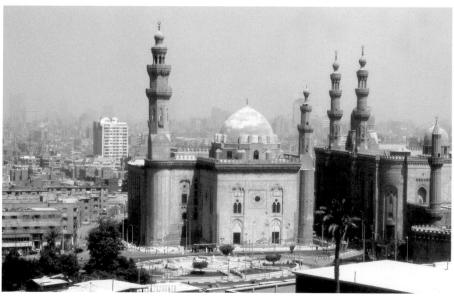

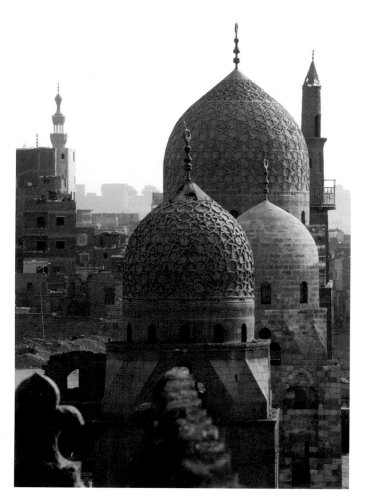

Above: Domes at the religious-funerary complex of Sultan Barsbay in the Northern Cemetery, Cairo, 1432.

Burji period. Their development began at the religious-funerary complex of Sultan Barsbay (1432) and culminated in the dome of the religious-funerary complex of Sultan Qaytbay (1472–4); both are in Cairo. On the latter, finely carved geometric patterns based on a star motif run in counterpoint with elaborate, foliate arabesque. Each of these two elements receives different sculptural treatment, the lines of the arabesque being bevelled to make them stand out. The technical difficulties of adapting such designs to the shape of a dome were considerable.

Top: Mausoleum-Madrasa of Amir Sarghitmish, Cairo, 1356.

Above: Mosque of Sultan Hasan, Cairo, 1356–61.

ILKHANID ARCHITECTURE IN IRAN

In Iran, Ilkhanid architecture generally followed the four-*iwan* plan for mosques and *madrasas* established under the Seljuks. The Masjid-i Jami' at Varamin (1322 onwards) consists of a monumental portal leading to an open court with four *iwans*, and a Seljuk-style dome behind the *qibla iwan*. Side entrances also lead to the two lateral *iwans*. In some cases, however, a more unusual form was taken. There is evidence that Ilkhanid architects, like others in the medieval Islamic period, worked from detailed plans, and a stucco plaque illustrating part of a *muqarnas* design has been excavated at Takht-i Sulayman, the summer palace probably built for Abaqa in western Iran (c. 1275 onwards).

As in Mamluk Egypt, many Ilkhanid complexes fused mosque, mausoleum, *madrasa* and other buildings into a single whole. The great tomb complex of Ghazan Khan at Tabriz (1297 onwards), of which nothing remains, included two *madrasas*, a guesthouse, hospital, observatory and library, together with its founder's mausoleum. The imperial context of Ilkhanid architecture was emphasized by its sheer scale: the huge *iwan* of the mosque of 'Ali Shah at Tabriz (c. 1315) was compared by contemporaries to that of Ctesiphon, and the dome of the mausoleum of Öljeitü at Sultaniyeh (1307–13) remains the highest in Iran.

Öljeitü's mausoleum is undoubtedly the most striking monument to have survived from Ilkhanid Iran. This vast building, the only significant part of the Ilkhanid capital Sultaniyeh still standing, originally formed part of a complex including a mosque, *madrasa*, a hospital and other structures. The blue-tiled dome, which is 53m high, sits on an octagonal chamber some 38m in diameter, from the crown of which spring the remains of eight minarets. The interior features eight huge vaulted niches with balconies. Structurally the building represented a considerable development on the square Seljuk tomb chamber, that is, a dome on an octagonal drum on a square base. The interior was decorated with brick and tilework, and by 1316 a second phase of decoration in painted plaster had been initiated.

Ilkhanid architecture made more extensive use of glazed tiles than is known elsewhere before this period, and had carved stucco decoration of exceptional richness. The

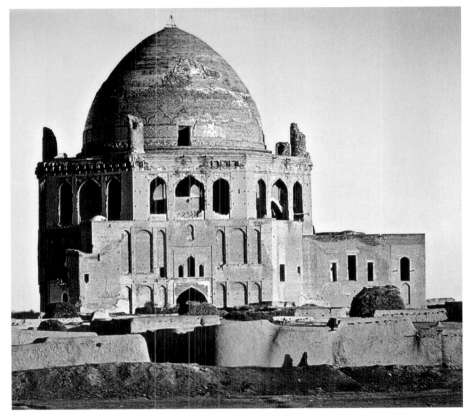

Above: Mausoleum of Öljeitü, Sultaniyeh, 1307–13.

Far left: Ilkhanid lustre tile with dragon. Iran, probably Takht-i Sulayman, c. 1275 onwards.

Left: Portal of the Masjid-i Jami' (Friday Mosque), Yazd, begun 1324–5.

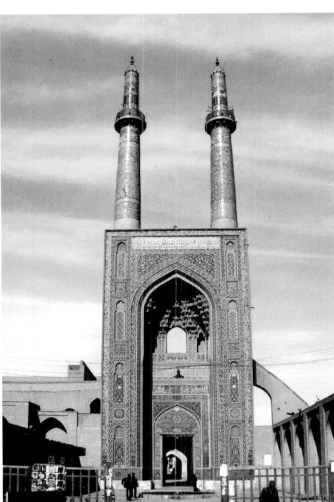

mausoleum of the shrine of 'Abd al-Samad at Natanz (1299–1312) originally featured a broad dado in carved lustre tiles, now dispersed among various collections including the Victoria & Albert Museum; and large friezes of tilework covered the walls of many other Ilkhanid buildings including Takht-i Sulayman and the shrine of Imamzade Yahya at Varamin (1262–3). The new *mihrab* ordered by Öljeitü in 1310 for the Masjid-i Jami' at Isfahan, an outstanding example of carved stucco decoration, was signed by Haydar, one of the pupils of the great calligrapher Yaqut al-Musta'simi. An inscription band in the mosque of the shrine complex at Natanz was also signed by Haydar.

TIMURID ARCHITECTURE IN IRAN AND CENTRAL ASIA

Timurid architecture essentially followed established formulas from Seljuk and Ilkhanid Iran – the court with four *iwans*, the dome behind the *qibla iwan*, and the imposing façade with a monumental *pishtaq* portal, often

bounded by twin minarets. But it also introduced some remarkable developments: in particular the evolution of the entrance complex into a self-contained area of the building, flanked by vaulted halls; and increasingly sophisticated systems of vaulting – including the use of transverse arches, which made it possible to roof far wider areas than before. Both of these features were in fact adopted from earlier monuments built under the Muzaffarids, for example the Masjid-i Jami' at both Yazd (1324–5 and 1365–7) and Kirman (1349).

The two most immediately impressive features of Timurid architecture are its extensive use of tilework and its gigantic scale. The latter characteristic is readily apparent in two of the earliest major buildings from the Timurid period, the Aq Saray or 'White Palace' at Shahr-i Sabz (1379–96), and the mosque of Bibi Khanum

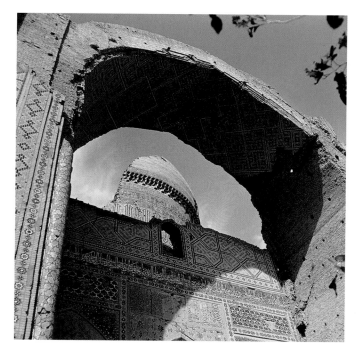

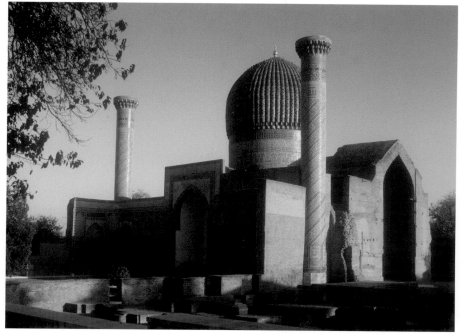

(1399–1404) at Samarqand, a new Masjid-i Jami' ordered after the capital was transferred to that city, with an *iwan* some 30m high.

The mausoleum of the Gur-i Mir at Samarqand (1404), part of a complex in which Timur himself was buried, set the formula for Timurid domes and decoration in mosaic tilework. It is an octagonal structure, with a high dome set upon a tall drum. An inner dome rises only to the height of the base of the drum; the outer dome is more than 10m higher, rising to a total height of some 34m. The outer dome protrudes slightly beyond the drum above *muqarnas* corbelling; it is ribbed and decorated with tilework. The drum is decorated with glazed and unglazed bricks arranged in geometric patterns, above a broad band of Kufic.

The repertoire of techniques found in Timurid tilework include *cuerda seca*, tile mosaic, carved relief tiles, and the less common *lajvardina* (involving the use of a cobalt-blue glaze and enamels). *Cuerda seca* was particularly common on earlier Timurid buildings but was increasingly superseded by tile mosaic. Many of these techniques are to be found in the remarkable group of tombs known as the Shah-i Zindeh at Samarqand (dating from 1370 to 1405), and are discussed in greater detail elsewhere (see 'Pottery and Ceramics'). Decoration in glazed bricks, known as *banna'i* technique, also featured extensively on Timurid architecture. The bricks were laid horizontally and vertically to create geometric patterns and inscriptions. Due to its relatively large scale, *banna'i* was particularly well suited to prominent exterior decoration. Ceramic decoration was complemented by painted plaster, and wood inlaid with ivory or bone. The latter became increasingly popular during the 14th and 15th centuries, and features on the doors of the Gur-i Mir.

Above left: Mosque of Bibi Khanum, Samarqand, 1399–1404.

Above: Gur-i Mir, Samarqand, 1404.

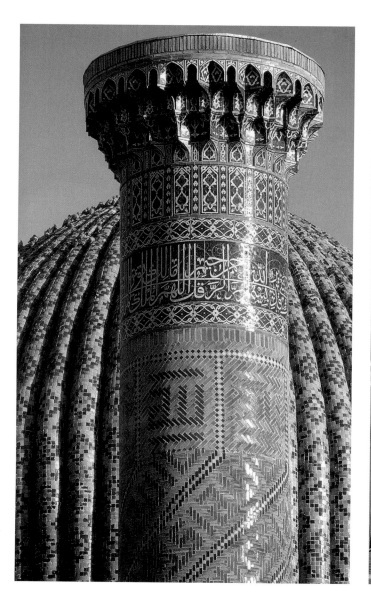

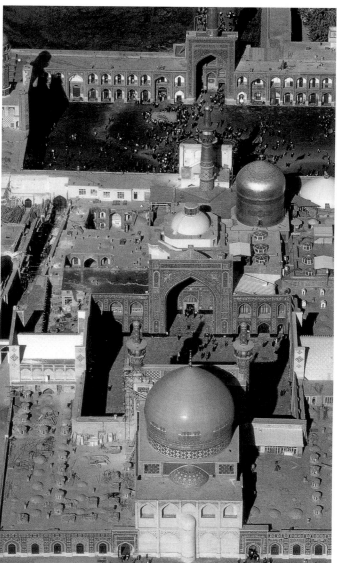

Far left: Detail of tilework on dome and minaret, Gur-i Mir, Samarqand, 1404.

Left: Aerial view of the Shrine of Imam Reza, Mashhad, showing the Mosque of Gawhar Shad, 1405–18 (lower portion of picture), and the gold dome of the shrine itself (the gold-plating was added during the Safavid period).

Later Timurid architecture was at its finest in the remarkable architectural projects of Shah Rukh and his wife Gawhar Shad at Herat and elsewhere. The great complex of Gawhar Shad at Herat (1417–38), sadly now almost entirely destroyed with the exception of a mausoleum and two minarets, was described by many who saw it as one of the most impressive monuments in the Islamic world. The interior of the tomb features a complex web of squinches and vaulting, and the minarets are sheathed in outstanding tile mosaic. Highly sophisticated systems of vaulting are also found at the shrine of 'Abdallah Ansari at Gazargah (1425–7), and the Ghiyathiyya Madrasa at Khargird (completed 1442). Both were the work of the architect Qavam al-Din of Shiraz, as was Gawhar Shad's ensemble at Herat.

The architecture of Central Asia during the 16th-century is exemplified by the monuments of the Shaybanids (or Uzbeks) at Bukhara, such as the Mir-i Arab Madrasa (1535), which follows the established patterns of the Timurid style.

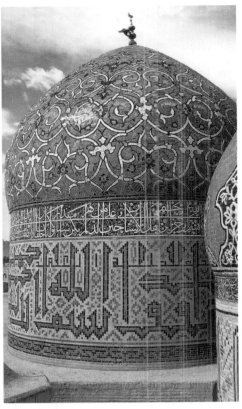

Left: Darb-i Imam, Isfahan, 1453–4.

Below: Entrance portal and domes of the Mir-i Arab Madrasa, Bukhara, 1535.

Above: Façade and minaret of the Shirdar Madrasa, Samarqand, 1616–36.

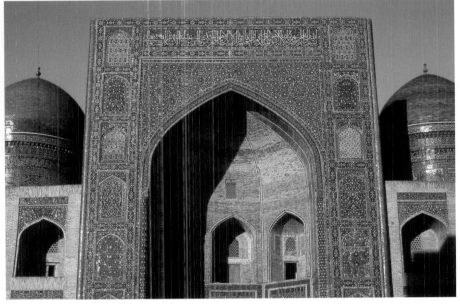

TURKMEN ARCHITECTURE

According to historical sources, the most spectacular Turkmen monument was the Nasiriyya complex at Tabriz, built under the Aq Qoyunlu rulers Uzun Hasan (1457–78) and Ya'qub (1478–90), but nothing of it remains. One of the few buildings to have survived from the Turkmen dynasties in western Iran is the Masjid-i Muzaffariyya, more commonly known as the Firuze-i Islam ('Turquoise of Islam') or Blue Mosque, at Tabriz (1465). Built at the order of the Qara Qoyunlu ruler Jahan Shah, it was originally part of a large complex. Its unusual form consists of a domed central area surrounded on three sides by nine domed bays, with a domed chamber of intermediate size on the fourth (qibla) side. The outstanding tilework of the interior and exterior includes glazed and lustre tiles as well as extensive tile mosaic. The interior decoration also includes a finely carved marble dado. Examples of Turkmen architecture have also survived in Isfahan. The Darb-i Imam (1453–4), a shrine featuring magnificent tile mosaic, was built by Jahan Shah; and repairs to the qibla iwan of the Masjid-i Jami', once again featuring exceptionally beautiful tile mosaic, were ordered by Uzun Hasan in 1475–6. In Anatolia, a lone mausoleum near Hasan Keyf marks the burial of Zaynal Mirza, one of Uzun Hasan's sons, who was killed in battle against the Ottomans in 1473. It is cylindrical in form, with a bulbous dome, and is decorated in brick and tile mosaic.

THE SAFAVIDS

Architecture in Iran under the Safavids continued in the tradition of Ilkhanid and Timurid monuments with very little change to structure and form. Nevertheless the large-scale architectural projects of the Safavids display a

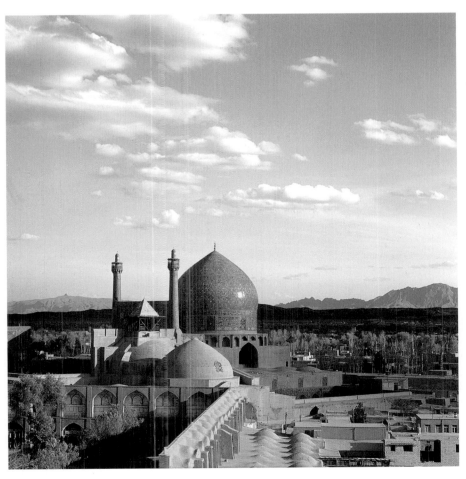

Above: Meydan-i Shah and Masjid-i Shah, Isfahan, 1590 onwards and 1612–30.

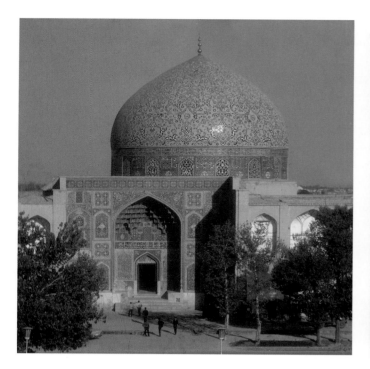

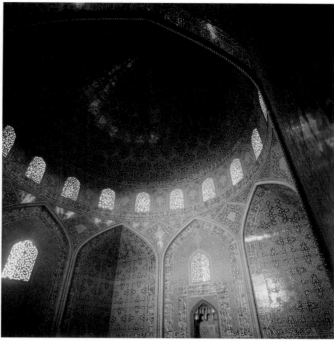

Left: Exterior and interior of the mosque of Shaykh Lutfallah, Isfahan, 1602–19.

remarkable unity, and are exquisitely refined. Their buildings are typically encased in a glittering shell of polychrome tilework. Little remains from the early Safavid period under Shah Tahmasp I (1524–76), but fragments in Nayin and contemporary descriptions of palaces in Qazvin attest to the existence of large-scale wall paintings in the style of contemporary miniatures.

Safavid architecture is exemplified by the lavish architectural projects of Shah ʿAbbas I (1587–1629) in his new capital Isfahan, which he set about transforming from 1590. Foremost among them was the great square, over 500m long, known as the Naqsh-i Jahan ('Ornament of the World'), now called the Meydan-i Shah or the Meydan-i Emam (1590 onwards). The mosque of Shaykh Lutfallah (1602–19) stands on the east side of

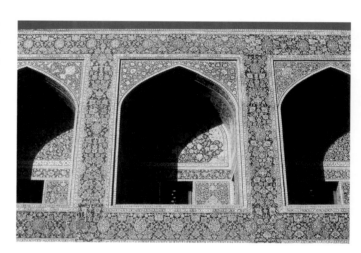

Left: Tilework at the Masjid-i Shah, Isfahan, 1612–30.

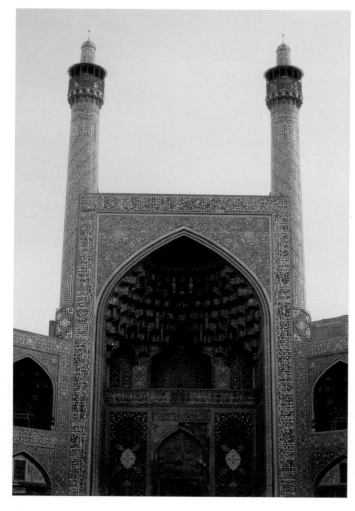

Above and right: Portal and *qibla iwan* of the Masjid-i Shah, Isfahan, 1612–30.

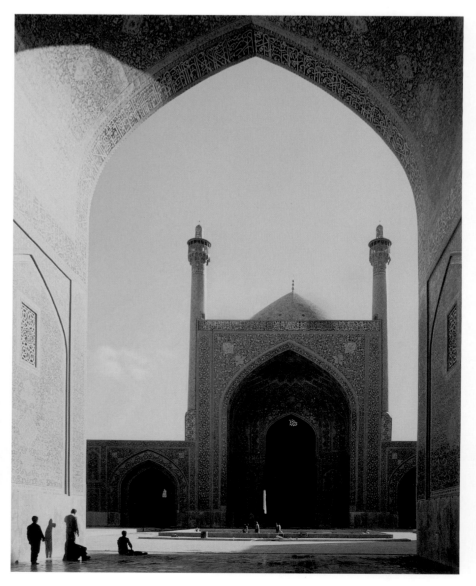

this square. It takes the form of a single dome supported by eight arches, resting on a square chamber. The transitional zone is disguised by 32 niches, and exquisitely beautiful tilework entirely sheathes the interior. This is one of the few occurrences of a single-shelled dome in Safavid architecture; most domes are double-shelled.

On the south side of the square is the Masjid-i Shah (1612–30), also known as the Masjid-i Emam. A monumental portal aligned with the square leads to an open court with four *iwans*, which, like the interior of the mosque of Shaykh Lutfallah, is set at an angle to the square to achieve the correct orientation towards Mecca. Twin minarets spring from the main portal and the *qibla iwan*, accentuating their height. The enormous dome behind the *qibla iwan*, some 52m high, is flanked by two covered chambers used as winter prayer halls; these lead to courts used as *madrasas*. The lateral *iwans* also lead to domed chambers, as at the mosque of Bibi Khanum in Samarqand. Almost the entire visible surface of the building is covered by tilework.

Safavid palaces have survived in some numbers. On the west side of the Meydan-i Shah stands a palace complex, the 'Ali Qapu ('Lofty Gate', c. 1597–1660), which has been enlarged and modified considerably over the years. It is dominated by a large, elevated porch with columns which faces onto the square. Perhaps the finest

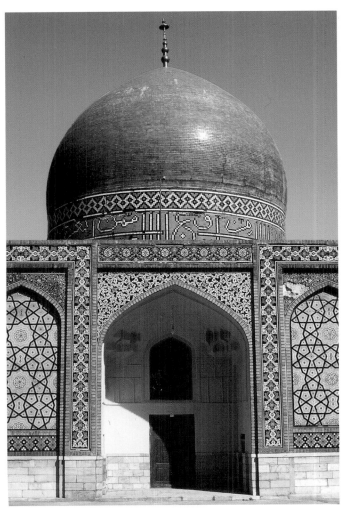

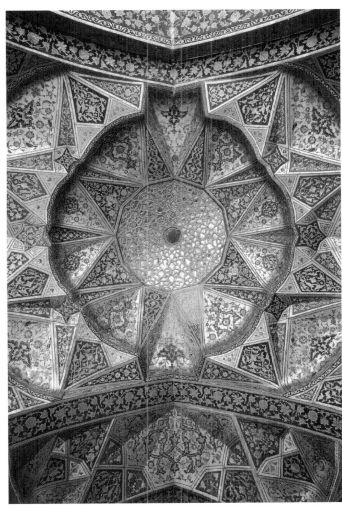

Far left: Gunbad-i Sabz, Mashhad, built by Shah 'Abbas I, 1602.

Left: Painted *muqarnas* ceiling, Hasht Bihisht, Isfahan, 1669.

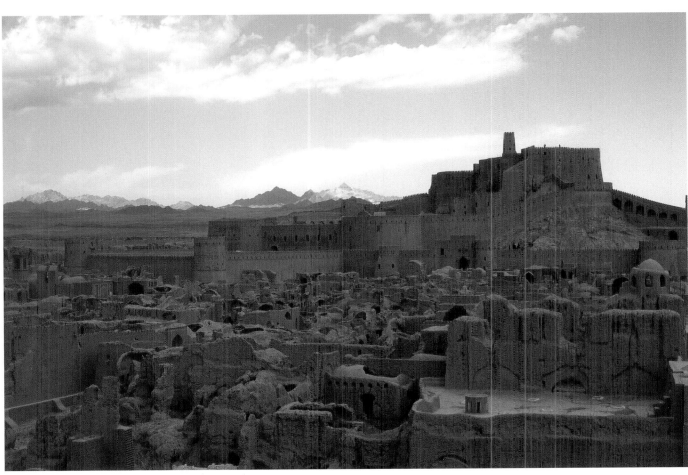

Left: The old town and citadel of Bam, on the trade route through south-eastern Iran, 16th–17th century, shown before its almost complete destruction in an earthquake in 2003.

Safavid palace however is the Hasht Bihisht ('Eight Paradises') in the Bagh-i Bulbul or Garden of the Nightingale, Isfahan (1669). This is a two-storeyed structure with a domed central hall surrounded by four corner chambers, between which four *iwans* open out onto porches and the gardens beyond. The central hall contains an octagonal pool and *muqarnas* ceiling, and numerous windows and grilles contribute a feeling of lightness and minimize the sense of enclosure. This form is also known from descriptions of Timurid and Turkmen palaces, and became especially popular in Mughal India.

The Safavid period, and in particular the reign of Shah 'Abbas I, also witnessed the establishment of numerous caravanserais on trade routes throughout Iran.

OTTOMAN ARCHITECTURE

Early Ottoman mosque architecture was characterized by the evolution of a domed space surrounded by domed or vaulted bays, a form that had been common in Anatolia since the Seljuk period. This development is illustrated by the mosque of Orhan Ghazi (1339) and the Yeşil Cami or 'Green Mosque' (1412–24), both at Bursa, which was the capital from 1326–1403 and remained a centre of imperial patronage thereafter. A domed central area is surrounded on three sides by domed bays, the dome of the *qibla* area being of intermediate size, and is preceded by a porch with five bays. The Uç Şerefeli Mosque at Edirne (1447) took these developments even further. A huge central dome rests on a hexagonal base, supported on two sides by the walls of the building and by two massive hexagonal piers in between, and is flanked by two pairs of much smaller domes. The porch is replaced by a courtyard surrounded by domed bays, with a fountain at its centre and minarets at each corner.

The interiors of the Green Mosque and in particular of the mausoleum adjacent to it, known as the Yeşil Türbe, are decorated with some outstanding tilework, which has been compared to Timurid tilework in Samarqand. Octagonal or hexagonal tiles are used for the dados, while *cuerda seca* appears on the *mihrab* and in the royal loge of the mosque. This ceramic decoration was the work of craftsmen from Tabriz, who had been deported

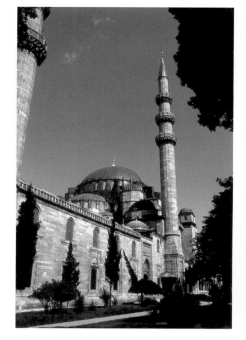
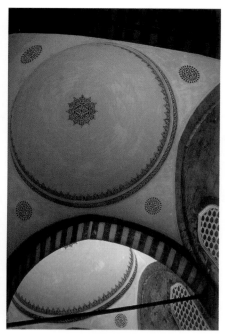

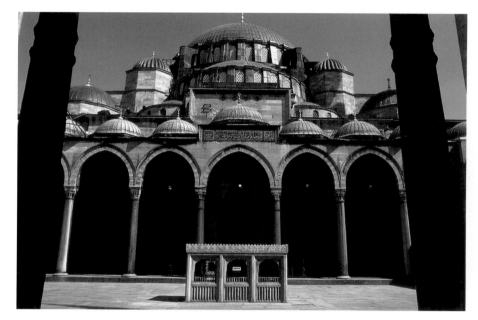

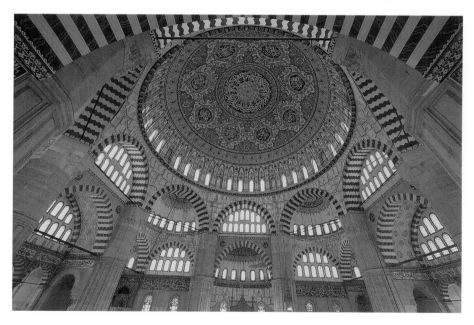

Above: Süleymaniye Mosque, Istanbul, 1551–7: exterior from northwest (top left), domed bays surrounding courtyard (top right); courtyard and mosque from main gate (above).

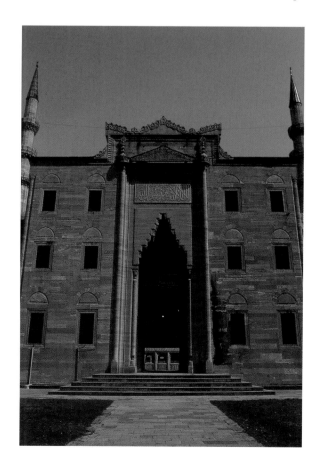

Above: Main (north) entrance to the courtyard of the Süleymaniye Mosque, Istanbul, 1551–7.

by Timur to embellish his capital Samarqand; they returned following Timur's death in 1405, and later worked in Anatolia. The *mihrab* in the mausoleum is signed 'the masters of Tabriz'.

Following the Ottoman conquest of Constantinople in 1453 – and arguably with the additional inspiration of the city's great Byzantine church (Hagia Sophia), dedicated in AD 537 – the evolution of the central domed space continued, with an increasing awareness of the implications of the semi-dome. The mosque of Bayazid II in Istanbul (completed 1507) features a large central dome buttressed by two semi-domes, one on either side along the main axis

Above: Interior of the Selimiye Mosque, Edirne, 1568–74.

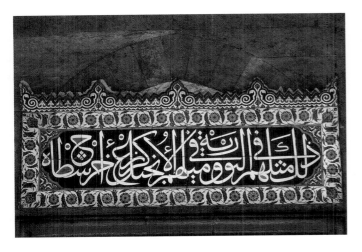

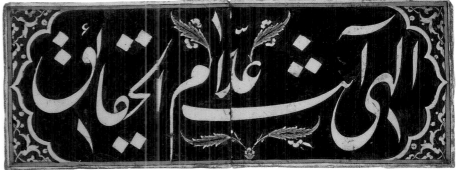

Left: Tile panel in the courtyard of the Süleymaniye Mosque, Istanbul, 1551–7.

Above: Two tiles from the head of a panel. Iznik, c. 1570–80.

of the building. The main dome of the Şehzade Mosque (1548) is surrounded by four semi-domes, with four smaller domes in the corners. The result when viewed from the exterior is a cascade of domes, and inside the building, a huge opening up of interior space. However, all of these precursors are dwarfed by the two great masterpieces of the architect Sinan, the Süleymaniye Mosque in Istanbul (1551–7) and the Selimiye Mosque in Edirne (1568–74).

The Süleymaniye Mosque was completed for Süleyman the Magnificent (1520–66). It stands in a superb location, commanding impressive views over the Golden Horn, and forms the centre of a large complex, including a number of *madrasas* with living quarters, shops and royal mausoleums. The huge dome is set upon four square piers, opening out into two half-domes which each expand into further domes. The Selimiye Mosque was built for Süleyman's son Selim II (1566–74). Its dome, over 31m across, is supported by eight arches which mark the transition between circular dome and square interior. These are in turn supported by eight massive piers, two of which are joined to the walls, the remaining six freestanding but pushed as close to the walls as structurally possible. Four semi-domes are located at the corners. The vast interior space is quite astonishing, and filled with natural light from a prodigious number of windows.

The interiors of Süleymaniye and Selimiye contain beautiful Iznik tilework, but this and other decoration is deliberately subordinated to the overall design. In both buildings the *mihrab* area is decorated with Iznik tiles, those in the Süleymaniye Mosque including calligraphic panels designed by Ahmed Karahisari. Exquisite tilework panels decorate the walls of the sultan's box at the Selimiye Mosque, and the Iznik tiles in the interior of Süleyman the Magnificent's octagonal mausoleum at the Süleymaniye Mosque are also exceptional. This ceramic decoration is complemented by finely wrought marble and bands of striped masonry. The use of Iznik tiles is more extensive at one of Sinan's other commissions, the Rüstem Paşa Mosque (c. 1561–2), where they cover not just the *mihrab* and surrounding area but the walls and piers as well.

Ottoman minarets are tall, slender structures, usually with three balconies and a sharply tapering conical roof. Their height is almost unprecedented – the two highest minarets at the Selimiye Mosque are over 70m – and their cylindrical or polygonal shafts often fluted to further accentuate it. Minarets rise from the corners of major mosques or their forecourts, and may be found in pairs or sometimes in groups of four or even six. Mosques with more than one minaret were a privilege of the sultan alone, however.

Palace architecture during the Ottoman period is exemplified by the Topkapı Saray in Istanbul (1459 onwards), a group of buildings set among gardens and pools, with a magnificent location between the Golden Horn and the Sea of Marmara. The Çinili Kösk or 'Tiled Pavilion' (completed 1472), built within the outer walls of the palace, is a two-storey structure consisting of a central

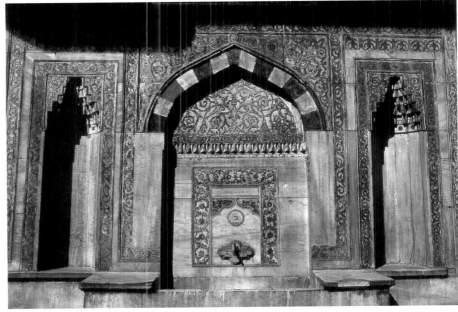

Above: Ahmed III Fountain, outside the Imperial gate of the Topkapı Saray, Istanbul, 1728.

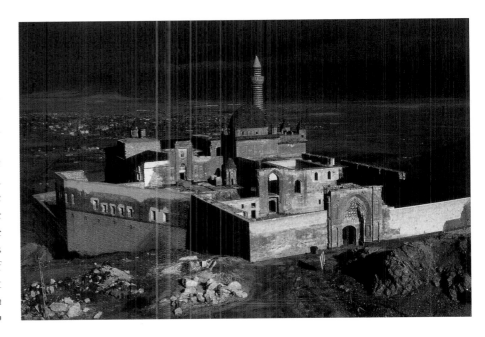

Above: Ishak Paşa Saray, Doğubeyazıt, completed c. 1784.

hall with four corner chambers, and large *iwans* opening between these on three sides, preceded by a porch. The plan is similar to that of Safavid and Timurid palaces, such as the Hasht Bihisht at Isfahan, while the tilework recalls that by Tabrizi refugees at Bursa and Edirne.

SULTANATE AND MUGHAL INDIA

Early Muslim architecture in the Indian subcontinent was an eclectic marriage of Islamic and local Hindu tradition. The large Friday Mosque known as the Quvvat al-Islam (meaning 'Might of Islam', 1192–6) at Delhi, constructed immediately after the Ghurid conquest, was built on a temple platform in the citadel of the defeated Rajput Prithvi Raj, using the spoils from Hindu and Jain temples. Re-used columns, with most of their figural sculpture removed, surround the courtyard and low Hindu domes stand over the *qibla* aisle. Superposed columns were used

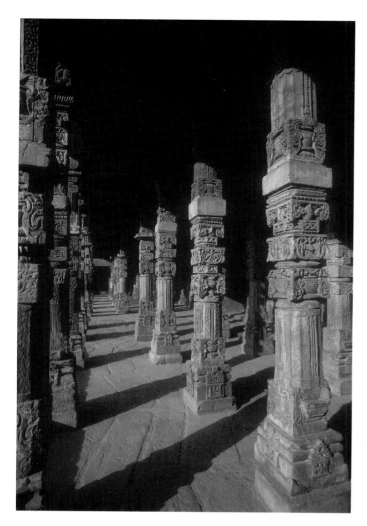

Above: Re-used columns from Hindu and Jain temples, Quvvat al-Islam, Delhi, 1192–6.

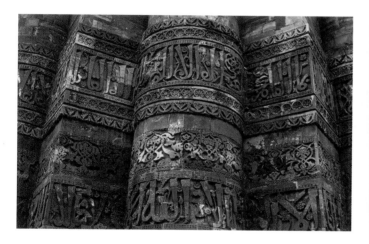

Above: Detail of stone carving on the Qutb Minaret, Delhi, c. 1200–12.

where necessary, a technique found in Jain temples. In 1198 a screen wall of pointed arches – which are not found in Hindu or Jain architecture – was erected on the courtyard side of the prayer hall. The Qutb Mosque at Delhi (1202–early 14th century) features a traditional hypostyle plan and large *qibla iwan*, together with Hindu-style pillars and heavy local ornament. The minaret is a spectacular construction, ribbed and surrounded by inscriptions and bands of ornament in carved stone.

Relatively little architecture has survived from the earliest years of Mughal rule in India, and most of this is actually attributable to Shir Shah Sur (1540–55), the Lodi ruler who drove Humayun into exile for a number of years. Shir Shah Sur's remarkable mausoleum at Sasaram (1538–45) takes the form of a large central dome surrounded by smaller domed pavilions of decreasing height, enclosed by a veranda, and stands in the middle of a huge artificial lake.

The mausoleum of Humayun in Delhi (1562–71) stands at the centre of a large *chahar-bagh*, a garden divided by water channels. It consists of a huge central dome, over 42m high, surrounded by four two-storeyed octagonal chambers crowned with *chhatris* (small domed

pavilions), and set on a large podium almost 100m square and containing 56 rooms. Its form is derived from Timurid and Safavid palaces, the scale perhaps influenced by Shir Shah Sur's mausoleum; the podium would appear to be derived from Hindu temples. It is built in a distinctive combination of red sandstone and white marble.

In the mausoleum of Akbar at Sikandra (1605–13), the profile of a huge central dome was replaced by a tiered arrangement of pavilions crowned by an open court. The mausoleum of I'timad al-Dawla at Agra (1622–8) features octagonal towers topped with *chhatris* at each corner, reminiscent of minarets; and in the mausoleum of Jahangir at Lahore (1627–34) these corner towers are taller and more prominent. These buildings show an increasing emphasis on detailed decoration and finish, including finely carved stone screens (*jali*), carved and painted plaster and, at the mausoleum of I'timad al-Dawla, marble inlaid with semi-precious stones.

The development of the Mughal mausoleum culminates in the Taj Mahal at Agra (1632–47), built by Shah Jahan for his favourite wife Mumtaz Mahal, who died in

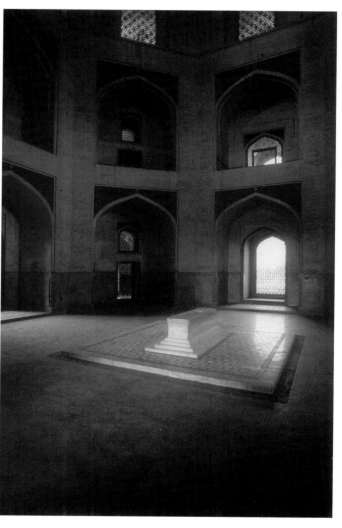

Left: Interior of the mausoleum of Humayun, Delhi, 1562–71.

Below: Mausoleum of Humayun, Delhi, 1562–71.

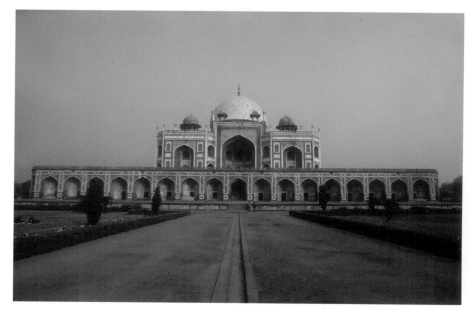

Above: Watercolour drawing of the cenotaph of Mumtaz Mahal, Taj Mahal, Agra, c. 1820.

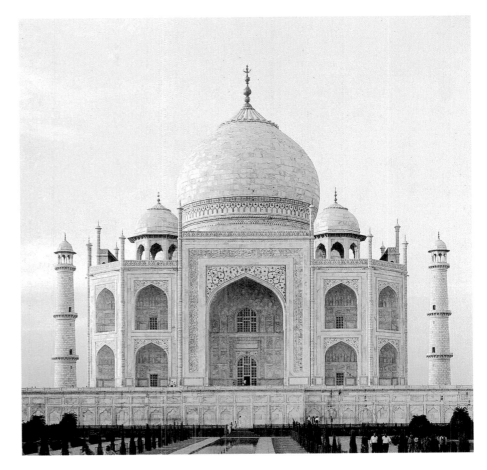

Above: Taj Mahal, Agra, 1632–47.

childbirth in 1631. The octagonal tomb consists of a huge, bulbous central dome set on a cylindrical drum, and is surrounded by four corner-pavilions crowned with *chhatris*, and between these four large *iwans*. The corner-pavilions are drawn closer together than those of the mausoleum of Humayun, accentuating the building's height. It stands on a high platform and is surrounded by four tall minarets. It is faced entirely with white marble from the quarries of Rajasthan, some of which is exquisitely carved – in particular the dado on the interior and exterior which depicts various species of flowering plants. The platform with the tomb is flanked by a mosque and a guesthouse in red sandstone. Unlike the mausoleum of Humayun, which occupies the centre of a *chahar-bagh*, the Taj Mahal stands at the northern end of a rectangular garden with an elongated pool at its centre. The garden is entered through a massive gateway on the south, from where the mausoleum is seen reflected across the pool.

The form of large Friday mosques in Mughal India is typically that of a monumental *qibla iwan* with *pishtaq* screen in front of multiple domes, preceded by a huge open court with minarets. The Masjid-i Jami' at Delhi (1650–56), built by Shah Jahan as part of his new capital Shahjahanabad, is one of the finest examples. A large dome rises behind the *qibla iwan*, flanked by two smaller domes; all three are bulbous in profile and decorated with vertical black stripes. The immense courtyard measures 91m on its longest side.

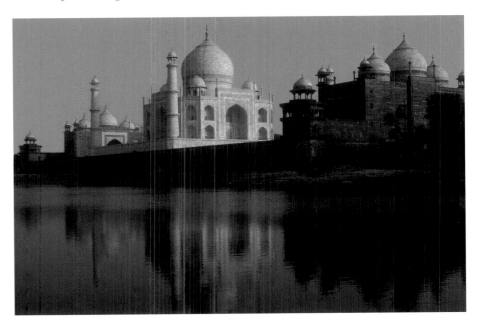

Above: Mausoleum flanked by a mosque and a guesthouse in red sandstone, Taj Mahal, Agra, 1632–47.

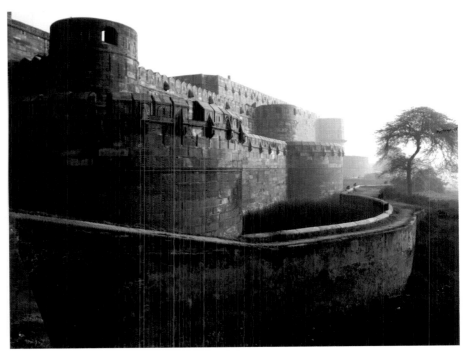

Above: Walls of the Lal Qila or 'Red Fort' (the palace in Shah Jahan's new capital, Shahjahanabad), Delhi, 1639–48.

Above: Two carved stone screens (*jali*). North India, later 16th century (left), and Agra, 1630–40 (right).

THE 19TH AND 20TH CENTURIES

During the 19th century Islamic and in particular Ottoman architecture was increasingly influenced by European architectural fashions. This trend was particularly strong under Sultan Abdülmecid I, and is typified by the introduction of the clock tower into Ottoman cities. The Küçük Efendi complex in Istanbul (1825) has a rolling Baroque façade; and the Dolmabahçe Saray, also in Istanbul (1853), features a long Neo-Classical façade and, in the interior, a huge chandelier of Waterford glass. The Dolmabahçe Saray is one of many buildings built by Karabet Balian, whose father Krikor was the first Ottoman architect to study in Europe. Similarly, in Egypt the governor Muhammad 'Ali (1805–48) employed the services of the French architect Pascal Coste. He, however, followed earlier precedents for his massive mosque in the Citadel at Cairo (1820–57), although they were Ottoman rather than Mamluk, particularly noticeable in the slender, fluted minarets. Despite such changes, a more traditional style prevailed in some other areas – at Khiva under the Qungrat dynasty, where architecture more or less continued to follow established Timurid formulas, and particularly in the domestic architecture of Yemen.

In an odd twist of fate, towards the end of the 19th century the European fascination with Islamic art resulted in a number of 'orientalist' features being imported into the Islamic world by European architects. The Sirkeci Railway Station at Istanbul (1890) – the terminus of the Orient Express, designed by the German architect Jachmund – features Moorish horseshoe-shaped arches and Indian *chhatris*, on a façade which is otherwise largely Neo-Classical. Such trends illustrate a period of revivalism, in which traditional elements were adapted to new forms. The Turkish architect Kemalettin, a pupil of Jachmund, built a number of office blocks in Istanbul, such as the Vakıf Han (1914–26). In this building a modern, steel frame is disguised under a façade of traditional cut stone, and the elevator machinery is hidden by domes.

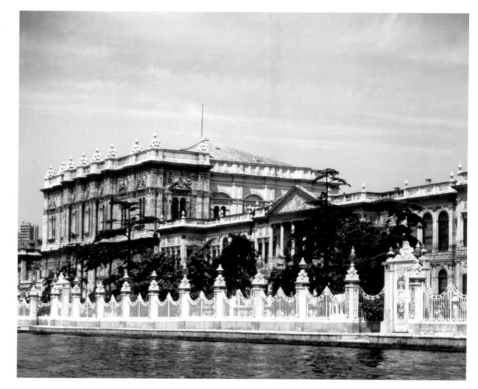

Above: Dolmabahçe Saray, Istanbul, 1853.

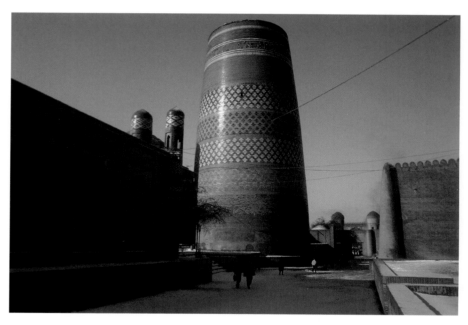

Above: Kalta Minaret, Khiva, begun 1852.

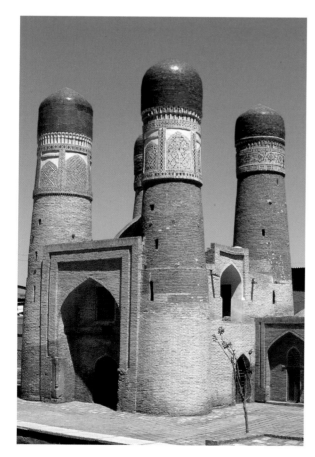

Above: Chahar Minar, Bukhara, 1807.

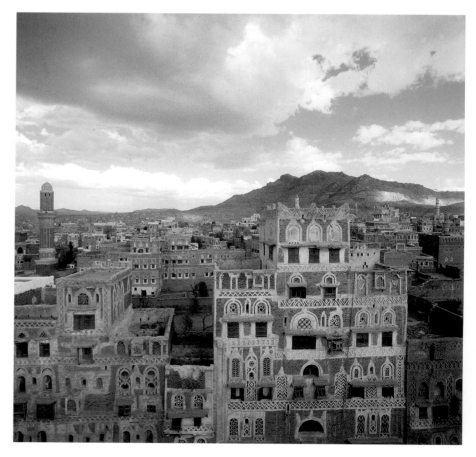

Above: Traditional architecture in San'a, Yemen.

Glossary

The following list includes relevant words in Arabic, Persian and Turkish, together with more general architectural and art-historical terms, some less commonly known geographical areas, and the literary works most frequently mentioned in the text.

'abd servant, slave; in the sense of God's slave, a common component of personal names

ablaq (literally 'pie-bald') two-tone masonry

amir commander, lord

Anatolia geographical region, Turkey; a modern term for Asia Minor

andalusi rounded script used in Islamic Spain

arabesque interlacing pattern of scroll-work, typically using stylized leaves

arg citadel

atabeg originally, guardian of a Seljuk prince; later, ruler of successor states to the Great Seljuks

Azerbaijan geographical region, northwest Iran and southeast Caucasus

bab entrance, gate

bagh garden

banna'i technique of decorative brickwork, frequently using glazed bricks

baraka blessing

basmala the invocation 'In the name of God, the Merciful, the Compassionate' with which each *sura* in the Qur'an begins, and often found at the beginning of inscriptions, too

bayt house or apartment, suite of rooms

bazar market

beg tribal leader

bezel grooved depression in a ring holding a stone in place

bidri Indian metalwork technique developed in the early 17th century; a vessel of zinc alloy is inlaid with silver and brass (and occasionally gold), then coated with mud and salts which turn the alloy black but leave the decoration contrastingly bright

Byzantium Eastern Roman Empire; also the ancient city on the Bosphorus that was rebuilt by Constantine I in AD 330 and called Constantinople, now Istanbul

cabochon polished, rounded gemstone

caliph (from Arabic *khalifa*) supreme Muslim leader and successor to the Prophet Muhammad

cami see **jami'**

caravansarai lodging place for merchants and travellers

chahar-bagh (literally 'four gardens') garden symmetrically divided into four sections by intersecting watercourses

chahar-taq square, domed structure with an arched opening in each side

chamfron metal plate protecting a horse's forehead and nose

chancery the private office of a ruler, preparing and distributing documents of State

chhatri kiosk or miniature pavilion, a common feature of Indian architecture

chinoiserie Chinese motifs such as lotus and peony scrolls, which were adopted into the repertoire of Islamic decoration

Circassian from the Black Sea region northwest of the Caucasus

cloud scrolls curved and convoluted ribbon-like ornament, a particularly influential Chinese motif

cönk distinctive oblong manuscript format, developed in Iran during the 15th century

cuerda seca (Spanish, 'dry cord') technique of pottery decoration in which lines of manganese purple pigment, mixed with a greasy substance that disappears in firing, prevent different coloured glazes running together

damascening technique of decorating metal with gold or silver inlay

dar palace or house; abcde, as in *dar al-Islam* ('abode of Islam'), a term in Islamic law referring to territory under Muslim control

dawla state, dominion, empire

dervish common term for Sufi mystic

die bronze or iron device with which a design or legend is applied to a heated, blank coin

Divan collection of poems arranged alphabetically; also a term for a Council of State

divani script primarily used in Ottoman administrative documents drawn up in the Sultan's chancery (see above)

Diyar Bakr geographical region in southeast Turkey, including the modern town of Diyarbakır

doublure inner lining of book cover, usually decorative

epigraphic relating to inscriptions

Fars province in Iran, including the town of Shiraz

fatiha opening chapter of the Qur'an

flan 'blank' piece of metal used to make a coin

fritware type of pottery with a hard, whitish body, composed of quartz, white clay and frit (itself composed of quartz with a soda flux)

ghazal short lyric poem or ode

Ghiordes knot symmetrical or 'Turkish' knot used in rugs and carpets

Ghur mountainous region in Afghanistan, southeast of Herat

gul rose

Gulistan ('Rose Garden') collection of stories by the Persian poet Sa'di (between 1213 and 1219–1292)

gumbad dome; tomb tower

Gurgan region in northern Iran, on the eastern Caspian shore

hadith tradition or saying of the Prophet or the Shi'ite *imams*, an essential tool for the interpretation of Islamic law

hajj annual pilgrimage to Mecca

hajji one who has performed the annual pilgrimage to Mecca

hammam bathhouse

han see **caravansarai**

haram (literally 'forbidden by religion') sacred or private quarters or territory, for example the Haram al-Sharif ('the Noble Sanctuary') in Jerusalem

harem women's private apartments; see **haram**

hasht-bihisht (literally 'the eight paradises') a favourite name for palaces and pavilions in Iran

Hellenistic relating to Greek culture from the death of Alexander the Great in 323 BC to the establishment of the Roman Empire by Augustus in 30 BC

Hijaz geographical region, northwest Arabian Peninsula

Hijra flight of the Prophet Muhammad from Mecca to Medina in AD 622, the date from which the Muslim era is calculated

hizam woven or embroidered textile band in eight sections covering the upper part of the *kiswa* of the Ka'ba (see below)

huqqa type of pipe, which draws the smoke through a container of water or other liquid in order to cool it; see also **qalyan**

hypostyle basic architectural form of mosque, consisting of a rectangular enclosure with a courtyard surrounded by porticoes, with a deeper, covered prayer hall on the wall orientated towards Mecca

ikat textile technique in which threads are tie-dyed before weaving

imam Muslim leader of prayer; also leader of a Shi'ite community

Islam (literally 'to surrender oneself') the Muslim religion, as communicated to the Prophet Muhammad and recorded in the Qur'an

Isma'ilis followers of Isma'il, the seventh of the twelve Shi'ite Imams

iwan vaulted hall or chamber, open at one end, in Persian architecture typically fronting the domed chamber containing the *mihrab* (see below)

jali stone or marble screen in India

jali large

jami' (from Arabic, 'to assemble') large mosque intended for communal Friday prayer, attendance at which is a duty of all adult Muslims

Jami' al-Tawarikh ('Compendium of Chronicles') illustrated world history written by the Ilkhanid vizier, Rashid al-Din in the early 14th century

Janissaries the elite Ottoman soldiery, generally recruited as children from the Balkans

Jazira geographical region encompassing northern Iraq and southeastern Anatolia, between the Middle Euphrates and the Tigris

juz' division of the Qur'an into equal sections

Ka'ba the structure which houses the much-revered black stone at Mecca

Kalila wa Dimna series of animal fables of Indian origin, translated into Arabic c. 750

kalıp stencil used in calligraphy

karalama calligrapher's practice sheet; see also **musawwada**, **siyah mashq**

kard knife or dagger with a long, straight, one-sided blade

khalifa see **caliph**

Khamse (literally 'five', usually translated in this context as 'Five Tales') classic collection of verse romances by the 12th-century Persian poet Nizami

khan traditional title of Turkish or Mongol ruler; tribal leader

khanjar dagger

khanqa lodge or centre for dervishes or Sufis

khaqan supreme ruler

Khurasan region of northeast Iran, including part of modern Afghanistan, notably the town of Herat

khutba the Friday sermon given in the name of the ruler, sultan or caliph

Khwarazm geographical region around Khiva in Central Asia

kilim type of carpet; a flat-weave rug without knots

kiswa textile covering for the Ka'ba in Mecca (see above)

kitab book

Kufic conventional term used for the early angular Arabic scripts, named after the Iraqi town of Kufa

lajvardina (literally 'of lapis lazuli') type of pottery decoration using a blue glaze and enamels

laqab honorific title

laqabi style of pottery decoration in which coloured glazes are contained by carved ridges

levha large calligraphic panel

Luristan geographical region in western Iran

lustre technique of pottery decoration in which metallic pigments are painted onto the surface of a glazed and fired object, before firing the object a second time in a reducing kiln. This leaves a thin metallic

film adhering to the glaze, with a lustrous sheen

madina city

madrasa (in Turkish, **medrese**) college for religious studies

Maghrib geographical region, northwest Africa and Spain

maghribi rounded script used in North Africa

mamluk bought slave; the dynasty that ruled Egypt 1250–1517

manar see **minaret**

maqsura sultan's place of private prayer within a mosque, usually an enclosure or a platform

marvered technique of glass decoration in which glass trails are pressed flush with the surface of a vessel by turning it against a flat stone or metal surface known as a 'marver'

mashhad martyr's shrine or mausoleum

masjid (literally 'place of prostration') mosque

masjid-i jami' Friday mosque; see **jami'**

Mazanderan geographical region, Iran's central and eastern Caspian shores

mazar mausoleum

Mesopotamia (literally 'between the rivers') geographical region, the area between the rivers Tigris and Euphrates in modern Iraq and Syria

mihrab prayer niche in the wall of a mosque, mausoleum or other building, indicating the direction of Mecca, towards which prayer is directed

millefiori (Italian, 'thousand flowers') see **mosaic glass**

millet religious minority granted a degree of self-government and freedom of worship within the Ottoman state. The three main *millets* were the Greek and Armenian Christians and the Jews

mina'i type of pottery decoration in which coloured enamels are applied over the glaze

minaret (from Arabic *manar*, 'lighthouse') tower, usually attached to a mosque although sometimes separate, from which the call to prayer is issued; a commemorative structure, such as a 'victory tower', of similar form

minbar pulpit in a mosque, used for sermons; a judge's seat in pre-Islamic times

mosaic glass technique for producing glass vessels, using horizontal sections of narrow rods made up of strands of coloured glass. These are arranged in a pattern, heated until fused, and shaped in a mould; also called **millefiore**

mudéjar Muslim inhabitant of Christian Spain

muezzin religious official who gives the call to prayer

mufradat individual letters of the Arabic alphabet; albums in which calligraphers practised writing them

muhaqqaq rounded script with well-balanced ascending and horizontal strokes, popular for use in Qur'ans from

the 13th century onwards; one of the six 'classical hands'

muqarnas decorative vaulting system used in architecture, composed of tiers of small niches; sometimes referred to as 'stalactites'

muraqqa' (literally 'a collection of fragments') collection of samples of calligraphy, paintings and drawings contained in an album

musawwada see **karalama**, **siyah mashq**

mushaf single-volume Qur'an

Muslim (literally 'one who surrenders himself or herself to God') follower of the religion of Islam

name letter, book

naskh clearly written, rounded scribal hand or 'copyist's script'; one of the six 'classical hands'

nasta'liq elegant script characterized by short ascending strokes and sweeping, elongated diagonal strokes, very popular in Iran for use in non-Qur'anic manuscripts

nisba epithet, often designating place of birth, such as al-Kashani, meaning 'from Kashan'

parison ball of molten glass which is inflated on a blowpipe; also known as a 'gather'

pishtaq raised arch and section of façade framing an *iwan* (see above) or entrance portal

pomander pierced vessel containing perfumes

pontil solid metal rod to which blown glass vessels are transferred from the blowpipe. The pontil leaves a scar on the base of the object, known as the 'pontil mark'

qadi Islamic judge

qalyan see **huqqa**

qasr fort

qibla the direction of Mecca

qit'a (in Turkish, **kıt'a**; literally 'a piece' or 'a fragment') calligraphic panel

qızılbash (literally 'red-head') tribal supporters of the Safavids, who wore the red cap known as the *taj-i Haydari*

qubba dome

Qur'an the text regarded by Muslims as God's final revelation to humankind. Believed to have been communicated to the Prophet Muhammad in his native city of Mecca, and in part during his sojourn in Medina, the 114 chapters or *suras* were collected under the third of his successors, the Caliph 'Uthman.

rab'a multi-volume Qur'an

rashidun (literally 'rightly guided') orthodox, often referring to the first four caliphs

rayhan script in which the vowels are written with a finer pen than the rest; one of the six 'classical hands'

Reconquista Christian conquest of Islamic

Spain, between the 13th and the late 15th centuries

riqa' script usually used on administrative documents, and sometimes for *sura* headings, colophons and dedications in Qur'ans; one of the six 'classical hands'

saff (literally 'a row' or 'a line') type of prayer rug on which multiple niches are depicted

saray palace

Sasanian the dynasty ruling in Iran at the coming of Islam, c. AD 225–651

saz type of decoration based on the leaves of the reed, common in Ottoman art; also a type of musical instrument

Sehna knot asymmetrical or 'Persian' knot used in rugs and carpets

sgraffiato (Italian, 'scratched') type of pottery decoration in which patterns were incised in the body of a vessel which had first been coated with a slip (see below), and covered with a lead glaze

shah Persian title for a king

shahada Muslim profession of faith: 'In the name of God, there is no God but God alone, Muhammad is the messenger of God'

Shahname ('Book of Kings') Iranian national epic and masterpiece of the great Persian poet Firdawsi (940–1021)

shamsa ornamental sun-disc or rosette

shaykh tribal or religious leader

Shi'a (singular **Shi'i**, from *shi'at 'Ali*, meaning 'the party of Ali') followers of the Shi'ite branch of Islam, who believe that following the murder of 'Ali in 661, the Caliphate should have passed to his descendants rather than to the Umayyads

shikaste (literally 'broken') script in which parts of a word are written on different levels

sikka ruler's right to place his name on coins issued under his authority

simurgh mythical Persian bird

Sind geographical region, coast of Pakistan

Sistan geographical region, province in southeast Iran

siyah mashq see **karalama**, **musawwada**

slip liquid clay, used as a coating for pottery

slip-carved technique of pottery decoration in which a slip is carved away from the vessel

slip-painted technique of pottery decoration in which earthy pigments are painted thinly onto a ground that has first been covered with a contrasting hue

squinch transitional zone composed of an arch or series of arches used to link a square space with the dome above it

stucco plaster made of gypsum or lime, used to coat walls and for moulded decoration

Sufi Muslim mystic

sultan title taken by Muslim rulers from the Seljuk period and later

Sultanabad ware type of pottery dating from the first half of the 14th century and named after the site in northwestern Iran at which it was discovered; it was probably made in Kashan

Sunni (from *sunna*, 'tradition') follower of orthodox branch of Islam, that is, the tradition of the Prophet Muhammad (as opposed to the *Shi'a*, those who follow the line of 'Ali)

sura 'chapter' of the Qur'an, of which there are 114

taj crown

taj-i Haydari Shi'ite cap with 12-ribbed crown (symbolizing the 12 imams), popular in Iran during the early Safavid period

tawqi' script usually used for administrative documents; one of the six 'classical hands'

thulth bold, monumental rounded script; one of the six 'classical hands'

tiraz ornamental band of calligraphy, used on textiles; also found in architectural decoration

tombak gilt copper

Transcaspia geographical region northeast of the Caspian Sea

Transoxania (literally 'the lands across the Oxus') geographical region northeast of Khurasan, including the towns of Bukhara and Samarqand

tuğra distinctive monogram of the Ottoman sultan, giving his name together with that of his father, the traditional Turkish title *Khan* and, later, the words 'ever victorious'

türbe tomb, tomb tower

Ulu Cami Great Mosque

vizier minister

wali governor

waqf endowment of land or property, made in perpetuity, the income from which supported a religious institution

waq-waq mythical talking tree

warp series of threads stretched lengthways over a vertical or horizontal loom, to which lengths of wool or silk are tied, in the manufacture of textiles and knotted rugs or carpets

watered steel high-carbon steel with a wavy pattern achieved through particular forging techniques

weft series of threads woven crossways over and under the warp (see above) of a rug or carpet

yataghan long sword with an inward-curving blade, scimitar

zehgir archer's thumb-ring

Further Reading

HISTORY AND REFERENCE WORKS

The Encyclopedia of Islam (second edition), Leiden 1960–2002

Arberry, A.J. (ed.), *The Legacy of Persia*, Oxford 1989

Bosworth, C.E., *The New Islamic Dynasties*, Edinburgh 2004

— , *The Ghaznavids*, Edinburgh 1963

— and Hillenbrand, C. (eds), *Qajar Iran: Political, Social and Cultural Change 1800–1925*, Costa Mesa, California 1992

Boyle, J.A., Frye, R.N., Jackson, P. *et al.* (eds), *The Cambridge History of Iran*, 7 vols, Cambridge 1968–1991

Cahen, C., *The Formation of Turkey* (trans. Holt), Harlow 2001

Frye, R.N., *The Golden Age of Persia*, London 2000

Grousset, R., *The Empire of the Steppes: A History of Central Asia* (trans. Walford), New Brunswick, New Jersey 1989

Hillenbrand, C., *The Crusades: Islamic Perspectives*, Edinburgh 1999

Hitti, P.K., *History of the Arabs*, London 2002

Holt, P.M., *The Age of the Crusades: The Near East from the Eleventh Century to 1517*, Harlow 1986

— , Lambton, A.K.S. and Lewis, B. (eds), *The Cambridge History of Islam*, 2 vols, Cambridge 1977

Hourani, A., *A History of the Arab Peoples*, London 2002

Inalcik, H., *The Ottoman Empire: The Classical Age 1300–1600*, London 2000

Kennedy, H., *The Prophet and the Age of the Caliphates*, London 1986

Lambton, A.K.S., *Landlord and Peasant in Persia*, London 1953

— , *Qajar Persia: Eleven Studies*, London 1987

Le Strange, G., *The Lands of the Eastern Caliphate*, London 1966

Lewis, B., *The Middle East: 2000 Years of History from the Rise of Christianity to the Present Day*, London 2000

— , *The Arabs in History*, Oxford 2002

— , *The Muslim Discovery of Europe*, London 2000

— (ed.), *The World of Islam*, London 1992

Manz, B.F., *The Rise and Rule of Tamerlane*, Cambridge 1999

Morgan, D., *The Mongols*, Oxford 1986

— , *Medieval Persia 1040–1797*, Harlow 1988

Ruthven, M., *Historical Atlas of Islam*, Cambridge, Massachusetts 2004

Setton, K.M. (ed.), *A History of the Crusades*, 5 vols, Madison, Wisconsin 1969–

Thackston, W.M. (ed.), *A Century of Princes: Sources on Timurid History and Art*, Cambridge, Massachusetts 1989

Yapp, M.E., *The Making of the Modern Near East 1792–1923*, Harlow 1988

ISLAMIC ART AND ARCHITECTURE: GENERAL AND REGIONAL STUDIES AND CATALOGUES

Aslanapa, O., *Turkish Art and Architecture* (trans. Mill), London 1971

Atıl, E., *Renaissance of Islam: Art of the Mamluks*, Washington, DC 1981

— , *Turkish Art*, Washington, DC 1980

— , *The Age of Süleyman the Magnificent*, New York 1987

Baer, E., *Islamic Ornament*, Edinburgh 1998

Behrens-Abouseif, D., *Beauty in Islamic Culture*, Princeton, New Jersey 1999

Brend, B., *Islamic Art*, London 1991

Blair, S.S. and Bloom, J.M., *The Art and Architecture of Islam 1250–1800*, New Haven and London 1996

Çağman, F. *et al.* (ed.), *Turks: A Journey of 1000 Years 600–1600*, London 2005

Canby, S., *The Golden Age of Persian Art, 1501–1722*, London 1999

Dodds, J.D. (ed.), *Al-Andalus: The Art of Islamic Spain*, Granada and New York 1992

Ettinghausen, R., Grabar, O. and Jenkins-Madina, M., *The Art and Architecture of Islam 650–1250*, New Haven and London 2002

Falk, T. (ed.), *Treasures of Islam*, London 1985

Ferrier, R.W., *The Arts of Persia*, New Haven and London 1989

Golombek, L. and Subtelny, M. (ed.), *Timurid Art and Culture: Iran and Central Asia in the 15th Century*, Leiden 1992

Jackson, A. and Jaffer, A., *Encounters: The Meeting of Asia and Europe 1500–1800*, London 2004

Jenkins, M. (ed.), *Islamic Art in the Kuwait National Museum: The al-Sabah Collection*, London 1983

Khan, G., *Bills, Letters and Deeds: Arabic Papyri of the 7th to 11th Centuries* (The Nasser D. Khalili Collection of Islamic Art, Volume VI), London 1993

— , *Selected Arabic Papyri* (Studies in the Khalili Collection, Volume I), London 1992

Komaroff, L. (ed.), *The Legacy of Genghis Khan*, New York 2002

Lentz, T. and Lowry, G.D. *Timur and the Princely Vision*, Washington, DC 1989

Petsopoulos, Y. (ed.), *Tulips, Arabesques and Turbans: Decorative Arts from the Ottoman Empire*, New York 1982

Piotrovsky, M.B. and Rogers, J.M., *Heaven on Earth: Art from Islamic Lands. Works from the State Hermitage Museum and the Khalili Collection*, London 2004

Piotrovsky, M.B. and Vrieze, J. (ed.), *Art of Islam: Heavenly Art, Earthly Beauty*, Amsterdam 1999

Pope, A.U. and Ackerman, P. (eds), *A Survey of Persian Art*, 6 vols, Oxford University Press 1938–9; third edition, 16 vols, Ashiya, Japan 1981

Robinson, B.W. (ed.) *et al.*, *Islamic Art in the Keir Collection*, London 1988

Rogers, J.M., *Islamic Art and Design 1500–1700*, London 1983

— , *Empire of the Sultans: Ottoman Art from the Khalili Collection*, London 2002

— and Ward, R.M., *Süleyman the Magnificent*, London 1988

Sweetman, J., *The Oriental Obsession: Islamic Inspiration in British and American Art and Architecture 1500–1920*, Cambridge 1988

Talbot Rice, D., *Islamic Art* (revised edition), London 1993

Talbot Rice, T., *The Seljuks*, London 1961

Vernoit, S., *Occidentalism: Islamic Art of the 19th Century* (The Nasser D. Khalili Collection of Islamic Art, Volume XXIII), London 1997

Welch, A., *Shah Abbas and the Arts of Isfahan*, New York 1973

Welch, S.C., *India: Art and Culture 1300–1900*, New York 1988

CALLIGRAPHY

Blair, S.S., *Islamic Inscriptions*, Edinburgh 1998

Fendall, R., *Islamic Calligraphy*, London 2003

Safadi, Y.H., *Islamic Calligraphy*, London 1978

Safwat, N.F. with a contribution by Zakariya, M., *The Art of the Pen: Calligraphy of the 14th to 20th Centuries* (The Nasser D. Khalili Collection of Islamic Art, Volume V), London 1996

Welch, A., *Calligraphy in the Arts of the Muslim World*, Austin, Texas and New York 1979

QUR'ANS

Arberry, A.J., *The Koran Illuminated: A Handlist of the Korans in the Chester Beatty Library*, Dublin 1967

Bayani, M. and Stanley, T., *The Decorated Word: Qur'ans of the 17th to 19th Centuries* (The Nasser D. Khalili Collection of Islamic Art, Volume IV), London 1998 (Part One) and 2005 (Part Two)

Déroche, F., *The Abbasid Tradition: Qur'ans of the 8th to 10th Centuries AD* (The Nasser D. Khalili Collection of Islamic Art, Volume I), London 1992

James, D., *Qur'ans of the Mamluks*, London 1988

— , *Qur'ans and Bindings from the Chester Beatty Library*, London 1980

— , *The Master Scribes: Qur'ans of the 11th*

to 14th Centuries AD (The Nasser D. Khalili Collection of Islamic Art, Volume II), London 1992
— , After Timur: Qur'ans of the 15th and 16th Centuries (The Nasser D. Khalili Collection of Islamic Art, Volume III), London 1992
Lings, M., The Qur'anic Art of Calligraphy and Illumination, London 1976
— and Safadi, Y.H., The Qur'an, London 1976

MINIATURE PAINTING

Beach, M.C., Mughal and Rajput Painting (New Cambridge History of India, vol.1.3), Cambridge 1992
Blair, S.S., A Compendium of Chronicles: Rashid al-Din's Illustrated History of the World (The Nasser D. Khalili Collection of Islamic Art, Volume XXVII), London 1995
Brend, B., The Emperor Akbar's Khamsah of Nizami, London 1995
Canby, S., Persian Painting, London 1997
Falk, S.J., Qajar Paintings, London 1972
Grabar, O. and Blair, S.S., Epic Images and Contemporary History: The Illustrations of the Great Mongol Shahnameh, Chicago and London 1980
Gray, B. (ed.), The Arts of the Book in Central Asia 14th–16th Centuries, Boulder, Colorado 1979
Leach, L., Paintings from India (The Nasser D. Khalili Collection of Islamic Art, Volume VIII), London 1998
Pinder-Wilson, R. (ed.), Paintings from Islamic Lands, Oxford 1969
Robinson, B.W. et al., Islamic Painting and the Arts of the Book: The Keir Collection, London 1976
Rogers, J.M., Mughal Miniatures, London 1993
— and Çağman, F. and Tanındı, Z., The Topkapı Saray Museum: The Albums and Illustrated Manuscripts, London 1986
Soucek, S., Piri Reis and Turkish Mapmaking after Columbus: The Khalili Portolan Atlas (Studies in the Khalili Collection, Volume II), London 1992
Talbot-Rice, D., Islamic Painting, Edinburgh 1971
Titley, N.M., Persian Miniature Painting and its Influence on the Art of Turkey and India, London 1983
Welch, S.C., A King's Book of Kings: The Shah-Nameh of Shah Tahmasp, New York 1972
— , Artists for the Shah: Late Sixteenth-Century Painting at the Imperial Court of Iran, New Haven, Connecticut 1976

BOOKBINDING

Haldane, D., Islamic Bookbindings in the Victoria and Albert Museum, London 1983
Raby, J. and Tanındı, Z., Turkish Bookbinding in the 15th Century: The Foundation of an Ottoman Court Style, London 1993

LACQUER

Khalili, Nasser D., Robinson, B.W. and Stanley, T., Lacquer of the Islamic Lands (The Nasser D. Khalili Collection of Islamic Art, Volume XXII), London 1996 (Part One) and 1997 (Part Two)
Robinson, B.W., Eastern Lacquer: An Exhibition of 50 Pieces of Persian, Indian and Turkish Lacquer, London 1986

POTTERY AND CERAMICS

Atasoy, N. and Raby, J., Iznik: The Pottery of Ottoman Turkey, London 1989
Atıl, E., Ceramics from the World of Islam, Washington, DC 1973
Caiger-Smith, A., Lustre Pottery, New York 1985
Carswell, J., Iznik Pottery, London 1998
Crowe, Y., Persia and China: Safavid Blue and White Ceramics in the Victoria and Albert Museum 1501–1738, London 2002
Denny, W.B., Iznik: The Artistry of Ottoman Ceramics, London 2004
Grube, E.J., Islamic Pottery in the Keir Collection, London 1976
— et al., Cobalt and Lustre: The First Centuries of Islamic Pottery (The Nasser D. Khalili Collection of Islamic Art, Volume IX), London 1995
Lane, A., Early Islamic Pottery, London 1947
— , Later Islamic Pottery, London 1957
Philon, H., Benaki Museum, Athens. Early Islamic Ceramics, London 1930
Porter, V., Islamic Tiles, London 2004
— , Medieval Syrian Pottery, Oxford 1981
Porter, Y. and Degeorge, G., The Art of the Islamic Tile, Paris 2002
Watson, O., Ceramics from Islamic Lands: The al-Sabah Collection, London 2004
— , Persian Lustre Ware, London 1985
Wilkinson, C.K., Nishapur: Pottery of the Early Islamic Period, New York 1973

GLASS

Carboni, S., Glass from Islamic Lands: The al-Sabah Collection, London 2002
— , Whitehouse, D. et al., Glass of the Sultans, New York 2001
— and Henderson, J., Mamluk Enamelled and Gilded Glass in the Museum of Islamic Art, Qatar, London 2003
Fukai, S., Persian Glass, Tokyo 1977
Goldstein, S.M., et al., Glass From Sasanian Antecedents to European Imitations (The Nasser D. Khalili Collection of Islamic Art, Volume XV), London 2005
Hasson, R., Early Islamic Glass, Jerusalem 1979
Kröger, J., Nishapur: Glass of the Early Islamic Period, New York 1995

METALWORK

Allan, J., Nishapur: Metalwork of the Early Islamic Period, New York 1982

Atıl, E., Islamic Metalwork in the Freer Gallery of Art, Washington, DC 1986
Behrens-Abouseif, D., Mamluk and Post-Mamluk Metal Lamps, Cairo 1995
Fehérvári, G., Islamic Metalwork of the 8th Century to the 15th Century in the Keir Collection, London 1976
Komaroff, L., The Golden Disk of Heaven: Metalwork of Timurid Iran, Costa Mesa, California 1992
Melikian-Chirvani, A.S., Islamic Metalwork from the Iranian World, 8th–18th Centuries, London 1982
Strong, S., Bidri Ware: Inlaid Metalwork from India, London 1985
Ward, R., Islamic Metalwork, London 1993

SCIENTIFIC INSTRUMENTS

Maddison, F. and Savage-Smith, E. et al., Science, Tools and Magic. Part One: Body and Spirit. Mapping the Universe. Part Two: Mundane Worlds (The Nasser D. Khalili Collection of Islamic Art, Volume XII), London 1997

ARMS AND ARMOUR

Alexander, D., The Arts of War: Arms and Armour of the 7th to 19th Centuries (The Nasser D. Khalili Collection of Islamic Art, Volume XXI), London 1992
Elgood, R. (ed.), Islamic Arms and Armour, London 1979
North, A., An Introduction to Islamic Arms, London 1985

JEWELLERY

Hasson, R., Early Islamic Jewellery, Jerusalem 1987
— , Later Islamic Jewellery, Jerusalem 1987
Jenkins, M. and Keene, M., Islamic Jewelry in the Metropolitan Museum of Art, New York 1983
Keene, M. et al., Treasury of the World: Jewelled Arts of India in the Age of the Mughals. The al-Sabah Collection, London 2001
Wenzel, M., Ornament and Amulet: Rings of the Islamic Lands (The Nasser D. Khalili Collection of Islamic Art, Volume XVI), London 1993

CARPETS AND TEXTILES

Atasoy, N. et al., Ipek: The Crescent and the Rose: Imperial Ottoman Silks and Velvets, London 2001
Beattie, M., Carpets of Central Persia, London 1976
Bode, W. von and Kühnel, E., Antique Rugs from the Near East (trans. Ellis), Ithaca, New York 1984
Dimand, M.S. and Mailey, J., Oriental Rugs in the Metropolitan Museum of Art, New York 1973

Erdmann, E., *Oriental Carpets: An Essay on their History* (trans. Ellis), New York 1960

Spuhler, F., *Islamic Carpets and Textiles in the Keir Collection*, London 1978

Tezcan, H., *The Topkapı Saray Museum: Carpets* (trans. and ed. J.M. Rogers), New York 1987

— , Delibaş. S. and Rogers, J.M. *The Topkapı Saray Museum: Costumes, Embroideries and Other Textiles*, London 1986

COINS

Album, S., *A Checklist of Popular Islamic Coins*, Santa Rosa, California 1993

Broome, M., *A Handbook of Islamic Coins*, London 1985

Spengler, W.F. and Sayles, W.G., *Turkoman Figural Bronze Coins and their Iconography, Vol I. The Artuqids*, Lodi, Wisconsin 1992

Spengler, W.F. and Sayles, W.G., *Turkoman Figural Bronze Coins and their*

Iconography, Vol II. The Zangids, Lodi, Wisconsin 1996

ARCHITECTURE

Barrucand, M. and Bednorz, A., *Moorish Architecture in Andalusia*, Köln 2002

Behrens-Abouseif, D., *Islamic Architecture in Cairo: An Introduction*, Leiden 1989 and Cairo 1996

— *The Minarets of Cairo*, Cairo 1992

Creswell, K.A.C., *Muslim Architecture in Egypt*, 2 vols, New York 1978

— , *A Short Account of Early Muslim Architecture* (rev. Allan), Aldershot 1989

Davis, P., *The Penguin Guide to the Monuments of India, Volume II: Islamic, Rajput, European*, London 1989

Golombek, L. and Wilber, D., *The Timurid Architecture of Iran and Turan*, Princeton, New Jersey 1988

Goodwin, G., *A History of Ottoman Architecture*, London 2003

— , *Sinan: Ottoman Architecture and its Values Today*, London 1993

— , *Islamic Spain*, London 1990

Grabar, O., *The Alhambra*, Cambridge, Massachusetts 1987

Hill, D., *Islamic Architecture in North Africa* London 1976

— and Grabar, O., *Islamic Architecture and its Decoration 800–1500*, London 1967

Hillenbrand, R., *Islamic Architecture: Form, Function and Meaning*, Edinburgh 2000

Hoag, J.D., *Islamic Architecture*, New York 1977

Irwin, R., *The Alhambra*, London 2004

Meinecke, M., *Mamlukische Architectur in Agypten und Syrien*, 2 vols, Mainz 1993

O'Kane, B., *Timurid Architecture in Khurasan*, Costa Mesa, California 1987

Pope, A.U., *Persian Architecture*, London 1965

Rogers, J.M., *Topkapi Saray: The Architecture*, London 1988

Sumner-Boyd, H. and Freely, J., *Strolling Through Istanbul*, Istanbul 1999

Tillotson, G., *Mughal India*, London 1991

Wilber, D., *The Architecture of Islamic Iran: The Il Khanid Period*, Princeton, New Jersey 1955

Museums, Galleries and Major Private Collections of Islamic Art

Ashmolean Museum, Oxford
Bodleian Library, Oxford
British Library, London
British Museum, London
Edinburgh University Library, Edinburgh
Fitzwilliam Museum, Cambridge
Keir Collection London
Nasser D. Khalili Collection, London
Royal Asiatic Society, London
Royal Scottish Museum, Edinburgh
John Rylands University Library, Manchester
Victoria and Albert Museum, London
Chester Beatty Library and Oriental Art Gallery, Dublin
Royal Ontario Museum, Toronto
Museum of Fine Arts, Boston
Cleveland Museum of Art, Cleveland
The Corning Museum of Glass, Corning, (NY)
Freer Gallery of Art, Washington, DC
Los Angeles County Museum of Art, Los Angeles
Metropolitan Museum of Art, New York
New York Public Library, New York
Textile Museum Washington, DC

State Hermitage Museum, St Petersburg
Museum of Oriental Art, Moscow
Museum für Islamische Kunst, Berlin
Bibliothèque Nationale, Paris
Institut du Monde Arabe, Paris
Musée des Arts Décoratifs, Paris
Musée Historique des Tissus, Lyon
Musée du Louvre, Paris
Museum für Angewandte Kunst, Vienna
Österreichische Nationalbibliothek, Vienna
David Collection, Copenhagen
Gulbenkian Museum, Lisbon
National Archaeological Museum, Madrid
Bardini Museum, Florence
Treasury of St Mark's, Venice
Biblioteca Ambrosiana, Milan
Abeggstiftung, Berne
Musée d'art et d'histoire, Geneva
Benaki Museum, Athens
Archaeological Museum, Rabat
Bardo Museum, Tunis
Topkapı Saray Library and Museum, Istanbul
Museum of Turkish and Islamic Arts, Istanbul
Vakıflar Museum, Istanbul

Archaeological Museum, Istanbul
Istanbul University Library, Istanbul
Islamic Museum, Cairo
National Library, Cairo
Coptic Museum, Cairo
Haram al-Sharif Museum, Jerusalem
The National Museum, Sana'a
National Museum, Damascus
Iraq Museum, Baghdad
L.A. Mayer Memorial for Islamic Art, Jerusalem
Carpet Museum, Tehran
Gulistan Museum, Tehran
Imam Reza Museum, Mashad
Museum of Decorative Arts, Tehran
Museum of Ancient Iran, Tehran
Reza Abbasi Museum, Tehran
Kuwait National Museum, Kuwait
Museum of Islamic Art, Qatar
Lahore Museum, Lahore
Islamic Arts Museum, Kuala Lumpur
Brunei Museum, Brunei

Photo Credits

All images copyright the Khalili Family Trust, except the following:

pp.11 (Süleymaniye, Istanbul), 13 (Masjid-i Shah, Isfahan), 27 (Great Mosque, Damascus), 29 (Samanid Mausoleum, Bukhara), 30 (Gunbad-i Qabus), 31 (Mausoleum of Sanjar, Merv; Kalan Minaret, Bukhara), 32 (Great Mosque, Divriği; Gök Medrese, Sivas), 34 (Alcazar, Seville), 38 (Süleymaniye, Istanbul), 158 (bottom), 162 (centre left), 163 (top right, bottom left, bottom centre, bottom right), 164 (bottom left, bottom right), 165 (top left, top centre, top right, centre right), 169 (left, centre right), 170 (bottom left, centre right), 171 (top left, bottom), 172 (top left, top right, centre right, bottom left), 173 (top left, centre right, bottom right), 176 (bottom left)
copyright Rudolf Abraham/Kamran Images

pp.26 (Dome of the Rock, Jerusalem, interior), 28 (Great Mosque, Samarra), 30 (Friday Mosque, Isfahan), 36 (domes of Sultan Barsbay, Cairo), 41 (Dolmabahçe Saray, Istanbul), 158 (centre), 159 (top right), 162 (bottom right), 166 (bottom left), 175 (bottom right), 176 (top right)
copyright Ancient Art and Architecture Collection

pp.34 (Mosque of Sultan Hasan, Cairo), 165 (bottom left), 166 (centre right)
copyright Doris Behrens-Abouseif

pp.30 (Vaso Vescovali), 32 (Blacas Ewer), 105 (bottom left), 112 (top left), 113 (bottom right)
copyright Trustees of the British Museum

pp.11 (Alhambra, Granada), 14 (Taj Mahal, Agra), 27 (Great Mosque, Cordoba), 28 (Great Mosque, Qayrawan; Mosque of ibn Tulun, Cairo), 29 (Great Mosque, Cordoba), 32 (Citadel, Aleppo), 33 (Alhambra, Granada), 34 (Mosque of Bibi Khanum, Samarqand), 39 (Masjid-i Shah, Isfahan; Taj Mahal, Agra), 160 (top, centre, bottom), 161 (top, centre). 162 (top left, top right), 166 (top right). 167 (bottom right), 168 (top left), 169 (bottom right), 170 (bottom right), 175 (top right). 176 (bottom right)
copyright Werner Forman Archive

pp.168 (bottom right)
copyright Georg Gester/White Star

p.170 (top right)
copyright Robert Harding World Images

p.172 (bottom right)
copyright Images and Stories/photographersdirect.com

pp.12 (Dome of the Rock, Jerusalem), 26 (Dome of the Rock, exterior), 40 (Khiva), 158 (top), 161 (bottom), 176 (centre right)
copyright Christine Osbourne/Copix

pp.29 (Pyx of al-Mughira), 33 (Baptistère de St Louis), 115 (top right), 138 (top right)
copyright photo RMN/Musée du Louvre

pp.31 (Quvvat al-Islam, Delhi), 32 (Qutb Minaret, Delhi), 33 (Mausoleum of Öljeitü, Sultaniyeh), 34 (Timurid tilework), 35 (Gur-i Mir, Samarqand), 97 (bottom left), 159 (bottom right), 163 (top left), 167 (top right), 168 (top right, bottom left), 169 (top right), 170 (top left), 171 (top right), 174 (top left, bottom left, top right, bottom right), 175 (centre right)
copyright Henri Stierlin

pp.29, 106 (top left), 142 (left)
copyright Victoria and Albert Museum

p.25
copyright World Religions Photo Library/Camerapix

Index